The Queen's Slave Trader

The Queen's Slave Trader

JOHN HAWKYNS, ELIZABETH I,

AND THE TRAFFICKING IN

HUMAN SOULS

NICK HAZLEWOOD

wm
WILLIAM MORROW
AN IMPRINT OF HARPERCOLLINS*PUBLISHERS*

HarperCollins books may be purchased for educational, business, or sales promotional use. For information please write: Special Markets Department, HarperCollins Publishers Inc., 10 East 53rd Street, New York, NY 10022.

FIRST EDITION

Designed by Claire Vaccaro

Printed on acid-free paper

Library of Congress Cataloging-in-Publication Data

Hazlewood, Nick.
 The queen's slave trader: Jack Hawkyns, Elizabeth I, and the trafficking in human souls / by Nick Hazlewood.—1st ed.
 p. cm.
 Includes bibliographical references.
 ISBN 0-06-621089-5
 1. Hawkins, John, Sir, 1532–1595. 2. Elizabeth I, Queen of England, 1533–1603—Relations with slave traders. 3. Great Britain—History, Naval—Tudors, 1485–1603—Biography. 4. Great Britain—History—Elizabeth, 1558–1603—Biography. 5. Slave trade—Great Britain—History—16th century. 6. Slave traders—Great Britain—Biography. I. Title.

DA86.22.H3H39 2004
382'.44'094209031—dc22 2004044940

04 05 06 07 08 WBC/RRD 10 9 8 7 6 5 4 3 2 1

For Caroline

Infatuate Britons, will you still proclaim
His memory, your direst, foulest shame?

—JOHN KEATS

"Lines Written on 29 May, the Anniversary of
Charles's Restoration, on Hearing the Bells Ringing"

CONTENTS

ACKNOWLEDGMENTS

I would like to express my gratitude to the many people that have helped me along the way with this project, in particular: Tom Holland, whose unraveling of seemingly indecipherable sixteenth-century Latin manuscripts was a wonder to behold; Marion Marshrons and Gail Dean, for their work on equally difficult Spanish documents; and Catherine Barral, for holding up the French end of the operation. I owe a debt of gratitude also to Francisco Sanchez Rico, for his work on my behalf in the Archivo General de Indias, in Seville; to Eurig Jeffreys, for pointing me in the right direction on the consequences of starvation and refeeding; to David Jeffreys, for his help with the early stages of the book; and to Luigi Bonomi, for his unceasing enthusiasm and energy.

I am especially grateful to staff in both the British Library's Rare Books and Music reading room and the Public Record Office at Kew, and also to Adam Perkins and Godfrey Waller in the Department of Manuscripts of Cambridge University Library.

I would also like to say many thanks to the following institutions for allowing me to study, and in many instances quote from, manuscripts in their possession: the British Library, Department of Manuscripts; the Public Record Office, Kew; the

Syndics of Cambridge University Library; the Archivo de Indias in Seville; and the Archivo General de la Nación in Mexico.

Finally I would also like to thank the following organizations and institutions for allowing me to use images in their possession: the National Maritime Museum, Greenwich, London; the British Library, London; Getty Images; the College of Arms, London; the National Archives at the Public Record Office, Kew; the Pepys Library, Magdalene College, Cambridge; and Plymouth Museum and Art Gallery.

A NOTE ON LANGUAGE AND GEOGRAPHY

Many of the documents used in the researching of this book were translated from medieval Latin, Spanish, and French. At other times the English was obscure or difficult to comprehend. I have endeavored to preserve the language in as authentic a fashion as possible, but wherever understanding would be undermined I have opted to make the language as readable as possible, without distorting the meaning.

Two points are worth mentioning: First, the Hawkyns family generally spelled their name in this way, while others wrote their name Hawkins. I have preserved the original family spelling, though occasionally when others write about or to them the alternative version has been employed.

Second, while journeys to Latin America in the sixteenth century present few problems in their geographical reconstruction—many names have remained unchanged, and the documentary evidence is detailed and accurate—the same cannot be said about West Africa. Hawkyns and his men sailed up and down rivers with names that no longer always apply, many of which were never put on maps, and others of which the names have

been buried by history. It is more often than not possible to accurately place locations from evidence within the narrative, but at times it proves elusive; suffice it to say that sometimes only the general rather than the specific location can be identified.

INTRODUCTION

At San Juan de Ulúa, on the Atlantic coast of Mexico, England's earliest venture into the slave trade came to a violent and calamitous end. Her first slavers, cut to ribbons by marauding Spaniards, died on their ships, in the sea, and on the *arrecife* Gallega, a small hummock of an island, where they were hacked down around the walls of the Casa de Mentiras—the House of Lies.

The year was 1568. Captain John Hawkyns, Queen Elizabeth I's personal slave trader, was among the few to escape. Around him his fleet was in tatters: his men drowning, his ships sinking beneath the ferocious bombardment of Spanish cannon fire. Along the shore, and in the bloodstained waters of the port, straggling survivors were rounded up by the victorious Spaniards. The shock of defeat set back decades England's involvement with the transatlantic traffic it would one day master. A battle-scarred Hawkyns wrote to the queen's secretary, William Cecil, that it had been a most "troublesome voyage.... [I]f I should write of all our calamities I am sure a volume as great as the Bible will scarcely suffice."[1]

After the Hawkyns debacle England had to wait until she began to collect colonies of her own for her involvement in the slave trade to be renewed and grow. By the early years of the eighteenth century the country's capitalists were investing energy, money, and

firepower in the struggle to assume control of the traffic in African captives. The trade was the key to power and wealth beyond anything previously experienced, and on the back of human misery England's businessmen, merchants, entrepreneurs, industrialists, and colonists punched their way into the modern age. English ships carried more than half the captives leaving African ports. Slaves became the fuel with which the emerging industrial nation powered its economy, and on which ports such as Bristol, Liverpool, and London grew wealthy.

Before them went Hawkyns. In a series of voyages to the west coast of Africa in the 1560s, Hawkyns burned down villages and hunted down the people. He attacked Portuguese caravels loaded with slaves, and robbed them of their cargo of "human cattle" or "specimens," as contemporary documents called them. Hawkyns threw his slaves into the holds of his ships, where they were shackled in wretched conditions while being shipped across the Atlantic to the Caribbean island of Hispaniola and the northern coasts of Latin America—present-day Venezuela, Colombia, and Mexico. Here they were sold to Spanish colonists who bought them, sometimes willingly, and sometimes at the end of a gun.

In their simplest form the Hawkyns voyages were exercises in turning a quick profit: for the queen, for himself, and for the group of rich London merchants and royal courtiers who had invested in the expeditions. Pure greed may have been a powerful motive, but the voyages had a greater significance: a succession of popes had handed control of the Atlantic to Spain and Portugal, to the exclusion of all others. The Hawkyns voyages represented an important attempt to gate-crash this cozy arrangement.

John Hawkyns is an important figure in English history, a hero of the 1588 defense of England against the Spanish Armada; yet no understanding of the origins of the English slave trade is complete without an examination of the man and the slaving voyages of his early years. This then is the story of the cruel and audacious slaving voyages of John Hawkyns, slave trader by appointment to Queen Elizabeth I.

The Burly
Grizzled Elder

ONE

John Hawkyns had tasted blood at a very early age. His killing
of a barber in his hometown is recorded in the Calendar of
Patent Rolls for July 1552:

> *Because the king learns by the record of Nicholas Slannyng, coro-*
> *ner within the borough of Plymouth, Devon, upon view of the*
> *body of John Whyte, late of Plymouth, "barbour," that John*
> *Hawkins killed him in self-defence:*

PARDON TO THE

SAID JOHN HAWKINS

FOR THE SAID DEATH.[1]

At the time of the royal pardon Hawkyns was barely twenty
years old. No more is known of the events leading up to the
tragedy, and nothing is known of how John Whyte was killed. It
certainly involved violence. Whether Hawkyns's innocence is re-
ally established by the pardon is neither here nor there—such
pieces of paper could be purchased by rich and powerful families.
What it does illustrate, however, is that even as a young man
from a wealthy background, John Hawkyns was very much a

product of the brutal time, place, and family that he was born into. From what is known of the Hawkyns family, the killing of Whyte could have resulted from the unpremeditated pub brawl of a young man, or from the serious factional fighting in a town that in its political rivalries and patronage, often presaged the boss politics of great modern cities such as Chicago.

John Hawkyns was born into one of the two or three wealthiest merchant families in the important seaport of Plymouth, a family that boasted a rich West Country pedigree and that would imbue him with a craving for luxury and intrigue, and quite possibly the lust for power that was to characterize all aspects of his life. There is uncertainty about his date of birth, but 1532 is the year etched onto a contemporary memorial tablet to him and is the most commonly accepted. His mother, Joan Trelawney, was a daughter of William Trelawney of Cornwall. His father, William, was the offspring of a powerful Tavistock merchant and the heiress of King Edward IV's sergeant-in-law, William Amadas of Launceston. As one seventeenth-century commentator noted, William Hawkyns was "a gentleman of worshipful extraction by both his parents and several descents."[2]

John had a brother William, thirteen years his senior, who in years to come would be his business partner, and quite probably a sister whose existence is almost completely absent from the records, except for the fact that she had a son called Paul. They lived together in a smart town house in a narrow lane at the end of Kinterbury Street, in the southwest quarter of Plymouth's old town. The house, bought when John was five years old, was clear evidence of the wealth of the Hawkynses: from their small back garden they could look down at the indisputable evidence of their familial power, the wharves and warehouses of Plymouth's inner harbor, Sutton Pool, where they ruled the roost over the bustle and business of the docks.[3]

The patriarch of this family, William Hawkyns, was an immense presence in the affairs of the town, and a profound influence upon both of his sons. The elder Hawkyns moved in

powerful circles. Political manipulation, maneuvering, and, no doubt, graft and patronage meant that he collected positions of power and influence. In 1523 he became collector of the subsidy for Devon, and the next year was made treasurer of Plymouth. He was elected mayor on two occasions, in 1532 and 1538, and member of Parliament in 1539—when he witnessed the final dissolution of the monasteries by the government of Henry VIII—as well as in 1547 and 1553.[4] In the year before he became town treasurer, William Hawkyns's personal income was a massive £150 a year. At not much more than thirty years of age, William Hawkyns was one of the five richest men in town.[5]

In order to achieve high office William Hawkyns did not balk at using foul play. In 1527 he was ordered before the court of common pleas in Westminster to answer allegations that, along with Peter Grisling, James Horsewell, John Coram, John Grace, and Lucas Cocke, he did beat and wound one John Jurdon from Plymouth "so as to endanger his life."[6] The charges resulted in little in the way of punishment. Soon after, Hawkyns became entwined in a bitter feud with one of his fellow bullyboys, Peter Grisling. In 1535 the struggle for power resulted in William Hawkyns being hauled to Westminster to appear before the secretary of state, Thomas Cromwell, who imposed on him a temporary ban from membership in the corporation of Plymouth.[7] Nevertheless, the feuding and scheming continued until Grisling conceded defeat and moved off to nearby Saltash, from where as mayor he unsuccessfully attempted to gain control over the harbor dues for the whole of Plymouth Sound.[8]

Shipping and mercantile activities were the cornerstones of William Hawkyns's life. As an energetic and successful businessman, he was a part of a thrusting, ambitious class that was pushing its way to the surface as England finally emerged from the dark ages of the Hundred Years War and the internecine conflict and regicide of the Wars of the Roses. This aspiring new middle class consisted of men who were to benefit from the

centralization of government, the broken stranglehold of Roman Catholicism, the spread of Protestantism, and a growing sense of national unity. They were men increasingly able to exploit a sophisticated network of commercial trading routes established by the Hapsburgs, linking southern Germany, Italy, the Netherlands, Spain, Portugal, and England.[9] And William Hawkyns was among them, taking advantage of this lucrative system from a very early age, making a huge pile from exporting tin and cloth to the Continent while importing wine from Spain, Portugal, Bordeaux, and the Canary Islands, pepper and sugar from Portugal, salt from La Rochelle, and fish from Newfoundland.[10]

In 1530, William Hawkyns initiated his most grandiose schemes yet, sailing from Plymouth to West Africa and from there to Brazil. In so doing, he became the first Englishman to carry out a triangular transatlantic trade. Fifty years later, his son John wrote down the story of those early voyages. Building on an idea he had got from contacts in Seville and Lisbon, John Hawkyns wrote that his father had sailed for Africa in his own ship, the *Paul*. On the Cess (now Cestos) River, in present-day Liberia, he traded with Africans for ivory and other commodities before pushing off across the Atlantic for the land of Brazil.

Since its discovery by the Portuguese in 1500, Brazil had been hotly contested by the French. In 1523 the Portuguese king, João III, issued instructions that all foreign ships found off its coast should be sunk. Had William Hawkyns been captured there would have been no mercy. Instead, his skills as a navigator, seaman, and merchant kept him out of trouble, and his trip was a success: trade with the Brazilian Indians was brisk, and his relations with them were so cordial that after a second voyage there in 1531 he brought a tribal chief back to England. In Brazil he left behind one of his closest confidants, Martin Cockeram. The Indian chief caused a stir, holding the royal court spellbound and fascinating Henry VIII. John Hawkyns recalled that at the sight of the Indian

the king and all the Nobilitie did not a little marveile, and not
without cause: for in his cheekes were holes made according to
their savage manner, and therein small bones were planted, stand-
ing an inche out from the said holes, which in his own Countrey
was reputed for a great braverie. He had also another hole in his
nether lippe, wherein was set a precious stone about the bignesse of
a pease: all his apparell, behaviour, and gesture, were very strange
to the beholders.[11]

Sadly, the chief died on board the ship carrying him home af-
ter a year in England. It might now be expected that the Indians
would cash in their pledge and take the life of Martin Cockeram.
Remarkably, however, the Indians listened to Hawkyns's expla-
nation with sympathy before handing Cockeram back without
hesitation. Not only that, the Englishmen returned home with a
ship full of precious Brazilian dyewood.[12]

Over the course of the next decade, Hawkyns continued with
sporadic but profitable voyages to Africa and Brazil. Few records
of his trips survive, but one expedition that left Plymouth in
1540 showed the profits that were to be made. The *Paul* left Ply-
mouth in the command of John Landy with the following
merchandise on board:

940 hatchets, 940 combs and 375 knives weighing 30 cwt of iron	VALUE £3 15s
5 cwt copper, and 5 cwt of lead in manelios [arm rings]	VALUE £6
three lengths of woollen cloth without grain	
19 dozen nightcaps, 10 cwt of copper and 10 cwt of lead	VALUE £14[13]

And though the value of the cloth on the ship is not accounted for (the customs duties on it were three shillings and six pence, so it would not have been of great value), the size of the profits was evident from the merchandise brought back eight months later:

92 tons of Brazil wood VALUE £613 6s 8d

one dosen olyfantes
teeth weighing 1 cwt VALUE £1 10s[14]

John Hawkyns could not but be shaped and influenced by the character, power, dynamism, and wealth of his father. William Hawkyns not only passed on to his son practical skills such as navigation and seamanship—John joined family runs to Bordeaux for wine—he also imbued him with a sense of confidence bordering on arrogance, a ruthlessness, and a vibrant energy that coursed through the veins of the Hawkyns male line. There was more than that, though. John Hawkyns was also shaped by the difficult times into which he was born. This was a dangerous and bloody era of shifting political and religious allegiances, and dark scheming conflicts that were to become central to Hawkyns's life once he had decamped to London to become a figure of international fame and infamy. It was, however, in Plymouth that his character was molded and his attitudes were shaped.

TWO

Legend has it that in 1200 B.C., Brutus, grandson of the Trojan Aeneas, and his men landed in the West Country. Here they found a race of pugnacious Cornish giants, all of whom they slew with the exception of their leader, Goemagot, a man said to be "twelve cubitts high and of such strength that with one stroke he pulled up an oak as it had been a hazel wand."[1] In a specially arranged contest, Goemagot incensed the Trojan warrior Corinaeus by breaking three of his ribs. Geoffrey of Monmouth recorded what happened next: "Corinaeus heaved him up on his shoulders. Mounting up to the top of a high cliff, he hurled the deadly monster into the sea, where, falling on the sharp rocks, he was mangled all to pieces and dyed the waves with his blood."[2] The cliff from which he dashed the giant was thereafter known as Lam-Goemagot, Goemagot's Leap, which in later years became Plymouth Hoe. Edmund Spenser wrote of the event in his poem *The Faerie Queene:*

> *That well can witnesse yet unto this day*
> *The Western Hogh, besprincled with the gore*
> *Of mightie Goemot whom in stout fray*
> *Corineus conquered, and cruelly did slay.*[3]

It suffices to say that the real origins of Plymouth are far less fanciful. There were settlements in the area of Plymouth as early as 1000 B.C., but its growth into an important town did not begin until after the twelfth century, when large amounts of tin were discovered on the western fringes of Dartmoor. The immediate benefactors had been the stannary towns of Tavistock, Ashburton, and Plympton, but as vast quantities of mining waste washed down from the moor, rivers and streams ran red and clogged up. Within a hundred years sandbars blocked the way to Plympton, the river became impossible to navigate except in small boats, and larger cargo ships were forced to wait at Sutton Pool near the mouth of the Plym.[4]

This position—where the estuaries of the Tamar and Plym Rivers merge and disgorge into the deep and sheltered waters of the sound—had many advantages, and a settlement began to develop. Cattewater at the opening of the Plym became the roadstead, while Sutton Pool developed as the location for jetties and wharfs. Trade flourished: textiles and metals poured out of the port; wine, sugar, garlic, onions, iron, and fruit poured in. Pilgrims to Canterbury in Kent and Santiago in Spain used the new port as a point of arrival and departure,[5] and in 1439, Plymouth was granted a royal charter. By the sixteenth century it was the most important town in Devon, the most important county of the West Country.

A map from 1540 shows how Plymouth would have appeared in Hawkyns's time. Tucked into a fold in the land, it was not a good-looking town, but an open sore of narrow, unsanitary streets and tightly spaced houses, huddled together for protection against the wind and rain.[6] The main thoroughfare ran from the recently abolished White Friars on its northern edge, past the market cross, and on to St. Andrews Church in the south. Parallel streets ran with gridlike regularity. Seven thousand people lived within the walls of a town where cramped conditions fostered the rapid spread of disease. In 1527 and 1550 the "sweating sickness" raged throughout Plymouth, and in 1570 the plague struck.[7]

Nevertheless, it was a prosperous place: behind the latticed windows of high Tudor homes lived rich merchants, successful guildsmen, and important government officials. Two major fairs were held every year, on the feasts of St. Matthew and St. Paul. Every Monday and Thursday saw a bustling market in the town square. For entertainment inhabitants could watch bulls or bears being baited by dogs, listen to troupes of musicians, attend morality plays in the church, or booze to their heart's content in drinking houses such as the Turk's Head, the Mitre Tavern, and the Pope's Head. On the eve of Freedom Day the newly elected mayor was marched around the boundaries of the town to remind him of the extent of his powers, and boys gathered raucously outside the guildhall to knock down a glove hung over its door. Next day boys from the old part of Plymouth would fight with out-of-towners—so-called Breton Boys—for the prize of a barrel of beer.[8]

Outside the town walls on the elevated ridge of Plymouth Hoe sat the fire beacon, with a store of dry furze at the ready in case of danger. Down below, where fishermen dried their nets on the waterfront and archers practiced their craft, most of the town's capital punishments were carried out. Here in 1548 sixteen-year-old John Hawkyns probably witnessed the putting to death of a Cornish rebel. A quarter of the Cornishman's body was taken to Tavistock to serve as a warning; his head and another quarter were skewered on a pole and exhibited from Plymouth Guildhall. Such executions were brutal but commonplace. The town's audit book coldly recorded the event:

Item paid for a dozen faggots and a quart of rhede for doing the execution upon the Traytor of Cornwall	8d
Item for timber for the gallows	12d
Item for making the gallows and for working at the Howe	14d

Item paid to John Wylstreme for doing execution upon the Traytor	6s
Item to lawes man for leading the horse when the traytor was drawen to execution	4d
Item for two poles to put the head and the quarter of the said traytor upon and for 2 crampys of iron for to stay the pole upon the Guildhall	10d
Item paid for the dyn' of the undersheriff of Cornwall being here when the traytor was put to execution	5s
Item paid to John Matthew for carrying a quarter of the traytor to Tavistock	12d
Item paid to William Bickford for wine at the receiving of the traytor of Cornwall	16d[9]

Lesser crimes were dealt with just as crudely: near Sutton Pool the ducking stool was used on "unruly" women, and the pillory, stocks, and whipping post were all frequently in use, for strict rules governed behavior in the town. Nobody but freemen and their families were allowed to live permanently within the city walls; strangers could spend no more than two days in the town, and had to be off the streets by seven in the evening, with everybody else indoors an hour later. To protect townspeople, constables prowled the streets, and a town beadle hounded beggars away to nearby Compton, and prostitutes to Stonehouse and Stoke. Ordered to prevent riotous houses, innkeepers permitted men and women to stay the night only on proof that they were married.[10]

Above all of this social regulation was the town corporation, presided over by the annually elected mayor. To get on in Plymouth one had to be a member, for the corporation—which consisted of

twelve aldermen and twenty-four councillors chosen from among the town's freemen—had its fingers in every pie.[11] With its origins in the Plymouth Merchants' Guild, the corporation was the engine of a system geared to self-promotion, exclusivity, and the elimination of competition within the town's walls, all under the guise of enforcing commercial regulations and fair trading practices. Its attention to detail was both impressive and intrusive; for example, in 1565 the mayor ruled that aliens could buy no more than a thousand fresh pilchards a day, and nobody else could buy more than five thousand, unless the fish were in danger of going bad.[12] The Hawkyns family, first through William senior, and then through the brothers William and John, became masters of playing the corporation to their own advantage.

For all of its wealth and importance to England, however, Plymouth—perched on the western edge of the kingdom, looking out to an open sea in an era of frequent wars and constant piracy—felt apart from the rest of the country and vulnerable. This feeling was not without reason: in 1403 thirty ships out of Brittany had sailed up the sound and into the Cattewater, from where twelve hundred men had rushed the town for a twelve-hour killing spree. Six hundred buildings were engulfed in flames and tens of citizens were murdered.[13] In consequence the centuries had seen a formidable array of fortifications—castles, walls, gun emplacements, and chains—put in place and occasionally put to use.[14]

Moreover, the town's isolation fostered a keen sense of self-reliance, self-defense, and, at times, self-rule. Plymouth was more than two hundred miles from London, a considerable distance in the sixteenth century, and the roads were atrocious. After a visit to the West Country, Secretary of State William Cecil commented that he had never seen or experienced "fouler ways."[15] The old Roman roads leading directly out of Devon had long been abandoned, in favor of a circuitous route linking convenient hostelries, refreshment stations, and the opportunity to change the horses at Tavistock, Okehampton, and Crediton.[16] At the same time the county was supplied by long chains of packhorses

trundling goods from town to town. As late in the century as 1593, Walter Raleigh was declaring it impossible to get ordnance to Plymouth because "the passages will not give leave."[17]

Plymouth's geographical isolation from the heart of England could not negate its undoubted importance to the country: it was a major seaport, and the advance defense against invasion from the west. This conferred on its people an arrogant sense of self-importance and individuality. Yet as much as they looked in on themselves with smug self-satisfaction, they also looked outward: the town was England's window on a wider world, and while the sea presented danger, it also offered possibility. Plymouth already had a reputation as a fishing port, but in the sixteenth century, as the new mercantile classes began to prosper, the call to push out over the horizon became irresistible. From here the town's great merchant families strode off into Europe, Iberia, the Mediterranean, and farther afield. It would have been no surprise to the people of Plymouth that over the course of the sixteenth century their town would become associated with the great majority of England's adventurers, explorers, pirates, and privateers—famous men such as Francis Drake, Martin Frobisher, Thomas Cavendish, the Gilberts, Walter Raleigh, John Davis—and the first English settlers of North America. Nor was it a one-way street, for it was here, too, that French, Spanish, Italian, and Portuguese traders came with exotic goods and boastful stories of marvelous countries and riches beyond belief.

Plymouth's geographical separation from the rest of England often allowed the townspeople to become a law unto themselves, and it was this that may have been the single most profound influence on John Hawkyns. Plymouth in the sixteenth century was a haven for the pirates and privateers that swarmed the English Channel and the waters off Spain and Portugal. As early as 1485 one chronicler had written of nearby Cawsand Bay that it was "an open road, yet sometimes offering succour to the worst sort of seafarers, as not subject to the comptrollment of Plymouth fort."[18] By the middle of the next century, such activities were

big business; and at the heart of this often shady underworld of plunder and pillage sat the Hawkyns family.

The distinction between piracy and privateering should have been simple: The former was straightforward robbery committed at sea, almost always with violence or the attendant threat of it. Privateers, on the other hand, carried out legally sanctioned attacks on trade ships of an enemy during a time of conflict, or against a ship that was deemed to have entered its own private war with an act of piracy. A privateer acted under letters of marque issued by the authorities, which protected the bearer from the punishments meted out to pirates. This was, however, a complicated age. When England was at war—as it frequently was in the sixteenth century—privateers made up a sizable part of its fighting force, assaulting and harassing enemy ships. Yet even in times of peace there was rarely a moment when fighting crews needed to fear unemployment, for this was a Europe in which conflicts exploded and subsided with frightening regularity. In the Low Countries, Calvinist rebels were always more than willing to hand out letters of marque to mercenary ships willing to attack the ships of their colonial masters, the Spanish. Huguenot leaders were equally keen to encourage attacks against the French, with whom they seemed to be continually in conflict around La Rochelle. Thus the Channel swarmed with ships looking for trouble. English, Dutch, and Huguenot privateers mingled freely, united by their thirst for loot; but more than that, because their attacks were aimed almost exclusively against Spanish and French shipping, they also represented the unofficial coming together of a Protestant navy. And though Elizabeth publicly decried the state of the seas around her island and introduced legislation to curb piracy, there was no doubt of the tacit approval that she and her government gave to those men marauding the Channel.

More than any other port in England or on the Continent, Plymouth welcomed these unruly swarms. The city was a natural home for them, an excellent, isolated shelter, overrun with

sailors, where a good proportion of the population was deeply implicated, and where a vast black market for goods taken at sea thrived. As one of the most important families in town the Hawkynses sat at the nerve center of this activity, directing actions, coordinating ships both of their fleet and others, and reaping the lucrative benefits.

It was inevitable that amid this frenzy, the fine line between piracy and privateering would be blurred and transgressed many times; in fact, even the elder William Hawkyns, who spent much of the 1540s "annoying the King's enemies," had a number of run-ins with the law. In 1545, with England at war with France, Hawkyns overstepped the mark by sending his ships after a Spanish vessel that he claimed was carrying French goods. When he sold the disputed booty even as an official inquiry looked into complaints against him, he was found guilty of contempt and spent a short spell behind bars.[19]

William Hawkyns's death in late 1553 or early 1554[20] did not put an end to the family business. His legacy was secure, and his sons' futures, both legitimate and otherwise, were firmly footed. He left them a large fleet of ships, wharfage, warehouses, and a wealth of experience and contacts. During the course of the next decade the position of privateer in chief would be assumed by William junior. At the same time, brother John enjoyed himself in the English Channel harassing and despoiling ships, particularly in those years when England was at war with France. Plymouth continued to welcome a shifting group of disaffected seafarers—pirates, Huguenots, and local adventurers.[21]

ALL OF these factors shaped John Hawkyns. As a major figure on the local political and mercantile scene, the young man had the swagger and arrogance that came with his station in life. The record shows that while he was strong and brave, and at times compassionate, he also had contempt for fools and social inferiors. He was not averse to acts of violence, and

may even have rejoiced in them. Nevertheless, from an early age his skills as a seafarer commanded the respect of both officers and men. Yet constructing a sound picture of him is difficult since so much of what has been written of Hawkyns amounts to little more than hagiography. History and literature have painted him as a man of action, a no-nonsense man of the sea, scornful of the fripperies of life and of meddling politicians. Typically Hawkyns has become a salty sea dog of Devon, a bold rover, the patriarch of Plymouth's (and by default, the nation's) sailors. In Charles Kingsley's popular children's classic *Westward Ho!* written in 1855, Hawkyns strides into a waterfront tavern shortly after the Spanish Armada had been dispersed in 1588. His purpose is to rally the troops:

A burly, grizzled elder, in greasy sea-stained garments, contrasting oddly with the huge gold chain about his neck, waddles up, as if he had been born, and had lived ever since, in a gale of wind at sea. The upper half of his sharp, dogged visage seems of brick-red leather, the lower of badger's fur; and as he claps Drake on the back, and with a broad Devon twang, shouts, "Be you a-coming to drink your wine, Francis Drake, or be you not?"...for John Hawkyns, admiral of the port, is the patriarch of Plymouth seamen... and says and does pretty much what he likes in any company on earth.[22]

It is an image backed up by Edmund Spenser in his poem *Colin Clout's Come Home Again*, where Hawkyns becomes Proteus, driving a herd:

Of stinking Seales and Porcpises together;
With hoary head and dewy-dropping beard,
Compelling them which way he list and whether.[23]

Yet the glimpses afforded by contemporary records illustrate a more complex man. From the many letters he wrote during the

course of his life—both the quality of their content and the clarity of his handwriting—and from the fact that he could speak some Spanish, it is possible to discern a man of intelligence and education. At the same time the image of a scruffy, "grizzled," and battle-hardened mariner is too simple. Elizabethan ships may not have been particularly sanitary places, but John Hawkyns had exquisite and expensive taste, and even while at sea he indulged himself with every available luxury. He often took a small orchestra of musicians on voyages for his own personal entertainment, and insisted on having his meals presented on fine plates of silver.[24] On his third slaving voyage he went to sea with no less than fifty changes of clothes; one eyewitness recorded seeing him wear over the course of the journey diverse "suits of apparel of velvet and silk with buttons of gold and pearl." This witness noted that the cost of Hawkyns's clothes, along with the furniture he had in his cabin, could have been as much as £250. Another of his men was to testify that Hawkyns's bed and furniture alone came to as much as £40.[25]

The few surviving portraits of John Hawkyns support this alternative image: though their provenance may be in doubt, they are unanimous in their depiction of a finely robed man, bright-eyed, alert, and attentive. He is shown to be sharp faced, with a well-groomed beard and mustache in the fashion of the day. In each portrayal he looks straight at the artist, with a piercing, unsettling, almost contemptuous glare, accentuated by the fire of his red hair. The signs of his wealth are there—in several, an expensive hat secured with a fancy hat pin and festooned with jewels nestles on his head, and a crisp white ruff accentuates the frame of his face; and in at least two portraits a long and dramatic necklace swoops over a doublet of velvet or brocade. In a fine portrait, probably painted in 1591 by the painter Hieronymus Custodis, one gloved hand rests at ease on his hip while the other delicately clasps the hilt of an elaborately decorated sword. Around his waist an elaborate girdle delineates a man both lean and fit, even in his later years. In another painting a small fleet

sits at anchor in the background, and is one of two that bear the inscription "Advancement by diligence."

Other evidence about Hawkyns the man is more difficult to track down. By the time he became an elder statesman he had acquired a reputation for rude behavior, curmudgeonliness. Whether it is fair to judge the young man by the man he became is open to question, but in the stories of English derring-do contained in the near-contemporary volumes of *Purchas His Pilgrimes*, there is a letter from a correspondent calling himself RM. He claimed to have known both Hawkyns and Francis Drake, and took the opportunity to compare and contrast the two of them. While Drake emerged well from the comparison, Hawkyns was clearly respected rather than liked. When it came to war, RM wrote, Drake was "of a lively spirit, resolute, quick and sufficiently valiant," but Hawkyns was "slow, jealous and hardly brought to resolution. In council Sir John Hawkins did often differ from the judgment of others, seeming thereby to know more in doubtful things than he would utter." Whereas Drake dealt with weighty matters with poise, Hawkins "did only give the bare attempt of things, for the most part, without any fortune or good success therein." Both men, RM continued, were "faulty in their ambition," though willing to put in the hard work necessary for success and glory. Hawkyns, however, had "malice with dissimulation, rudeness in behaviour, and was covetous in the last degree." The author concluded that though both had risen through their own virtues and the fortunes of the sea, "there was no comparison to be made between their well-deserving and good parts, for therein Sir Francis did far exceed. This is all I have observed in the voyages wherein I have served with them."[26]

Faint praise indeed. That Hawkyns was deemed to be surrounded by a general air of difficulty was backed up by Thomas Maynard's account of Hawkyns's last voyage in 1595. He was, says the author, "a man oulde and warie . . . entering into matters with so laden a foote that the others meate would be eaten before his spit could come to the fire."[27]

There is no doubt that in later life Hawkyns made enemies more readily than he made friends. There were allegations that while treasurer of the Royal Navy he used his position to further his own wealth. Hawkyns was accused of buying materials at one price and selling them on to the queen at a grossly inflated rate. Another accuser alleged he was building and fitting out ships in his own dockyards with materials purchased for the queen's navy. Indeed, in 1583, articles were drawn up "against the injuste mind and deceitful dealings of John Hawkyns." In these it was said that his "deceit and contempt committed against her Majesty and common weal" had caused "the decayed state of her highness' navy."[28]

The charges may have been harsh: as treasurer of the navy, overseeing streamlining and cutbacks, he was bound to make enemies of those who would lose out on contracts; but the suspicion remains that there was a germ of truth in the complaints and that John Hawkyns was both greedy and covetous. An interesting incident throws light on the allegations against him. On 11 October 1573, Hawkyns was attacked and stabbed by a deranged man while in the Strand. It was a case of mistaken identity—the attacker, Peter Burchett, had wanted to kill a close adviser to the queen, Sir Christopher Hatton. Hawkyns was gravely wounded, and on what he believed to be his deathbed, he made a last will and testament that stated that all his worldly goods amounted to less than five hundred pounds. In the articles drawn up against him ten years later it was noted that despite having spent the previous decade as treasurer of the navy—a job for which there was scant financial recompense—Hawkyns had managed to accumulate a considerable fortune. Without being corrupt, how could he have become so rich? Though Hawkyns was never charged with any offense, the allegations did not disappear. William Cecil settled instead for the drafting and implementation of a new set of regulations against possible future abuses.[29]

At the very core of John Hawkyns, however, was a deeper, more

important mystery. The middle years of the sixteenth century, from the divorces and executions of Henry VIII through the defeat of the Spanish Armada, were years of religious turmoil, controversy, and bloodshed. John Hawkyns's slaving voyages were a symptom of a newly energized Lutheran power willing to issue a challenge to the Catholic world. It is strange, therefore, that at the top of these missions sat a man who was at the very least ambivalent about where his religious loyalties lay.

In Tudor England politics and religion were rarely far apart, and for a man of Hawkyns's social standing it was imperative to declare one's religious allegiances. It was also dangerous. The years since the death of Henry VIII had witnessed great swings in the country's religious orthodoxy. During the brief reign of Edward VI (1547–53), a rampant Protestantism had gained the ascendancy and unleashed a wave of persecution of Catholics. Under his successor, Mary, the tide had turned; hundreds of Protestants had been burned at the stake, including some of the most eminent men in the land: the archbishop of Canterbury, Thomas Cranmer; the bishop of Worcester, Hugh Latimer; and the bishop of London, Nicholas Ridley. As John Hawkyns prepared for his first voyage to Africa in October 1562, the Protestant Queen Elizabeth fell sick with suspected smallpox. There was no certainty that she would be alive when he returned, and even less certainty over her succession.

Hawkyns was a West Country man, and both Devon and Cornwall had been ablaze with religious controversy. In 1548 the county's archdeacon, William Body, had been hacked to pieces by a mob in Helston for trying to introduce centrally ordained limitations on religious processions, the prohibition of handing out bread after mass, and the removal of crosses and altar lights from churches. A year later, when Hawkyns was only seventeen, rebels rose against the Act of Uniformity, which enforced further changes to church services and imposed the new, all-English Book of Common Prayer. Thousands marched and fought with the authorities. The city of Exeter was besieged, and Plymouth was saved

only by stout resistance around the castle. It is surprising that a family as prominent as the Hawkynses left no record of their activities during this troubled period.

In 1552, William Hawkyns Sr. did not make it to Westminster for the Protestant Parliament of the duke of Northumberland. It may be that he was too old or too frail—but when Mary became queen and with Catholicism restored, William Hawkyns felt able to attend the Parliament of 1553. It might be ascribing too much of this to religious loyalties, but in the years to come there would be plenty of evidence that John Hawkyns was far from unswerving in his allegiance to the Protestant ascendancy of Queen Elizabeth.[30]

THREE

With the end of a war against France that had been waged since 1557, and an end for the moment to his privateering activities, John Hawkyns seems from 1559 to have oriented his activities away from Plymouth and made a new home in London. He was still influential in the West Country and spent a great deal of time there—he had become a freeman of the town in 1556, and in 1560 he was a councillor there—but he appears to have decided that there was more power and money to be made by moving in the influential circles that surrounded the royal court, Parliament, and the finance houses of the capital city and that the time was ripe to open up a new arm of the Hawkyns business operation. Around this time his only son, Richard, was born. There is some mystery about this, as John Hawkyns did not get married until January 1567, but if indeed his son was born out of wedlock, it was never a hindrance, since Richard went on to become a renowned mariner in his own right.[1]

Hawkyns's increased gravitation toward London opened a new phase in his burgeoning career, one in which important doors to high places flew open. He arrived in the capital with a big idea: the capture of Africans in Guinea, and their sale to slave-hungry Spanish colonies in the West Indies and South

America. It was an idea new to English merchants, and one Hawkyns had taken to after several business trips he had made to the Canary Islands. Here Hawkyns,

> by his good and upright dealing, being grown in love and favour with the people, informed himself among them by diligent inquisition, of the state of the West India....And being amongst other particulars assured that Negroes were very good merchandise in Hispaniola, and that store of Negroes might easily be had upon the coast of Guinea, resolved with himself to make trial thereof.[2]

John Hawkyns had originally gone to the Canary Islands on business for his father. The islands' most important product, the sweet, fortified wine malmsey (otherwise known as malvasia or malavesie), was a hugely popular tipple in England. Perhaps best known these days because it was in a butt of malmsey that, according to Shakespeare, Richard III had drowned the duke of Clarence, the wine had its origins in the Peloponnese village of Monemvasia (from which it derived its name). Malmsey had flourished in the Canaries, and by the middle of the sixteenth century it was attracting the attention of enterprising English merchants, many of whom made Tenerife the center of their operations. Freelance traders such as Richard Grafton and Charles Chester supplied English ships and took wine and sugar back on their own vessels. In 1553 the powerful London merchants Hickman and Castlyn opened up operations on Gran Canaria, where Edward Kingsmill acted as their factor. On Tenerife they were represented by both William Edge and Thomas Nicols, who reported that production of the wine had "soared to more than 12,000 pipes a year."[3]

By the early 1550s William Hawkyns the elder had muscled in on the act, establishing a frequent and regular traffic between Plymouth and Tenerife. Small ships of twenty to fifty tons shuttled back and forth, their holds laden with barrels of malmsey for a three-month return voyage that was generally pleasant and

relatively trouble-free. Tenerife, with the sharp peak of the Pico de Teide mountain at its heart and its "sweet air," could be an agreeable and relaxed place to do business.[4] For this reason the Canary trade was an excellent enterprise on which to cut one's teeth, and from early in the decade William Hawkyns allowed his son John to make several unsupervised trips.

These business ventures were crucial to John Hawkyns's career. Besides gaining valuable experience, the young man made priceless contacts and laid down the foundations of a more ambitious operation. He forged bonds of friendship with some of the most powerful men in the islands, in particular the patriarchs of the powerful de Ponte family, and by 1560 he had two factors acting for him in the archipelago: Enrique Nunez, a Portuguese Jew, and John Lovell, a distant relation.

Pedro de Ponte, John Hawkyns's particular friend, was the son of Cristobal de Ponte, a half-Genoese converted Jew who had come to Tenerife as a conquistador, and who for his part in crushing the indigenous Guanche people had been rewarded with a substantial allotment of land in the southern regions of Adeje, Garachico, and Daute. From here the de Pontes became power brokers in the politics and economics of the island. Cristobal built sugar factories, farmed his land, and ran a booming mercantile business. In 1527 he signed a contract for the importation of African slaves into the Canaries, from where they were either reexported to the West Indies or sold into slavery on the islands.

At the same time his son Pedro immersed himself in the business. In 1537 he began acquiring influential political positions when he became *regidor*—a councillor—on the island's council. His social standing was enhanced by his marriage to the daughter of Alonso de Belmonte, another powerful member of the island's council. Pedro's three boys would rise to high-ranking positions in either Tenerife's army or its council, and many of his eight daughters forged important family alliances through marriage.

Pedro was an expert at using his father's wealth to expand the

family's mercantile ambitions. He traded meat with the island of Hierro and wine and sugar with England, and dispatched ships laden with fruits, wines, and wools to the West Indies. In 1552, Cristobal died, leaving Pedro the family estate at Adeje, where he built a small fortress to protect his sugar operations against French pirates marauding the coast.

There is every likelihood that when John Hawkyns undertook voyages to the Canaries, he lodged in the de Ponte home—his father and Cristobal de Ponte had carried out a great deal of business—and in Pedro de Ponte, Hawkyns found an influential and powerful ally. It was almost certainly Pedro who introduced Hawkyns to the idea of trading in slaves.

At their closest point the Canaries lie just sixty-seven miles off the coast of Africa, and by the sixteenth century they had become home to thousands of black slaves purchased on the Cape Verde Islands and used by the Spanish in the farming of wheat, sugar, and vines and in the production of malmsey. There were Africans employed in the de Ponte business, working the depopulated countryside around Adeje. Many more were to be seen in fields and sugar mills all across the island. They would have become a familiar sight to Hawkyns during his stays on the island.

It is recorded that in 1560, Hawkyns sailed to Tenerife on his ship the *Peter.* It may have been now that their joint enterprise was agreed upon. Pedro de Ponte suggested the collection of Africans from Guinea and their sale to Spanish colonies in the Americas. He offered to open up the Indies to Hawkyns; volunteered to provide him with the wisdom of his experience, protection, and expert pilots to guide him to the Caribbean; and promised to ensure that contacts and ready markets would be awaiting him. The profits, de Ponte believed, would be massive, though the dangers for an Englishman sailing into the waters of Spanish America would be substantial. For his part Hawkyns would be expected to supply ships, crew, arms, victuals, and merchandise for trading. Hawkyns was seduced by the idea, and sometime between 1560 and 1562 the two men agreed to do business.[5]

S OON AFTER moving to London, John Hawkyns found him-
self mixing with the big guns of England's mercantile and
political worlds. They were men enthusiastic to hear of any new
scheme that might enhance their wealth, while the opportunity
to have a tilt at the Spanish set their pulses racing. Hawkyns
moved into the orbit of former and future lord mayors of London,
met significant figures in the all-powerful Society of Merchant
Adventurers, and talked to men with experience trading with the
Guinea coast of West Africa. And as his reputation grew he rose
still higher, gaining access to the mightiest in the land: Secretary
of State Sir William Cecil, the powerful earls of Leicester and
Pembroke, and the queen herself. To anybody who would listen
he sold the idea of a slaving voyage, telling of his network in the
Canaries and of the waiting merchants in the West Indies.

Expeditions of this scale needed tight organization and signif-
icant financial backing. At John Hawkyns's behest a syndicate
was formed. This was normal practice: a group of rich merchants
coming together to underwrite much of the capital outlay, form a
board of directors, and sell shares to business associates. Then
when the voyage was completed, they would divide up the spoils
and dissolve the syndicate.

The men who bought into John Hawkyns's adventure were
Benjamin Gonson, treasurer of the Royal Navy; William Wynter,
a fellow magnate and master of the ordnance of the navy; the
immensely wealthy chief officer of the Mines Royal Sir Lionel
Duckett; a Mr. Broomfield, about whom little is known; and Sir
Thomas Lodge, who in late 1562 was preparing to become the
next lord mayor of London.[6] Four of them had already invested
in expeditions to the Gold Coast, and between them they could
muster enormous clout in both the moneyed cliques of the city
and the political-military cabals of the court.

FOUR

W hat John Hawkyns sold these men was in many ways a modest adventure: an expedition of just three ships and a crew of scarcely one hundred men. Like his father before him, he could have handled the enterprise alone. But he recognized its wider significance. His proposal offered more than just the prospect of a lucrative new commodity: human beings. It was political dynamite. For standing in his way were the two most powerful nations in the Western Hemisphere, if not the whole world: Portugal and Spain.

With the approval of a succession of popes, these two Catholic superpowers had divided the world into exclusive and zealously defended zones. Decades of dispute and warfare between Portugal and Spain for dominion in African waters had culminated in two key treaties by which the Iberian powers had carved up the world. In 1479–80 the Treaty of Alcaçovas had ceded to Spain the long-contested Canaries; Portugal had won exclusive rights to the navigation of the seas around Guinea, was granted the right to supply Spain with slaves, and secured her claim to Madeira and the Azores.[1] Fourteen years later, at the pope's behest, Spain and Portugal signed the Treaty of Tordesillas. Somewhere between the forty-first and forty-fourth meridian, fifteen

hundred miles west of the Cape Verde Islands, a north-south line was drawn through the Atlantic Ocean. Everything to the west of it, except the yet-to-be discovered Brazil, was deemed Spanish; everything to the east, including the whole of Africa and Asia, was ruled Portuguese.[2]

Portugal had led the way to Africa in the early modern age, driven by the thirst for gold, slaves, ivory, spices, and the desire to crush Islam. From the early years of the fifteenth century she pushed out across the Atlantic, colonizing Madeira, the Canaries, and the Azores, and then claiming dominion over West Africa.[3] At the helm of this extraordinary expansion sat the remarkable Henry the Navigator. Prince Henry was a catalyst to discovery. He had fought alongside his father at the Battle of Ceuta in 1415, where, in defeating the Moors on their own soil, he had earned his spurs and awakened in himself a Christian zeal, which became his guiding spirit.[4] Driven by the desire to smash the infidel and deliver a fatal blow to the Muslim world, Henry became haunted by the need to find the mythical Christian king Prester John, whose lands were located somewhere in "Ethiopia" and were in danger of being swamped by Islamic hordes.[5] He also needed cash for the large and extravagant court he ran at Lagos in southern Portugal. With this in mind he dispatched ships around Africa's coastline with the hope of reaching bountiful goldfields.

The results were staggering. Using the newly developed caravel—a ship that could both ride the African currents around the continental shelf and overcome the same currents on the return voyage[6]—Portuguese explorers crept gingerly farther and farther around the coast of West Africa. In 1434, after twelve years and fourteen failed attempts, their ships finally sailed past Cape Bojador on the Western Saharan coast. Two years later, Portuguese ships had advanced four hundred miles beyond the cape, and over the next decade more than fifty ships passed it.[7] Sub-Saharan Africa, with its black rather than Arab population, had been reached.

Senegal and Sierra Leone soon fell under Portuguese sway, and

even Prince Henry's death did little to slow the momentum. Soon the Cape Verde Islands were colonized and a further two thousand miles of coastline had been explored.[8] Ships belonging to the wealthy Lisbon entrepreneur Fernao Gomes sailed along the Grain Coast, the Ivory Coast, and the Gold Coast. They reached the islands of Fernando Po and São Tomé, plied the Bights of Benin and Biafra, and in 1472 crossed the Equator for the first time.[9] Occasionally, wars with Spain would intervene and slow the progress, but still the Portuguese pushed on. In the early 1480s the powerful fortress of São Jorge da Mina was built on the Gold Coast of present-day Ghana, and Portuguese caravels passed the Congo. In 1487, Bartholomeu Dias rounded the Cape of Good Hope, to be followed ten years later by Vasco da Gama, who continued his journey on to India. The Portuguese were the undisputed European masters of Africa, and until 1598 theirs was the only state with any foothold on the African continent.

The voyages of discovery, whose prime motive had been the search for gold and spices, soon revealed that slaves were a more readily available precious commodity. In 1441, Antao Gonçalves and Nuno Tristao seized a dozen Berbers and took them back to Portugal, where they were handed over as gifts to Prince Henry. Tristao went on to take a further 14 captives from Arguin Bay two years later.[10] In 1444, Lancarote de Freitas returned from Heron Island, just beyond Cape Blanco, with 235 slaves.[11] As his six ships disgorged the Tuareg captives onto the Algarve shore, Prince Henry came to the shore to survey the scene and take receipt of his royal share—46 captives.[12] Gomes Eannes de Zurara, biographer of Prince Henry, witnessed the scene:

> *What heart could be so hard as not to be pierced with piteous feeling to see that company? For some kept their heads low, and their faces bathed in tears, looking one upon another. Others stood groaning very dolorously, looking up to the height of heaven, fixing their eyes upon it, crying out loudly.... [O]thers struck their faces with the palms of their hands, throwing themselves at full*

length upon the ground; while others made lamentations in the manner of a dirge.[13]

It became clear that slavery was an enormously profitable business. At first the captives were mainly Berbers and Tuaregs of the Saharan littoral, but as the Portuguese ventured farther south, into sub-Saharan Africa, increasing numbers of black Africans were picked up. By 1448 almost a thousand slaves had been brought back from Africa to Portugal for lives in domestic service or on farms in the country's sparsely populated interior.[14]

As the new colonies on Madeira, on São Tomé, and, in the sixteenth century, in Brazil began to produce sugar, the slave trade grew into the most important aspect of Portugal's dealings with the Guinea coast. But first the Portuguese had a lesson or two to learn. Portuguese sailors traditionally arrived on the shores of Africa, leaped from their ships in heavily armed gangs, screamed, "São Jorge and Portugal!" and rounded up all the Africans they met. However, before long the Africans became wise to the game. They set watch on the shore and abandoned villages in times of danger. Crucially, they also fought back. In 1445, Gomes Pires and his crew were forced to flee Cape Verde under a cloud of poisoned darts.[15] Cadamosto, a Venetian in service to the Portuguese, described an attack he witnessed on the Gambia River:

> *[T]hey appeared very well-built, exceedingly black, and all clothed in white cotton shirts: some of them wore small white caps on their heads, very like the German style, except that on each side they had a white ring with a feather in the middle of the cap, as though to distinguish the fighting men. A negro stood in the prow of each canoe, with a round shield, apparently of leather on his arm. They made no movement towards us, nor we to them; then they perceived the other two vessels coming up behind me, and advanced towards them. On reaching them, without any other salute, they all threw down their oars, and began to shoot off their arrows.*

The Portuguese ships fired their cannons to scare the Africans, who dropped their bows in astonishment, before resuming their advance. The Portuguese responded with crossbows, killing one man with a shot in the breast. "His companions perceiving this, pulled out the arrow and examined it closely, in astonishment at such a weapon."[16]

In 1446 an expedition under the leadership of Nuno Tristao ended in disaster after he and twenty-one of his men rowed up the Gêba River on a slave hunt. They were ambushed by a dozen canoes. Four men were killed before they could get back to the ship, and two more were wounded pulling up the anchors. Over the course of the next days seventeen more men, including Tristao, died from the effects of poison darts. The ship was left to drift for nine weeks in the hands of five cabin boys.[17]

In 1448 the Portuguese began to adapt their strategy and engaged African chiefs and nobles in the slave trade. A small fort was built on Arguin Island, where slaves were, for the first time, purchased. In 1456, King Afonso V sent Diogo Gomes as a peacemaker to Guinea. During the course of two trips he successfully established diplomatic relations with a host of powerful Africans, and by the time of his second trip more than seven hundred Africans per year were bought with African help and sent back to Europe.[18]

The balance of power had shifted. The Africans with whom the Portuguese dealt now set most of the rules for trade.[19] In Sierra Leone, for example, newly arrived ships were obliged to send ashore hostages as soon as they anchored. Taxes and gifts were expected in payment. All along the Guinea coast the Portuguese were restricted to the immediate landfall and the estuaries and mouths of some of the major rivers. African control over the supply of slaves and other goods was ensured. Slavery was not new to the continent—it had been prevalent in both Saharan Africa and the Songhai Empire—but what was now being demanded and supplied was the traffic in human beings on an unprecedented scale. A variety of new and imaginative methods were

needed to satisfy Portuguese demands: criminals, no matter how minor or trumped up their crimes, were consigned to the pens, kidnapping became common, and the greatest source of supply was to be warfare, the prisoners of which were sent into slavery. West Africa became an area in which conflicts were positively encouraged by tribal chiefs and their Portuguese paymasters.[20]

Business was conducted through interpreters. Africans who had been picked out from the earliest Portuguese ventures and trained in both languages were used on return journeys to negotiate with their own people.[21] Their work was dangerous, as they were often viewed with suspicion. Many were killed or attacked as collaborators. Cadamosto witnessed one such incident in which an interpreter was sent ashore on his own to deal with an angry crowd that "began furiously to strike at him with their short Moorish swords, and quickly put him to death."[22]

For the Portuguese the gains of trading rather than raiding were enormous. Africans wanted quality metal products such as swords, knives, pots, and pans; textiles, tapestries, and ready-made clothes; brass and copper bracelets; brightly colored beads and trinkets; toys and curiosities; horses and firearms. In return the Portuguese obtained gold, copper, iron, salt, ivory, beeswax, and many other goods,[23] and the number of slaves began to rise. By the end of the fifteenth century it seems likely that more than a thousand African captives a year were being shipped to Europe.[24]

Trading posts were established at key locations, and the Portuguese colony on the Cape Verde Islands, three hundred miles off the coast of Africa, became pivotal as a holding station for captives. Every slave officially obtained on the Upper Guinea coast in the fifteenth and sixteenth centuries was brought to this small archipelago, where as many as six thousand at a time were held in huge barracoons—stockades for holding captives—before being loaded onto ships for the journey to Portugal, Spain, or the Americas.[25]

Naturally Portugal sought to protect its privileged position in whatever ways possible. When papal bulls and the threat of

excommunication were not enough, they used all the resources they had to hand, notably violence, deception—the hiding of chronicles and altering of maps so as to avoid foreign interest—and diplomacy.[26] The Portuguese crown authorized the sinking of all foreign ships found off Guinea and the throwing of their crews overboard. In 1482 they erected a prefabricated castle on the Gold Coast at São Jorge da Mina. A powerful symbol of Portugal's power, the fort also came to symbolize the frailty of its hold on the African continent: the land on which it stood was leased from a tribe headed by the chief Caramansa, the walls were surrounded by a sizable African settlement by the name of Dondou, and, save for occasional seaborne raids on villages believed to have traded with foreigners, the garrison was usually too scared to leave the premises.[27]

This frailty was evident elsewhere. Following da Gama's voyage to India, Portuguese interests shifted east, toward the lucrative spice trade. Throughout the sixteenth century it expanded its empire to take in Sri Lanka, the Moluccas, Goa, Malaysia, and parts of China and Japan, all guarded by a chain of more than forty forts and factories.[28] Although this growing empire was a tremendous achievement, it was also an enormous drain on Portugal's scant resources. The more Portugal became involved in the East, the less energy and effort it had for defending its African interests. In the late fifteenth century, French pirates began to sniff around West Africa, and by the middle of the next century they were creating havoc. Dieppe-based ships terrorized Portuguese caravels off Guinea in the 1530s.[29] In 1542, Jorge Vaz, a Cape Verdian, wrote to the Portuguese king about French pirates who had attacked a ship moored off the Guinea coast: "they robbed the crew and put them below the deck and nailed down the hatchways upon them, and by firing bombards at them they sent them to the bottom of the sea, where they perished, and only those of the crew escaped who happened to be on land and a shipmaster who escaped by swimming." Later, after the same French vessel captured one of Vaz's own crafts, he wrote "and

they plundered it and slew the horses on board and sprang a leak in the ship, so that it would sink to the bottom. The crew of this ship all escaped, because, when they saw themselves surrounded by the ships, they abandoned ship and made for land."[30]

In many parts of Africa, the Portuguese were forced to relinquish absolute control to the French, particularly on the Gambia and Senegal Rivers. By 1557 the situation had become so acute that the Portuguese seafarer Francisco Pires wrote to his queen from São Jorge da Mina: "Madam. I wrote to your highness . . . to tell you how this coast is overrun by corsairs, and to submit that our lord the king should be pleased to command it to be protected. This year there were so many ships of the corsairs here that they glutted the whole coast with many goods of every kind, as Cristovao d'Oliveira will tell your highness. He sent two large ships of the corsairs to the bottom."[31]

FIVE

Across the Atlantic in the Americas, the Spanish were facing a whole different set of problems and challenges. From the moment Christopher Columbus appeared off the coast of Hispaniola in December 1492, the days of the Indian peoples of the Caribbean and South America were numbered. The holocaust that was unleashed on them, as wave after wave of Spanish colonists settled on American shores, would over the next half century fill mass graves with corpses and bring entire tribes to the point of extermination. Before long there would be a crisis of labor, a shortage of workers to exploit the mineral and agricultural wealth of the new Spanish colonies. This was the shortage from which John Hawkyns would try to profit.

The area that Columbus had stumbled upon, and which would soon become the killing fields of conquistadores and settlers, stretched from the Florida Peninsula in the north to the mouth of the Orinoco River in the south. It encompassed the Caribbean and the Gulf of Mexico, and was delineated by a chain of beautiful islands that swept in a graceful arc from Cuba and the Bahamas to Trinidad. At its other boundary stood the coastline of continental America: the northern shores of present-day Venezuela, through the isthmus of Central America and Mexico, to the southern

fringes of North America. It seemed to these new arrivals that with unlimited land, untold mineral wealth, and in the Taino (as the Arawak Indians of Hispaniola have come to be known)[1] and Carib Indians an abundant supply of cheap labor, they had discovered a paradise on earth. "I found very many islands filled with people without number," Columbus recorded, "and all of them I have taken possession for their highnesses."[2]

Life was tough for the Spanish: virulent diseases, scarce food, and hostile Indians dogged their daily struggle. Nevertheless, by the early years of the sixteenth century the number of Spaniards on Hispaniola had rocketed to twelve thousand. Their success, however, came at great cost to the natives. Estimates of the numbers of Taino who died in the genocide that took place in the first five decades of Spanish occupation range from sixty thousand to eight million.[3] And their fearsome neighbors the Caribs suffered, too. Over the previous hundred years they had driven the Taino out of the Lesser Antilles and parts of the South American coast, and by the time of Columbus's arrival they had reached Puerto Rico. They so terrified the Spanish with their reputation—true or not—for cannibalism that in 1503, when Queen Isabela optimistically entreated her colonists to treat the Indians "well and lovingly,"[4] she specifically excluded those people "called Cannibales . . . who wage war on the Indians who are my vassals, capturing them to eat them as is their custom."[5]

There were many cruelties inflicted upon the Indians. In 1497 land in the Indies was distributed among the colonists and, under a regime known as *encomienda*, Indians living on these lands would pay tribute to the landholder in the form of labor, money, or both. In return the Indians would be offered the protection of the Spanish crown and taught to be good Christians. This was a license to enslave the Indians, to remove their connection with the land, and round them up into forced labor gangs. It gave the conquistadores what they so craved: power, land, and a sense of aristocracy. For the Indians, it ushered in a reign of terror.

As the Spanish pushed out across the Caribbean they drenched

the Americas in blood. According to the influential cleric Bartolomé de Las Casas, who witnessed much of the colonization, the Spanish "fell like ravening wolves upon the fold." He wrote that they treated the Indians like "piles of dung in the middle of the road." On Hispaniola they kicked their way into Indian villages, "slaughtering everyone they found there, including small children, old men, pregnant women, and even women who had just given birth."

> They hacked them to pieces, slicing open their bellies with their swords as though they were so many sheep herded into a pen. They even laid wagers on whether they could manage to slice a man in two at a stroke, or cut an individual's head from his body, or disembowel him with a single blow of their axes. They grabbed suckling infants by the feet and ripping them from their mothers' breasts, dashed them headlong against the rocks. Others, laughing and joking all the while, threw them over their shoulders into a river, shouting: "Wriggle, you little perisher."

Las Casas claimed that the Spanish fed their victims to their dogs, tied them to stakes and lit fires under their feet, put them on spits and roasted them alive or hung them thirteen at a time from wide gibbets. Resistance, disobedience, and even mere reluctance were punished with summary and severe injustice. Indian chiefs grilled over a slow fire "howled in agony and despair as they died a lingering death." When an exhausted native bearer could go no farther "they cut his head from his shoulders so they would not have to break the chains that held the line of prisoners together, and his head would fall to one side of the baggage train and his trunk to the other."[6]

The preaching of men like Las Casas against the unfolding tragedy had results. Yet laws designed to make the Spanish settlers treat the indigenous people with respect had the opposite effect. Forced into grueling labor, subjected to cruel punishments, intimidated into Spanish clothes, coerced into eating Spanish

food, and corralled into settlements near Spanish towns, many Indians slumped into depression and despair, their traditional way of life pulverized, the rhythm of the centuries stilled. The native birthrate plummeted, suicide soared, and self-induced abortion became commonplace.[7]

YET THERE were deadlier killers on Spanish ships than swords, harquebuses, and bloodhounds. The colonists brought with them germs from which the Indians had little immunity. There had always been disease in the Americas, including forms of tuberculosis, amoebic dysentery, and Chagas' disease, but the low density of the Indian populations, and the fact that they tended not to practice animal husbandry, meant that disease propagation was low. While Columbus's first voyage to the Indies made little difference to the disease environment, his second, in 1493, was a different matter. From this point on the Indians all across Hispaniola faced an unremitting barrage of sickness, famine, and violence. The Spanish brought smallpox, measles, typhus, the black death, cholera, and possibly malaria and yellow fever: top-notch killers that mercilessly laid waste to huge swaths of the adult population.[8] In December 1518, Cuba and Hispaniola were hit by a devastating smallpox epidemic that wiped out as many as half of the remaining Taino. By the middle of the sixteenth century, barely six decades after their first contact with the white man, the Taino were extinct. In the words of one Spaniard, they died "like fish in a bucket."[9]

CONQUERING THE Indies and the Americas was one thing, but the New World was useless to the Spanish unless it could be turned to profit. This meant working the land and plundering its mineral wealth; above all else it meant searching for gold and silver. For this the Spanish needed labor, but the natives they had so badly abused were not up to the task. At first

they had been forced into a wide variety of hard and dangerous jobs. On Hispaniola they panned for gold, worked in mines, tilled the soil, and tended thriving cattle and pig herds. By 1508, Hispaniola had its first sugar mill. Within fifteen years there would be more than twenty on the island, and by 1548 there were thirty-five.[10] Indians were used at every stage in the production of sugar, from tending the raw crop in the fields to fermenting the molasses used for rum. It was a complex and intensive process that chewed up workers in much the same way that the sugar mills chewed up the cane they were fed.

Forced labor was channeled into a variety of other tasks, including indigo dye processing, domestic service, and even such skilled artisanal jobs as blacksmiths, masons, carpenters, and cobblers.[11] Worst of all was pearl fishing, which, with its extreme physical demands, placed massive strains on both the body and mind of a slave. Las Casas described it as one of the "cruellest and most damnable things in the whole of creation."[12]

The Spanish realized early on that the Indians were not the beasts of burden they required. Their death rate was too high, their sickliness made them too feeble. Slave hunters with bounties to replace the depleted labor force swept through the Bahamas, bleeding them dry of more than forty thousand people, but then the harsh conditions simply killed those off in quick order, too.[13] A labor shortage threatened to cripple the Caribbean and Mesoamerican colonies. Another solution was needed. There was barely enough of a population in Spain to cope with the immense military and agricultural needs of the country itself, never mind sufficient to answer all the labor problems of the New World. So Spain turned its attentions to the African slaves its Iberian neighbor was offering.

LEGEND HAS it that there were black people present on Columbus's first voyage to the Caribbean, and during the 1490s there followed a trickle of Africans, mainly to be used as

domestic servants to the new colonists. The first real surge in African numbers occurred in 1502 with the arrival of the new governor of Hispaniola, Frey Nicolas de Ovando, who was allowed to import slaves to carry out work that would otherwise have been done by the ailing and declining Indian population. It hardly constituted a flood: in fact, within a year of Ovando's landing he requested a halt to slave imports as they were proving too troublesome. Nevertheless, in 1505, King Ferdinand sent 17 slaves to Hispaniola, with the instruction that "all of these be getting gold for me,"[14] and in 1510 he sent another 250 of his strongest slaves to work in the mines of Buenaventura and Concepción on the island.[15] Three years later, sensing the potential for profit, he effectively formalized the growing trade by claiming a tax of two ducats for every head of slave sold in the Indies.[16]

The Spanish were ambivalent about the use of Africans. They feared that an influx of pagans would undermine their Catholic project for the Caribbean, and in 1506 it was ruled that only Christianized Africans, born and living in Spain or Portugal, would be allowed entry to the Indies.[17] Nevertheless, as the Spanish spread across the islands and onto mainland America, the demand for labor outstripped supply. In 1518, Charles V agreed to allow the shipment of *bozales*—unchristened captives—directly from Africa.[18] From this moment on, and for the rest of the sixteenth century, almost all of the slaves brought through official channels were purchased from the Portuguese barracoons on the Cape Verde Islands.

Even now slaves did not flood into Spanish America, but throughout the sixteenth century there was an increase in volume: one calculation estimates that between 1521 and 1550 an average of five hundred Africans were officially disembarked in the West Indies every year, rising thereafter to more than eight hundred a year.[19] By the end of the century as many as seventy-five thousand captives had been shipped across the Atlantic.[20]

Their arrival in the New World was the final nail in the Indians' coffin. The sweltering mangrove swamps of Upper Guinea

and the dark West African hinterlands from where the captives were rounded up were laboratories of deadly tropical disease. Malaria and yellow fever were the main killers, but the ships from Africa brought with them an awesome catalog of disease that also included leprosy, scabies, yaws, miosis, bilharziasis, roundworm, guinea worm, hookworm, diarrhea, dysentery, nutritional disorders, sleeping sickness, African trypanosomiasis, tuberculosis, bacterial pneumonia, smallpox, diphtheria, whooping cough, measles, mumps, and influenza.[21]

Many Africans died in transit to the Americas, and a substantial percentage died on or soon after arrival. However, equipped with an array of immunological defenses forged in their sweltering homelands, they had a greater chance of survival than the Indians with whom they now mingled. Indians were being hit from all sides—by violence and both European and African diseases. Though rooted in racist misconceptions, the Spanish (and the Portuguese in Brazil) constructed a mental picture of the hardy African and the feeble Indian: each African, it was reported to King Ferdinand, was worth four Indians. The Indian became dispensable; the African became a brutalized workhorse. The sixteenth-century historian Antonio de Herrera wrote, "These Negroes prospered so much in the colony that it was the opinion that unless a Negro should happen to be hung he would never die, for as yet none have been known to perish from infirmity."[22]

THE SPANISH needed African labor, but feared and distrusted it. Despite the shackles and manacles they arrived in, the slaves were often troublemakers, loath to take orders and prone to rabble-rousing among the Indians. As early as 1503, Ovando had won a temporary suspension of the importation of all slaves into Hispaniola. He pointed out that they were fleeing from their owners and setting up outlaw settlements in the mountains and forests. From here they carried out violent raids on Spanish towns and haciendas. Ovando's fears were prescient.

Over the coming years confrontations between master and slave flared up, and escape became a daily fact of colonial life. The first large-scale uprising occurred over Christmas 1522, when African slaves working at a sugar mill belonging to a son of Christopher Columbus on Hispaniola murdered whites in and around their plantation.[23] Revolts continued: in 1529, four years after having been built, Santa Marta, on the Colombian coast, was razed by rebellious slaves. In Mexico there were slave insurrections in 1523, 1537, and 1546. Puerto Rico experienced trouble in 1527, and in the early 1540s plantation owners on Hispaniola were terrorized by bands of *cimarrónes,* as the escaped slaves were known. In 1552 a slave named Miguel led an army of eight hundred former bondsmen that forced Venezuelan mines to close and brought terror to the Spanish population.[24]

The Spanish response was nervous and repressive. A curfew in Cartagena required all slaves to be off the streets by sunset. Africans were not allowed to use horses, and in many places were prohibited from carrying knives or anything that might be construed as a weapon. Punishments were severe. Unauthorized absences from a place of residence would result in a whipping. In Santo Domingo on Hispaniola, slaves missing for fifteen days or more received one hundred lashes and had a twenty-pound weight fixed to their leg for a year when they were recaptured. Proof of involvement in *cimarrón* activity would lead to execution. In 1540 a slave by the name of Pedro Gilafo was caught after an absence of three weeks from his Costa Rican workplace. The authorities were unsure of what he had been up to, so they boiled him alive just in case. Africans having sexual relations with Indians could generally expect a flogging, but in parts of Central America the punishment was the removal of genitalia.[25]

Nevertheless, as sugar plantations, sugar mills, and silver mines began to dot the New World, the demand for African slaves continued to climb. In 1518, Charles I (soon to be the Holy Roman Emperor Charles V) acceded to colonial pressure and allowed the shipment of more *bozales*—who were considered less

trouble than Africans brought from Spain—and granted his friend Lorenzo de Garrevod, duke of Bresa, the exclusive right to ship four thousand Africans to Hispaniola, Cuba, Puerto Rico, and Jamaica. But Garrevod was a Flemish courtier, with no ships, no depots, and in fact no interest in the complicated process of slave trading. He immediately sold the rights, and after a chain of sales during which various parts of the grant were carved off, a group of Genoese merchants acquired the majority of the privilege for twenty-five thousand ducats. They bought and shipped some slaves before selling once again, making a huge profit in the process.[26]

The king's award to Garrevod was supposed to be exclusive, but it never was. Over the coming years many much smaller licenses would be sold, allowing individual merchants the right to carry slaves across the Atlantic. Licenses were bought for large sums, they were sold only to Spanish merchants, and in the great majority of cases the Africans were purchased in the Cape Verde Islands and transported in Portuguese ships. Nonetheless, despite a system creaking with corruption and overreliant on the rather thin honesty of Portuguese traders, slaves did still get shipped to the Spanish Americas. Indeed, between 1529 and 1537 the crown doled out more than 360 licences to take Africans to Peru alone.[27] So many Africans began to appear in the islands of the Caribbean that the Spanish historian Gonzalo Fernandez de Oviedo y Valdes was to write of Hispaniola "there are so many Negroes in this island as a result of the sugar factories that the land seems an effigy or an image of Ethiopia itself."[28]

Throughout the middle of the sixteenth century the demand for forced labor among ordinary colonists remained high, and frequently outstripped supply. The licensing system brought the crown short-term financial benefits but forced prices up. It became common practice for settlements to do backhand deals with smugglers, who, not having paid for their license, could keep their prices down. Nevertheless, the majority of slaves were still supplied by merchants based largely in Seville. At times the Spanish

crown became apprehensive that these powerful merchants might corner the market and make unreasonable profits at the expense of both the king and the settlers, and in an attempt to keep control of the situation the crown continued to hand out large contracts to privileged individuals and companies. These mostly resulted in failure. In 1528, for example, two representatives of a large German banking house paid twenty thousand ducats for the right to carry four thousand Africans to the Indies. As they were to discover, however, all slave merchants were at the mercy of their Portuguese fixers, and the captives they landed in the Caribbean were of such poor quality that their contract was terminated early. In 1552, Hernando Ochoa was awarded a seven-year monopoly to deliver twenty-three thousand Africans to the Spanish Indies. He was to pay eight-ducats-a-head duty, but he also failed to deliver, and his contract was annulled, too.[29]

In 1556, in an effort to stabilize the market and prevent profiteering, the Spanish crown placed a cap on the price of slaves in the Indies. No slave, it ruled, could be sold for more than one hundred ducats. However, with profit margins cut, many merchants lost interest in the business. The price limit was removed five years later, but the economy was wallowing in recession and few slave ships were licensed. Sugar plantations and mills, haciendas, mines, and pearl fisheries were all forced to buy slaves wherever they could find them. The door opened for men with few scruples, fewer morals, and big ambitions.[30]

WHILE IT had become increasingly common for English ships to be found off the coast of Guinea, until now her merchants had fought shy of offending the Spanish. Hawkyns was proposing to change this. With the modesty of this gentle nudge into the Americas, Hawkyns was offering to test dangerous waters. The prize for success was too big to be ignored any longer: in the Americas the decades of pillage were giving way to settlement and economic development. The islands of the West Indies

were being turned over to ranches and plantations, while in Mexico and South America, the discovery of vast quantities of precious metals was attracting a great influx of new immigrants and providing riches beyond the imagination. If England wanted to be a major player on the world stage, if it wanted a share of these new spoils, now was the time to begin to challenge the papal division of the world.

Adding color to the voyage was the atmosphere of intense religious hostility and instability that pervaded England and Europe. The death of Queen Mary in 1558, at the age of forty-two, had drawn a curtain across one bloody chapter in English history. Her brief reign had seen the restoration of Catholicism and a bloodbath of persecution. Barely four months after her death, her half sister Elizabeth had, through the Acts of Supremacy and Uniformity, restored Protestantism as the official religion of England. The Book of Common Prayer was reintroduced, papal jurisdiction was renounced, and the monarch was to be known as supreme governor of the church. Fourteen bishops, including the archbishop of York and the bishop of London, were kicked out of office for refusing to swear the Oath of Supremacy. Protestant placemen were drafted to fill the gaps. After the dark years of Mary there were Protestant hard-liners in and around the court keen to challenge the Catholic world orthodoxy. For them the slave voyages were an interesting experiment that opened up the possibility of a low-intensity, undeclared war on Catholicism.[31]

The Pilot Fish

SIX

The slave hunters slipped their moorings in October 1562. There were three ships: the *Swallow*, the *Jonas*, and, at their head, the *Solomon*, captained by John Hawkyns. There are no descriptions of the scenes at Plymouth that day, no account of the excitement, the fear, the anxiety, and no record of any debate concerning the morality of the venture. Three decades later, Hawkyns's son, Richard, departed from the same port with a fleet headed for the South Seas. The run-up he described would have been familiar to his father: eleventh-hour hitches, a crew on a drunken rampage, and last-minute desertions. For two days Richard Hawkyns, his officers, and the justices of the town busily rounded up their men. The behavior of his ships' company, Richard Hawkyns wrote,

> *forced us to search all lodgings, taverns and ale-houses. (For some would ever be asking their leave and never depart) some drink themselves so drunk, that except they were carried aboard, they of themselves were not able to go one step: others knowing the necessity of the time, fained themselves sick; others, to be indebted to their hosts, and forced me to ransom them; one his chest; another, his sword; another, his shirts; another, his card and instruments*

for sea. And others to benefit themselves of the imprest [advance wages] given them, absented themselves; making a lewd living in deceiving all, whose money they could lay hold of: which is a scandal too rife amongst our seamen.[1]

Likewise there are no descriptions of the conditions as John Hawkyns's small fleet pulled out of the harbor and through the mouth of Cattewater into the sound: no record of whether it was a typical October day with stiff, rain-flecked breezes blowing away the last remnants of summer, or a cold, stern warning of the winter to come. What is certain, however, is that Hawkyns himself was sailing into a storm. Neither the Portuguese nor the Spanish were pleased with his adventure, and Hawkyns could rest assured they would not let the matter rest.

SHIPS IN this fleet were small. At 120 tons, the largest was the *Solomon;* the *Swallow,* commanded by Thomas Hampton, weighed 100 tons; and the *Jonas,* under the control of an unnamed master, was a mere 40 tons.[2] Conditions would have been much as any experienced sixteenth-century sailor would have expected: overmanned, cramped, poorly provisioned, and uncomfortable. Hawkyns boasted that because he feared the spread of sickness he "took with him not above 100 men,"[3] yet even this ratio of one man to every 2.6 tons of shipping constituted overmanning. Large crew numbers were a common response to the high death rates expected on a Guinea voyage, the threat of piracy, and the difficulty of handling primitive equipment.[4] It suggests that Hawkyns was ready for trouble.

Crews on Guinea expeditions commanded higher wages than ordinary merchant mariners, and they also benefited from the plentiful opportunities for private onshore trading.[5] Research among surviving wills of those who sailed to Africa in the 1550s and 1560s shows a group of men who could afford a change of clothes and their own bedroll, who carried weapons such as knives,

swords, and even handguns, and whose belongings justified own-
ing a sea chest. When ships docked, many sailors bought chick-
ens, goats, and other animals to serve first as pets, and later in the
journey, fresh food.[6] These were tough times: at home, inflation
was rocketing (the cost of living had quadrupled in Tudor
England), the countryside was overpopulated, hungry towns
were dens of disease, and vagrancy was rife.[7]

The sea, therefore, had its attractions, but the catering was
probably not one of them. An account of the victualing of the
Royal Navy in 1560–61 suggests the fare that would have been
eaten by John Hawkyns's men. It was hardly mouthwatering, but
included biscuits, beer, fresh beef, salt beef, bacon, Newfoundland
fish, mudfish, stockfish, white herrings, red herrings, salt butter,
cheese, salt.[8] These provisions had to be stored, as did the ships'
equipment, which included masses of "pulleys, shovels, scoops,
spades . . . water buckets . . . grinding stones . . . chromes . . . stuff
for killing rats . . . ballast baskets . . . Compasses."[9] And then there
was the merchandise with which slaves, gold, and ivory could be
purchased. Woolen cloth was the main stock: standard broad-
cloth, stored in packs of ten, from East Anglia and the West Coun-
try; lighter, coarser fabrics known as kerseys, from Hampshire,
the Kennet Valley of Berkshire, and Yorkshire; and wool "cot-
tons" from Lancashire and Wales. Space on these ships was at a
premium.[10]

B Y L A T E October 1562 the small fleet was approaching the
Canaries, seven volcanic islands that were in many ways more
African than European.[11] The weather would have been warm,
comforting rather than stifling. Hints of eucalyptus and pine,
carried on balmy sea breezes, greeted the ships as they skirted
the islands, which in classical times had been dubbed the Fortu-
nate Islands for their warm, sensuous climate and lush, fertile
soils. The Canaries were the site of the mythological Elysian
Fields, the final resting place of ancient Greek heroes such as

Achilles, where the gods smiled and rewarded the virtuous with an afterlife of relaxation, hunting, and banqueting. The islands took their name, it was said, from the large number of dogs there—*canis* is Latin for dog—and it was there that legend had it Atlas slew the dragon in the garden of Hesperides and stole the golden apples for Hercules. Even the climate's aridity had been magically solved; as one sixteenth-century English traveler wrote,

> *In one of these islands called "de Fierro" [El Hierro] there is, by reports of the inhabitants, a certain tree that raineth continually, by the dropping whereof the inhabitants and cattle are satisfied with water, for other water have they not in all the island. And it raineth in such abundance that it were incredible unto man to believe such a virtue to be in a tree, but it is knowen to be a divine matter, and a thing ordained by God.*[12]

The Canaries were a vitally important crossroads in transatlantic traffic. Since the final defeat of the indigenous Guanche in 1496, the islands had grown into a booming trading post, a place where merchants and traders of all European nations came, exchanged information, and made deals. It was an advanced base camp for exploring the wider oceans, a last staging post between Spain and Africa, and from there the New World. It was from the Canaries that Christopher Columbus had headed west toward the Americas. Here on these rocky volcanic outcrops ships could refresh and replenish stocks, victuals, water, and wine before making the short hop to Africa or being swept off by the Atlantic current to the Caribbean and South America.

Hawkyns was headed for Tenerife. The sharp, towering Pico de Teide, visible from 150 miles offshore, guided him in, its snow-covered crown rising starkly from the halo of black pumice in which it sat. For Hawkyns the Pico de Teide was both a fingerpost and a warning signal: he knew he had to be alert. Despite his good relations here, trading on Tenerife and in the islands was not all smooth going. A royal edict of September 1558 had

commanded that foreign ships calling at Spanish ports be searched by Inquisition inspectors looking for Lutheran books and merchandise. As recently as March 1562 the English pinnace the *Fleur de Lys* had been impounded in the Canaries, her sails removed and the crew subjected to charges of Lutheranism.[13] As part of the crackdown the English factors Thomas Nicols and Edward Kingsmill had both spent time in prison on charges of heresy.[14]

There were other reasons the locals might be less than welcoming. In recent years the Canaries had suffered the frequent and unwanted attentions of English pirates. In 1560 the notorious Southampton pirate Edward Cook had seized a Spanish ship loaded with silver, and then harried ships off the islands, harassed ports, and even robbed the English merchant Richard Grafton of a cargo of sugar and molasses as he sailed from La Palma. In December of that same year John Poole and Thomas Champneys had wreaked havoc on the ports and shipping around the archipelago. They were captured off Santa Cruz de la Palma, but three weeks later they forced open the prison door, seized a ship, and sailed off with her freight of wines and oils while the locals celebrated Christmas.[15]

It was probably because of these events that Hawkyns avoided Tenerife's main port at Santa Cruz and headed instead for the Adeje stronghold of Pedro de Ponte out its southern tip. Here he went ashore to receive the hospitality of his old friend. De Ponte assured him that he was expected in the Antilles and that there were people ready to buy from him. He handed the Englishman a list of contacts, and took the opportunity to review strategy one last time. With business out of the way, the Spaniard laid on "friendly intertainment." Meanwhile, out at sea, out of gunshot and sight of coastal patrols, Hawkyns's fleet replenished its stocks and provisions, filling barrels and butts with wine and fresh water.[16]

Curiously, when the opportunity presented itself, Hawkyns and his men also attended church. Was this Hawkyns displaying

his diplomatic prowess, or a sign of a religious ambivalence in the captain? In 1568, Mateo de Torres, a vicar on the island, was asked by the Inquisition whether the Englishman was "covetous and held to be a Lutheran," to which

> [h]e replied no, that not even this deponent held him to be so be-
> cause another time that he was in Tenerife, seven years ago, he
> saw him hear Mass, and that from [Hawkyns's] ship there came
> some Englishmen of the common people of the ship to buy birds
> and other things that they required, and that this deponent heard
> the confession of one of them, and that others saw them hear Mass
> and that of the higher people none came out because they were
> afraid, and that he had heard tell that there are many Lutherans
> in England and that there are also Catholics.[17]

In the first week of November, Pedro de Ponte delivered his pièce de résistance: a pilot from Cadiz named Juan Martinez. The man who would guide Hawkyns across the Atlantic was rowed out to the *Solomon* under the cover of darkness. Without him the expedition had no chance of finding the Indies. His presence on board was highly illegal and would have been considered treacherous by the Spanish authorities.[18] The fleet weighed anchor and edged slowly toward Africa, the secrecy of the operation intact. Within a week Pedro de Ponte was elevated by his peers on the island's council to interim governor of Tenerife. The council noted that he was "a Gentleman so principal, so good, so learned, rich and pure of conscience that had not aggravated even to his enemies if he had them."[19]

SEVEN

Ly late December 1562, John Hawkyns was reported to be
stalking African waters. The English were not new to Africa;
ever since the middle of the sixteenth century they had been
buzzing around causing trouble—indeed, Hawkyns's father had
made two and probably more trips to Guinea. But English knowl-
edge and experience of Africa were not yet extensive, and though
they increasingly enjoyed challenging Portuguese claims to au-
thority, most English merchants still had reason to be wary.

Just eighty years before John Hawkyns appeared off the
Guinea coast, King Edward IV had acceded to demands by the
Portuguese embassy that a fleet being readied by two London
merchants, Tintam and Fabian, "be broken up" and that the king
of Portugal's rights as lord of Guinea be formally acknowledged.
For nearly half a century afterward, the English lapsed into inac-
tivity in Africa. In the 1530s their interest revived: the ships of
William Hawkyns took a good look at Guinea, and English trade
with Barbary—the coast of North Africa—was stepped up.[1]

The year 1553 marked a watershed in English adventurism.
Frustrated and impatient at the stifling of their commercial aspi-
rations, English merchants finally began a concerted push on the
outside world. The straitjacket of smothered ambitions was cast

off. To the southwest the Atlantic was officially closed to them by the two most powerful nations on earth, Spain and Portugal, and to the north, the doors to the Baltic and northern Europe's most important ports were shut tight by the trading cartel of the Hanseatic League.[2] In 1553, however, Richard Chancellor and Hugh Willoughby, under the sponsorship of the Mystery, Company and Fellowship of Merchant Adventurers for the Discovery of Unknown Lands, attempted to find a Northeast Passage to the Spice Islands of the Far East. Willoughby and his men froze to death, their ship, the *Bona Esperanza*, crushed by Arctic pack ice. Chancellor managed to find his way to Moscow and into the court of Ivan the Terrible, where he was entertained lavishly and laid the foundations of the soon to be influential Muscovy Company.[3]

In August of the same year, the pirate Thomas Wyndham sailed for West Africa with significant backing from the City of London. His three ships—the *Primrose*, the *Lion*, and the *Moon*—carried a crew that had been pressed into service, as well as two Portuguese advisers, Antonio Anes Pinteado and Francisco Rodrigues. It was a fractious voyage. Soon after passing Madeira, Wyndham and Pinteado fell out, exchanging "opprobrious words." According to one source, by the time they reached the Gold Coast, Wyndham was seething and declared publicly of Pinteado, "This whoreson Jew hath promised to bring us to such places as are not, or as he cannot bring us unto: but if he do not, I will cut off his ears and nail them to the mast." They pushed on into the Bight of Benin and anchored offshore, where the conditions were insufferable, "smothering heate with close and cloudie aire and storming weather of such putrifying qualitie that it rotted the coates off their backs, or else for coming too soone for the scorching heat of the sunne, which caused them to linger in the way."[4]

While Pinteado and a group of gentlemen traders headed upriver to do business with the king of Benin, back on the coast fever was killing as many as five men a day, including Wyndham himself. When Pinteado returned, the surviving crew turned on

him, spitting in his face and drawing their swords. Without enough men to navigate her, the *Lion* was deliberately sunk; Pinteado was "thrust among the boys" as the cook's assistant and was dead within a week. The *Primrose* arrived back in England with just forty men alive, barely a quarter of its original crew. In her hold sat 400 pounds of twenty-two-carat gold, 36 butts of melegueta peppers, 250 tusks, and the complete head of one elephant "of huge bignesse," soon to be displayed in the London home of Sir Andrew Judd. The death toll had been appalling, but the profits were massive.[5]

Other expeditions followed in quick succession. In November 1554, John Lok led three ships to the Gold Coast, and between 1555 and 1558 another Englishman, William Towerson, made three voyages of vastly differing fortunes to Guinea. Each was beset by a high death toll, skirmishes with the Portuguese, and violence against the African population. On Towerson's final voyage his flagship, the *Tyger*, sprang a leak and slipped slowly into the depths, to be followed soon after by another ship of the fleet, the *Christopher*, whose ship's company "perished and was utterly lost."[6]

NEVERTHELESS, SUCH expeditions were a measure of how far English confidence had grown in the years since Tintam and Fabian had been forced to abandon their adventure. So alarmed were the Portuguese at these developments that their ambassador in Spain wrote to his king that if they delayed in stationing a fleet off Elmina "which may send both the French and the English likewise to the bottom of the sea without mercy, this business may have no end in her kingdom."[7] On 14 March 1561, Emanuel D'Aranjo, a Portuguese envoy, blustered his way into the English court. He demanded an immediate end to English incursions into Guinea. Elizabeth was polite but skeptical.[8] The next month D'Aranjo issued a declaration in which he dismissed all suggestions that his monarch's monopoly was not intact in

Africa. Those foreigners seeking a way into Guinea were little better than burglars in the night, chasing their "own singular profit and gain, and to take away the peculiar profit and dominion of the King of Portugal."[9]

But he was fighting a losing battle. Elizabeth publicly proclaimed her support for Portuguese dominion in Africa, but privately conspired against it. In September 1561, John Lok left London at the head of a small fleet to explore the possibility of an English fort on African soil. His instructions, among others, were to make note of the rivers and harbors of the West African coast, to test the state of the ground, and to investigate what timber might be available to use. He was to discover where supplies could be obtained, where the nearest water source was, and what help could be expected from the locals.[10] The syndicate funding the operation consisted mainly of City of London bigwigs, but it also included in its initial stages both Benjamin Gonson, the treasurer of the navy, and William Wynter, the surveyor of the same. All four vessels belonged to the queen.[11]

At a meeting with William Cecil the Spanish ambassador, Alvarez de Quadra, bishop of Aquila, demanded to know more of the queen's involvement, but received only weasel words in reply. "They excuse themselves," he wrote to the duchess of Parma, Spain's regent in the Low Countries, "by saying that the Queen had sold these ships to certain merchants here, and they cannot prohibit them from going to buy and sell their wares where they think fit."[12] In the next month King Sebastian of Portugal wrote to Elizabeth to demand that any of her citizens should be forbidden from going to Guinea "under pain of death."[13]

Meanwhile Lok's expedition stumbled along. In September 1561 two of his ships collided in fog off the Straits of Dover. Then in November all the vessels were dispersed around the coast by a wild storm. Lok abandoned the enterprise, claiming that the ships were not up to the task and that it was too late in the year to go. There would be "calamity and inevitable danger of men," he wrote; "it can only end in disaster."[14] The expedition would

resume in the new year, though no fort resulted. The queen took a third of the profit as her share—a very healthy one thousand pounds.[15] In the meantime Quadra again visited Cecil to demand an end to English expansionist activities. The response he received was the last thing he wanted to hear. He reported to Philip II that Cecil had told him "that the Pope had no right to partition the world and to give and take kingdoms to whoever he pleased."[16] Cecil's words signaled a new sense of confidence, one that would allow John Hawkyns to swagger onto the world stage.

EIGHT

The west coast of Africa had been known to Europeans as Guinea since the fourteenth century. The region, whose name derived from the Berber *akal n-iguinament*—"the land of the black men"[1]—encompassed a coast that stretched more than two thousand miles, from Cape Verde in the north, swinging around Cape Palmas in the south, and on east, past the Niger Delta to the Bight of Benin. On a modern map of Africa it includes the countries of Senegal, Gambia, Guinea-Bissau, Sierra Leone, Liberia, Côte d'Ivoire, Ghana, Togo, Benin, and Nigeria. Europeans gave the coasts exotic names reflecting their commercial value: the Gold Coast, the Slave Coast, the Grain Coast, and the Ivory Coast. That they knew these lands merely as "coasts" reflected these lands' resistance to European intrusion, owing to their mangrove swamps, forests, diseases, strange people, and even stranger creatures.

The Upper Guinea Coast, which most interested John Hawkyns, is a vaguely defined expanse running a thousand miles from Cape Verde to Cape Palmas. For most of its length the coastline here is low and flat, with a shallow continental shelf generating dramatic tidal shifts that have allowed the sea to penetrate a long way inland. The coastal plains rarely exceed 130

feet above sea level, and the result is a largely uniform littoral plain, with a buildup of alluvial deposit and an abundance of salt pans. Farther inland, beyond a belt of mangrove swamps and muddy lagoons, the land begins to undulate, and where the heavy rains have not eroded the soil it becomes grassier and more forested. Large mountains pierce the sky of the deep interior, and ranges such as the Fouta Djallon act as the watershed to the great African rivers of the Senegal and the Niger.

Rivers were crucial to West African life. The flatness of the coast and the power of the sea meant that there were few natural harbors, and life was more often carried on in the hinterland. The dozens of rivers here include big powerful beasts, snaking from the mountains to the west and southwest, rivers such as the Senegal, Gambia, and Corubal, the Sierra Leone and Great and Little Scarcies, the Cestos, Rokel, and Casamance. Flat and wide at their mouths, and lined along their inlets by tracts of woody mangrove trees, they and their tributaries were the lifeblood of West Africans, who settled along their banks as far into the interior as their canoes could carry them. The rivers gave them mobility, allowed trade, and fostered community and identity, but they could also bring danger: in the rainy season they flooded, and in times of trouble, they brought enemies.

Only at Sierra Leone is the symmetry broken. Here the low coastal plain is suddenly interrupted by the peninsula of present-day Freetown, an impressive clump of hills rising abruptly from the sea to a height of almost three thousand feet. The mouth of the river is a drowned estuary, caused by ancient geological uplift that has given it steep sides, good shelter, and, in nearby raised beaches, an ideal location for settlement. In spite of treacherous rocks at the river's mouth it is the best natural harbor in the whole of West Africa.

Africans had lived in coastal Guinea for thousands of years, and though they often had common roots, hundreds of languages and dialects were spoken, suggesting that while the rivers and plains of West Africa had eased transportation and trade, they

had also reinforced tribal and state isolation. Putting a name to a tribe, as an outsider, is a complicated business. Nomenclature has changed; tribes have been absorbed, killed off, or have simply disappeared. Africans that Europeans met in the fifteenth and sixteenth centuries may have been understood to go by one name, but in the twenty-first century they are known by another. Major tribes with influence at the time of Hawkyns's voyages included the Jelofs (Wolofs) and Serer of Senegal; the Djola and Mandinka of Gambia; the Casanga of the Casamance River area; the Bram, Biafrada, and Banyun of Guinea-Bissau; and the Baga, Temne, Landuma, and Bulom of Sierra Leone.[2] These last four were known as Sapes by the Portuguese and other Europeans.

West Africans were intelligent, resourceful people. The Moorish traveler Leo Africanus wrote of Mali that the people there "excell all other Negroes in wit, civility, and industry; and were the first that embraced the Law of Mahumet."[3] They kept cows, goats, and chickens for food, hides, and ritual sacrifice, caught fish in the rivers and occasionally in the sea, and cooked with palm oil. Swamps and salt flats made crops difficult, though rice was a relatively easily produced staple, and salt, produced from crystals on mangrove leaves, from evaporation of the saline waters, and from the salt-rich soils of the region, was a valuable commodity in transcontinental trade. Traders who came to the area found no shortage of merchandise to be bartered. Many tribes had fine reputations for the textiles they wove. There were hides for leather goods; vegetable juices for dyes; and pottery, peppers, beeswax, honey, resin, and any surpluses the people had of rice, millet, and palm oil. Gold and ivory, or "olyfantes teeth," were particularly prized, the latter being traded by Sapes who had successfully hunted down an elephant or hippopotamus with poisoned harpoons.[4]

West African people were sophisticated, with organized structures to their societies and beliefs, and productive outlets for their craftsmanship and husbandry. Yet, without ever having

met an African, Hawkyns would have had a notion of them as subhuman savages, and that allowed him to be untroubled by any moral qualms as he headed for African waters with the intention of taking slaves.

Those few English explorers who had traveled to sub-Saharan Africa had returned with tales of exotic locations "halfeway in purgatorie or hell," where the people were primitive and, as John Lok said of "beastly living, without a God, law, religion, or commonwealth, and so scorched and vexed with the heat of the sunne that in many places they curse it, when it riseth." In Africa, he added, elephants warred with dragons, their congealed blood mingling into "that substance which the apothecaries call sanguis draconis, dragon's blood, otherwise called cinnabaris."[5]

Furthermore, preconceptions of what Africans would be like were based not only on the words of these first English explorers, but also on readings from the Bible and popular medieval legends and tales. From 1360 the account of the travels of Sir John Mandeville reached an English audience, as did the reports of Ethiopia and Prester John.[6] The Latin translation of the Moor Leo Africanus's travel writings was available in England from 1556, and a year earlier the chronicles of historian and traveler Francisco Lopez de Gomara made their first appearance in English. He wrote of the power of color:

> One of the marveylous thyngs that god useth in the composition of man, is coloure: which doubtlesse can not bee consydered withowte great admiration in beholding one to be white and another blacke, beinge coloures utterlye contrary. Sum lykewyse to be yelowe whiche is betwene blacke and white: and other of other colours as it were of divers liveries.[7]

For men like Hawkyns, the question of color was crucial. When forced to consider the idea of blackness for the first time, the English, like many other Europeans, fell back on ancient conceits:

blackness meant darkness, evil, filth, impurity, and barbarity, the very reverse of their own being. In England this contrast of opposites was exemplified by no less a person than the queen herself: lily-white of complexion, pure of heart, virginal, and, in the words of the poet George Puttenham:

Her cheeke, her chinne, her necke, her nose,
This was a lilly, that was a rose;
Her hand so white as whale bone,
Her finger tipt with Cassidone;
Her bosome, sleeke as Paris plaster,
Held up two bowles of Alabaster.[8]

If the English were white and civilized, then, the thinking went, Africans, with their naked black skins and strange, "primitive" behavior, must be savages. In the early 1560s the English poet Robert Baker sailed twice to the "burning shore" of Africa. The people, he said, were "black beasts," "fiends more fierce / than those in hell that be."

And entering in, we see
a number of black soules,
Whose likeliness seem'd men to be,
but all as blacke as coles.
Their captain comes to me
as naked as my naile,
Not having witte or honestie
to cover once his taile.[9]

The sixteenth-century traveler George Best wrote: "the cause of the Ethiopians blacknesse is the curse and naturall infection of blood, and not the distemperature of the Climate."[10] So ingrained were such ideas and attitudes that by the time Hawkyns set off for Guinea he believed he had a moral license to capture black Africans.

HAWKYNS'S PROGRESS from Tenerife was not rapid. On the way to Sierra Leone he carried out at least one raid on the Barbary Coast of Western Sahara, where, according to the report of a Spanish official, he seized two boats and a small advice-boat known as a *pataxos,* and also "took a ship of Sebastian Alvarez, which was in the port of the coast of Berbesin in the which they took seven slaves and took in these a Negro by the name of Manuel Mandinga, cabin boy, the which was in the ship's arsenal."[11] Farther south, along the northern stretches of the Upper Guinea Coast, Hawkyns's fleet prowled estuaries, rivers, and inlets in search of Portuguese slave ships to attack, African villages to raze, and trading stations to deal with. The heat was oppressive, sitting heavily on the land, like a hot poultice, the air motionless and shimmering like a mirage. Mosquitoes swarmed the mangrove trees, and the surf broke like a thunderclap on the low sand banks. Relief came only with the occasional breeze of the cool, dry Harmattan wind that swept down from the Sahara.

With no legitimate reason for being in the area, and no contacts, the Englishman resorted to tactics that were a throwback to those abandoned by the Portuguese over a century earlier: he hunted down Africans spotted on the coast, and dragged captives from their homes or their fishing canoes and threw them into the holds of his ships. Caravels heading for the Cape Verde Isands would have been his prey, too, as would the slaveholding stations in Sierra Leone, where Portuguese factors and *lancados*—unofficial traders outlawed from Portuguese society— living in small settlements on land, or for greater safety in semipermanently moored ships, would have been given the choice of sell or fight. John Hawkyns dismissed his activities in Africa with just fifty-nine words. Writing twenty years later of himself in the third person, he reported that after leaving the Canaries

From thence he passed to Sierra Leona, upon the coast of Guinea,
which place by the people of the country is called Tagrin, where
he stayed some good time, and got into his possession, partly by
the sword, and partly by other means, to the number of 300 Ne-
groes at the least, besides other merchandises, which that Country
yieldeth.[12]

The Portuguese were far more forthcoming. Angry at his in-
cursion into their territory, they claimed that Hawkyns used
bullyboy tactics, bludgeoning resident traders in a series of sur-
prise attacks, clubbing, torturing, and terrorizing Portuguese fac-
tors into handing over valuable quantities of Africans. Hawkyns,
they maintained, was responsible for at least six vicious assaults
on Portuguese traders.

According to their accounts, in the final days of 1562 the En-
glishman led his fleet, which now consisted of four ships and
three well-armed smaller vessels, into Sierra Leone's "River of
Rocks" (probably the Rokel), where he and his men stormed
aboard a ship captained by John de Espindola. Seven witnesses
testified to this terrifying attack. The crew were clubbed and
beaten, and between two hundred and five hundred captives
were siphoned away, along with the ship and its cargo of ivory,
wax, and gold. Soon after, Blasius da Veiga, a captain and knight
of Santiago, was subjected to an even more horrifying ordeal. At-
tacked by the Hawkyns ships in the "Caces" River,[13] da Veiga not
only suffered the loss of his ship, two hundred African slaves, and
all his artillery and weapons, he almost lost his life when the
English intruders took a personal dislike to him. His crew were
insulted, robbed, and tortured, and da Veiga had a noose placed
around his neck and was "nearly killed. He was saved by the in-
tervention of John de Espindola," who begged that da Veiga be
spared. The ship was taken into a harbor on the Mitombi River,
and da Veiga and his men were thrown overboard. They had lost
fifteen thousand ducats' worth of freight.[14]

Four further cold-blooded attacks followed. Anthony Figuiera

lost four thousand ducats when seventy slaves he was holding captive in a small boat were seized, along with freight that included ivory and wax. John Valascus, who had "lived in Sierra Leone for many years," was surprised by Hawkyns and lost seventy slaves and a ship. Martin de Sequiera and his men were "clubbed and tortured and thrown out onto land in the greatest poverty" when Hawkyns and his men fell upon them. Sixty slaves were seized and all Sequiera's artillery was stolen. Finally, one Emanuel d'Aragon was left in "complete destitution" by a Hawkyns onslaught.[15]

If the Portuguese allegations are to be believed, then in all of these raids Hawkyns accumulated over nine hundred Africans; seized large quantities of ivory, wax, and gold; added six vessels to his fleet; and robbed his victims of more than sixty thousand ducats. There is reason to be cautious with their claims. It was after all illegal for the Portuguese to trade with the English. If found guilty they could be severely punished. So it was only sensible to claim they had been attacked if in fact they had contracted with the English voluntarily. Nonetheless, the allegations cannot be easily dismissed. Hawkyns was a man schooled in the shady netherworld of piracy and privateering, raised on the roughneck streets of Plymouth and the turbulent waters of coastal Britain. Violence coursed through his veins. Here was a man for whom direct action, the thrill of the kill, the adrenaline rush of the chase, the satisfaction of the catch, were always among life's finer pleasures. If there was a paucity of records for this his first adventure in Africa, there would be plenty of evidence from his later voyages to demonstrate that he was not slow in resorting to violence to achieve his ends, particularly where the Portuguese were concerned.

Shortly before pulling away from Guinea, Hawkyns took stock. He holed up in a safe haven, unloaded the captives from their various vessels—probably onto the extra ship he would take— transferred the other spoils of his raids, and then sank or burned the unwanted vessels. He may even have sent one ship back to

England with much of the valuable nonhuman booty. Belowdecks on the ships that remained in his fleet between three hundred and nine hundred Africans were held captive in dark, dank, rat-infested holds. Nobody saw fit to record the conditions faced by the slaves, but there can be no doubting the squalor and the resulting pain and suffering. Hawkyns, though, considered the slaves as just another cargo, a valuable commodity differing from his precious load of linens and cloths only in their perishability.

For the hundreds in chains it was a different story: they were about to embark on a claustrophobic nightmare of a journey that could take six or seven weeks, depending on winds and weather conditions. It has been calculated that as many as a quarter to a third of those packed onto slave ships in years to come would not survive the journey across the Atlantic.[16] Body flux (as dysentery was called), smallpox, measles, and the flu could quickly spread to epidemic proportions. Parasites abounded—Guinea worms could grow to four feet in length—causing diarrhea and vomiting, and the darkness, malnourishment, and foul water combined to cause deficiencies in vitamins A, C, and D, leading to night blindness, scurvy, depleted calcium, and withered bodies.[17] And yet any concern Hawkyns had about sickness and death rates among the captives was informed by financial rather than moral scruples: a dead African was another dent in his profit margins.

By January 1563, his business complete and his preparations finished, Hawkyns was ready to cross the Atlantic, now with one more vessel in his fleet than when he had left Plymouth.

NINE

In keeping with the African half of his voyage, Hawkyns's account of the Caribbean leg leaves much to be desired. He simply reported that he carried his African "prey" over the ocean and had "reasonable utterance" and "peaceable traffic" in his dealings with the Spanish there, though he was "always standing on his guard."[1] There is nothing more. Fortunately, the Spanish archives offer much of substance.

Hawkyns's small fleet, now four strong, reached Puerto de Plata on Hispaniola's north coast in early March 1563.[2] He was not the first Englishman to attempt to trade in the Caribbean; there had been small-scale surreptitious commerce between English merchants based in Spain since the 1520s.[3] Nor was he the first Englishman to sail into the region: one ship was chased away from Santo Domingo in 1527 when it blew off course while searching for the Northwest Passage.[4] Thirteen years later the *Barbara* of London went on an ill-fated rampage around the Caribbean that resulted in the death of most of her crew.[5] Hawkyns, however, may well have been the first Englishman to deliberately sail to the Indies with the intention of opening up a new trading operation.

The decades since Columbus first touched land in the Indies had seen a growing rift between settlers and the Spanish crown. The government in Spain was accused of having lost touch with the problems and pressures facing their colonists, and of failing to understand their hunger for luxury goods, and the necessity of a good supply of cheap labor. Hawkyns's haul of Africans and European textiles satisfied very real unmet needs on the island, and his arrival would be welcome.

What he found was that in the sixty years since settlement began Hispaniola had changed profoundly. A long, largely abandoned coastline, with isolated unprotected settlements and weather-beaten remnants of ghost towns, greeted Hawkyns. Years of attacks by French and Portuguese corsairs, and the general population drift away to Mexico and Peru, had drained the area of life and vibrancy. Sugar production was still important, but cattle ranching was the most significant industry. Thousands upon thousands of cattle—too many to eat—roamed the island, useful only for tallow and leather. The heat was unbearable, mosquito clouds blackened the skies, and underfoot an especially unpleasant worm could bore into human soles, inflating feet to the size of a human head, driving the victim insane. "They have no remedy . . . but to open the flesh, sometimes three or four inches, and so dig them out," recorded one visitor.[6]

The coastal population was vulnerable to attack. The island's major city, Santo Domingo, was two hundred miles away. The Audiencia—the judicial and administrative council that along with the viceroy or governor acted as the government—was forever making pleas to the authorities in Spain for new defenses, but as the island's importance diminished and new cities such as Havana on Cuba and Cartagena and Portobelo on the mainland grew in stature, Hispaniola's cries increasingly fell on deaf ears. The north coast, with its unpatrolled yet reasonable ports, became a honeypot for smugglers. It was no surprise to find John Hawkyns making his way there.

JUAN ORTIZ Oñate, a forty-year-old merchant of Santo Domingo, was among the first to spot the ships. On 10 March 1563, as he was preparing a vessel to sail from Puerto de Plata, Oñate received the disturbing news of an approaching fleet. He quickly weighed anchor and slipped out to sea. What he saw made him anxious: two large ships, a caravel and a *pataxos,* with two skiffs acting as outriders, heading toward land. He knew immediately they were foreign, since it was obvious they were lost. The merchant rushed back to land, made his ship safe, raised the alarm, and, on the instruction of a local official, removed the artillery from his vessel and placed it on a sandbank ready for action.[7] Fear spread swiftly: Alonso Arias de Herrera, the president of the Audiencia, wrote that the population was terrified "lest they march inland to pillage the country."[8] Miguel de Luzon, a merchant of Santo Domingo working on the north coast that day, later told a tribunal that when a ship approaches "everyone goes up into the hills and leaves their homes and property unprotected." But this time they did not. Despite the widespread awe at Hawkyns's fleet's impressive military power, the locals did not abandon their homes, run for the hills, or even go into hiding.[9] Instead, as Oñate set up his guns, people from the town began to gather on foot and horseback to watch events unfold. One of the English skiffs was heading toward them, gliding along a tongue of water edged by the lip of the golden sandbank. As it progressed, its crew sounded the water's depth, looking for a safe berth for the larger vessels.[10]

In the swelling crowd, Francisco Ceballos, the crown treasurer, announced that the visitors should be permitted to come ashore. Oñate disagreed, arguing that allowing the boat to dock and its occupants to climb the bank would expose their vulnerability. Oñate added that "the only talking they should do with them should be with shots, one after the other." There was a general

murmur of agreement. Oñate's guns were loaded, primed, and fired. Shots splashed around the approaching boat. The skiff raised a white flag, but behind it, believing the gunshots to be signals that port had been found, the fleet began to edge forward. More shots rained down on the boat. It began to take on water, and the crew screamed that they had come in peace. The barrage continued. The men on the skiff lowered their flag and rowed away. Out at sea the ships halted and moved back. For the rest of the afternoon, and the next day, the English vessels scouted the coast, sailing to and fro, regrouping to consult, and parting for further reconnaissance. Then, on the third day, "as dawn rose they appeared in the port with the wind in their sails," said Oñate, "and in the afternoon they came straight at the port and were upon the said sandbank and did not dare to risk the reefs and went to put to anchor at a point called Cabo de Franceses."[11]

A skiff bearing the fleet's Spanish pilot, Juan Martinez, his personal African slave, and an English resident of Cadiz recorded only as William was dispatched to the shore. Here they were met by two local men, Diego de Mendibil and Francisco Viera. Word was sent to Francisco Ceballos at his sugar mill, who rushed to the scene. Once again a crowd collected. A letter from Hawkyns was handed over. It said they came in peace, and they had Africans to sell and a rudder to repair. Hawkyns added that he had a permit from the queen of England for which "they had given a surety of ten thousand pounds, which is forty thousand ducats, that they would not hurt anybody." Could the townsfolk, Hawkyns's letter asked, send up a plume of smoke over a port where the English would be allowed to land?[12]

Oñate later claimed that he warned the treasurer that the English were corsairs, but in spite of this Francisco Ceballos was more than a little welcoming. Shortly after the initial meeting, Oñate spotted Hawkyns's three couriers being entertained with many others in the home of the treasurer, and heard them say "they had come from England and gone directly to La Palma [sic] because they had a contract with Pedro de Ponte to go and

barter in Guinea." and that they had bought the caravel from the Portuguese in Africa for five hundred ducats. As Oñate listened he realized that the three men were telling different and contradictory versions of the same story: about whether the slaves were bought or stolen, about whether Hawkyns had permits for trading in Guinea, and about how they had come into possession of the caravel. He turned on Ceballos and demanded that no help be given, as it would surely result in death and robbery. The treasurer disagreed: the English, he said, were here with goodwill and might be starving. A ferocious row broke out between the two men: Ceballos grabbed Oñate by the shirt and told him that "if he carried on talking the way he was, he would hang him and that the King would punish him if he did not do what he wanted." Oñate pushed the treasurer back and waved in his face a letter the king had sent to the Audiencia. The king had ordered that no one should barter with the English "on pain of death," Oñate screamed; he would make sure that Ceballos's backsliding was reported. Stunned by this threat, Ceballos ordered his nephew and a colleague to go to the English ships and ensure that nobody from the island went on board to fraternize or trade. It was a token gesture. There were murmurs among the Spanish that they should attempt to capture the ships, but instead the English were given a pilot, who guided them into the haven of La Isabela, thirty-five miles away.[13]

L A I S A B E L A was the site of Columbus's second settlement on Hispaniola, but it had existed as anything more substantial than a hamlet for only a year, and that was back in 1493. Inland, however, lay a fertile farming region known as La Vega, where sugar plantations flourished, and demand for slave labor was high.[14] Hawkyns remained in port for as long as forty days, hauling his ships one by one onto the sandbanks for careening and so that the rudder of the caravel could be repaired. At the same time shops and stalls were erected from frames carried on

the ships and trading in slaves began. Hawkyns was anxious to
get his captives off the ship before any more died, and business
was good.

After a month, and with a good proportion of his slaves dis-
posed of, Hawkyns wrote to the Audiencia to proclaim his inno-
cent intentions and declare his love and respect for the Spanish
king. It was a naive attempt to establish his legitimacy, and the
Audiencia was having none of it.[15] Hawkyns had broken Spanish
law in at least three ways: he was a foreigner in Spanish Ameri-
can waters, an uninvited guest and therefore a trespasser; he had
no license to trade from the Spanish crown; and the goods that
he traded had not, as required, been cleared by the bureaucratic
machinery of Spain's Casa de Contratación ("House of Trade")
in Seville. Each of these offenses alone was considered serious;
that he had committed all three was enough to brand him a dan-
gerous felon. The Audiencia commissioned one of the island's
wealthiest men, the lawyer Lorenzo Bernaldez, to ride against
Hawkyns, with orders to capture or kill him, and confiscate all of
his goods.[16]

Bernaldez left Santo Domingo early on Easter Sunday, aiming
to cover the 180 miles to La Isabela by following unusual back
routes. He claimed he wanted to avoid detection, and at times he
cut a path through virgin forest land so that his horses could get
through. On the way north he drafted all the men he met, black
and white, telling them they were "wanted to go against negroes
in rebellion." Four days of sleeping rough followed. By the time
he came within striking distance of La Isabela he had a posse of
as many as 120 men on horseback. He posted guards on the main
road, and sent out spies. He promised that the man who killed
Hawkyns would be rewarded with two hundred pesos, and a fine
gold chain that he removed from around his neck and held up
for all to see. Bernaldez wanted to know when, how, and with
whom Hawkyns came ashore. However, he feared that the visi-
tors had been forewarned of his arrival, and it seemed he was
correct: when Hawkyns came ashore it was on the opposite bank

of the river to the hiding Spanish, and on the only occasions Hawkyns left his ship he was surrounded by a personal body-guard of 20 men, each armed with a harquebus. Bernaldez later claimed that he was not deterred, but that one attempt by a raid-ing party to swim the river ended in failure when strong currents washed away their horses, and on another occasion a nighttime raid on an exposed hut frequented by the English resulted only in the capture of 3 hapless sentries.[17]

The Spanish commander publicly concluded that Hawkyns was too powerful and too canny to be taken by force. Others agreed that it would be futile to resist: Miguel de Luzon later told an inquiry "it was not possible to do any damage to him [Hawkyns] even if all the island had joined in, because with one round of fire no man would remain standing in the said port." Yet the suspicion remains that Bernaldez left Santo Domingo with no intention of confronting Hawkyns, and that his whole journey was a sham concocted to enable him to trade with the Englishman.[18]

On 19 April 1563, Bernaldez and Hawkyns struck a deal. The Englishman said he had arrived in the Indies by the misfortune of the weather, he had 140 slaves chained up in his ships, and he was willing for the moment to hand over three-quarters of them to Bernaldez, plus the caravel he had taken in Guinea. In return he wanted the release of his captured sentries and the right to sell off the remaining 35 slaves he carried. Selling these, he said, would allow him to pay his crew and afford the repairs. He would then go home and petition Philip II for the return of the Africans handed to Bernaldez. The Spaniard agreed, and granted him twenty days in which to complete his sales, after which, the license stated, Bernaldez would be allowed to "freely attack" him. Hawkyns permitted four inspectors on board his ships to confirm that he had only 140 Africans. The crown's share was received on the seafront at La Isabela by Treasurer Ce-ballos, who for safekeeping took them to Puerto de Plata. Having received the captives for the crown, Bernaldez proclaimed loudly

that the license he had issued was worthless and flew in the face of a royal proclamation specifically banning such traffic. He promptly saddled up and rode off back to Santo Domingo to report on his success. The whole business was a charade. Bernaldez even gilded the lily by telling one witness that he was allowing the deal to proceed for the benefit of the Africans and to stop Hawkyns "from killing them all and throwing them in the sea."[19] Five months later the slaves were auctioned off to the colonists, raising for the crown's coffers more than fifty thousand pesos.[20]

There was clearly subterfuge at play here. It was ridiculous to believe that John Hawkyns was carrying just 140 Africans. Bernaldez knew there were many more. Shortly after Bernaldez's departure from La Isabela, the president of the Audiencia, Alonso de Herrera, wrote to the crown that he suspected Hawkyns had more slaves hidden away than he had declared. It was likely that many—probably most—of the slaves had already been sold in the five weeks Hawkyns had been on Hispaniola before Bernaldez turned up, but there were certainly more to offload. Bernaldez came to La Isabela, ensured his cut of the booty (one accusation would be that as a sweetener, he was given more than 100 slaves to dispose of as he wished), made a public display of doing the king's work by announcing the ban on traffic, and then departed in the sure knowledge that as soon as he was out of the picture, trading would restart.[21]

New slaves began to appear in the houses and fields of Hispaniola. There were sightings in the smaller villages of the north of the island—La Yaguana, Santiago, and La Vega. Three "specimens" were known to be in the possession of Juan de Guzman. Tomas Fuentes, the mayor of La Isabela, had an African woman; Cristobal de Santisteban obtained at least two slaves to work as servants in his home, one of whom was ten years old and purchased for seventy ducats. Lope Estevez had a black man in domestic service, as did Francisco Martinez, and a man named Segura living in Puerto Real had bought six. In that same ham-

let, Alonso de Herrera had picked up four or five Africans, as had Alonso Cornejo and Francisco Terreros. Alonso Vivas in Santiago had five new slaves bought from Hawkyns, and Crown Treasurer Ceballos himself was known to have at least two. Juan Carrasco in Monte Christi had secured "six large negroes and a small one and two negro women."[22]

Amid all these known deals there were complications. Some, like Terreros, wrangled over prices. The Spanish suspected a quantity of slaves were being taken back to England. Others were used as bribes to grease the palms of local bureaucrats.[23] More significantly, the newly arrived slaves were beginning to die or escape. As many as 12 perished in La Isabela soon after arrival. Fourteen of the 105 left in the hands of the crown were dead before the auction could be organized, and much to his new owner's chagrin, the young boy purchased by Santisteban died of measles soon after. Other Africans were reported to have escaped from La Isabela, and others disappeared from Monte Christi on Corpus Christi Day while washing clothes in the Yaque River.[24]

HAWKYNS MOVED his center of operations to Monte Christi, a thirty-mile sail west along the coast. Behind him at La Isabela he left the Portuguese caravel, still being repaired but now in Spanish ownership.[25] There was little more to his new location than a few more people and a good location on the Yaque River, but he still had slaves to sell, and markets to tap into. By now Hawkyns and his flotilla were a familiar sight, and the general good demeanor of his men meant that their arrival in port caused little consternation among the merchants there. Nevertheless, as a precaution the royal proclamation against trafficking was posted throughout the town, and in case of trouble extra guards were stationed on the streets day and night.[26] Yet in spite of this, trading continued, and more slaves and cloth were disembarked from the ships. Cristobal de Santisteban saw many individuals receiving bribes and remembered seeing

*negroes and merchandise being brought off the said ships and all
the rest were provisions brought from England and Canaria
where they had docked and as far as the merchandise was con-
cerned, he knows that they brought up to two bales of woven hemp
and two hundred yards of ruan [cotton cloth from Rouen in
France], and four or five pieces of telilla [a type of thin woolen
cloth].*[27]

Cristobal de Santisteban was central to events in Hispaniola.
A young man who was a citizen of Seville, he had lived in the In-
dies for ten years and also ran an accounting business in the
Canaries. He often traveled between Santo Domingo and Tene-
rife in ships loaded with merchandise belonging to his brother
Pedro.[28] If anybody truly knew what was going on in Monte
Christi it was Santisteban. Soon after Hawkyns pulled into the
town, the head of the local garrison, Colonel Diego de Ribero,
approached the Englishman and suggested a hostage swap. He
was concerned at the damage that the English fleet might—if a
change of mood took them—inflict upon the town. Hawkyns
agreed to the exchange without hesitation, sending "three of the
main people from his ships as hostages" to stay in the house of
Juan de Guzman, while he received on board "one of the most
important people from onland." That man was Cristobal de San-
tisteban, and he was about to go way beyond his role as hostage.[29]

Trade in Monte Christi was brisk, and highly profitable.
Wagons stacked high with hides queued up along the dock to
Hawkyns's ships. Hundreds of hides were piled nearby to dry
in the baking sun. This was the payment for goods received.
Diego Martinez, Francisco Martinez, Bartolome Delgado, Fran-
cisco Terreros, Ponce de Cabrera, and Cristobal de Santisteban
were among those paying for slaves in kind.[30] Indeed, their bills
were so great that even though the Spanish charged Hawkyns
"more than double what is usually paid," the English ships
were very soon full. Hawkyns strolled along the quayside in
search of a solution.[31]

Shortly before Hawkyns's arrival in Monte Christi, three ships had docked there: an *urca* (a large, armed, flat-bottomed vessel) belonging to the Martinez family and mastered by Alonso de Campos, a ship captained by Pedro de Estrada, and a ship under the command of Juan Ortiz Oñate. The dockside, though rudimentary, was busy: hides, sugars, and ginger were being loaded into ships for transportation to Spain.[32] Among those taking advantage of these sizable ships were the Santisteban brothers. Hawkyns now requisitioned space on these vessels. There is confusion in the documentation as to how much space he needed, and whether he needed two or three ships, but for certain Hawkyns claimed the Martinez *urca Nuestra Señora de Clarines,* and reclaimed the caravel, the *Sancto Amarco,* that he himself had brought from Guinea. Repairs to this had been completed, and it was ready for a voyage to Spain. Hawkyns's hides—almost five hundred in the *urca* alone—were loaded into all available spaces, and to disguise their true ownership Cristobal de Santisteban entered them into the register in his name, and consigned them to Hugh Tipton, an English merchant in Seville, and a Richard Cazon, who lived in Cadiz.[33]

Santisteban would later claim that he was coerced into cooperating with Hawkyns, saying that as a hostage on board the *Solomon* he was in no position to argue. To deny Hawkyns his request would have plunged the town into crisis and threatened the ships—the *urca* alone, he claimed, was worth over one hundred thousand ducats—and Hawkyns could just as easily have seized it as requisitioned it. Besides, Santisteban argued, by sending the registered cargo to Spain he was ensuring that the business passed through the Casa de Contratación, earning valuable revenue for the crown. Santisteban further claimed that by registering the merchandise clearly he was highlighting its presence on board, and ensuring its confiscation on arrival in Spain. Everybody in Monte Christi knew that the goods really belonged to Hawkyns, he added, and there was no attempt to deceive, just to extricate himself from a tricky situation.

His excuses were disingenuous. The truth was that Cristobal
de Santisteban did everything in his power to aid Hawkyns. He
had been acting as registrar for Hawkyns's hides from as early as
13 March 1563, several weeks before he became a hostage. The
Englishman's hides were stored on the *urca* alongside those of
his brother Pedro de Santisteban, compounding the disguise. He
wrote covering letters to Hugh Tipton, advising him of new
business and informing him that he was acting as a front for
Hawkyns, and to a resident of Seville, Diego Martinez Beltran, in
which he authorized Beltran to hand over 285 ducats to Tipton:
money the Englishman would have to pay in order for the illicit
hides, ginger, and sugars to clear customs at the Casa de Contrat-
ación.[34] It is not beyond the bounds of belief to conclude that
Cristobal de Santisteban, with his willingness to help Hawkyns
and his contacts in the Canaries, was the central contact promised
to the Englishman by Pedro de Ponte.

The question of why Hawkyns went through this charade is
begged, however. Why had he not just chartered the ships and
dispatched them to Plymouth? Why had he not just repeated the
bluff, aggressive behavior he had employed off Guinea? The an-
swer seems to lie in his belief that if he could be seen to be acting
correctly, and with respect for the Spanish in the Indies, then
they would appreciate his overtures of goodwill, contrast them
with the rank hooliganism of the French, and allow him to re-
turn unchallenged at a later date. There were numerous refer-
ences to Hawkyns's good conduct on Hispaniola, and how he was
the very antithesis of the rampaging corsair. The sending of the
three ships to Spain to pay the duties expected of them allowed
him to further his upstanding image. If challenged he could
claim the mantle of responsible merchant, keen to do what was
expected of him at whatever personal cost. Further proof came
when it was time to leave for home. The three loaded Spanish
ships, at least two of them carrying Hawkyns's goods, set sail on
or about 10 June 1563—the date of the letter from Cristobal de
Santisteban to Hugh Tipton. Thomas Hampton, captain of the

Swallow, traveled on the *urca* to watch over the freight and handle any problems on arrival in Spain.[35] It was agreed with the authorities in Monte Christi that Hawkyns's fleet would sit in port for a further ten days, with Santisteban still on board as a hostage, "so that the Englishmen would not set off in pursuit." Despite all their dealings and their apparent amity, there was still a fear among the Spanish that once on the open seas Hawkyns would act treacherously, steal the ships, pillage their freight, and return to England with a belly full of loot. Hawkyns was happy to alleviate their concerns.[36]

With sufficient blue water between the transport ships and Hispaniola, Hawkyns, in his own words, "disimboked, passing out by the islands of the Caicos, without further entering into the bay of Mexico."[37] He left behind him a simmering row. Not everyone on Hispaniola had been pleased about the events on the north coast. Licentiate Echegoyan, a judge in the Audiencia, used the occasion to exacerbate a personal feud with Lorenzo Bernaldez by blowing the whistle in a series of letters to Spain. From May 1563 he began alerting the king of the "very ugly," "dirty," and "scandalous" business that was being conducted on the island. He pointed the finger of blame at the Santisteban brothers, "through whose hand passed everything bad that had happened there," but he saved his true vitriol for the "recently converted Jew" Bernaldez. The trading license Bernaldez had issued Hawkyns was "tinted with deceit," a tawdry arrangement with Lutheran heretics. Why had Bernaldez not arrested the English? Why was he being allowed to hush up his dealings? Echegoyan claimed Bernaldez was "laughing" at authority and must not be allowed to get away with it, and warned that "the island will shortly become England unless a remedy is applied."[38]

In the months after Hawkyns's departure, the Audiencia dispatched two men, Licentiate Juan de Villoria and a receiver of the Audiencia, to Monte Christi to investigate the goings-on there, and arrest those responsible.[39] In August 1563, Bernaldez

wrote to the king to defend himself, worried that "your Majesty may order me to be beheaded." Toward the end of the year Villoria returned from the north "with prisoners and brought those who appeared to be guilty of bartering with them before the courts, to the extent that those towns were left almost without people because there are very few inhabitants." At the same time Echegoyan reported to the king that the 105 slaves had been sold and the money would be paid into the treasury.[40]

All of this was bad news for two men in particular: Cristobal de Santisteban and Hugh Tipton. Echegoyan's first letter to the king arrived in Spain shortly after the *urca* bearing Hawkyns's cargo. At Sanlúcar de Barrameda, at the mouth of the Guadalquivir River, officials climbed on board and impounded the freight. In Seville, Hugh Tipton was arrested. John Hawkyns's representative, Thomas Hampton, went on the run. Back in Hispaniola, Cristobal de Santisteban was thrown into jail on charges that included robbery. Proceedings against him would continue for years. Meanwhile the *Sancto Amarco*, destined for Cadiz, failed to turn up. Too trusting of the crew that had guided it safely and without trouble from Guinea, Hawkyns had allowed the ship to sail unsupervised. It cruised past Cadiz to Lisbon, where it was nabbed by slave traders.[41]

Hawkyns had lost two ships full to the gunwales with hides, sugar, ginger, gold, silver, and jewels, but for the moment he was oblivious of his loss. The journey home took three incident-free months. In the middle of June 1563 there were reports of two English ships behaving suspiciously off Santa Cruz, Tenerife; but assuming that he had not left Hispaniola until after the tenth of that month, it is not possible that these were Hawkyns's ships. Hawkyns almost certainly called at the island on his way home to confer with Pedro de Ponte, report on his successes, allocate to his partner his share of the proceeds, and make preliminary plans for another voyage. Then, with business completed, the Hawkyns ships sailed on to England, with news of the losses in Spain and Portugal. These would rankle for years to come, but

the profits he had made were nevertheless enormous, and he was buoyed by the knowledge that those Englishmen of influence who were monitoring his progress would now have every reason to believe that it was time to kick the Spanish door open a little further.

TEN

The England to which John Hawkyns was returning was a troubled land. In 1562 the country had become embroiled in a bloody civil war in France—the so-called Commotions. For the promise of Calais at a later date, Elizabeth had entered the conflict in support of the Huguenot Protestants against their Catholic neighbors, but when both sides buried the hatchet and joined arms, English forces found themselves caught in the wrong place at the wrong time. Humiliation followed at Le Havre, where, enfeebled by illness and hunger, the earl of Warwick was forced to surrender in July 1563. Squalid and embittered, the returning English troops brought home more than their despair—they brought with them bubonic plague. By September the black death had laid waste to London: at its peak three thousand people were dying every week, and more than a quarter of the city's population went to an early grave.[1] William Camden wrote in his annals of England that it was "such a contagious pestilence, that it grievously affected the whole realm: and out of the City of London alone, which consisteth of an hundred and twenty one parishes, there were carried forth to burying about 21,530 corpses."[2]

The practice of daubing plague-ridden houses with blue crosses

had to be abandoned because, in the words of the chronicler Richard Grafton, they "increased so sore, and the citizens were crossed away so fast, that at length they were fain to leave their crosses, and to refer the matter to God's good merciful hand."[3] Those that could—the rich and the powerful—fled the city for the countryside. The queen, so recently recovered from a mysterious bout of smallpox, was quarantined at Windsor. Plans were afoot to run the government from the disused monastery at Syon, and the legal term in Westminster was adjourned until safer times.[4]

There were fears, too, that the for once united French would take the opportunity to grab the Channel Islands,[5] and as if that were not enough, there was disturbance at the nation's perimeter. In Ireland the troublesome Shan O'Neill was leading a sporadic campaign of terror aimed at uniting all the tribes of Ulster to his cause: the expulsion of the English back across the Irish Sea. Scotland's dense political problems and internecine religious struggles increasingly spilled over into the affairs of her neighbor as well. In August 1561, Mary Stuart had returned home to Edinburgh from France following the death of her husband the French king François II. To many in Catholic Europe she was the rightful heir to the English crown, and a standard-bearer for the return of the "old religion." Not only had Elizabeth's restoration of Protestantism distressed Catholics across the continent, but to them her right to the throne was invalid because she was the child of the illegal marriage of Henry VIII and his second wife, Anne Boleyn. Mary's claim, on the other hand, through her grandmother Margaret Tudor, sister of Henry VIII, was clean and unsullied by divorce or illegitimacy. As a Catholic with influence in France, and to a lesser degree Spain, Mary would be a threat and source of discord for decades to come.

Hawkyns preoccupied himself with the various tasks that accompanied the end of an expedition. Crews were generally contracted to remain in service for twelve days after docking to assist with the unloading of cargo and the general repair and maintenance of ships. Only then would they be paid off. Hawkyns would

have to warehouse his cargo, call in the auditors to assess its value, get it off to market, and, soon after arrival, report back to the project's eagerly awaiting sponsors. They would quickly organize the dividing up of the profits according to shares.

News of the disappearance of one of his freights and the impounding of another at Seville—along with the imprisonment of Hugh Tipton and Cristobal de Santisteban—reached Hawkyns as soon as he came ashore, probably from the waiting Thomas Hampton, who had already managed to escape back to England. Hawkyns was furious. He told himself that he had acted properly at all times, that he had acted reasonably and responsibly in the Caribbean, and that in sending the cargoes to Spain he was obeying Spanish law. He seems to have genuinely believed that he was acting in goodwill, and to have hoped that this would be understood and accepted. That the Spanish had had the audacity to seize his goods—narrowing his profit margins—was nothing less than a slap in the face. On the question of the ship lost in Portugal, he lodged a complaint with the High Court of the Admiralty, a formal, perfunctory gesture that was unlikely to result in any redress of his grievance. He cared less about this loss because there was no point of principle at stake: he and other English adventurers already felt they could visit Portuguese territory with relative ease and impunity. There was more to lose, and more to gain, by establishing a precedent with Spain. On this matter he sought an immediate audience with the queen, and just days after landing it was granted. On 8 September 1563, Elizabeth wrote from Windsor to Thomas Challoner, her ambassador in Madrid. She had, she informed him, written to Philip II

in favour of this bearer, John Hawkyns, touching such matter as partly by the writing herein sent, and partly by his own declarations shall appear unto you. Our will and pleasure is that your understanding thoroughly the cause, and well informing yourself of the equity thereof, do take opportunity to communicate the same

in our name to the King and to help and assist our said subject in the setting forth of his said suit.[6]

It was a remarkable intervention. In a time of constant piracy and continual problems on the high seas, it was not unheard of for Elizabeth to show interest in the activities of her favored subjects. But to grant Hawkyns an audience as soon as he reached home, to permit him to break her quarantine, to break her concentration at a time of such troubles, and then to instruct her ambassador to personally intervene with the Spanish king, demonstrates more than just a passing concern; it suggests a direct interest in the project, possibly of herself, and certainly of her ministers.

The letter also provides the first hint that Hawkyns was on his way to Spain, or so it seems, for the evidence of his actually ever arriving there is scant and wholly ambivalent. In December 1563, Hugh Tipton—by now at liberty—wrote to Ambassador Challoner from Seville. In a postscript to the letter he described the Hawkyns problem in detail, adding that Hawkyns's goods had been sold and "the money put into the King's chest with three locks. . . . I do now write to Master Hawkyns who I think is with your lordship on this day, and who will inform him of all largely."[7] The implication is clear: Hawkyns was in Madrid, probably having arrived for a consultation with the ambassador. Yet there is little information on his activities. In February 1564 an aide-mémoire of issues raised by Challoner with Philip II included the intriguing scribble "Hawkyns's matter," but by this time Hawkyns would have left for home, where there was plenty of unfinished business for him to attend to.[8]

On 5 July 1564, Challoner, a competent and cultured ambassador, fluent in Latin, French, Italian, and Spanish, and who had written several books,[9] wrote to Hawkyns that any optimism he had once held had now evaporated. "This is the worst time that might fall between us and them this twenty years for expedition of any suits to be obtained by favour or response of amity further than the bare right or justice of the case will bear," he wrote.

Then, hinting that Hawkyns had considered another trip to Spain to sort the matter out, he added, "There is small hope here, by way of ordinary justice to prevail. So as in mine opinion you did well not to come hither yourself."[10]

Instead he suggested a new strategy: Hawkyns would procure one of the king's favorites "to ask the whole as forfeit. For example, to promise to give four or five thousand ducats to one that should ask at the King the whole, and be bound to render to his factors the rest."[11] If indeed Hawkyns tried this new line of attack, it failed. As the ambassador had stated, Anglo-Spanish relations were beginning to sour badly. In the summer of 1563, just prior to Hawkyns's arrival in Plymouth, Philip got wind of a joint English and French plot to settle Florida. The plan fell through, but it left the Spanish king decidedly uneasy.[12] Piracy, too, was straining relations. English men-of-war stalked the Channel and the Bay of Biscay, ostensibly in search of French ships, but making frequent illicit raids on Spanish vessels and ports along the Basque coast. In one of many atrocities, the pirate Thomas Cobham chased a Spanish galleon carrying Inquisition prisoners from the Low Countries to Cadiz. Out in the Bay of Biscay he intercepted his prey, forced it onto rocks, and released the convicts. He ordered that the Spanish crew be wrapped in the mainsail, which was sewn up and thrown overboard into the sea, drowning every one of them.[13] In another incident a fleet of eight English merchantmen attacked a French ship off Gibraltar— since the two countries were at war, she was a legitimate target. The Spanish saw it otherwise, and a fleet under Alvarez de Bacan intervened, capturing the English ships and 240 men, who were subsequently dumped in the dungeons of Seville. Hugh Tipton told Challoner that de Bacan kept the prisoners "in chains, and feeds them with bread and water, with which ill entertainment certain of them are dead."[14]

Relations had not been helped by the behavior of the Spanish ambassador in England. Alvarez de Quadra, bishop of Aquila, was a curmudgeon who had reluctantly taken up the job in 1559.

Of fragile health and quick temper, he believed he deserved better than the miserable gray dampness of London. From his embassy in the Strand, he organized an efficient, if rather obvious, intelligence-gathering network. The authorities believed he associated too freely with reprobates and dissidents, Irish rebels and disaffected clerics. They intercepted his mail off Gravesend to check his reports to Philip II. Then, following a series of unfortunate incidents at his residence, and suspicions that he was allowing English subjects to take Catholic mass there, all of the locks to the embassy were changed. Quadra had the ignominy of having to request a gatekeeper to let him in and out.[15] Elizabeth thought he was a "most disagreeable" man and demanded his recall, a demand that Philip II received with contempt. "Certainly he took it in disdain," wrote William Camden, "that this his ambassador was without his privity confined within his house, subjected to examinations, and publicly reprehended."[16] In August 1563, Quadra died in poverty, having fled to the countryside to escape the plague. Despite the importance of his office, the pay was poor, and his corpse was held in custody for ten months until debts he had run up were paid off. Only then could it be shipped to Naples.[17]

His replacement, Guzman de Silva, the canon of Toledo, was a breath of fresh air to his English hosts, a congenial, intellectual cleric with a steely determination and intelligence. On his arrival in England in June 1564, he was greeted by Elizabeth in Latin and Italian and was granted an immediate private audience. That the new ambassador was a shrewd and pleasant operator was a great relief to the queen, who called him a "comely tall priest."[18] His subtlety won him allies and influence at court and allowed him to, among other things, force the English to reduce the incidence of piracy against Spanish ships. He would not remain in the country long—he, too, found the climate disagreeable and the financial recompense poor, and by 1568 was on his way to the Spanish embassy in Venice. In those four years, however, he was to play an important role in the Hawkyns voyages.

IT WAS a sure sign of the success of Hawkyns's first slaving
voyage, and of the interest with which it had been viewed,
that when time came to propose a second venture there were
many, more influential persons willing to provide the capital.
The possibility of huge gains was enough to interest many, but
there were other pressing concerns. Just as England was a trou-
bled land in the early 1560s, so, too, was her export business. The
country had become too dependent on the sale of cloth to the
huge international market at Antwerp. So important was the city
to English exporters that there was an English Quay there, and
in the city's English House the immensely powerful Merchant
Adventurers had their headquarters. However, there were major
problems. The Low Countries were becoming increasingly un-
stable, and were about to become the site of appalling civil and
religious conflict. There was also resentment in the Netherlands
that although English traffic to Antwerp had burgeoned, recip-
rocal markets in England were becoming increasingly closed.
Prohibitive customs duties and outright protectionism—such as
in 1563, when a ban was placed on the import of cutlery into
England—raised many hackles. Using the pretext of the plague,
the Netherlands banned the importation of English cloth and
woolen goods that November. As the news trickled through to
merchants in London, forty ships loaded with seven hundred
thousand pounds' worth of cloth destined for Antwerp were sit-
ting in ships in the Thames ready to go. It was a dreadful blow,
and although the ban did not last long—it was rescinded in May
1564—it sufficed as a warning to English traders that they
needed to both diversify and expand their markets.[19]

Hawkyns provided such an opportunity. With characteristic
vigor he had set about organizing his next voyage almost as soon
as he touched land. The sponsors who came forward included
new names. Gonson and Wynter were still there, but now there
were powerful voices from both the City and the court: Sir

William Garrard, haberdasher, merchant adventurer, and former lord mayor, signed up; so did Sir William Chester, an extraordinarily wealthy former lord mayor and governor of the Muscovy Company; and Edward Castlyn, a merchant with important contacts in the Canaries. Chester acted as the syndicate's treasurer, Castlyn as its victualler.

It was the names from the royal court, however, that caught the eye. These were truly powerful players. They included William Cecil, the queen's personal secretary; Lord Admiral Clinton; the earl of Pembroke; and Robert Dudley, the recently created earl of Leicester. Dudley was the queen's personal favorite—many believe her lover—the son of the earl of Northumberland, who had been executed for treachery in 1553 during the struggle to succeed Edward VI. Dudley was made earl of Leicester in 1564 and given a vast quantity of land in order to make him eligible to marry and thus nullify Mary Queen of Scots. Until selling it for almost seven thousand pounds, he had also been the major license holder for the export of undyed cloth, England's most significant export commodity.[20]

And Elizabeth seemed happy to have her most trusted advisers so deeply involved. If her part in Hawkyns's first voyage had been played from the wings, she now edged stage front. The queen wanted in, and she wanted a share of the profits. As late as 1563 she had expressed a certain distaste for the Hawkyns project, even stating that "[i]f any African were carried away without their free consent it would be detestable and call down the vengeance of Heaven upon the undertakers."[21] But with the balance sheets in front of her, and an understanding of the global significance of the Hawkyns undertaking, she changed tack. While not offering financial support—an option that would have allowed her to profit without revealing her hand publicly—she went a step further: she ordered that Hawkyns be given the seven-hundred-ton *Jesus of Lubeck* for his use. This monster of a ship had been purchased by Henry VIII from the Hanseatic League in northern Germany and was now old and creaky—a 1558

review of ships in the navy had condemned her as "much worn, and of no continuance and not worth repair."[22] Nevertheless, she had been patched up, and was now a formidable, if still rather dilapidated, presence on the oceans. The *Jesus* was more than the sum of her rotten planks. The ship was a public sign of royal patronage, a seal of approval for Hawkyns and his slaving voyages. He would henceforth be able to fly under the queen's flag. Elizabeth, that icon of English history, was about to become the first royal slave trader, the first English monarch to promote and benefit from the enslavement of Africans. The virginal mask, it seems, began to slip, the plaster-of-Paris purity sullied by the desire for hard cash. And hard cash there would be. No contract or charter for this adventure has survived the years, but similar documents for contemporary projects show that in return for supplying one ship, fully prepared, rigged, and furnished, as well as supplied with artillery and munitions, Elizabeth could expect "one full sixth part of the clear and whole gain and profit." Although she would have paid as much as five hundred pounds toward the onboard victuals, she would not have been responsible for finding or paying the crew.[23] Therefore, if all went according to plan, the queen could expect a healthy return on her decrepit man-of-war.

THE PREPARATIONS were watched with dismay by the newly arrived Spanish ambassador. He got wind of the plans shortly after reaching England. On 24 July 1564 he had an audience with the queen, where he demanded to know what Hawkyns intended and sought guarantees that Hawkyns would not be plundering the Americas again. Elizabeth treated him courteously and "replied graciously on all points." A week later he gave his king details of the intended fleet: it would consist of four ships, would have "twenty four pieces of artillery large and small, mostly of bronze, but some of iron and one hundred and forty men," and would be heading back to Guinea.[24]

Philip responded swiftly, thanking de Silva and informing him that he had passed on the information to the king of Portugal and his ambassador. He also instructed de Silva to find out everything he could about the adventure, to "learn of the objects in view and progress made . . . and at the same time you will cleverly do your best, as adroitly as possible, to hinder the voyage being undertaken. If you cannot prevent it I shall be glad to know what steps you have taken with that object."[25] It was a license to commit both espionage and, if the opportunity should arise, sabotage. On 28 October, George Gilpin, an English agent and bilingual secretary working in Antwerp, wrote to William Cecil with the disturbing news that an armada had been sent from the Low Countries "to make towards Cape Verde and there wait for such English ships as are gone or shall go towards the Indies."[26] Spanish spies were everywhere: in Plymouth, in London, and in the heart of the royal court.

In November, Aires Cardosso, the latest Portuguese ambassador, arrived in London and called on his Spanish counterpart. Cardosso had come with the object of forcing the queen to stop Hawkyns from leaving, but he was too late: with great irritation he learned that the fleet had already sailed.[27] Together the ambassadors obtained an audience with Elizabeth, and in a bad-tempered meeting on 19 November, Cardosso made a number of demands and delivered several guarded threats. Hawkyns's ships should have been stopped, and any others preparing to head for Guinea should be stayed and disarmed immediately, he told her. In order to preserve the ancient friendship between Portugal and England, all of her subjects must be forbidden from making such voyages. As for those that, like Hawkyns, had already gone, Elizabeth must "cause them to be chastised and punished at their return, with such punishments as your Majesty shall think reasonable for their disorder and insolence, in breaking the ancient laws and customs of the Crown of Portugal."[28]

On 24 November the queen replied to the Portuguese ambassador in writing, pointing out to him that his request was in

many ways academic, since the ships had sailed. Nevertheless, as she had told Cardosso's predecessor, although she saw no real reason why she should prevent her subjects from going to African lands subject to the Portuguese, she would agree to this in order to preserve the friendship of the two nations. However, and it was a big however, as for sailing into those parts of Africa where the Portuguese king had no more than tacit dominion and where French ships seemed to navigate with impunity, "her Majesty findeth it not reasonable that she should prohibit her subjects to use their navigation into those parts, otherwise, than the subjects of the French King and other dominions are known yearly to use, offending thereby no dominion, nor country of any Christian prince."[29]

Although her response was couched in politeness and phrases of mutual amity, Elizabeth knew that Portugal had no real control over most of Africa, and her message was clear: there was to be no ban and no punishment for Hawkyns and his men.

Eleven

With a prosperous wind filling the sails, Hawkyns's new fleet pulled anchor and crept out of Plymouth Harbor on 18 October 1564. There was an immediate mishap in port: on cutting the foresail of the *Jesus*, the ship whiplashed around, and "a marvellous misfortune happened to one of the officers in the ship who," wrote crew member John Spark, "by the pulley of the sheet was slain out of hand, being a sorrowful beginning to them all."[1]

And yet the tragedy was not allowed to dampen a spirit of high optimism: Hawkyns was in command of the queen's ship, and he had the official sanction of the mightiest people in the land. On the eve of sailing he had been summoned to Enfield Palace for a private audience with Her Majesty. During the course of a lively and detailed conversation they discussed the aims of the voyage, and the hopes and aspirations of both, and finally she gave him confidential instructions. The meeting was secret, but it is known that it was cordial, that the queen was keen to voice her support for John Hawkyns, and that her orders concluded with a phrase that has echoed down the ages: "serve God daily, love one another, preserve your victuals, beware of fire, and keep good company."[2]

The new fleet consisted of four ships. In the lead was the lumbering *Jesus,* which, with her four masts, magnificent poop, and formidable forecastle, was in spite of her age and condition nothing less than a huge floating fortress, from whose deck Hawkyns commanded an artillery of impressive firepower. Behind her trailed the *Solomon*, spruce and refreshed from the first adventure the year before; the *Tiger,* a fifty-ton bark; and the *Swallow,* a thirty-ton pinnace, which was not the same vessel that had made the previous journey. Between the four ships were divided 170 crew and a number of gentlemen adventurers and their servants whose role included handling much of the trade in Africa and the Americas, and looking after the business interests of the expedition's sponsors back in England. These included John Chester, the son of the operation's treasurer; Anthony Parkhurst, who had come from Spain to join the voyage at the recommendation of Thomas Challoner; George Fitzwilliams, who was set to enjoy a long and controversial career with Hawkyns; Thomas Woorley; and Edward Lacy. In addition to the usual victuals— the biscuits and beef, the bacon and beer, the peas and cider— they carried in their holds beans and more peas sufficient to feed 400 African captives, cots in which they could sleep, and shirts and shoes in which they could be dressed both to preserve their dignity and to be presentable in the slave markets of Spanish America.[3]

Thirty miles out to sea, the fleet converged with another headed in the same direction. The *Minion,* the *John the Baptist,* and the *Merlin* were going to Guinea to trade gold and, if possible, build a fort. David Carlet, the expedition leader, commanded a company of men that included carpenters, smiths, and general craftsmen. In the hold of his ship were the tools and materials for erecting a preliminary base, a foothold for English trading on the African continent[4]—further proof, if needed, of the more brazen approach being adopted by the English with regard to Portuguese Africa.

There was no rivalry between the two fleets; rather, the opposite was true. Their missions were completely different, and besides, the underwriters of Carlet's mission included Sir William Garrard, Benjamin Gonson, Sir William Chester, and Thomas Lodge, so there was a great deal of overlap.[5] For greater protection they agreed to sail together, but after three days of pleasant sailing and good progress, the wind picked up, the sea began to boil, the skies blackened, and, beckoned in by a fierce northeasterly, a great storm broke around them. It began at nine o'clock on the night of 21 October and lasted until eight the next evening. In the swirl and battering of gigantic waves the ships were scattered to all points of the compass. First the *John the Baptist* and the *Swallow* disappeared from sight, and then the *Minion* and the *Merlin*. When the weather abated Hawkyns found his flagship, the *Solomon*, and the *Tiger* alone on a restless sea and ignorant of the fate of the others.[6]

Anxiety among the crews was partially relieved the next night, when "to no small rejoicing" they stumbled upon the *Swallow,* sitting thirty miles north of Cape Finisterre, waiting for a wind that would take it around the corner of Spain's north coast and on into the Atlantic. For two days the reunited ships sat patiently, waiting for a southwesterly, before Hawkyns decided to retreat into the shelter of the grim Galician port of Ferrol, where for five days the crews could stretch their legs, get relief, and take refreshment after the rigors of the storm.[7]

A member of the flagship's crew, John Spark kept a detailed journal of the voyage. Spark was a future mayor of Plymouth[8] and probably, bearing in mind his origins and future standing, a confidant of Hawkyns. He neglected to record the English activities in Ferrol except to note that Hawkyns took the opportunity to summon the masters of his ships and lay down the law. The shock of the storm and the easy dispersal of the two fleets had reminded him of the need to clarify reporting lines and emphasize procedure. The smaller ships were to be ahead of the *Jesus* at all

times, and aweather of her, too, he instructed them. Each ship was to communicate with the flagship at least twice a day, and if Hawkyns raised his ensign over the poop, or struck up two lights at night, then they were to come in immediately. If the *Jesus* showed three lights, then she was turning. In bad weather the smaller ships should tuck in alongside the flagship, and if this was not possible, they should seek shelter alongside the *Solomon*, and make for Tenerife with all haste. Any ship in difficulty should put up two lights and fire gunshot. Any of the company losing track but then coming back should make three yaws—quick, darting movements out of the direct line—and strike her mizzen three times. Hawkyns concluded his lecture with the queen's words on the importance of keeping good company, and sent his men off to do their jobs.[9]

On 26 October there was further cause for rejoicing, for the *Minion* came into view off Ferrol. There was much celebration and firing off of ordnance, but the festivities were short-lived, for Carlet's ship brought bad tidings: disaster had struck in the English Channel. Following the ructions of the storm, the *Minion* had gone in search of the *Merlin* and found her safe and sound, but after two days of sailing together a negligent gunner on the smaller ship had accidentally set fire to the gunpowder store. The result had been a massive explosion that blew out the poop, killed three men, and dreadfully burned many others. The *Minion* had moved in to the rescue, swiftly transferring the survivors onto her before the *Merlin*, in a "most horrible sight to the beholders . . . sank before their eyes." The other ship in Carlet's fleet, the *John the Baptist*, had gone on to Guinea alone, and unsurprisingly the crew of the ship pulling into Ferrol "had no mirth."[10]

On 30 October the ships departed Ferrol, and within five days they had passed Madeira. Two days later they reached the Canaries, but surprisingly, Hawkyns failed to recognize Tenerife. The Pico de Teide was cradled in thick fog, and he sailed west believing that he was off Gran Canaria. Carlet, on the other hand, was a good ten miles ahead of him and had recognized the island. He

continued on, his fleet speeding off on its own. Hawkyns was never to see either Carlet or his ships again.

Meanwhile, for two hours the following day, Hawkyns coasted the next island he came upon, puzzling over its unfamiliarity, awaiting the dispersal of cloud which he believed would reveal the Teide. Only when it had cleared did he realize that he was well off course, and that he was in fact doing a circuit of La Palma. Quickly he ordered an about-face: by the afternoon they had reached La Gomera, and as night fell they were off Adeje, on Tenerife, his familiar resting place, where Hawkyns expected a warm welcome.

One of the *Jesus*'s boats was lowered into the calm, warm waters below, and the commander was rowed ashore. He carried a letter he wished delivered the three miles to the *casa fuerte* of Pedro de Ponte. As he neared the shore he spotted two gangs of men carrying guns heading toward him along the main road. Behind them trooped as many as eighty more, armed for a fight "with halberts, pikes, swords and targets, which happened so contrary to his [Hawkyns's] expectation that it did greatly amaze him, and the more because he was now in their danger, not knowing well how to avoid it without some mischief." They were obviously spoiling for a fight, and Hawkyns was startled. He encouraged his mariners to row out of range of gunshot while he called out to those on shore that he meant no harm, that he was no pirate, and that he was a close friend of Pedro de Ponte. From out of the mob stepped a familiar face. Nicolas de Ponte, the son of Pedro, calmed the situation, told the men to step aside, and called Hawkyns in. The Englishman was relieved and climbed ashore, shaking de Ponte's hand vigorously and saying that he urgently needed to speak with his father.[11]

Pedro was away on a short business trip but would be back soon. Meanwhile, John Spark wrote, the ships spent seven days repairing masts and taking on refreshment; and when Pedro de Ponte did arrive home from Santa Cruz, John Hawkyns was treated to "gentle entertainment as if he had been his own brother."[12]

While relaxing in the south Spark found time to enthuse about
the quality of the island's wine, made from "grapes of such big-
ness, that they may be compared to damsons, and in taste inferior
to none,"[13] and to recount a legend of phantom Canary Islands
that flitted across the horizon "which have been oftentimes seen,
and when men approached near them they vanished."[14] Yet he
neglected to mention the serious and unexpected trouble Hawkyns
found himself in. Toward the end of his stay on the island,
Hawkyns, in the company of Pedro de Ponte, sailed his ships the
sixty miles north to Santa Cruz, where he hoped to complete his
replenishments. But while there, on 14 November, Licentiate Juan
de Rada, lieutenant of the governor of Tenerife, indicted Hawkyns
on the grounds that he and his men were Lutherans and that they
had "done many crimes in disservice" to Philip II.[15] Hawkyns's
ships were boarded without warning and subjected to a spot
search by the Inquisition. Surprise was registered by the authori-
ties at finding African women on board—they were almost cer-
tainly slaves that Hawkyns had not sold on his previous voyage,
but why they were on board, and what function they were being
forced to perform, is open to speculation. Yet such a question did
not greatly vex the authorities. They were far more interested in
another crime they believed Hawkyns guilty of. According to the
charge sheet, the Englishman had brought to the island "a coffer
of church vestments" and sold them to Pedro de Ponte. These
vestments included "nine capes, the which appeared open, used
and served before and that they concluded that in England they
neither say Mass nor celebrate the divine worship, the said Juan
Acles [John Hawkyns] like a Lutheran must have taken them or
robbed of some monastery or church."[16]

At least three men came forward and denounced Hawkyns as
a heretic, throwing in for good measure that he was a pirate, too.
The ornaments and the slaves were confiscated. Pedro de Ponte
advised Hawkyns to provide information proving that the items
did not belong to him, that he was merely transporting them; but
it seems that with the authorities closing in on him, Hawkyns

decided not to hang around. The very next day his fleet weighed anchor and sailed away from Tenerife.[17]

WITHIN FIVE days they were off the Barbary Coast, spotting ten Portuguese fishing boats with which they had hoped to trade, but which fled at the first sight of foreign sails. That same day the sea acted treacherously once again. One of the ship's boats carrying two men was capsized by a high wave and strong buffeting wind. The best efforts of the *Jesus* to turn and collect them were thwarted. Instead, the ship was blown a full mile and more from the upturned boat. Fortunately, Hawkyns had marked the accident by the position of the sun, and ordered "twenty four of the lustiest rowers" into the ship's great boat. With the wind to their backs, and straining at the oars, they came to the capsized boat and despite their "small hope of recovery," found the two men sitting wet but tight on her keel.[18]

A further five days of coasting the continent, and the fleet reached Cape Blanco. Here, according to the English, they traded peacefully with Portuguese fishermen for mullet, dogfish, and pargos.[19] But Spanish witnesses told a different story. Fishermen Andrea Estevez and Juan Vaez Cabrera reported that Hawkyns entered the makeshift port of Angla de Santa Ana with all guns blazing, and "bombarded forty ships that were there fishing, the which were Castilian Christians and Portuguese, and they forced them to give them a certain quantity of provisions."[20]

A few more days' sailing, and the slave hunting could begin. On board there was a sense of excitement as the Guinea coast came into view—the prospect of snaring Africans on the coast produced an adrenaline rush. However, at Cape Verde, where they intended to unleash the first of their raiding parties, they found their cover had been blown: David Carlet, on board the *Minion*, had warned the Africans of Hawkyns's approach, allowing them to "avoid the snares we made for them."[21] This was galling for Hawkyns, who was livid with anger and frustration.

He blamed Carlet, possibly even accused him of deliberate sabotage, but a more likely explanation was that the passing of Carlet's fleet had put the local people on their guard, alerting them to the need to be ready to flee at a moment's notice.

The Hawkyns ships scoured the area for a further eight days, angling for "fish with heads like Conies [rabbits], and teeth nothing varying, of a jolly thickness, but not past a foot long, and is not to be eaten without flaying or cutting off his head"[22] and making tentative contact with the local people, whom they found civil, goodly men. Over these frustrating days they failed to capture slaves, but they managed at least to gather up a marooned Frenchman who reluctantly, and after much persuasion, allowed himself to be rescued. He had been one of nineteen survivors when a bark from Dieppe broke up off the Cape Verde Islands. Lifeboats had carried them to the mainland, where he and his compatriots had lived for over six weeks on meat and drink supplied by the locals. He had fallen out with the others, who were now living inland, but he was enjoying himself so much, and his entertainment among the Africans was such, that it took great pleading from a small French contingent in the English crew to finally make him come on board.[23]

On 7 December they moved on again. On a small island at the mouth of the Corubal River, in present-day Guinea-Bissau, they found a huge colony of witless gannets on which the sailors were able to take out their exasperation. The birds had never seen humans before and sat passively as the crews waded through them with clubs and poles. The birds were piled high into the boats, which moved off only when in danger of sinking. Next, with the two larger ships riding out at sea, the *Tiger* and the *Swallow*, their boats acting as outriders, stole up on another island, where they hoped to capture their first human prey. Eighty men clad in armor climbed onto the beach, with the instruction to catch as many Africans as possible. But their approach was clumsy and noisy: the locals ran away into the woods, leaving their pursuers able to do little more than stand, watch, and then walk on until they came to

a river, which they could not cross for being so weighed down. On the opposite bank, two men sprang up and fired arrows at them. The English discharged their harquebuses. The Africans, like the gannets before them, were ignorant of the deadly power they were confronting, and taunted the hunters: leaping up and down, crying out peculiar screams, and turning in circles. Finally one of the gunshots grazed a man on the thigh. He looked down on his wound with a puzzled expression, trying to work out how it had happened and why his leg was bleeding. The English gave up and returned to their ships. Hawkyns had hoped to cruise farther up-river, along the Corubal and into the Rio Grande, but lacking a pilot experienced in the navigation, and fearing the shoals of rocks that cut through the river's surface when the water was low, they turned about and headed for Sierra Leone.[24]

TWO DAYS of lashing winds and persistent rains followed. When the storm subsided on 10 December the ships continued south until coming to rest off Sherbro Island, which they called the Island of Sambula. The fleet had separated in the storm, and for two days the *Jesus* and the pinnace waited for the others to join them. What followed was a rampage through the nearest African villages, made all the more shocking by the nonchalant way in which Spark committed it to paper. The following was the full English version of their pillage. They went ashore every day, Spark wrote, "to take the inhabitants with burning, and spoiling their towns."[25]

The Hawkyns expedition had arrived at an interesting moment in West African history, and Spark was astute enough to note it, though without understanding its significance. For decades the Mane tribespeople had been pushing out from the interior and around the coast. In recent years they had made Sherbro Island a stronghold from which they were now advancing. Spark did not get the names right, but he noticed a distinct difference among the peoples, whom he divided into Sapes and

Samboses. The latter, he recalled, had been in the area for only three years, and had through war enslaved the former, whom they now forced to farm the land for them. It was a dreadful relationship, Spark noted, that ran counter to appearances: the Sapes, despite being civil, had adopted a ferocious look that included filing their teeth to a point "which they do for bravery, to set out themselves, and do jag their flesh, both legs, arms and bodies, as workmanlike as a jerkinmaker with us pinketh a jerkin." There was no doubting who were the bosses: the Samboses, Spark wrote, not only lived on the victuals the Sapes harvested, but would in times of famine eat their slaves as well. The Sapes were also useful as sacrifices to the English predators: when Hawkyns and men went ashore hunting slaves "we took many in that place, but of the Samboses none at all, for they fled into the main."[26]

Amid the carnage Spark was moved to comment on the high quality of African craftsmanship and the organization of their settlements. At a time when Plymouth was little more than an open sewer on the landscape, and London a pestilential hovel astride the Thames, Spark described houses that had lofts made from sticks where food was kept, and sections set aside for bedrooms, marked out with mats of palm leaves and mattresses, and a kitchen near the main entrance. Houses were homes, too, of mice and exotic lizards, some over a foot long. Villages on Sherbro Island, he wrote, were

> *prettily divided, with a main street at the entering in, that goeth*
> *through their Town, and another overthwart street, which maketh*
> *their towns cross ways: their houses are built in a rank very orderly*
> *in the face of the street, and they are made round, like a dovecote,*
> *with stakes set full of Palmito leaves, instead of a wall: they are not*
> *much more than a fathom large, and two of heighth, and thatched*
> *with Palmito leaves very close, other some with reede, and over the*
> *roofe thereof, for the better garnishing of the same, there is a round*
> *bundle of reede prettily contrived like a bower.*[27]

At the center of the average village was to be found a larger, higher house, alongside which sat a place where matters of justice were discussed, criminals were tried, wars were agreed upon, and arrangements for harvesting of crops and production of palm wine were finalized. It was "made of four goode stanchions of woode, and a round roof over it, the ground raised round with clay, a foot high, upon the which floor were strawed many fine mats: this is the consultation house . . . in which place, when they sit in counsel, the King or Captain sits in the middes, and the Elders upon the floore by him . . . and the common sorte sit round about them."[28]

Spark added that in warfare the Africans were well organized: "In their battles they have target men, with broade wicker targets [shields], and darts with heads at both ends of iron." One end of the dart was like a double-edged sword, a foot and a half long, with the other end acting as a counterweight so that it flew level.

And when they espy the enemy, the Captain to cheer his men crieth, "Hungry," and they answer "Heygre," and with that every man placeth himself in order, for about every target man three bow-men will cover themselves, and shoot as they see advantage, and when they give the onset they make such terrible cries that they may be heard two miles off.[29]

On 21 December the English finally decided it was time to move on, grabbing as much fruit, rice, and millet as possible to go with the Africans they had seized. The moment gave the Africans an opportunity for revenge. Shortly before departure, men from the *Tiger* were loading pumpkins into their boat. As they were set to leave, the ship's carpenter asked them to wait a moment while he gathered a pile that he had put to one side up the beach. Africans hiding in the trees spotted him walking unarmed toward them: they stole up behind him, slit his throat from ear to ear, stripped him naked, and dumped him to the ground, where he bled to death.[30]

Africans were not the only ones on the receiving end of Hawkyns's wrath. The English were on the lookout for Portuguese barracoons, and in a series of lightning attacks they looted and burned Portuguese vessels and settlements up and down the coast. The Portuguese claimed they acted like a band of pirates, stealing Africans, wax, ivory, gold, and kola nuts. In one attack they burned a ship because "the cargo of the vessel did not please Joannes de Canes [John Hawkyns]";[31] in another they killed a Portuguese trader. One ship's captain, Bartholomaeus Valascus, was "thrown out on to land after suffering many blows and acts of torture."[32] Hawkyns's men clubbed the Portuguese, insulted and robbed them, and in the words of one eyewitness "inflicted a great and bloody slaughter on those living there, to say nothing of the naval calamity."[33] There were times when the Portuguese were un-doubtedly complicit with Hawkyns, whether through fear or de-sire, but if they are to be believed, the English assailed as many as seventeen ships or trading stations, seizing more than six hundred slaves, making away with more than fifty thousand ducats of freight and shipping, and leaving the traders on shore in the "direst poverty" or "utter destitution."[34]

After the events on Sherbro Island the ships sailed north for a day, and then, with the two larger ships sitting at its mouth, the *Tiger* and *Swallow*, accompanied by two boats, cruised up the Callowsa River. Hawkyns was on the lookout for more Portuguese barracoons, and three days and sixty miles upriver the English got lucky. On 27 December they emerged from the river with "two caravels loaden with Negroes." Under interrogation, the Portuguese on the caravels told Hawkyns of an African town called Bymba, where a huge store of gold was guarded by fewer than forty men and one hundred women and children. The fleet immediately shifted its center of operations along the coast, stationing themselves off Bymba. After four hours of observations Hawkyns ordered forty men to climb into their armor and take up arms. With the Portuguese guiding them in, they landed boat after boat, but before Hawkyns could enforce discipline, his men

leaped ashore and scattered along the beach. Driven into a frenzy by the prospect of gold, they ran through the village, ransacking houses and terrorizing the people. But English greed left them isolated and vulnerable. Attacking African homes in ones and twos, they became easy prey. The people fought back, and drove the invaders to their boats and even into the water. Some made it; others were hacked down as they ran or drowned at the water's edge. Others of Hawkyns's men were cut off in the town and forced to make a final desperate stand against the African anger. Hawkyns himself had taken an orderly group of twelve men into the town. When he returned to the beach he found two hundred Africans "shooting at them in the boats, and cutting them in pieces." On spotting Hawkyns and his men, the African resistance retreated. Hawkyns climbed into one of the boats and ordered it back to the ships. It had been a costly adventure. For the capture of ten slaves, seven of his best men had been killed, including Master Field, the captain of the *Solomon*, and another twenty-seven had been wounded.[35]

There was a lesson here, but the question was whether Hawkyns was ready to learn it. After three days of licking wounds and restoring spirits, the ships pulled away for Tagrin at the mouth of the Sierra Leone River. Here the English intended to refill their water butts and carry out last-minute repairs before heading off across the Atlantic. In the meantime the two smaller ships headed to the Casseroes River for five final days of business. When they returned to Tagrin final preparations for departure were carried out, but as the crews attended to their duties on shore, they were set upon by Africans, who wounded many and smashed the water butts and casks. The attack threw the schedule back a further five days while the carpenters and coopers carried out repair work. The *Swallow* took the opportunity to sail upriver in search of more slaves, but instead met up with Portuguese traders who told them of a great battle that was about to take place between two tribes, one from Tagrin and the other from the interior. It would happen in six days' time, they said, and if

Hawkyns's men were to hang around, there might be a great number of new captives to round up. But the *Swallow* could not wait; she was a sickly ship, and she turned around because of the "death and sickness of our men, which came by the contagiousness of the place." It was time for the English to clear African waters, and this they did three days after fortuitously avoiding one last ambush from the local people on 18 January 1565.[36]

TWELVE

In the third week of March 1565 the fleet approached the coast of Venezuela and Hawkyns sighted mainland South America for the first time. His fleet was now seven strong, having seized three ships from the Portuguese in West Africa. The journey so far had been largely uneventful. The Spanish armada that he had feared might be lurking in wait for him had failed to materialize, but out in the Atlantic the winds and currents had dropped, and for three weeks the ships were becalmed on a sea only occasionally ruffled by minor distant tornadoes. John Spark for once expressed concern about the captives and the effect the delays would have on their chances of surviving. With so great a "company of Negroes," he wrote, there was barely sufficient drinking water, and they were in such fear that many never thought to have reached to the Indies, without great death of Negroes, and of themselves."[1] Undoubtedly Africans had begun to die: those who had been captured early in the voyage would have been belowdecks for as long as ten weeks, huddled in the acrid darkness, wallowing in dank, fetid conditions, living off diminishing rations of beans and peas. Fortunately, as despair had begun to set in, a wind had arisen and blown them

to Dominica, where they arrived on 9 March. Here, for want of fresh supplies, they revived the surviving Africans with puddled rainwater.[2]

At Margarita, the next island on their schedule, the ships caused panic. Although they stayed out at sea, and although the mayor of the main town, Asunción, was happy to supply beef and sheep, the governor was less pleased.[3] Not only did he refuse to meet them, he sent a caravel to Hispaniola to warn the viceroy of the presence of English ships in the Indies. From there Don Antonio de Osorio, president and captain general of Santo Domingo, rushed an alert around the colonies and added a warning that nobody should trade with them. The English should be resisted "with all the force they could."[4] In the meantime on Margarita the residents of Asunción "were so afraid, that not only the Governor himself, but also all the inhabitants forsook their town, assembling all the Indians to them, and fled into the mountains." Worse still for the English, Hawkyns was expecting to pick up a pilot here, but was not allowed to take him on board.[5]

With a pressing need for water, there was no reason for Hawkyns to hang around. On 22 March the fleet reached Cumaná, on Venezuela's by now struggling Pearl Coast. In the early years of the century this, along with the nearby island of Cubagua, had been among the richest and most heavily populated stretches of Spanish America.[6] The colonists' wealth had been based on pearl fishing, but they had overfished the seabeds, devastating stocks and their ability to replenish themselves. Much of the area had been abandoned for the more fertile pastures of the Gulf of Panama, while those that remained in dusty mainland outposts such as Cumaná struggled desperately to scratch out a living. As early as 1535, Gonzalo Fernandez de Oviedo y Valdes was writing in his *Historia General de las Indias,* "the Christians have been so hasty to search for these pearls that they have not contented themselves with divers in getting them; they have discovered other devices such as

rakes and nets, and they have extracted such a quantity that scarcity has begun to set in and they are no longer found in abundance, as at first."[7]

Hawkyns did not waste time. Two Spanish sentries pointed him six miles down the coast to a watering hole called Santa Fe, where for six days the English took refreshment and the opportunity to revive both themselves and their human cargo. Arawak Indians "of colour tawny like an olive" approached them, bringing bread and corn, chickens and pineapples. They provided the English with what was possibly their first ever sighting of sweet, convolvulus potatoes, which the English got in exchange for beads and pewter whistles, glasses and knives, and of which they commented that they "be the most delicate roots that may be eaten, and do far exceed their parsnips or carrots."[8]

John Spark had a fascination for the Indians: he noted their color, their jet-black hair, their abhorrence of bodily hair, which they "daily pull off as it grows." He recorded their near nakedness and their poor diets. Women, he observed, did not "delight" in having children, which left many deformed, and while young "they destroy their seed, saying that it is fitted for old women." What was more, after giving birth new mothers went "straight to wash themselves, without making any further ceremony of it, not lying in bed as our women do." He remarked, too, on the deadliness of their weapons and the strength of the poison used on their arrows, which, composed as it was of the juice of innocent-looking apples and the venom of bats, vipers, and adders, would send a man to his grave within a day. Later, at the end of March and in early April, as the fleet made its way along the coast, passing between the mainland and Tortuga Island, Spark commented on the less friendly, more cunning Carib Indians of these parts who attempted to entice Hawkyns ashore with flashes of gold and offers of trade. Hawkyns ignored them, for as Spark declared, they were devourers of men, "bloodsuckers both of Spaniards, Indians and all that light in their laps."[9]

O N TUESDAY 3 April 1565 the English fleet pulled up by the small, decaying town of Burburata, near the present-day Venezuelan town of Puerto Cabello. The settlement consisted of little more than a few households strung along a creek, but it had a fine harbor providing an excellent shelter for large ships, and a good embarkation station from which to explore the Venezuelan hinterland. Most important, it gave visitors access to nearby gold mines. If it had not been for the unwanted attentions paid it by French and Portuguese corsairs, the port would have thrived. Since 1553, however, the constant assaults by pirates, coupled with not infrequent raids by Indian tribes, had resulted in a marked depopulation of the town in favor of Nueva Valencia, twenty miles inland beside a mountain lake.[10]

Hawkyns surveyed the scene, clambered into a boat, and was rowed into the heart of the port. As he scrambled ashore he was met by three officials: Antonio de Barrios, the town's lieutenant and deputy treasurer; Diego Ruiz de Vallejo, its accountant; and an alderman, Agustin de Ancona, who, along with Cristobal Llerena, a Portuguese African that Hawkyns had rescued in Guinea, acted as interpreter.[11] Pleasantries were exchanged: he had come in friendship, Hawkyns declared, quickly falling back on his stock excuse that he had been driven there not by intention, but by bad weather. He had merchandise that would interest them, and since there was no enmity between England and Spain, they should issue him a license to set out his stalls and trade in the town.[12] Their response cannot have been unexpected: they had been forbidden by their sovereign "on pain of death" from dealing with foreigners, they told the Englishman; at the very least they would forfeit their goods if they did. They urged Hawkyns not to molest them. He could bring his ships into port to revictual, but he should then leave as soon as possible.[13]

Hawkyns persisted. He wanted his license, and he had reason

to believe that Alonso Bernaldez, governor of Venezuela, currently 180 miles away at Coro, would be happy to grant him one. The governor was a nephew of Lorenzo Bernaldez, the collaborating licentiate of Santo Domingo from Hawkyns's first voyage, and the Englishman was carrying a letter of introduction. If that was not enough, Hawkyns also promised the governor an enticement of "six yards of brocade and three of cloth and four fine quality rolls at sixteen ducats the yard, in all colours and fine gold and silver cloth . . . and two slaves and two hundred yards of ruan and more if necessary."[14]

Should that fail to do the trick, Hawkyns hinted at the possibility of violence. He wanted to sell Africans and was willing to pay the appropriate duties on his sales, but he would have no truck with obstruction. It was their choice: he had a crew to feed and pay, and if the local bureaucracy stood in his way, he would take his own measures to cover the costs and expenses of his expedition.[15] This was an unwelcome threat. The ships' arrival had already caused panic in the town: on first sight of sail anxious citizens had begun to pack their bags and valuables in readiness for flight. The town officials begged Hawkyns to stay his hand, to give them ten days in which to get an answer from the governor. The captain huffed and groaned like a great bear, repeated his threat, then conceded. The next day, as the English ships glided into Burburata, nineteen-year-old Juan Pacheco left for Coro carrying to safety the town's treasure chest and a letter from de Barrios urging Bernaldez to come to the port to repair the situation. The message reeked with anxiety and fear of retribution. Hawkyns, it read, "threatens with great oaths to do what harm and damage he may be able." His cargo was worth more than one hundred thousand pesos, and he carried more than four hundred slaves. "I see no better remedy," de Barrios wrote,

> than to let this fellow sell, for in addition to the duties he will pay, a quantity of gold will be smelted. . . .

*Greater evil is ahead of us, for if the town is burned it will mean
its abandonment, in addition to which we will be turned into the
woods in weather bad enough to kill us even were we strong, as we
are not, but very sickly.*[16]

I T DID not take long for Hawkyns to grow impatient. His first
day in port was peaceful enough, but by the second, nagging
thoughts that he might be delaying just to receive a negative re-
sponse began to play on his mind. Besides, the condition of the
African captives was beginning to concern him. Many were
falling ill, and he feared losing large numbers of them over the
course of the next ten days. Procrastination was likely to cost him
dearly in men's wages, used supplies, and dead slaves. It was in
his own words "mere folly" to delay longer. On 6 April he pre-
sented an application in writing to the town authorities that he
be allowed to sell thirteen sick and lean Africans to alleviate the
situation.[17]

The request was granted, and Hawkyns set out a couple of
stalls on the seafront in anticipation of a rush of interest. It failed
to materialize. Whether this was because sick Africans were not
considered a great buy, or because the wealthier citizens had se-
creted their money to the mountains, is not clear. Certainly there
was a fear that trading on such a flimsy basis without a real li-
cense could spell trouble later. Whatever the cause, the result was
no sales on the first day. The next day brought some haggling,
but still no slaves were sold. The colonists claimed the price
Hawkyns was asking was too high. He suspected a ruse to under-
mine his prices and delay his departure. He decided to call their
bluff. Summoning the principals of the town, he announced his
decision to leave. He apologized for having disturbed them, but
in the absence of a proper license, and with no prospect of a de-
cent profit, he would be moving on. The authorities quickly fell
into line, promising to encourage sales while they waited for the
arrival of the governor.[18]

Over the coming days purchases of a few of the sicker

Africans was completed. The sales were enough to keep Hawkyns in port, but only just. Juan Pacheco later reported that the English commander grew increasingly restless: railing against the time it was taking the governor to arrive, threatening to destroy the whole coast if a license was not granted him, and saying "he would quickly enough destroy everything and do much more damage than he described, for he had great means to do it; and if even a slight occasion were given him for displeasure, merely burning this town, which would be the easiest possible thing for him to do, would suffice to destroy its inhabitants."[19]

Sometime between 14 and 16 April the governor finally arrived in town and met Hawkyns immediately. The Englishman came ashore to greet him, and relations were evidently warm. One Spanish observer noted the pleasure they took in each other's company, adding that as the governor and Hawkyns were embracing, "the said Licenciado Alonso Bernaldez asked the captain if he wanted to talk publicly or in secret."[20] Hawkyns replied

> that he wanted to talk only to him and so they went off on their own and were there for an hour or so, and they bade farewell to each other most respectfully, and after the Englishman had gone, the said Licenciado said... "I swear that this man seems to me to be a man of his word and in his reasons he says and shows that if he is not satisfied, he would do and say such that he would show that he is lord of the sea and the land."[21]

Next Bernaldez took counsel from among the leading citizens of both Burburata and Nueva Valencia. From what followed it is clear that he was keen to trade with the English, but first the right noises had to be made. In case of later questions it had to be made to look as though the colonists had faced severe coercion, and had had no choice but to purchase from Hawkyns. Witnesses remembered talk of the need to "consider the lesser evil and damage" that would result from trafficking with Hawkyns, that there was a need to ensure that the city "might not be ruined nor

its citizens perish," and that there were fears of many deaths if Hawkyns was crossed. Juan Pacheco predicted that if they defied Hawkyns they would have to abandon the town and

> *Many would die of sickness occasioned by the rainy season, and if scattered in the woods their lives would be endangered, especially since in these regions there are very many Indians and they have killed many Spaniards. They are on the alert to learn when there are French in the port in order to fall on the people of the town and destroy them, as they have done on certain occasions.*

A proposed expedition against Indians at Caracas would have to be called off, he added, and then concluded, "God, Our Lord, and his royal majesty will be better served by granting the said licence than by ruining the people of this city and Valencia and risking the safety of the whole province and the entire coast."[22]

It was agreed to grant Hawkyns the license he craved, "sufficient to pay their wages and to strengthen the said armada."[23] Crucially, the license did not exempt Hawkyns from paying a customs duty of thirty ducats on every slave sold. The duty came as a shock to the Englishman, who believed such taxation made it impossible for him to make a profit, and his smoldering temper boiled over.[24] As morning broke on 19 April, Antonio de Barrios and Diego Ruiz de Vallejo ambled down to the waterside with their interpreter, Agustin de Ancona, and called out to the English commander. Hawkyns climbed into a skiff and floated out to see what they wanted. They had come for the customs duty in advance, they told him, plus 7.5 percent tax for each African he intended to sell. Hawkyns exploded, bellowing that "they were trying to make a fool of him." He had had enough. From his pocket he took out the newly granted license and tore it to shreds, allowing the pieces to float on the sea.[25] The Spaniards tried to placate him, soothing his fury with a promise to try and win a concession from the governor, but as they made their way back to Bernaldez, the *Jesus of Lubeck* fired off a booming round of

heavy ordnance. Hawkyns was declaring the peace over. On his ships more than one hundred men dressed in armor and carrying bows, arrows, harquebuses, and pikes were ordered to prepare for battle.[26]

Startled by the sudden threat, the governor sent Agustin de Ancona to treat with the captain, and to assure him that everything possible would be done to meet his demands. Shortly after Ancona had gone to meet with the Englishman, Juan Garcia, a resident of the town who had been up on a nearby hill, rushed to the gathering townspeople and reported breathlessly that the English were approaching land in a warlike fashion. Those Spaniards who had horses mounted them and waited for the return of Ancona. The news he brought was not good: Hawkyns claimed that they were playing with him, and wanted to get their hands on his cargo without paying. He was willing to pay the 7.5 percent tax, but nothing more. They could send him a new license along the road, but he was now unable to prevent his men from marching on them. Frenzied discussion followed, after which Ancona was sent out once again to tell Hawkyns that all his demands would be met, and that confirmation in writing would follow. Bernaldez turned to Diego Ruiz de Vallejo to start issuing orders and prepare for the worst. Minutes later Ancona arrived back with more bad news: "the said English captain had told him not to keep sending him so many messages or men, unless it was to send him the permit that he wanted, because he would kill anyone who went there."[27]

The drums of the English grew louder, their flag flapping in the breeze as they cut toward the Spanish. The orderly ranks of fighting men could be seen getting closer. Ancona rode out on horseback again to tell Hawkyns the permit was coming. Meanwhile, Bernaldez and officials quickly scribbled out the new license and gave it to Juan Pacheco and Pedro Martinez to deliver. It seemed to do the trick. The English harquebusiers fired off a fusillade to signal the end of hostilities. But Spanish relief was premature. No sooner had they dismounted and begun to return

to their homes than another gunshot whizzed over the town. The English were once again on the march. On the right-hand side of town, a squadron of soldiers had been setting an ambush, and those who had been returning to the ship had changed direction and were intending to join up with their colleagues. As Bernaldez issued instructions from his lodgings for the making safe of the town, he received a visit from John Spark.[28] His captain was happy with the new license, he told the governor, but the men were not, for they found "so little credit in their promises." They wanted the Spanish to supply two hostages or face the consequences.[29] As Spark talked, a warning signal was heard outside: the English were approaching the town. Bernaldez called for volunteers. Sebastian de Avila and Vicente Riberos stepped forward and agreed to accompany Spark back to the advancing English.[30] The English halted their approach and turned for their ships. Trading could open in earnest now.

If there were ever any doubts about the state of Hawkyns's relations with the colonists, this episode dispelled them. His threatened assault on the town was more than a theatrical bluff to allow the authorities there to pretend they had been forced to trade. The threat was real. The Spanish were already complicit, having agreed to trade in slaves and cloth. It was their attempt to place a mantle of legitimacy over the affair by claiming taxation and customs duties for His Majesty's treasury that had galled Hawkyns. He was not pretending to attack the town; this was no false assault: he was using bullyboy tactics to make sure that taxation did not gobble up his profits.

For nine days trading continued slowly but steadily. Men, women, and children as young as eleven years of age were up for sale at 90 pesos of fine gold, well under the price of 125 or even 130 pesos that slaves fetched when sold through official channels. Alongside the sale of captives, other stalls did a good trade in cloths from Rouen and England, wines from the Canaries, and spices, oils, and vinegar.[31] Although there were no great problems, Hawkyns noticed that those making the purchases tended

to be the poorer of the town. The rich hovered around the edges waiting for the fitter slaves to come on the market. He kept his eye on the rich settlers watching him and suspected that as the poorer settlers ran out of money, the wealthier citizens would move in and try to force prices down. To compound his fears, an official bar on trading after 26 April was mooted by the authorities. Some in the town argued that by this date they would still be able to claim they had allowed Hawkyns just sufficient trade to meet his wages and repairs bill.[32]

Hawkyns decided to force the issue. When the people of the town awoke on 29 April they found the stalls gone, and the English ships sitting out at sea as if preparing to leave. Burburata's wealthier citizens stood aghast. Had they missed their chance? Meanwhile the Hawkyns fleet was joined by the *Dragon Vert*, a ship out of Le Havre. Both fleets fired their guns in welcome, and Jean Bontemps, the captain of the French ship, joined Hawkyns on board the *Jesus*. Bontemps had been off the African coast at Elmina, and he brought news of David Carlet. The *Minion* and the *John the Baptist* had arrived while he was there and Portuguese caravels had attacked them. Bontemps had fled and sailed for the Americas. Carlet and a dozen of his men had been taken prisoner, and the *John the Baptist* had been captured.[33] Neither Carlet and his men nor the crew of the *John the Baptist* were ever seen by the English again. Progress reports from the Azores claimed most of the *Minion*'s men were dead or dying, but she limped home with more than twenty thousand crowns in gold, and a large quantity of malachite and ivory in her hold. Whatever the human cost, it was a cargo guaranteed to make her London backers salivate.[34]

Accompanied by the French ship, Hawkyns reentered Burburata. The colonists had had time to think, and traffic resumed at a brisk pace, this time with the full participation of the more affluent of the town. As many as one hundred and forty Africans were sold into slavery in Burburata: among the transactions recorded, Diego Perozo bought for himself a woman and a small

boy, both of whom died shortly afterward; Bartolome Romero "bought two or three specimens from the Englishmen"; Joaquin Ruiz bought another; and the messenger Juan Pacheco purchased two. For his part, Alonso Bernaldez was widely believed to have chosen twenty of the fittest-looking slaves for himself, in addition to the two that Hawkyns had already given him as a bribe. For this acquisition the governor paid partly in gemstones and partly by an order of payment for six hundred pesos, which Hawkyns was to take to Rio de la Hacha down the coast. Here, the governor said, crown officials owed him money and would reimburse the Englishman.[35]

In a last-minute touch of drama, two hundred Indians attacked the port on the night of 3 May with the intention of burning the town down and killing as many Spaniards as possible. Hawkyns watched with amusement from the deck of his ship. His presence in town proved of benefit to the colonists, for in their current state of vigilance they were ready for the fight. They forced the Indians back without suffering any damage or deaths and captured one sorry individual who as punishment "had a stake thrust through his fundament, and so out at his neck."[36]

THE FOLLOWING morning the English ships pulled up their anchors and set sail, heading north and west in the direction of Curaçao and Rio de la Hacha. Behind them they left a tangle of accusations, intrigue, and factional fighting. Spanish crown officials would soon move in to investigate allegations of the town's involvement with Hawkyns, and in particular the willingness of Governor Bernaldez to grant the "Lutheran pirate" a license to trade. A year later when charges came to be laid against him, Bernaldez faced a host of allegations, including failure to punish "blasphemies . . . or friars and clergymen living as married men and bachelors, and sorcerers and pimps, profiteers and usurers and fortune-tellers," allowing justices in the province to have games tables in their houses, and allowing card

games where a lot of money was won and lost.[37] Agustin de Ancona even went as far as to testify that he believed that there had been no demand for slaves in Burburata, and that the whole Hawkyns affair had been set up for the personal gain of the governor. He had benefited not only from the purchase of slaves, but also from a massive bribe that Ancona said consisted of

> *six yards of brocade and two rolls of gold cloth and silk thread and another of silver thread, and about ten or twelve yards of red cloth which the said Englishman [Hawkyns] told him cost sixteen ducats the yard in England, and another lot of coloured cloth, and another of black cloth, and two hundred yards of Rouen cloth, and two rolls from Holland, and a velvet robe and some velvet breeches and a satin doublet, and flour, which this witness weighed, and was as much as seven arrobas [just over 175 pounds], a roomful of wine of about nine arrobas [just over 38 gallons], there was I don't know how much paper, beans, chickpeas, harquebuses, lances, vinegar, oil... [and] two black slaves.*[38]

It was a large bribe, and shows that the profits Hawkyns was expecting to make were huge. Bernaldez was found guilty of issuing an illegal permit and making personal gains. He was fined to the value of the Africans and merchandise that had changed hands in the weeks that Hawkyns was in port, and then sent back to Spain in chains as a prisoner to face the wrath of the king.[39]

THIRTEEN

I t took two weeks for the slaving fleet to appear off Rio de la Hacha. The journey around the South American coast had taken them to the island of Curaçao, where despite difficulty finding a secure anchorage they had loaded every available space with cattle hides. The English found the island a remarkable, though not particularly wholesome, place to pass their time. There were so many cattle that the Spanish killed them solely for their hides, and left the carcasses and flesh to rot or be devoured by wild dogs. John Spark estimated that the skinned corpses of at least one hundred thousand cattle littered the island. He himself "saw in one field, where a hundred oxen lay one by another all whole, saving the skin and tongue taken away." The hides were dirt cheap, and Hawkyns availed himself of more than fifteen hundred.[1]

With their anchors dragging in rough seas and the ships rocking uncomfortably, there was relief when it came time to move on: around the promontory of Cabo de la Vela, on the Guajira Peninsula of present-day Colombia, and then sixty miles southwest to the town of Rio de la Hacha. On the morning of 19 May 1565, having anchored at sea overnight so as not to overshoot the town, the *Jesus* and three other vessels slipped into Rio de la Hacha's tumbledown port.[2] Rio de la Hacha was the third at-

tempt at a settlement in the region. The previous two had failed because the hard, hot ground made it impossible to plant orchards or sow crops, and the humidity and lack of decent drinking water made conditions unbearable. At its new location things were hardly better: forty or fifty households scratched out a living alongside the area's characteristic white sandy beaches. Though livestock flourished and the Hacha River (which took its name from an ax the first Spanish had given local Indians after being led to it) was a good source of drinking water, the land the settlers farmed was barely able to support maize production. There was no gold in the area, but the Guajiran salt flats provided some income. However, the town did have one truly lucrative industry: pearl fishing. There had been no overfishing here, and oysters were plentiful.[3]

The people of Rio de la Hacha had been expecting the ships. A caravel dispatched from Hispaniola under the command of Alonso Perez Roldan had alerted them twenty days earlier, and the citizens had also been warned of the dire consequences of trading with the English. As a result, Hawkyns was greeted by the eerie spectacle of a silent and abandoned town. Women, children, and valuables had gone first, followed soon after by the men. The royal coffer had been transported ten miles inland, as had all the gold, silver, and expensive clothing that the townspeople were afraid might be pillaged.[4]

Hawkyns was not thrown off his stride. He sent word to those in hiding that he had come to trade and not despoil. Messages passed back and forth. The townspeople agreed that the royal treasurer, Miguel de Castellanos, and another leading townsman should meet with Hawkyns. The interview was not long in coming, and took place against a backdrop of vacant buildings and echoing streets. The Englishman opened with his well-tried yet hardly convincing patter: his fleet had been forced off course by filthy storms, and he was now desperate to sell slaves and merchandise in order to pay his men. He showed off the bricks and bars of gold that he had earned through peaceful trade on the

voyage so far, and produced testimonials of good behavior from those with whom he had trafficked, including the governor of Venezuela, Alonso Bernaldez.[5]

Castellanos was impressed, but gave Hawkyns the only reply that he could: it was forbidden to trade with the English, and it was his duty to put an end to the incursion. However, since he had neither the will, the resources, nor the capability to do so, he suggested another course of action. The people of the town were scared of getting in trouble with the authorities, but at this moment they were even more terrified of offending Hawkyns. They also desperately needed slaves. To trade voluntarily could lead to severe punishment, but if Hawkyns brought his men ashore heavily armed, in a pretense of attacking the town, perhaps burning down a couple of houses—they were after all only made from straw and could quickly be replaced—then that would radically alter the situation. The men of the town could feign a defense and then legitimately claim that overwhelming odds had forced them to barter. Both sides would be happy, and there would be plenty of witnesses to back up the story.[6]

Hawkyns agreed. To make the ploy seem realistic it was agreed that the Spanish would publicly and deliberately annoy the commander by signaling unwillingness to trade with him. The ruse began with a letter that Hawkyns received as light began to fade in the early evening of 21 May. In it Castellanos proposed an outrageous offer to buy slaves at half the price they had been sold for in Burburata. Hawkyns dashed off an immediate reply in which he railed against the citizens of the town for "deal[ing] too rigorously with him" and attempting to "cut his throat in the price of commodities" even though they would never be able to buy slaves at such low prices again. The anger in the letter peaked with a very public threat: "seeing as they had sent him this to his supper, he would in the morning bring them as good a breakfast."[7]

Next morning a broadside from the ships gave the town a rude awakening. More than 100 men in armor were loaded onto

the ships' boats, in the bows of which were small cannons. Meanwhile, onshore and perfectly choreographed, as many as 150 Spaniards on foot and 30 on horseback lined up in battle formation and marched from the town to the sound of a drum. As they reached the shore, they waved to the English and taunted them. Hawkyns ordered two cannons to be fired, and at the thunder of the barrels the Spanish dropped to the ground. Then, as the boats neared the beach, the settlers' makeshift infantry broke ranks and dispersed. Those on horseback put on a braver display, riding back and forth with white leather shields in one hand and javelins in the other. Yet it was all show: as soon as English feet scrunched upon the sand, a messenger greeted them under a flag of truce and asked for an explanation. Had they not granted every reasonable request? the messenger asked. Hawkyns grunted, and marched his men on toward the town, where small detachments were assigned to torch two or three houses.[8]

The exhibition of power complete, Hawkyns and Castellanos met to parley out of earshot, though in full public view. The captain stood in armor; the treasurer sat on horseback with his javelin raised. Full trading rights were agreed to, and the English were allowed to set up shops on the waterside. A license was handed to Hawkyns signed by all the town's dignitaries. The agreement would be cried throughout the town so that everyone would know of it, and there would be an exchange of hostages to cement the peace.[9] The license permitted him and his men "freely and without impediment to trade and sell and do business in this city with all its burghers and inhabitants, transient and permanent, in whatever slaves, cloths, linens, wines, arms and other merchandise the captain may bring."[10]

With the formalities completed, trading could begin. English crew members hauled ashore the structure of a rudimentary shop, and when that was constructed, proceeded to ferry their merchandise to land using the ships' boats.[11] One Spanish document recorded that Castellanos "and all the other inhabitants bartered and bought a large number of slaves, amounting to

three hundred slaves and a great deal of merchandise, wine, flour and cakes, cloth and ready-made clothing and lingerie and many other kinds of merchandise." To this shop, it was noted, "everyone went to barter as if they were ordinary vassals sent there with a royal licence." The same document, which was drawn up after an inquiry into the events in Rio de la Hacha, also pointed out that the English skiffs "which brought the said merchandise from the said ships, were ashore for three days and three nights, and that the said inhabitants could very well have burned them, and they did not do so, because they were carrying out the said bartering."[12]

Miguel de Castellanos headed a cabal of friends, relatives, and political allies that included some of the most influential figures in town: the mayor, Rodrigo Caro; the crown's tax collector, Lazaro de Vallejo Alderete; and two councillors, Domingo Felix and Balthasar de Castellanos—the brother of the treasurer, who was said to have bought at least fifteen slaves. Others named as being involved included de Castellanos's brother-in-law Cristobal de Ribas, and three important local men: Hernando Castilla, Francisco de Lerma, and Marcos de la Peña.[13] Each needed slaves and had the means to pay, but so scared were they of being punished that they virtually became agents for Hawkyns. Castellanos knew that he had to draw all of the town's citizens into the sale— the poor as well as the rich—if he was to avoid denunciation by any disaffected soul or opportunist. This wealthy faction therefore cajoled their townspeople into indulging, they ensured that all decisions taken on the matter were signed by every single citizen, and they purchased enough slaves to share around. They made sure the whole town was implicated.[14]

A FRICANS SOLD in Rio de la Hacha were particularly unfortunate, for they were destined to be used in one of the toughest and most arduous of slave labors: pearl fishing. Along this stretch of South American coast, pearls grew to the size of

hazelnuts, and their collection placed extreme physical and mental stresses on the fishers. The fishers were banned from marrying or having any sexual relations, because it was believed that it would make them too buoyant.[15] In any one working day groups of five to seven men rowed out to sea in small boats, and while one stayed on board, the rest, equipped with only a net tied to their necks or waists, and possibly a couple of rocks to weigh them down, plunged into the deep, cold waters. Divers worked from dawn to dusk, breaking the water's surface only to deposit their catch, perhaps eat an oyster, and then dive again. Pearl divers were reported to be able to hold their breath for astonishing periods.[16] After watching divers near Rio de la Hacha, the Jesuit Joseph Acosta wrote in 1588 that their work was

> done with great charge and labour of the poor slaves, which dive six, nine, yea 12 fathoms into the sea, to seek for oysters, the which commonly are fastened to the rocks and gravel in the sea: they pull them up, and bring them above the water to their canoes.... The water of the sea in this part is very cold, but yet the labour and toil is greatest in holding of their breath, sometimes a quarter, yea half an hour together, being under the water at their fishing.[17]

The water held many dangers: it was cold and dark, there were perilous currents, and divers frequently drowned. In 1558 government legislation had banned the use of Indians as divers, prescribing instead the use of African slaves. A decree issued at Veracruz noted that "because the bodies of drowned Negroes have not been removed from oyster fisheries, many sharks are present and haunt the places with great danger to life."[18] It was, as Las Casas pointed out, truly awful work for the divers, who were

> forced to spend their last days in agony, and the nature of the work is such that they perish in any case within a few days, for no

*man can spend long under water without coming up for air, and
the water is so cold that it chills them to the marrow. Most choke
on their own blood as the length of time they must stay under
water without breathing and the attendant pressure upon their
lungs makes them haemorrhage from the mouth; others are car-
ried off by dysentery caused by the extreme cold to which they
are subjected.*[19]

That the waters were dangerous was illustrated by an unfor-
tunate incident. The river, which pumped beautiful clear water
out into the sea, was home to alligators "of sundry bignesses,
some as big as a boat with four feet." Their power and danger
fascinated the English crew members. From the semisafety of
the riverbanks, they killed time observing the huge creatures
hunting prey. Hawkyns, who had made a habit of firing cannon
shot at crocodiles in Guinea, struck one alligator with a pike and
watched as the "monstrous" beast writhed "three or four times,
turning in sight, and sunk down." One alligator got his revenge
when "a Negro, who as he was filling his water in the river was by
one of them carried clean away and never seen after."[20]

Naturally, the incident did not interrupt the bartering. Spanish
officials were to complain later that Hawkyns sold so much mer-
chandise that he was able to leave with a "great quantity of gold
and silver and pearls and cut jewels...amounting to a large
sum."[21] One hyperinflated estimation of that sum was that he had
cost the Spanish treasury two hundred thousand ducats from his
dealings at Rio de la Hacha alone. Others suggest the trade had
been worth between fifty thousand and seventy thousand ducats.[22]
Whichever estimate was correct, there can be no doubting the
massive profits that Hawkyns was making.

Not that everything was smooth going. Strangely enough, it
was the credit note for six hundred pesos forwarded by Bernaldez
in Burburata that raised many hackles. The flimsy sheet of paper
threatened to cause a genuine outbreak of hostilities and tem-
porarily fractured the entente between the Spanish and English.

The matter became an issue just as a small force of men commanded by a captain arrived unexpectedly from out of town. Hawkyns and Castellanos had cleared all the matters between them, and had moved on to settling Bernaldez's bill. It may be that in different circumstances this would not have been a problem, but with the arrival of outsiders Castellanos felt he needed to demonstrate once again some resistance to the English. He refused to pay the bill, and "certain words of displeasure" passed between him and Hawkyns. As the Englishman returned to his ships, Castellanos mustered his men and ordered them into their armor. Hawkyns was genuinely worried: his unsuspecting men were occupied in a variety of tasks, such as cutting wood and collecting water, and the Spanish were apparently better armed than before, having secretly acquired more arms simply by gathering up English weapons left lying around. In the town John Spark and a colleague stumbled accidentally upon the unfolding drama. The two ran to the shore, pursued by men on horseback, scrambling to safety only when their chasers turned back in the face of more English sailors. The next morning Hawkyns loaded three boats with armed men and cannons and headed for the beach, intent on resolving the problem once and for all. In the end, reason triumphed. Hawkyns and the treasurer conferred and shook hands. The captain accepted the Spaniard's assertion that it was not his bill, it had nothing to do with him, and that it was wholly unreasonable to expect him to pay. The bill would have to be settled at a later date.[23]

With friendship restored, it was time to prepare for departure. There was a final exchange of pleasantries and gifts. Hawkyns gave Castellanos two African trumpeters; the treasurer gave him a new anchor to replace one damaged on the voyage. They discussed "what kind of merchandise he should bring in future, and [the Spaniards] gave him a list because the said English captain said that he would come back many times."[24] Finally Hawkyns demanded a testimonial of his good behavior—a document he could flash to any who would accuse him of bad or threatening

demeanor. Castellanos promised one, but only when the ships were ready to sail and he could be certain they were about to leave.[25] So it was that at four in the afternoon of 30 May, with his ships' anchors weighed, Hawkyns received the much prized certificate of good conduct. It was basic, but stated everything he wanted: that from the moment of arrival to departure "the said captain and the men of his fleet have traded and transacted business with all people of this town in the slaves and merchandise which their vessels brought, maintaining the peace and without disturbing it, and working no harm to any person whatsoever of any quality or condition."[26] As they broke port the English ships fired a fusillade of cannon shot as a farewell, which was responded to by four big guns and thirty harquebuses from the shore. John Spark noted that this was the first time they had known the Spanish had such weaponry.[27]

Once again Hawkyns was sailing out oblivious of the mess he left behind him. Investigations launched by the authorities in Santo Domingo into the activities of the people of Rio de la Hacha, and in particular those of Miguel de Castellanos, would run for years. Those slaves that could be accounted for—that were still alive, had not escaped, and could be found—were confiscated. Local inquiries were subverted by bullying, collusion, and bribery. Investigations by officials from Hispaniola were obstructed by influential sympathizers on the island. Finally, Castellanos would be severely reprimanded and fined. His and his cabal's knuckles rapped, they would be more cautious in the future.[28]

FOURTEEN

The English ships bobbed around the Caribbean and Gulf of Mexico for weeks, which led to speculation as to what they were up to. The Spanish thought that Hawkyns was delaying his journey in order to attack one of the two annual treasure fleets due to sail from Mexico and Cartagena. Back in England the Spanish ambassador, Guzman de Silva, certainly believed this was what he was planning. In November 1565, shortly after the fleet's return, the ambassador wrote to Philip II that once Hawkyns left Rio de la Hacha "[t]hey then touched at La Margarita, Cartagena, Cabo de la Vela and other places, thus spending a fortnight awaiting the fleet from the mainland, or New Spain [Mexico], in order if possible to capture one of the ships."[1]

It must be assumed that by La Margarita he meant Santa Marta, a short breeze down the coast from Rio de la Hacha. But despite the ambassador's assertions, it is unlikely that Hawkyns was after the Spanish fleet. He was still keen to present a favorable face to the Spanish: hence the importance of the testimonials and safe-conducts that he brandished. To attack the fleet would be an inexcusable act of piracy for which he could expect no royal support on his return. Besides, with only one decrepit man-of-war to call on, such an attack would have been too risky an

enterprise. There is no evidence that he did hang around or that he visited either Santa Marta or Cartagena. If he did head in their direction it may well have been to sell any remaining slaves on board. But according to John Spark's account, on leaving Rio de la Hacha the fleet headed for Hispaniola, where with their holds emptied of slaves and merchandise they could hope to load up with more cattle hides.

Prevailing currents and winds in the Caribbean and Gulf of Mexico meant that for ships under sail, there was only one way out and one route home: to go with the flow of the Gulf Stream and be driven out via the western tip of Cuba and then through the Florida Channel. For the English ships to be heading north and east, toward Hispaniola, was ambitious. According to Spark, the journey started to go badly awry when they were caught in mid-Caribbean by two days of cloud cover. Matters were not helped by an overreliance on Cristobal Llerena, the African raised in Europe whom they had rescued from Guinea, and who had been acting as an interpreter. He claimed to have knowledge of the area, even to be a resident of Jamaica. This should have been useful, for when the clouds lifted the English found that the island in front of them was not Hispaniola but Llerena's homeland; yet he seemed confused.

> [O]n perceiving the land, he made as though he knew every place thereof, and pointed to certain places, which he named to be such a place, and such a man's ground, and behind such a point was the harbour, but in the end he pointed so from one point to another, that we were leaboard of all places, and found ourselves at the West end of Jamaica before we were aware of it, and being once to leaward, there was no getting up again.[2]

Believing what Llerena was telling him, Hawkyns did not make contact with any of the inhabitants on the island. Not only had they missed Hispaniola, they had passed over Jamaica, too, and the captain was furious at having lost the opportunity to load

up to two thousand pounds' worth of hides. Spark jotted down that Llerena "was a plague" to the captain, though the poor man seems to have been genuinely and hopelessly lost: at one point he donned fine clothes and was taken ashore in a pinnace to where he expected to find his wife and friends. Three years in captivity had muddled his brain, and he found no sign of habitation.

The force of the current took Hawkyns by surprise, and the ships soon found themselves overshooting a huge portion of Cuba, too, and with it opportunities to load more hides and refreshments. Instead, they scouted out the numerous deserted islands lying in Cuba's shadow until, in the face of growing desperation, they found one with a water supply of sorts "which although it were neither so toothsome as running water, by the means it is standing, and but the water of rain, and also being near the sea was brackish, yet did we not refuse it, but were more glad thereof, as the time then required, than we should have been another time with fine conduit water."[3]

It was but a brief stop. On 20 June they began to round Cape San Antonio, Cuba's western tip, and proceeded to nudge gently into the Florida Channel. The weather began to churn up the waves, and dark storm clouds billowed over the horizon. The sea in these parts was full of shoals, and they could not risk being dashed against them. So sudden was their departure that one of the smaller ships had to cut its cable and lose her anchor to get away.[4] If ever there was a moment on this voyage to suspect that Hawkyns fancied attacking the treasure fleet it was now, because with Havana barely a sniff away, and the currents for once favorable, it took the ships more than three weeks to reach the city. What he was up to is not clear from Spark's account, but it seems they were taking soundings off the Florida coast, looking for freshwater, and filling their boats with hundreds of birds and great turtles from the low sand Tortuga Islands. Florida was an interesting prospect to the European powers: it was said that deep in one of its forests sat the source of eternal youth; but more important, it was the strategic linchpin to Spanish America.[5]

Within touching distance of Cuba, it jointly commanded the major exit route from the Caribbean. The country that controlled the peninsula was instantly a major power in the area. Naturally, England and France would have liked to claim it. For its part, Spain was determined to discourage foreign interest by any means necessary. Horrifying bloodbaths would follow, but for the moment Hawkyns was probably giving its coast the once-over, looking for natural harbors, checking out water supplies, and preparing a report to present back in England.

After more than twenty days of wandering they moved on, but with no experienced pilot in the fleet, a comedy of errors followed. They twice overshot a water source near Havana. On 11 July they decided to pinch their bellies and make a dash for Florida. The next day, in the Keys, the *Jesus*'s pinnace and one of the boats off the *Solomon* were separated from the fleet while scouring the islands for water. The ships pulled away for fear of wrecking on the reefs, "shooting off a piece now and then, to the intent the boats might better know how to come to them." There was a danger that the fleet could begin to break up disastrously. On 13 July two of the smaller ships held their position in the hope that the missing sailors would arrive. In the meantime the *Jesus* was carried by the current over the horizon. A deadline of midday was set. If the boats had not appeared by then their crews would be given up for dead. Just as the clock struck twelve and the ships prepared to move off, there was great rejoicing. The pinnace and the boat were spotted in the distance. Twenty-one tired, hungry, and disheveled mariners were pulled on board. No one was more relieved than those rescued: on one of the Keys they had pulled ashore and "found a dead man dryed in a manner whole, with the other heads and bodies of men, so that those sort of men are eaters of the flesh of men, as well as the Cannibals."[6]

By 14 July the fleet was intact once more, and anxiously scuttling along the coast in search of freshwater and a French Huguenot colony that was known to be in the area. Contrary to

their expectations, the Floridian Indians whom they came across were gentle and helpful, impressing with their intelligence and their ability to make deadly weapons. The land, too, though somewhat low and dull, with scarce little of the desperately sought drinking supply, was found to be

> marvelously sweet; with both marish and meadow ground, and goodly woods among. There they found sorrel to grow as abundantly as grass, and near their [the Indians'] houses were great store of maize and millet, and grapes of great bigness, but of taste much like our English grapes.
>
> Also deer great plenty, which came upon the sands before them.[7]

Days passed before they finally came to the mouth of a river, which Hawkyns entered in the pinnace. After a short distance he came across an eighty-ton French ship and two boats. With the permission and guidance of the sentries, Hawkyns added a bark to his convoy and sailed a further six miles to where a small French garrison was housed in Fort Caroline. They arrived on 3 August to scenes of rejoicing, the French commander René de Laudonnière commenting that as sails came into view his men began to whoop and holler so enthusiastically "that one would have thought them to be out of their wits, to see them laugh and leap for joy."[8]

The French fort had a sad history, one that was heading inexorably toward tragedy. In 1562, facing religious strife at home and having heard stories of cities of gold and silver, the Huguenot Jean Ribault had led an expedition to Florida. He would claim the land for France, and attempt to build naval bases to challenge Spanish supremacy. Life was, however, tough on the peninsula: food and water were in short supply, the Indians were aggressive, and there was little evidence of any great supply of precious metals. Ribault returned to Europe to cajole more settlers, but became embroiled in the ongoing civil war. While in exile in England he managed to interest Queen Elizabeth in the possibility of a joint

Anglo-French assault on Florida, but delay followed delay, and in 1564, Laudonnière took the initiative, sailing from France in order to restore the colony and reinvigorate the great project.[9]

As the English sidled into view, Laudonnière sent out boats to greet them while at the same time readying his troops in case the visitors proved to be hostile. Word came back that it was John Hawkyns, and he was in need of freshwater. The Englishman stepped ashore, taking with him bread and two much appreciated flagons of wine. The atmosphere was convivial; Laudonnière had not tasted wine for seven months, and it brought him great pleasure. He granted Hawkyns's wish and the following day brought up a "great shipboat" to begin the process of filling the water butts. There was a festival atmosphere, Hawkyns handing over more bread to the hungry Frenchmen, Laudonnière slaughtering sheep and chickens from the fort's dwindling and carefully preserved supply.[10]

The reasons for the garrison's rejoicing soon became clear: Laudonnière had a thoroughly miserable tale to tell. He and his men had been in Florida for more than fourteen sorry months. There had originally been two hundred of them, but they had brought little food and few resources from France. Starvation had driven them farther and farther upriver. Here they quickly succeeded in eating all of the maize that the Indians could supply them with. Desperate measures followed: some of the French agreed to fight with the Floridians against their enemies in return for milk and food; others pulled up roots and crushed acorns, stamping on them and washing the remains to sweeten their bitterness. Yet many of the men were indolent in the extreme and would not even "take the pains so much as to fish in the river before their doors, but would have all things put in their mouths." Laudonnière's attempts to enforce discipline resulted in mutiny, the rebels stripping him of his armor and imprisoning him. Eighty of the mutineers stole a bark, a pinnace, and all of the remaining food and headed for Hispaniola and Jamaica, where for a short time they pillaged Spanish settlements.

They grew overconfident: after seizing two caravels loaded with wine and cassava, they harbored in Jamaica, where they were arrogant enough to amble ashore as and when they pleased. Here the Spanish pounced on them, and dragged twenty men to the scaffold. Twenty-five escaped back to Florida, but four of the leading mutineers were immediately strung up from a gibbet. Meanwhile others of those who fled Jamaica made a nuisance of themselves with the Floridian Indians, provoking what turned out to be a predictably unequal war. Frenchmen were slaughtered in the forests, and others were set upon by huge groups of Indians astute enough to know that they should aim their arrows at faces and legs instead of the armored bodies. By the time Hawkyns arrived, the food supply was drying up. The forty surviving men had less than ten days' victuals and apparently no prospects.[11]

While sympathetic to their plight, the English thought the French were wholly to blame for their predicament. They were all soldiers with little practical experience of founding a settlement. Spark observed that they wanted "to live by somebody else's sweat." He noted the real potential of the land, which he said was rich with, among other things, meadows, pastureland, cedar and cypress woods, herbs, roots, and gum. There was also a ready supply of meat in the abundant fauna that included deer, foxes, hares, rabbits, and possibly "lions, tigers and unicorns" as well as alligators and snakes. The rivers and seas were teeming with salmon, trout, pike, bonitos, and roach. And if all that was not enough, the French could have adopted the practice of the Indians, who "when they travel have a kind of herb dried, which with a cane, and an earthen cup in the end, with fire, and the dried herbs put together do suck through the cane the smoke thereof, which smoke satisfieth their hunger, and therewith they live four or five days without meat or drink." The English had encountered tobacco for the first time, and though the Frenchmen did use the weed, they disliked it because "it causeth water and fleame to void from their stomacks."[12]

While cogitating on the potential of Florida, Spark also noted that there seemed to be plenty of gold and silver in evidence. Without any known mines in the area, the speculation was that it came from the holds of Spanish ships wrecked on the perilous sandbanks to the southwest of Florida. Spark claimed the French had exchanged axes for pure gold but later became greedy, snatching gems and precious metals from the Indians. Eventually the Indians stopped wearing their jewelry, their gold and silver necklaces, and their breastplates. Like so many of their other actions, Spark surmised, the French soldiers' behavior was counterproductive.

Out of sympathy for their predicament, and also hoping to get them off the peninsula, Hawkyns offered Laudonnière and his men a lift home. He might have expected the French commander to jump at the suggestion, but Laudonnière was troubled by it. He did not know the current political situation that existed between England and France, and although he trusted that Hawkyns would deliver him home, he feared that the Englishman might also be attempting to deliver Florida to his queen. To his men's dismay, he rejected the offer.

Once more mutiny erupted. Laudonnière's soldiers were nearing breaking point. Hawkyns, for his own amusement, stirred them up, telling them they were doomed if they stayed, and had no chance of escaping in their dilapidated vessels. Outrage spread among the small garrison. Laudonnière made tentative inquiries as to whether Hawkyns would consider selling one of his smaller ships, and received a positive answer. French soldiers coming back to base that evening heard the news and assembled at the door to their commander's chamber, telling him that if he did not take up the English offer they would abandon him. Laudonnière promised to consult his officers and answer in an hour. To a man they agreed to buy the bark, but not with silver from their store, which might ignite Elizabeth's desire for Florida. Instead they would pay with their artillery.

Laudonnière went to Hawkyns with four of his officers and together they inspected the ship. They agreed it was worth seven hundred crowns, for which they handed over four cannons and a quantity of iron and powder. Hawkyns threw in twenty barrels of meal, six pipes of beans, a hogshead of salt, and wax to make candles with. He also sold Laudonnière fifty pairs of shoes for his men against a bill that would be met when the Frenchman returned home. As a present Hawkyns handed the commander jars of oil, vinegar, a barrel of olives, another of biscuit, and a great quantity of rice. To the French officers he also gave gifts.[13]

After three days Hawkyns moved on, unaware of the tragedy that was about to unfold in Florida. Later that month the colony's founder, Jean Ribault, returned from France with newly recruited settlers and supplies. It was a great boost for the ailing fortress. However, barely a week after his arrival, a small group of Spanish ships were spotted off the coast and Ribault foolishly went in pursuit. Without being aware of it he was abandoning the fort at its moment of greatest danger, for Spain's most feared commander in the Indies, Pedro Menendez de Aviles, had landed a large force south of the French settlement. In Ribault's absence it marched straight into the fort and massacred almost all of its occupants. Underneath the dangling feet of those that he hanged, Menendez left a plaque stating that they had been executed as heretics, not Frenchmen.

The Spanish then learned that Ribault's fleet had been dispersed by a heavy storm and that the survivors had come ashore. Menendez rounded them up and butchered all but ten who could prove that they were Catholics. Ribault was beheaded. Laudonnière was spared. In France there was outrage. Spanish ships were attacked in revenge, and three years later Dominique de Gourgues, a seafarer from La Rochelle, sailed to Florida and hanged everybody he found there. Behind him, he left a notice that they had been killed as murderers, not Spaniards.[14]

MEANWHILE, OUT in the Atlantic, Hawkyns may have come to regret his generosity toward the Frenchmen, for his journey home was hampered by bad weather and "contrary winds." As they tacked back and forth across the Atlantic, their newly replenished food stocks began to run low. Despair set in, and in their "great misery," as Spark described it, they resorted to "fervent prayer." Their invocations were met when finally a stiff breeze blew them up the eastern seaboard of America to the banks of Newfoundland and its rich fishing grounds. Here they caught mountains of cod, and bought more from two French ships for payment in gold and silver. Soon after, they were driven by a "good large wind," and on 20 September 1565 the slave ships pulled into Padstow in Cornwall. Twenty white men had died during the voyage, and an unrecorded number of Africans. Hundreds had been sold into servitude, but in the ships' stores the gold, silver, pearls, jewels, sugar, and hides were piled high— ample compensation, it was considered, for the human cost. John Spark concluded his account with a paean to Hawkyns, suggesting that "[h]is name be praised therefore evermore. Amen."[15]

Cat and Mouse

FIFTEEN

With the *Jesus of Lubeck* anchored at Padstow, the sponsors of the enterprise sought permission to delay delivering her back to the queen's navy until the spring of 1566. The initial contract stated that she was to be returned intact to Gillingham in Kent before the Christmas festivities began, but the transatlantic journey had taken its toll: the aging ship was the worse for wear and in urgent need of attention. She limped around the Cornish coast to Hawkyns's Plymouth dock, where a refit and repairs costing five hundred pounds—a quarter of her estimated value—were authorized.[1]

In the grand scale of the adventure, such a massive sum was a mere trifle. The enterprise's accounts are nowhere to be found, but there are references to the great store of treasure Hawkyns brought back as "profitable to the venturers, as also to the whole realm."[2] One estimate claimed that the slave run had seen a 60 percent return on its investment,[3] another that it was bringing in fifty thousand ducats' profit.[4] Hawkyns's patrons would have been delighted. The accolades would have been great, and the sixth part received by Elizabeth was surely enough to bring a broad smile to her blanched face; indeed, she felt moved to grant Hawkyns a coat of arms, which, in the arcane language of heraldry, was "settled

upon him and his Posterity by William Hervey Clarentieux . . . thus worded in the Patent 'He bears Sable on a Point wavee a Lion Passant Gold, in chief three Besants.' " The coat of arms bore an explicit celebration of John Hawkyns's manhunting exploits: at the crest of the coat of arms was drawn a squat African, "a demy Moor, in his proper colour, bound and captive, with annulets on his arms and ears."[5]

Success like this brought a clamor for more adventures, and fostered disquiet in the Spanish camp. Even as Hawkyns hobbled homeward from Newfoundland, Guzman de Silva wrote to Philip II with uncharacteristic bitterness that "[t]hese people [the English] must be waxing fat on the spoils of the Indies."[6] On 1 October he informed his king of the arrival in England of the slave ships and of the profits he believed them to have made at Spanish expense. He also alerted Philip II to rumors that were reaching him of the collaboration of governors and officials in the Indies. He had very real fears about the consequences:

If Hawkyns tells the truth about having permission from the governor to trade freely . . . it would cause considerable inconvenience, unless measures be taken to prevent it in future, because the greed of these people is such that they might arrange to always undertake similar voyages, and besides usurping the trade of those who traffic under your Majesty's license, I do not believe that a ship would be safe if they were strong enough to take it. I will try to get information on this point and advise your Majesty.[7]

For a week he waited as his spies went to work, listening to the stories coming out of Plymouth and conferring with secret contacts on the expedition. On 8 October de Silva wrote that though he had learned nothing new, the possibility that Spanish officials could have granted the Englishman licenses to trade "seems incredible to me."[8]

The ambassador had every reason to believe that Hawkyns would be setting the wrong kind of example. Already others were

headed for Guinea, possibly with the intention of trading in slaves. A group of unnamed and unfeted Englishmen were arrested in Puerto Rico attempting to sell Africans,[9] and in December 1564, Thomas Fenner, a gentleman pirate of Sussex, set off with three ships on an ill-fated voyage. Rocked by storms, and battered by French men-of-war—who killed fourteen of his men—he turned for home empty-handed.[10] In September 1565 the *Mary Fortune*, a ship belonging to Vice Admiral William Wynter and his brother George, was set upon by Portuguese men-of-war in the Cess (or Cestos) River. Most of her crew perished; others were sent into captivity at Elmina.[11] The Wynter ship was most probably not engaged in slave trading, but the increased English activity in Guinea made the Spanish as nervous as their Portuguese neighbors. De Silva adopted a three-pronged plan for bringing an end to the incursions: espionage activities were stepped up, he would court John Hawkyns, and he would lay down the law to the queen and her council.

On 20 October, de Silva contrived to bump into Hawkyns in the palace of Westminster. They greeted each other courteously, and the captain told the ambassador that he was tired after the exertions of the voyage, but that the Spanish need not worry, as he had acted peacefully in the West Indies, and always with permission of the officials there. They had, he said, been only too happy to grant him licenses and certificates. Far from placating de Silva, these words would have confirmed his greatest fears. To his mind Hawkyns was being either naive or mischievous. De Silva smiled politely and held his tongue. Instead of attacking Hawkyns, he said that it would make him most happy to see the certificates, and invited the Englishman to dine with him.[12]

By the time they sat down for dinner a few days later, de Silva had digested a "secret report of one of those who had accompanied him [Hawkyns]" and knew of the "private arrangement" Hawkyns had made with the leading officials at both Burburata and Rio de la Hacha. What his spy told him also strengthened

his belief that the English had intended to attack a Spanish fleet and also to land at Havana.[13] Nevertheless, the dinner went well. De Silva was determined not to put Hawkyns on his guard. He wanted the captain to talk so he would be able to condemn him to the queen using words out of his own mouth. So he listened as the captain gave a general account of the voyage: of how he had traded "greatly to the satisfaction of the Spaniards everywhere," and of the unpaid bill from Burburata that Hawkyns still held on to. At one point the captain hinted at some unhappiness between himself and his backers. De Silva's ears pricked up. Any rift could provide a point of leverage for bringing the escapades to an end. Shortly after dinner he noted:

> The owners who provided the capital for him are, I am informed, dissatisfied with him, and believe he has brought more gold than he confesses. He on his part does not appear contented with the sum they have paid him and this may lead to the truth coming out. He is now rendering his accounts and I learn from the person who has to receive them that he credits himself with 1,600 dollars given to one of the governors for leave to trade, and also for the bill for 600 dollars from the other governor which was not presented for payment in accordance with an arrangement between them.[14]

What appears to be a significant rift between Hawkyns and his backers crops up nowhere else in the record. Hawkyns was not averse to playing fast and loose with other people's money. Nor was he slow to demand due respect for his efforts. However, in light of how the de Silva–Hawkyns relationship was about to unfold, such tittle-tattle may well have been an attempt by the Englishman to appear to be taking the ambassador into his confidence. Whatever the truth, in the same report de Silva contradicted himself, writing that the profits Hawkyns has returned with were so great that many merchants were being encouraged to follow in his footsteps. A story was doing the rounds, he added, that

Hawkyns himself would be sailing out again in May, and that "he will not lack friends."[15]

The Spanish ambassador contemplated what action to take. As he did so, leading figures in the enterprise deemed it politic to publicly distance themselves from Hawkyns. As the Spanish increased the pressure, major investors Benedict Spinola and the earl of Pembroke disingenuously claimed that they had believed the voyage would only be going to Guinea. William Cecil told the ambassador that he had been offered shares, but had refused them because he did not like such adventures. De Silva refused to believe such obvious claptrap. He considered going to the queen with what evidence he already had and demanding severe action against Hawkyns, but decided to bide his time and be certain of his facts first. "I will see the licenses the captain says he has from the governors," he noted, "and if there appears to be any ground the Queen shall be addressed on the subject."

If there is any way of getting him punished it will be expedient as an example to others, but if not, it will be best to dissemble in order the more easily to capture and castigate him there if he should repeat the voyage. If his suspicion is not aroused and he makes the voyage he will touch on the coast of Spain, and I will be on the alert to advise his movements.[16]

Hawkyns and de Silva were embarking on a game of cat and mouse in which it was not always clear who was the cat and who the mouse. At the beginning of February 1566, Hawkyns, who had been spending time in Plymouth, ran into the diplomat again and raised for the first time the issue of the ship and hides that had been confiscated in Seville on his first slaving voyage. De Silva listened attentively to the whole complaint, promised to bring the matter to Philip II's attention, and then persuaded Hawkyns to take dinner with him. Across the table de Silva once again demanded to see the trading licenses. It would be an act of good faith, he said, proof that he had not acted improperly, proof

that he could be trusted. Hawkyns promised to bring the licenses. Their conversation was convivial and wide ranging. De Silva detected an ambivalence in the captain's attitude. In a letter scribbled off to Spain immediately after the meal, he wrote:

> [H]e appears to be a clever man. He is not satisfied with things here, and I will tell him he is not a fit man for this country, but would be much better off if he went and served your Majesty, where he would find plenty to do as other Englishmen have done; he did not appear disinclined to this. They have again asked him to make another voyage like the last, but he says he will not do so without your Majesty's license, as it is a laborious and dangerous business.... It seems advisable to get this man out of the country, so that he may not teach others, for they have good ships and are greedy folk with more freedom than is good for them.[17]

Had de Silva unearthed an ambivalence at the heart of Hawkyns? The captain's attitude to religion, and the old religion in particular, was not always clear; in fact, one could argue that it was deliberately unclear. His apparent attempts to maintain goodwill on at least the first two slaving voyages have been cited by many as proof of a desire to impress Philip, the so-called King Catholic. Had de Silva exposed a true sense of mixed loyalty? Or was Hawkyns merely playacting? These were questions that would run and run.

Barely a week later Hawkyns produced the much-sought-after licenses. De Silva had translations made and passed them on to Philip II with a note stating that he now had grounds enough to demand an audience with the queen to let her "know the excesses that have been committed." However, he held his fire. In the face of great flattery from the ambassador, Hawkyns was showing an unexpected willingness to comply with the Spanish. He even offered practical help. For a guarantee that no harm would be done to him, he offered to put together a fleet of four sizable ships, manned with five hundred handpicked men,

to serve the Spanish crown against the perpetually dangerous Turks in the Mediterranean. All he desired in return was the proceeds from the sale of the hides he had sent to Seville, and for which Hugh Tipton and Cristobal Santisteban had been arrested. De Silva rubbed his hands with glee. He reported home, "I have answered him in a way that will enable me to learn more of his business and keep him in play, so that he may not return as they want him to do on a similar voyage to his former one."[18]

February passed and de Silva received no more news of any new Hawkyns voyage, nor was there an official response to the captain's offer from Spain. By the third week of the month Hawkyns was getting fidgety, almost overeager. On 23 March he demanded to know whether the ambassador had received any reply from Philip II, offering at the same time to increase his proposed fleet to five ships, including one of the queen's navy. De Silva soothed his anxiety with calming words, though noting privately that he was stringing the captain along to stop him from heading off to Africa again: "I am keeping him in hand, because I understand that there are many people urging him to make another voyage like the last. He is so skilful in these voyages that he assures me that he has ten or twelve servants who understand the navigation of those parts as well as he does himself. These people are so greedy that if great care be not taken they may do us much harm."[19]

Within a week Hawkyns came knocking at de Silva's door. Had he heard anything yet? he demanded with a resigned weariness. The Spaniard replied in the negative, and assured him once more of the time it took his country's bureaucracy to both make and transmit decisions. He would be in touch as soon as he heard something. In the meantime de Silva was troubled by informed gossip of two English ships that were about to head off secretly to the Indies to buy hides. "There is great need to be on the alert everywhere to prevent these people from trading," he wrote on 30 March. "Or else to do them all possible harm, and to discourage them from going."[20]

There wasn't another meeting between the two men until early May, and now de Silva began to have qualms about their dealings. For his part Hawkyns seemed keener than ever to hear news from Philip II, adding that since the season was beginning to get late he was preparing his ships just in case he was called upon to use them. The idea that Hawkyns was readying a fleet rang alarm bells: de Silva's spies were telling him that Hawkyns was about to head back to Guinea and South America; but could it be that those spreading the stories were jumping to conclusions, in ignorance of the two men's dealings? Or was Hawkyns about to pull a fast one? If need be, de Silva would approach the queen on the matter.[21]

The rumor mill started to crank up. Stories of Hawkyns's imminent departure began to flow in, and de Silva began to feel that he may have been duped. Nevertheless, his information was not yet concrete enough to make demands of Elizabeth. It was sufficient, however, to issue another warning to the governors in the Americas of the dire consequences of trafficking with the English. It was an uncertain game that de Silva had initiated, with the ambassador himself being forced to trust someone he felt was intrinsically untrustworthy. His confidence in Hawkyns fluctuated. By August he had had another change of heart, dispelling any notion of possible betrayal. He wrote to Spain that he now regretted having suspected any subterfuge. "I believe now however, that I did him an injustice," he wrote. Hawkyns had been to visit him on 2 August and expressed his sorrow that his proposal had not been taken up. Nevertheless, the offer of help would still be there next year. If the King Catholic had a change of heart, Hawkyns, together with a contingent of Spanish galleys, would harry Turkish ships all over the Levant, all summer long.[22] On learning of this, Philip II was more circumspect than his ambassador. "Keep your eye on what he does," he instructed.[23]

October brought more vacillation on the part of the ambassador, and then a change of heart that was no mere palpitation. In

the first days of the month, he dispatched a spy to reconnoiter the docks and quays of Plymouth for evidence of an expedition that he had heard rumors of. By 10 October, de Silva had in his hands the news he had dreaded receiving: ships were being got ready to capture slaves in Africa and then consign them to the Indies. That very afternoon he presented his findings to Elizabeth in person. Their discussion was robust. De Silva went straight onto the attack: Did she recall the assurances she had given him two years earlier, that John Hawkyns would go to no place in His Majesty's Indies where a special license was required? And did she know that despite these assurances, Hawkyns had gone to precisely those places? Was she also aware that the only reason he had not complained earlier was that to do so would have been impolitic, in light of the deep involvement of senior members of her council? The whole affair had caused great annoyance to the Spanish king, he said, and now this very day he had learned of a new adventure with exactly the same objectives in mind. Would she forbid it immediately?

It was pointless for Elizabeth to deny the part her councillors had played, and if challenged she would have found it difficult to deny her own culpability. Instead, she resorted to Hawkyns's lame excuse that he had been forced off track by adverse winds, but that once he found himself in Spanish waters he had traded only after obtaining licenses from the governors and officials on the spot. In the same way that she had challenged the Portuguese ambassador in years gone by, she insisted that it was necessary for her subjects to know which places were forbidden to them, so that they might not go there in the future. De Silva must have been tempted to laugh aloud: those places were well enough known to one and all already, he told her. It was not right that Philip II should be expected to build forts and station garrisons to protect his rightful colonies against the subjects of those he considered friends. What about the French? countered Elizabeth. Their sailors were swarming all over the Caribbean; why were they allowed? Because they were largely "robbers and pirates," retorted de Silva.[24]

The ambassador's assertiveness paid off. Secretary of State Cecil was summoned and instructed to examine those that were leading the new expedition. If they were found wanting he was to prohibit them. De Silva was satisfied, writing to his king on 12 October, "I quite believe that the measures they adopt will be good," adding that in case they were not, advice should be sent to wherever any expedition might touch so that "they may find resistance."[25]

Even as de Silva scrawled out his latest letter home, the Privy Council was meeting. It was important that as the queen's representatives they appeared to be acting swiftly. By the end of the afternoon they had written to David Lewes, judge in the High Court of the Admiralty, instructing him to make arrangements to ensure that John Hawkyns and three other characters preparing suspect voyages—George Fenner (who would later be allowed to make a voyage to Guinea), John Chichester, and William Coke—be stopped from going to "certain privileged places (as is planned) by the King of Spain."[26] Minor legal wrangling followed, but by 17 October the Privy Council was able to send a letter to the mayor of Plymouth and the officers of the town demanding that they

> cause a shippe that is there prepared to be set to the seas by John Hawkins, which is meant to be sent in voyage to the King of Spain's Indias, to be stayed and not suffered in any wyse to go to the seas until the matter be here better considered, charging the owner of the said shippe or the setter forth of her, in the Queen's Majesty's name, to repair immediately hither to answer unto that shall be objected against him.[27]

On Wednesday 30 October, John Hawkyns appeared before the Privy Council and promised that he would not send any of his ships to the king of Spain's American colonies, nor would he send anybody else out to these "privileged territories." The next day he appeared before David Lewes in the Admiralty's principal court

and agreed to pay a bond of "five hundred pounds of sound royal English coinage."[28] The bond's conditions stated that it was known that his ship the *Swallow* was ready to sail, and that he must forbear to send this or any other ship on a voyage to the West Indies, or lose his money. A letter was sent to the authorities in Plymouth that in light of the bonds taken, the *Swallow* could "now be set at liberty and suffered to depart when commodity shall serve."[29]

De Silva was delighted. His game of brinkmanship had apparently paid off. On 4 November he wrote to Philip II saying that despite great arguments in the Privy Council, and stark differences of opinion, the queen herself had ordered that Hawkyns be dealt with rigorously. De Silva recommended that the king call in the English ambassador and express his thanks for Elizabeth's action. Unbeknown to de Silva, as he rested on the laurels of a job done well, just five days after he wrote his letter, a fleet of ships belonging to John Hawkyns slipped out of Plymouth Harbor and into the Atlantic for an expedition of the type he believed he had succeeded in preventing.[30]

Sixteen

On 9 November 1566 four small ships, the *Paul, Solomon, Pascoe,* and *Swallow*—little more than four hundred tons in all—left Plymouth under the command of John Lovell. All four belonged to John Hawkyns, all were headed to West Africa, and all would carry captives into slavery in South America. Every condition imposed by the High Court of the Admiralty against Hawkyns was being broken, every condition excepting one: he himself was not going. Hawkyns had used the protracted talks between himself and de Silva—and the offer of a fleet to sail against the Turks—as the perfect cover for readying a fleet to return to the Indies. No one but Hawkyns knew whether his dealings with the Spanish ambassador were ever serious or how difficult it was for him to break the terms of his bonds, though it is to be suspected that he judged the potential returns of the voyage would easily cover the cost, and besides, just two months later, on 20 January, he married Katherine Gonson, daughter of his long-standing sponsor Benjamin. It would appear that this was one Guinea voyage on which he never intended to go.[1]

Lovell carried the shopping lists presented to John Hawkyns by the people of Burburata and Rio de la Hacha on the last trip. Lovell was probably a distant relative of Hawkyns: over the years

a number of his relatives would be dotted around his various enterprises. In the crew of one of Lovell's ships there was another family member, the young Francis Drake, who was probably Hawkyns's cousin. Little is known about Lovell; indeed, not a great deal is known about the voyage at all. Of the few glimpses that can be snatched of the man, it is known that in the late 1550s and early 1560s he had been a resident factor in the Canaries for the Hawkyns family. The fact that he was commanding this expedition suggests that he had been on at least one, if not both, of the previous slaving voyages. He appears to have been a strident Protestant, rigidly enforcing daily services, ridding his ships of the old religion. The Welshman Morgan Tillert would later recall that during the voyage Francis Drake had forced him to convert with the words "God would receive the good work that he might perform in either law, that of Rome or that of England, but the true law and the best one was that of England."[2] On Tenerife, Lovell was reported to have been aggressive and rude. He told the mayor of Garachico that "he vowed to God that he had come to these islands and that our Lady, who is at Candlemas, should be burnt, and that on the fire they should roast a goat."[3] There were other allegations that while in the Canaries, Lovell did indeed cause unspecified destruction. Of the limited peeks one gets into the operations and motivations of this man, few do much to raise his reputation above that of a pirate and a religious zealot. The events of this voyage would do little to enhance his standing.

If Portuguese accounts are to believed, Lovell took the relatively easy option when it came to gathering slaves. Portuguese patrols on the Upper Guinea Coast were turning up the heat, but for Lovell it was not to be the danger of Sierra Leone, or the hard, dirty work of the slave hunt. He would not even attempt peaceable trading. Instead he lingered around the Cape Verde Islands like a hungry wolf and waited for loaded ships to pass by. Though it was bloody work, it was also easy pickings. Accordingly, he "pillaged far and wide," making off with vessels crammed with Africans, wax, and ivory.[4] Within sight of Santiago, the main

island in the archipelago, Lovell allegedly stormed a large ship headed for the island of São Tomé. The ship's commander, Joannes Pires Moreno, and all of his crew were savagely clubbed and thrown overboard, "some of whom were then cruelly killed by the English."[5] Franciscus Pardus suffered a similar fate as he headed for Brazil, and Simon Caldeira, anchored off the island of Maio, could do nothing but watch in despair as his cargo of salt was unloaded and his ship was "forced down and sunk by the same pirate."[6] Finally, just before heading off for the Caribbean, Lovell's ships set upon the vessel of Mendes Riberius, ransacking it as it left the island of Fogo.[7]

HAVING FINISHED with Africa, the ships trekked across the Atlantic and passed Margarita in May 1567, sailing in the wake of several French ships that were prowling the area. Off Burburata, Lovell teamed up with the fleet of the pirate Jean Bontemps, and together they attempted to bully the Spanish into buying from them. This should not have been necessary— after all, in the previous year the colonists had placed their orders, so they should have been ready with their purses open, eager for slaves and merchandise. However, things had changed. The air was stiff with punishments and reprisals. Alonso Bernaldez, governor of Venezuela, had been kicked out of office in May 1566 for, among other things, dealing with Hawkyns; his replacement, Pedro Ponce de Leon, was in no mood to traffic with outsiders. Likewise, in Rio de la Hacha a cloud had settled over the future of the town's treasurer, Miguel de Castellanos. A judge had arrived from Hispaniola to investigate the events of two years earlier.[8] Now was not the time for compounding their problems. Not only could they not trade openly, it was imperative they make a great show of genuine resistance.

Bontemps pulled into Burburata first, closely followed by Lovell. Together they made grand overtures to the people there, promising a gift of one hundred slaves to the royal treasury if

they were allowed to set up shop in the town and sell two hundred of their captives. Permission was sought from Ponce de Leon: messengers were sent to his residence in Coro, but he was not impressed and refused to countenance the proposal. In the meantime Lovell and Bontemps began to play fast and loose. They tricked a number of Burburata's burghers with the hand of friendship into walking into a trap. These worthies were carried out to the anchored ships, thrown into cells, held hostage, and told that if they did not allow trading to begin they would be transported at once to France, where an unpleasant fate awaited them. As the men sat in chains, notice arrived from the governor that he would not allow trafficking of any kind. The burghers were lucky, for they found Bontemps and Lovell in surprisingly compassionate moods, and all were released. However, two of the hostages, merchants from Nuevo Reino in Granada, were found to be carrying 1,500 pesos. Bontemps and Lovell took the cash in exchange for twenty-six slaves.[9] Back on shore, the authorities refused to believe their story, and the slaves were confiscated.

The ships moved on to Rio de la Hacha, where they found the people waiting and prepared to stand their ground. All of the town's citizens had been ordered to ready their weapons, and no one fit to bear arms was allowed to leave for the hills. Men were stationed in strategic positions and dug in for a fight. Daylight was hardly half an hour old when the French ships were spotted ten miles off the coast. Castellanos quickly gathered all the women, children, and invalids at his house, and implemented the much used evacuation plan. At the same time the men were mustered and marched down to the seafront.

Bontemps sent word via a messenger that he came in peace and wished only to trade. His prices would be very moderate, he added. Castellanos replied that the municipal authorities would have to meet to discuss the situation; they would get back to him the next day. He was buying time: meanwhile, he oversaw the completion of the evacuation of the noncombatants and organized a caravel to sail to Santa Marta and Cartagena with a warning of

the approaching French and English fleets. The town then steeled itself for the fray. At daybreak a letter was delivered to Bontemps that no trading would be allowed and that Castellanos "and all the citizens of this city were agreed to risk their lives and possessions in obedience to the royal command."[10]

The French moved their ships in closer so they could range their artillery on it. They flew pennants and flags to celebrate the coming hostilities, and then sent ashore an invasion force. Four hours of skirmishing followed, during which no landing was made and at the end of which the invaders were forced back onto their ship. As the gunfire subsided, Bontemps was rowed to the beach for one last parley. He received the same reply as his emissary, and by the afternoon his ships had raised anchors and were on the move to Santa Marta.[11]

Lovell arrived on 18 May, shortly after the debacle, to find a town ready, well defended, and buoyed by its recent triumph. Attempts to negotiate a deal were confidently rebuffed, and for almost a week he sat with his ships offshore, perplexed about what to do next. This was hardly the welcome he had been led to expect. Over the coming six days he sent out boats to coast alongside the town, feigning attacks, terrorizing the inhabitants, keeping them on their guard, scouting for weaknesses, and hoping to seize the town through an act of carelessness on the part of the Spanish. There were several skirmishes. The English trained their guns on the town, and took the opportunity for the occasional bout of target practice, but the bombardments were ineffective.[12] The Spanish returned fire, killing and wounding a number of the English. After it was over, Castellanos was compared by the city authorities to "another Horatius," the savior of ancient Rome.[13]

At the end of the week, an exasperated Lovell met Castellanos to propose a compromise: he would put ashore a quantity of the Africans he had as cargo if Castellanos would give him a signed certificate to the effect that he had done this. But Castellanos refused to deal and strongly advised Lovell against such an action, threatening to "do his best to prevent it." Lovell stormed off.

The next evening, an hour after dusk, English boats rowed down the Hacha River and set ashore "ninety-two pieces of blacks, all old, and very sick and thin."[14] The Africans were unloaded on the opposite bank to the town, the water was high, and there was nothing the colonists could do to stop it from happening. The English returned to their ships, pulled anchor, and, in the words of the Spanish, "sailed away in very great desperation and grief."[15] Before morning the ships were out of sight.

SEVENTEEN

Back in England, de Silva had taken his eye off the ball—the Lovell expedition had passed him by completely. On 21 January 1567 he met with Elizabeth over dinner at Nonsuch House, and he reported back to Philip II that he had "thanked her from your Majesty for having ordered Hawkyns and the others who were going to the Indies to be stopped, and I also thanked Secretary Cecil for what he had done. He replied that the Queen had given the orders most willingly, although the Council was divided."[1]

News of the Lovell expedition continued to elude the Spanish ambassador, and if, as seems unlikely, John Hawkyns forfeited the bonds he had taken out against going to Guinea and the Indies, then the matter was not made public. Then, as summer approached, rumors began to filter through of great preparations for another Guinea expedition. De Silva's spies began to warn of stories they were hearing coming out of Kent and Devon. On 31 May Guzman de Silva wrote to his king from London, "I am informed that they are going to fit out four fine ships and a pinnace at Rochester, two of them belonging to the Queen. The matter is kept very secret and nothing has been done yet to the ships except to caulk them."[2]

Worse still, the rumors put Hawkyns at the head of the expedition, supported by rich aldermen and queen's councillors. The ambassador promised to try to prevent the fleet from going to the Indies, and also put the Portuguese on the alert by sending a message to their king.[3] By mid-June he was so certain that the English were up to something that he demanded to speak to Elizabeth. Once again she fobbed him off. In the presence of William Cecil she agreed that there were preparations to go to Africa, but that was all. Ships were being got ready to sail to Elmina to exact retribution from the Portuguese for the sinking of Vice Admiral Wynter's *Mary Fortune*. She had had the merchants in question before her, she told de Silva, and made them swear that they would not be going to any of the Spanish territories. The ambassador was dubious; he was convinced that the fleet would be collecting slaves, and he knew that there was only one place where they could profitably be taken.[4] On 26 June he promised the King Catholic to "use all efforts to prevent their going . . . but the greed of these people is great and they are not only merchants who have shares in these adventures, but secretly many of the Queen's Council."[5]

Nevertheless, Elizabeth acted cautiously. These were turbulent years in English politics: instability north of the border was sending shock waves throughout the land. In March 1566, David Rizzio, the private secretary and confidant of Mary Queen of Scots, had been butchered before her eyes in a palace coup headed by her husband, Henry Darnley. In February 1567, Darnley was himself assassinated—strangled and blown up—by one of his coplotters, Mary's lover, the earl of Bothwell. By June the Scottish queen was a prisoner in Loch Leven Castle; by July she had abdicated the throne, and her one-year-old son, James, was proclaimed king. The Catholic powers were watching events in Britain with great interest; Elizabeth could not afford to give them the excuse they craved to intervene.

As July arrived, however, it was becoming impossible for Hawkyns to disguise his activities. Reports were reaching de Silva

thick and fast, and a sense of urgency informed his letters back to Philip II. On 12 July he told the king that Hawkyns was putting together a fleet of nine well-armed ships. Four of them belonged to the queen and were being prepared in Rochester, from where they would sail to Plymouth to join up with the rest of the fleet. His spies were able to supply him with detailed information:

> They have brought out from the Tower of London lately the artillery, corslets, cuirasses, pikes, bows and arrows, spears, and other necessary things for the expedition. They say that 800 picked men are to go, and the sailors to work the ships are engaged by order and permission of the Queen, paid at the same rate as for her service.[6]

Cecil had attempted to reassure the Spanish ambassador, and the revelation that there were to be two Portuguese Jews guiding the expedition went some way to convincing de Silva that Hawkyns's plan was to head for the East Indies. Nevertheless, he remained suspicious, and in another audience with the queen reminded her of the steps taken in the previous year to stop Hawkyns and George Fenner from going to Guinea. Now, he told her, he had heard that Hawkyns was about to set off again. He wanted to know what she proposed.[7]

Elizabeth tried to smooth over the problem. She told de Silva that she had met with both Hawkyns and Fenner and "in her presence she had made them swear that they would not go to any part of the Indies where trade was prohibited . . . and she had again commanded them not to do so." Cecil backed his monarch up, but de Silva was tenacious: he put to her the widely publicized reports of the fleet's preparations, of the presence of four of her ships, and of the powerful weaponry that had been collected from the Tower. Elizabeth responded politely that it was true that two of her ships were in the fleet, and yes they were well armed, but she had lent the ships to merchants as was her common practice, and the weapons were on board to protect the fleet

from French pirates and "against the ill-treatment of the Por-
tuguese." She concluded with a plea to the ambassador to believe
her when she said the fleet would not be causing the Spanish any
problems, nor would it be going to any prohibited place. Cecil
concurred, swearing a great oath that this was the case and that
nothing more than a journey to Africa was planned.[8]

The meeting was over. De Silva departed claiming satisfac-
tion in public, but convinced of the queen's duplicity in private.
Despite her assurances, he was certain that Hawkyns would be
heading for the Caribbean after Guinea, because, he confided to
his king,

> beside the trifles they take to barter for the slaves, they are taking
> a large quantity of cloths and linens which are not goods fit for
> that country, and they also carry quantities of beans and other
> vegetables which are the food of the blacks, and the slaves are not
> usually taken anywhere but to New Spain and the islands.

In the same letter of 21 July he also named Pedro de Ponte
and his son Nicolas as central to the English operations; likewise
a number of Spaniards in the colonies "with whom these people
have a mutual arrangement with regard to the profits. If it were
not for these Spaniards helping them to the islands these expedi-
tions would never have commenced."[9]

De Silva's spies were now working around the clock to keep
him in the picture. By the end of the month he could have had no
doubt as to the real purpose of the Hawkyns operation, for it had
been penetrated to its very core. On 26 July the ambassador noted,
"I am also told by a person who is going with them, who assures
me that Hawkyns has never made a voyage without Pedro de
Ponte of Tenerife being interested in it." There could have been
nothing more galling for the Spanish than the way their own cit-
izens were helping Hawkyns. De Silva wrote to Philip II that his
agents were telling him that even though the English ships
would be carrying enough troops to land as many as five hundred

men "without counting the men necessary to protect the ships," the colonies could, if they desired, resist with force; "but they have got up a scheme with the Governors by which the latter pretend they dare not resist them as they threaten to use force, and then they arrange together after protest has been made, to divide the profits. This agrees with what I said happened last time."[10]

THE QUEEN'S two ships departed London for Plymouth on 30 August. They carried stores for the whole fleet, and were accompanied on the short journey by a supply ship carrying extra victuals. Shortly before they left, John Hawkyns made a special visit to de Silva to set his mind at rest. He reiterated that he would go nowhere that would offend the King Catholic and revealed that the queen had issued a specific set of instructions to this intent. The ambassador was relieved. Hawkyns's word was backed up by intelligence from elsewhere: it seemed that the presence of the two Portuguese guides really did mean the expedition was heading for Africa, where it would attack the fort at Elmina, punish the Portuguese, and look for gold. The expedition would not carry slaves to the Indies. News also reached de Silva that the queen had sent Vice Admiral Wynter to order Hawkyns to keep out of the Americas, and "[i]f he did to the contrary she would have his head cut off."[11]

IN SEPTEMBER Lovell sailed into Plymouth. It had been four months since he left Rio de la Hacha, and he had been up to no good. The details are sketchy—absent completely from the English records—but it seems that once his ships sailed out of port he decided to step off the coattails of Jean Bontemps, who was despoiling the town of Santa Marta, and head for Hispaniola. Here, the Spanish alleged; he sacked and robbed the exposed coastal settlements of the island, doing "very great damage."[12]

One can only guess at the frosty reception Hawkyns gave his

kinsman. Lovell arrived with 50 unsold Africans still huddled in the holds of his ships and had dumped 92 at Rio de la Hacha without receiving payment. Another 26 had been confiscated at Burburata, though at least they had been paid for in advance. Puzzlingly, this accounts for only 168 slaves. Lovell had attacked four Portuguese ships apparently crammed with Africans off the Cape Verde Islands. One can question the veracity of the Portuguese stories, but it seems unlikely that the ships would have crossed the Atlantic without a full load of Africans to sell. It is possible that some were sold and not recorded, but Lovell's desperation to get the "sick and the thin" slaves off his ships at Rio de la Hacha suggests a sadder possibility: that there was an epidemic on board his fleet, and the death toll was high. The Africans had been shackled below for weeks. It was expected that relief would come and conditions would ease at Burburata with the sale of slaves there. Instead, the reluctance of the citizens to trade meant that ships were forced to sail on. Could it be that Lovell abandoned the slaves at Rio de la Hacha because by then so many of his cargo were dying—and presumably being thrown overboard—that it was the only way to ease the spread of sickness through the slaves, and indeed through their English captors? As for the 50 slaves still on board the Lovell ships, there was to be no respite. At Plymouth they were transferred onto the waiting fleet to make the journey all over again.

EIGHTEEN

The queen's ships—the *Jesus of Lubeck* and the *Minion*—
arrived in Plymouth at the end of August. They had under-
gone a thorough overhaul at Rochester: seams caulked, rigging
renewed, hulls careened. As they weighed anchor and prepared
to head down the Medway River toward open sea, they suffered
one of those unfortunate and ill-reported events that were begin-
ning to characterize the start of a Hawkyns expedition: there are
few details, but a crew member keeping a journal recorded that
somehow the ships "then slew a maiden, a pitiful chance."[1]

The fleet that came together at Plymouth consisted of six ships.
Hawkyns was to ride once more on the *Jesus,* which was to be mas-
tered by Robert Barrett. The *Minion* was a powerful four-masted
man-of-war under the command of Thomas Hampton. She was
more than three hundred tons burden, but at thirty years old and
creaking at the seams, she was considered by many to be a bad
talisman: her previous voyages to Guinea had seen appalling
death rates among her sailors. In 1561, John Lok had abandoned
an expedition owing to the bad state of the ship, claiming she
would cause "calamity and inevitable danger of men," adding
that the ship's waterworks and footings were "spent and rotten."[2]

In supplying these two substandard ships the queen was claiming a third share of the profits.

The ships were well armed: the *Jesus* alone carried twenty-two frontline cannons, forty-two pieces of secondary armament, fifty-four barrels of gunpowder, and a huge quantity of ball. In addition, in June 1567, Hawkyns placed an order for ordnance needed to defend a fort in Africa. His purchases included five tons of cannons and guns (sakers, falcons, and falconettes), suits of chain mail, pikes, bows, two hundred sheafs of arrows, and halberds (ax heads on long staffs).[3]

Awaiting them in Plymouth were four ships of the Hawkyns line: the 150-ton *William and John,* named after the Hawkyns brothers and captained by Thomas Bolton; the 100-ton *Swallow,* recently returned from the Lovell voyage; a 50-ton bark, the *Judith,* on which Francis Drake would later take command; and finally the *Angel,* a vessel of just 32 tons. Spread among the fleet were, according to one source close to Hawkyns, 408 men, including the merchant factors, the ships' boys, and a company of soldiers in the charge of Edward Dudley.[4] No document explicitly states who the adventure's financial backers were, but after the success of the previous two voyages, the project seemed certain to provide a rich bounty and therefore great support. One report said that there were as many as thirty investors in the operation and that they included the earls of Leicester and Pembroke, William Garrard, Lionel Duckett, Benjamin Gonson, and William Wynter. Also involved were Rowland Heyward, a knight and alderman, and, despite his protestations to the contrary, William Cecil.[5]

The preparations had reached a point where it was no longer possible to keep the enterprise under wraps. Nevertheless, the version put about publicly continued to be that they were off to attack the Portuguese at São Jorge da Mina, and that two Portuguese guides, a merchant by the name of Antonio Luis and a pilot called Andre Homem, who also went by the name Gaspar Caldeira, would lead them to a new and unexploited gold mine

just sixty miles from the coast. Luis and Homem were possibly disaffected Portuguese Jews on the run from the Inquisition. They had made contact with William Wynter through one Gonzalo Jorge living in London, to whom they had made an audacious but hardly new proposal. In fact they had been doing the rounds with their plans for at least a couple of years. In 1565 they had sold the idea to the Frenchman Pierre de Monluc. Unfortunately, the company of 750 men he had put together had been sidetracked into attacking Madeira on the way to Africa. The island's capital, Funchal, was sacked, but Monluc was killed and the enterprise collapsed.[6] Undaunted, the two Portuguese men had turned next to Philip II for backing. The Spanish king had replied by inviting them to present their idea to his court, but they distrusted his offer of safe-conduct, and decided against going.[7] Now they were trying their luck with the English—and it looked as if they were being taken seriously. They were also being treated like lords: in London they were allowed to come and go at their liberty, and after having been brought overland by the merchants taking part in the voyage, they were personally greeted by John Hawkyns, who "had them well entertained and also showed them in what order all the ships and all other things stood. The Portugals, confessing that they had never seen this better performed, said that they thought themselves happy [to be] under such a captain and of so great experience as our general was known to be of."[8]

But were the Portuguese guides what they said they were? Or were they just a convenient decoy used by Hawkyns to throw the Spanish ambassador and his agents off the scent? De Silva was no longer willing to risk the possibility. In August, heeding his king's instructions to do all in his power to prevent a further incursion into the Caribbean, he decided on a course of out-and-out sabotage. On 30 August Hawkyns was called to the deck of his flagship. What he saw was cause for great concern: heading straight into the Cattewater where the *Jesus* and *Minion* were riding at anchor were "seven sails of great ships and in them

4,000 soldiers besides mariners, and two small barks who waited on them." The ships were bedecked in flags "with their banners of the kinges armes of Spaine displayed."[9] They had passed St. Nicholas's Island at the entrance to the harbor but had not, as was the accepted custom for foreign visitors, dipped their ensigns and lowered their topsails. Hawkyns could not take the risk: any damage to his fleet could set them back too long to get to Africa in the dry season. The English ships opened fire, shooting six or seven shots high at the royal banners and sails of the flagship. There was a pause to give the ships a chance to respond. Still they advanced. Young Richard Hawkyns, present on the day, remembered that notwithstanding the attack, the foreign ships "persevered arrogantly to keep displayed" their flags. His father ordered another round of fire, but this time lower. The flagship was hit. The fleet slowed; the flagship dipped its ensigns, took in its topsails, and turned away from the Cattewater, leading the fleet to anchor out of range of the Hawkyns guns.[10]

A boat was lowered from the lead ship and rowed into shore carrying a message from its Flemish admiral, Alphonse de Burgougne, baron de Wachen. The messenger delivered de Wachen's complaint to the mayor of Plymouth, but he received short shrift and was told to address his grievances to Hawkyns in person. The envoy climbed on board the *Jesus* and was summoned to where Hawkyns was walking with his bodyguards. What was the meaning of the intrusion? the Englishman demanded to know. The messenger spoke up:

Right worshipful sir, the Lord of Camphyre [de Wachen], my master, general of this fleet, who today through foul weather at the sea came into this port, being as he is a subject unto the King of Spain with whom your prince hath amity, marvels why you should either shoot at his ships or forbid him this place where you ride.[11]

Hawkyns replied tersely that the admiral had "neglected to do the acknowledgement and reverence, which all owe unto her

Majesty, (especially her ships being present) and coming with so great a navy, he could not but give suspicion by such proceeding of malicious intention." He gave the ships twelve hours to leave or face the consequences.[12] The messenger left for his ship. According to Richard Hawkyns, de Wachen then paid a personal visit to the *Jesus* to clear the air. At first Hawkyns refused an interview, but when the baron demanded to know what offense he had committed, he was allowed on board. He informed Hawkyns that in accord with instructions from the queen herself, the ships had been cordially treated in every English port in which they had so far called—all except Plymouth. Hawkyns pointed out that if an English ship had sailed into a Spanish port bearing her flags she, too, would be fired at, and if she persevered she would be chased out to sea. Was that not correct? he asked.

> *The Spanish general confessed his fault, pleaded ignorance, not malice, and submitted himself to the penalty my father would impose: but entreated that their princes (through them) might not come to have any jarre. My father a while (as though offended) made himself hard to be entreated, but in the end, all was shut up, by his acknowledgment, and the ancient amity renewed, by feasting each other aboard and ashore.*[13]

An hour later Hawkyns sent the commander a package of food including capons, chickens, and beer.[14] With hindsight Hawkyns was sensible to beware of the Spanish fleet, as it was distinctly possible that de Silva had called in de Wachen to stir up trouble in Plymouth, perhaps destabilize the situation and cause some damage that might make Hawkyns miss the season for sailing out.

The trouble did not end there. Three days after the set-to with de Wachen, a Spanish ship from Biscay sat in the Cattewater. Her captain was Luis de Rugama, and in her hold sat Flemish religious prisoners, captives of the troubles afflicting the Spanish Netherlands, who had been condemned to serve on galleys and in mines. As the afternoon wore on, the ship's crew slept off the

aftereffects of a heavy drinking bout; but while they took their siesta a small boat stole alongside. Masked men clambered on board, made their way quietly to the prisoners, struck their irons, and helped them off the ship. One of the ship's guards woke up, the alarm was sounded, and in the melee that followed, some Spaniards were wounded and three may have been killed. The masked men and the prisoners rowed ashore and disappeared into the crowded Plymouth streets.[15]

The captain of the Biscayan ship was incensed, and claimed Hawkyns was behind the raid. He demanded the prisoners be restored at once.[16] Vehement complaints were fired off to the queen. In London de Silva adopted a high moral and threatening tone:

> *Your mariners rob our subjects on the sea, trade where they are forbidden to go, and fire upon our ships in your harbours. Your preachers insult my master from their pulpits, and when we remonstrate we are answered with menaces. We have borne so far with their injuries, attributing them rather to temper and bad manners than to deliberate purpose. But, seeing that no redress can be had, and that the same treatment of us continues, I must consult my Sovereign's pleasure. For the last time, I require your Majesty to punish this outrage at Plymouth and preserve the peace between the two realms.*[17]

William Cecil feigned to take the matter seriously, publicly rebuking Hawkyns and sending an official to investigate. De Silva's strategy of causing trouble, if this is what it was, was having some effect, yet he failed to put an end to the adventure. The distractions were, however, making it imperative for Hawkyns to get under way. His problems were not over, though: at the end of the second week of September, with the fleet waiting for a good wind, Hawkyns awoke to the news that his Portuguese guides had disappeared. They had been lodging on shore in the company of merchants, but according to an anonymous chronicler of Hawkyns's third voyage, they "were fled away.... And these villains as it

appeareth that long before they had pretended to work this feat, for now having made a great sum of money in the hands of the merchants adventurers, after, it was understood, went over into Brittany in a bark of the same country."[18]

There was much speculation as to where they had gone. De Silva would write to Philip II that they had been secreted out of the country at the behest of the Portuguese ambassador, and that they had been promised a pardon and a safe-conduct there.[19] Other rumors claimed that they had been hung, drawn, and quartered on their arrival in France.[20] It was all idle speculation; what was important was that they had gone. On 30 September Lord Clinton, the lord high admiral, wrote to Cecil criticizing Hawkyns. He had heard how the Portuguese guides had moved freely about London, he noted, and had given "Hawkyns warning of it, and advised him to restrain them, and take good regard to them lest they should slip from him, but now he sees he followed his own mind, which hath not proved well."[21]

Remarkably, although Hawkyns's stated mission was now apparently on the rocks, the man himself did not bat an eyelid. No search parties were sent out to look for the Portuguese, no plan to find other guides was instigated, and no great soul-searching or conferring with officers about abandoning their plans seems to have taken place. Instead, Hawkyns greeted the news with uncommon stoicism and a ready-made alternative. He argued that since the ships were assembled and ready to sail, and the men were mustered, it would be folly to do nothing—he might as well go on another slaving voyage. It was an astonishing feat of versatility, a change of purpose that might have been thought impossible to achieve in so short a time: foodstuffs for hundreds of slaves, along with manacles, would have to be ordered and delivered, the building materials for the fort would have to be unloaded, textiles and other goods for trading would have to be brought in, and guides to the Indies would have to be arranged with de Ponte. Unless of course this had always been the intention, and the Portuguese miscreants had been nothing more than a

smoke screen behind which Hawkyns hid his real purpose. After
the interventions of the Spanish embassy in the previous year,
Hawkyns had needed a ruse that would hold long enough to fool
the Spanish ambassador and his spies. The Portuguese guides did
not disappear; they were disappeared. Five years later a young
crew member, John Perin, would remember seeing a Portuguese
man named Antonio punished at the capstan on the *Jesus* while
it sat in Plymouth. The man was threatened with death, and
heavy weights were placed on his neck and arms and left there
for hours.[22] Could this have been Hawkyns making life difficult
for his guides and driving them away? If so, in the game Hawkyns
and the Spanish ambassador had been playing, Hawkyns was in
fact the cat and de Silva the mouse.

On 16 September Hawkyns wrote to the queen seeking her
permission to alter his plans. He declared that he had never be-
lieved that the Portuguese could deliver what they had prom-
ised, and having fleeced his merchants they had vanished. He
promised that there would be no dishonor involved in converting
the mission, and guaranteed that with God's help he could bring
home a profit of forty thousand marks (marks were a measure of
currency frequently used in this period to signify 160 pence, or
two-thirds of a pound).

> *The voyage I planned is to lade Negroes in Guinea and sell them*
> *in the West Indies in truck, gold, pearls and emeralds, whereof I*
> *doubt not but to bring home great abundance to the contentation*
> *of your highness and to the relief of the number of worthy servi-*
> *tures ready now for this pretended [intended] voyage which oth-*
> *erwise would shortly be driven to great misery and ready to*
> *commit any folly.*[23]

George Fitzwilliams brought the official go-ahead for the new
project from William Cecil ten days later. The notice also con-
tained three counts of rebuke against Hawkyns: that he had been
careless in his handling of the Portuguese guides; that he had

been unnecessarily aggressive toward de Wachen's squadron; and that he had had no right to get involved in the matter of the Flemish prisoners.[24]

On 28 September Hawkyns's fury at the accusations had subsided sufficiently for him to calmly answer the allegations, and on all three counts he washed his hands. Regarding the Portuguese guides, he claimed that he had always been on board ship, while they were always onshore. He admitted that he had had qualms about the rather raucous relationship they had built up with the factors assigned to look after them: "to be plain with your honour," he said, "I thought all ill employed for that they used great prodigality and small temperance." In the matter of the attack on de Wachen's fleet, he argued that he had behaved perfectly correctly. He had acted in accordance with the law and just as any other captain would have done; furthermore, once the trouble was resolved he had feasted the Spanish admiral and given him many gifts. However, in the first instance, "I greatly feared their warlike working which as it appeared would have lain in the place called Cattewater, where the *Jesus* and *Minion* rid." On the escaped convicts, Hawkyns was rather vague and somewhat confused. He seems to have accepted that unwittingly he did have a part in the affray. He claimed that while the Spanish crew was ashore the prisoners released themselves, but were chased by a Spanish boat. Men on board the *Jesus* witnessed the event, jumped into their own boat, and joined the chase, catching the prisoners and bringing them onto the English ship. Hawkyns said that he knew nothing of it until the prisoners were on board, at which point he ordered they be restored to their Spanish jailers. This was done, he claimed, but five or six days later a Flemish ship pulled into port and released the condemned men. To emphasize both his plight and his innocence he added childishly that he knew the Spanish were out to get him. "I know they hate me," he wrote, throwing in once again his long-standing grudge about the confiscation of his goods in Seville, "and I the worse for them by forty thousand ducats

which is not unknown to the ambassador of Spain, I hope one day they will make me recompense of their own courtesy."[25]

Hawkyns had got his gripes off his chest. The most important issue for him was that he had the permission he needed to sail, that he had been explicit about his intentions to deal in slaves in the Americas, and that the queen had raised no objection. It was now time to proceed with the business at hand, to get out to sea before anything else could get in his way. On 2 October 1567, John Hawkyns's third slaving voyage began. Behind him he left the usually well-informed de Silva floundering, unaware until well into the month that the English ships had sailed.

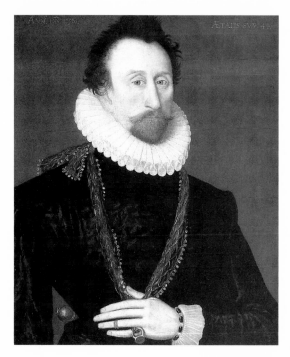

Portrait of "Sir John Hawkins" from 1581. The inscriptions are inaccurate—by 1581 Hawkyns was probably forty-eight, or forty-nine, not forty-four; the spelling of his name is in a more modern form; and he was not knighted until 1588—suggesting that either the portrait or the writing were not contemporary.
(Reproduced with the permission of the National Maritime Museum, Greenwich, London)

Her lily white complexion "as sleeke as Paris plaster," Queen Elizabeth I portrayed circa 1565, clad in regal ermine and holding the symbols of her office. *(With acknowledgment to the Earl of Warwick, photograph by Gwilym Streets. Reproduced with the permission of Getty Images.)*

The town of Plymouth and Plymouth Sound as pictured in a chart of 1540. *(Reproduced with the permission of the British Library)*

The Atlantic world, including the west coast of sub-Saharan Africa and the east coast of South America, from the Diogo Homem atlas of 1558. *(Reproduced with the permission of the British Library)*

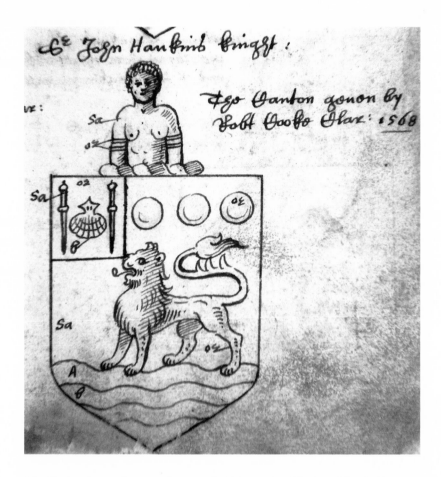

John Hawkyns's coat of arms, at the crest of which was placed "a demy Moor, in his proper colour, bound and captive, with annulets on his arms and ears." *(Reproduced with the permission of the College of Arms)*

"your good Lordshipps most faythefully to my power John Hawkyns." John Hawkyns's signature and handwriting from a letter of 1571, a time when literacy levels were low, point to a man of education. *(Reproduced with the permission of the National Archives, London)*

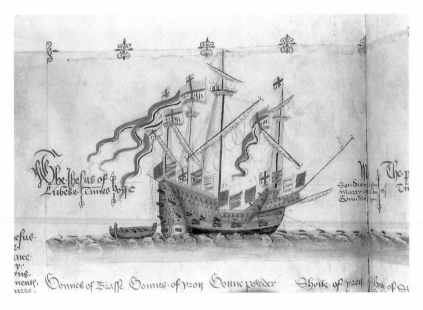

The flagship of John Hawkyns's fleet the *Jesus of Lubeck*. *(Reproduced from* Anthony's First Roll *with the permission of the Pepys Library, Magdalene College, Cambridge)*

"Advauncement by dilligence." A portrait of John Hawkyns, taken from an engraving in Henry Holland's *Herωologia Anglicana* of 1620. *(Reproduced with the permission of the National Maritime Museum, Greenwich, London)*

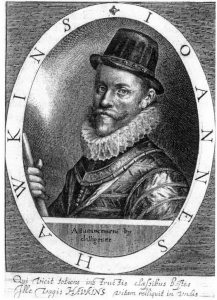

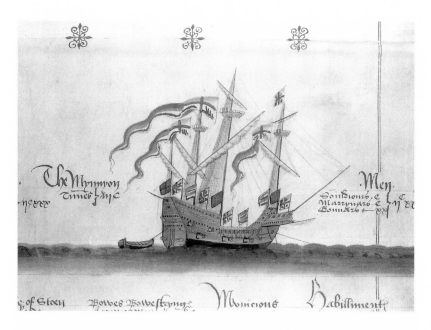

The queen's ship the *Minion*, all flags flying. *(Reproduced from* Anthony's First Roll *with the permission of the Pepys Library, Magdalene College, Cambridge)*

Procello agitatus coram prestantissimo
dño doctore Syinone Cabral Regio
senatore & criminali pretore, causarumqȝ
Jndiæ, ac Quinææ supremo iudice circa quã
dam supplicatione ab Antonio guũcal
uez & Duardo Leone contractatorib9
cum quibusdam articulis oblatam super
latrociniis: quæ Britanni, qui alio nomine sũt
Angli appellati, in fluuiis & in Serra Lyoa
pȩroram maritimam guinææ, & pȩralias jn
sulas portugallensibus inuexerunt.

Anno à natiuitate Domini millesimo, quingen=
tessimo, sexagessimo octauo, mense Jullij, octauo die in
Ciuitate Olyssiponis coram prestantissimo domino Doc
tore Simone Cabral Regio Senatore, ac prætore, causa
rumqȝ Jndiæ ac Guinææ supremo iudice, apparuerunt
Antonius Guuncaluez Degusman, et Duardus Leo –
incola, & ciues Olyssipponenses, existentes redemptores
vectigalium et contractahionis in regione Promontorij
Viridis, vulgò Cabouerde, Et in fluuys, Et ora maritima
Guinæa. Qui quadam supplicatione cũ suis articulis

Introduction to Portuguese depositions made in 1568, "concerning acts of piracy which those Britons, who are otherwise called English, have committed against the Portuguese in rivers and in Serra Lyoa along the coast of Guinea . . ." Hawkyns is called Joannem de Canes, and John Lovell is referred to as Joannem Cobel. *(Reproduced with the permission of the National Archives, London)*

obtulerunt ad suum ius conseruandum, & ad perpetu
am probationem de rapinis, prædis, latrocinijs, vi,
contumelijs, verberibus, cruciatibus, & alijs detrimen
tis: quæ per Joannem de Canes vnius classis An=
glicæ præfectum, & per Joannem Cobel alterius clas
sis Anglicæ etiam præfectum, & per alios quoqué
eius dem societatis prædones contra maiorũ exempla
& contra ipsius humanitatis iura hominibq Portugua
Lensibus sunt inuecta in ora maritima, in Serra
Lyoa, in fluuijs Sancti Dominici, in alijs insulis
ac regionibus ad serenissimũ Lusitaniæ Regẽ perti
nentibus. Quapropter predicti supplicantes petunt, vt
testes exhibendi cũ iuramento solemni de articulis ob
latis interrogentur, & eorũ dicta per me Francis=
cum Gunncalues publicũ notariũ in acta publica
redigantur, publicaq exemplar testimoniale ad suis
iuris conseruationẽ exhibeatur supradictis contracta
turibus ad perpetuã rei memoriam. & predictus
notarius subscripsit unà cũ domino pratore ~

 Franciscus Gunncalues pu
blicus notarius:

Supplicationis & articuloṝ forma pro
parte Antonij Gunncalues degusman
& duardi Leonis contracta turium.

The island fortress of San Juan de Ulúa near Veracruz, Mexico. The fortifications were largely added after the battle with Hawkyns. *(Nick Hazlewood)*

The Isla de Sacrificios off the coast of Veracruz, Mexico. It was here that the *Minion* sheltered and took stock after the battle at San Juan de Ulúa. *(Nick Hazlewood)*

Hawkyns supplied a list of the "places arrived at and times in the voiage made with the Jesus and the Mynyon" after arriving back in Cornwall from his third slaving voyage. *(Reproduced with the permission of the National Archives, London)*

Detail from the schedule of losses suffered by John Hawkyns and fleet at the battle of San Juan de Ulúa, as presented to the 1569 inquiry. (*Reproduced with the permission of the National Archives, London*)

the same article to be true, ffor this deponent beleveth that there
were in the said Jesus skynn men w[hi]ch had ther provision some
more and some lesse / whereof some of them as the surgeons
and others of charge in the same shyppe had provision
worthe x[li] ster. And divers of the companie lost xxx[li] and
xxv[li] in value as he sythe /

Ad vigesimum septimum articulum dixit That there was
remayninge in the Jesus at her departure from Cartagena as
aforesaide xx clokes whereof the like of everye of them were
worthe and solde communlie in the west Judias this last
voyadge x[li] ster. ffor this examinant was present
when the saide John Hawkins did sell at Barborcatta and
other places thereabouts the like for viij and ix pesos of
goulde as he sythe /

Johannes Hawkyns Civitatis London yeo[man]
s rospec etatis annorum aut eo circiter testis etiam in
hac parte per p[ar]t[em] articulis note et pro parte pr[edict] will[el]m
Garrard propositus et dato productus juratus et examinat
dixit et deponit ut sequitur

Ad primum articulum in vim sui presiti juramenti
deponit et dixit That in the yere 1567 articulato pr[edict]
will[el]m Garrard knyght Rowland Heyward Aldorman of

Record of the evidence given by John Hawkyns—Johannes Hawkyns—to the 1569 inquiry into events and losses at the battle of San Juan de Ulúa. *(Reproduced with the permission of the National Archives, London)*

"I have to pray your honour to suspend your opinion of me for that although I have had a painful journey yet because it hath not had a prosperous end, there are some which can be contented to speak the worst in everything and to find many faults . . ." John Hawkyns wrote to William Cecil on March 6, 1569—here written as 1568 under the old system of calculating the year—against those who were speaking ill of him. (*Reproduced with the permission of the National Archives, London*)

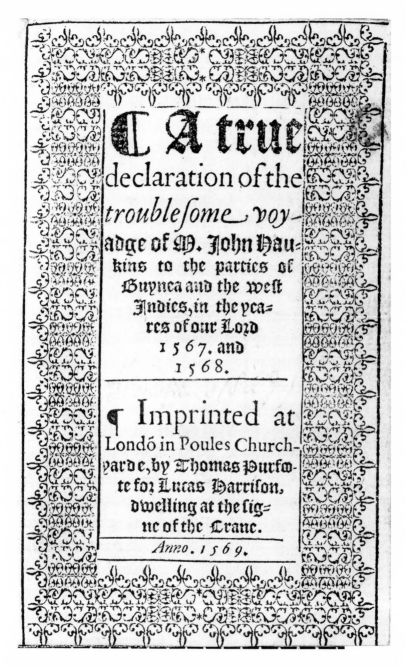

The cover sheet from 1569's *A true declaration of the troublesome voyadge of M. John Haukins to the parties of Guynea and the West Indies, in the yeares of our Lord 1567 and 1568*, written by John Hawkyns. *(Reproduced with the permission of the British Library)*

"Of late a sickness and death hath begun amongst us . . . at this instant six more of the company lie at the point of death . . ." A desperate letter from the English prisoners Thomas Fowler, George Fitzwilliams, and John Varney to William Cecil, smuggled out of Seville, February 25, 1570. *(Reproduced with the permission of the National Archives, London)*

THE RARE

Trauailes of *Iob Hortop*, an Englishman,
who was not heard of in three and
twentie yeeres space.

Wherin is declared the dangers hee escaped in his voiage to Gynnie, where after hee was set on shoare in a wildernes neere to Panico, hee endured much slauerie & bondage *in the Spanish
Galley.*

Wherein also he discouereth many strange and wonderfull things seene in the time of his trauaile, as well concerning wilde and sauage people, as also of sundrie monstrous beasts, fishes and foules, and also Trees of wonderfull forme and qualitie.

LONDON
Printed for VVilliam VVright. 1591.

The 1591 cover sheet of *The rare travailes of Job Hortop, an Englishman, who was not heard of in three and twentie years space*, written by Job Hortop on his return from Mexico. *(Reproduced with the permission of the British Library)*

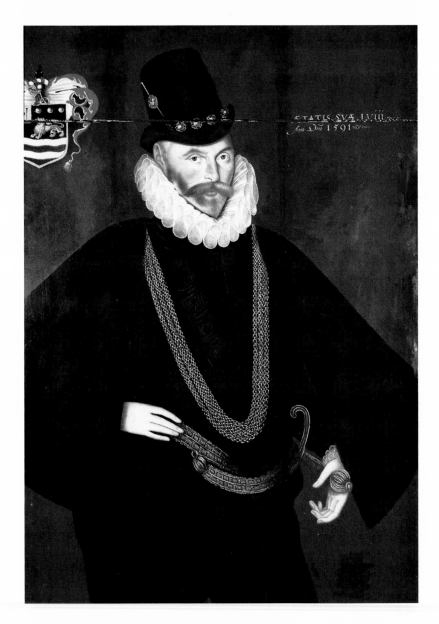

Sir John Hawkyns in 1591 at the age of fifty-eight, with his coat of arms authenticating the picture. Painting by Hieronymus Custodis (fl. 1589–95), oil on panel. *(Courtesy Collections of Plymouth City Museum & Art Gallery ©)*

Disaster

Nineteen

On the eve of the third voyage the loading of the provisions and merchandise was complete. In the cargo holds of the six ships were bales of linen, silks, taffetas, woolen cloths, dyed sheets known as pintados, brocades, cloaks, crates of manilios—metal armbands—and boxes of pewter and ironware.[1] And in among all of this was the most valuable freight of all: the fifty Africans Lovell had brought back with him a month earlier. Nothing is recorded of their brief stop in Plymouth: whether they were allowed ashore, or even above deck; whether their existence was common knowledge, or if for the sake of caution on Hawkyns's part they were kept hidden in the depths of his ships.

Hawkyns took the opportunity to march his officers and crew to church for a final service of thanksgiving. More than four hundred men packed the pews of St. Andrew's, taking communion, reciting the Psalms of David, praying for their souls, and watching as their captain took "a solemn oath from a very rich brother of his that the government of that post, which he left to him, would be executed faithfully and with upright justice, over which a minister preached a special sermon."[2] At the end of the service, Hawkyns handed two or three doubloons to the minister who had administered the communion.[3]

The next morning was 2 October, and with a fair wind filling their sails, Hawkyns led his most important expedition thus far out of its safe anchorage and into the choppy waters of the English Channel.[4] It was to be a voyage that would change everything, and as if to mark the fact, there were to be many different accounts of what was about to follow. In contrast to the measly 720 words Hawkyns committed to paper on his first adventure, the word count for this third voyage would run into many thousands: there were accounts by Hawkyns himself, an anonymous but detailed record kept by a crew member close to John Hawkyns on the *Jesus of Lubeck* (archived in a manuscript called Cotton Otho E VIII), memorials written by participants years later, and vivid judicial statements made by many of the less fortunate men who departed the Cattewater that day. These accounts do not always make producing an accurate record any easier: they frequently contradict one another; they get dates wrong; some were written with the hindsight and wisdom of three decades, while others were extracted under the most vicious extremes of torture. Nevertheless, with careful use, they provide a valuable insight into the events that would unfold over the next year.

Significantly, the records allow a fascinating peek into the personal lives and backgrounds of almost a quarter of the sailors, soldiers, merchants, gentlemen, and boys on the voyage. They provide answers as to why many of the men joined the expedition. Although no commission of impressment exists, a substantial number of men claimed that they had been coerced into service. The young Richard Temple claimed in 1569 that "he being in the said port of Plymouth the said general John Hawkyns under the commission he held from the Queen of England ordered him to go on board the flagship of his fleet to serve there as a gentleman adventurer."[5] It was said of the twenty-year-old William Cornelius, who had been sailing sardine ships to and from Flanders since the age of twelve, that "one day as he was going along the street unsuspectingly they fell upon him suddenly and hurried him on

board as they were short of people owing to the fact that they were going to Guinea which had the reputation of being an unhealthy country where they would die from fever and that they had taken him as they had done with many others."[6]

Others had more personal reasons for signing up. The Welshman Morgan Tillert had joined to pay off gambling debts that had left him penniless, and had secretly hoped to jump ship before the fleet set sail, but "the risk that they might have caught and killed him" had been too great.[7] John Gilbert boarded the *Minion* having just been released from a French prison.[8] John Hawkyns's thirteen-year-old page, Miles Phillips, was the son of a London merchant, and had lived at home with his parents until "according to what his mother had told him John Hawkyns came one day to eat in their house and with the consent of his father and herself had taken him to Plymouth where he shipped on the flagship."[9]

The crews of the ships were dotted with relatives of the Hawkyns family: Francis Drake was a young cousin and, as was typical of the day, had lived from an early age in the Hawkyns house.[10] Paul Horsewell was the son of Elizabeth, an otherwise unrecorded sister of John Hawkyns. He was brought up in John Hawkyns's London home and at the tender age of ten joined the *Jesus*, where he was known as Paul Hawkyns.[11] Robert Barrett, the master of the *Jesus*, was a cousin of Francis Drake, and his brother-in-law Thomas Goodal, who had recently returned from a trip to Newfoundland, was a servant on Barrett's ship.[12] In 1573 it was reported that Thomas Ebren, who was the son of a deceased merchant and who acted as servant to the cooper on the *Jesus*, was also a member of the Hawkyns family.[13]

There were those, too, who were on the expedition to perform tasks outside the normal ambit of seafaring or soldiery. There were, for instance, the supercargoes or factors: the representatives of the London merchants who sailed to keep an eye on their master's stock, organize its sale, and ensure that its accounting was carried out accurately and according to the book. These were

usually gentlemen adventurers, men of "quality," like the one-eyed George Fitzwilliams, a close and much trusted associate of Hawkyns. Others included William Clarke on the *William and John*, Valentine Green, Michael Soul, Thomas Fowler, and John Turren. Interestingly, it seems that being a gentleman, and of a social class superior to the general seafaring body, was no guarantee against impressment: Richard Temple, John Corniel, and Christopher Bingham would all later claim to have been forced into service, though as will become clear there are reasons for doubting the truth of such assertions.[14]

Hawkyns carried an orchestra, too, for his and his officers' entertainment: a six-man band that included at least two fiddlers, Gregory Simon and John Brown, and William Lowe, a dwarfish son of a blacksmith, who was taught the bass viol and organ during the course of the voyage, and whose appearance would cause the authorities in the Americas to debate whether he was seven or twenty years old.[15]

In an age when life expectancy was significantly shorter than it is nowadays, and in a career that was full of danger, it comes as little surprise to discover that most men on Hawkyns's voyages fell into an age bracket that stretched from the late teens into the thirties. There were, however, notable exceptions: Richard Hakluyt might write of seafarers in his *Principall Navigations* that "since no kind of men of any profession in the commonwealth pass their years in so great and continual hazard of life . . . so few grow to grey hairs,"[16] but there were older men on this expedition: men like the gunner John Farington, who was said to be sixty years old and who expressed himself with difficulty, even in his own language;[17] John Hall, the cooper on the *Jesus*, who was fifty-nine;[18] and a Scotsman known simply as James, who was the ship's dispenser and was described as "tall, thin and elderly."[19]

The figures are, however, skewed by future events: almost a quarter of those for whom there is some kind of record came on the ships as cabin boys, pages, stewards, and servants. Their ages ranged from nine to sixteen, and most would have been

there at the behest of their parents, who may have paid to ensure that their sons received a decent grounding in the arts of seamanship.[20] John Perin, who entered service at the age of fifteen, was the son of one of Queen Elizabeth's cooks.[21] John Lee was on board because his father, Henry, who had been a servant of Philip II during the reign of Mary, was the chief gunner on the *Jesus*.[22] The unfortunate eleven-year-old Andres Martin was the son of a dead Breton pilot, who had been sent to Plymouth to learn English, and who three days later found himself pressed into service as servant to the quartermaster on the *Judith*.[23]

Most of the men were single. Among those for whom marital status is recorded there were three times as many unmarried men as there were married, though the figure is inflated by the preponderance in the records of ships' boys. There were exceptions: John Hall had six sons;[24] William Collins had a wife and son in Gravesend.[25] A few of the younger men, like Pablo de Leon, Michael Soul, and Richard Temple, had made last-minute proposals to their loved ones before heading off to sea.[26]

The voyage had effectively begun in two ports. Much of the loading and preparatory work had been carried out in the southeast of England and London, while the fleet had come together for final adjustments and late additions in Plymouth. It is not a great surprise, therefore, to discover that the overwhelming majority of men appear to have come from either the West Country or the capital. Of the sixty-five men whose origin is revealed in the archives, seventeen came from Cornwall, Devon, or Bristol, and twenty-five from London. This is not to say that it was an exclusive arrangement. It is important to remember that men claiming to come from London had often been attracted there from other parts of the country. But that aside, men came from all over: George Day was from Hull,[27] Thomas Stephens and Richard Temple began life in Leicester,[28] George Fitzwilliams resided in Yorkshire,[29] and a man calling himself Diego Hen was from Preston.[30] The Celtic fringe, too, was well

represented: men like John Evans, Morgan Tillert, and John Brown came from Wales,[31] while William Cornelius and another John Brown came from Ireland.[32] And there were those who came from even farther afield: the locksmith Pablo de Leon, in charge of the fleet's harquebuses, was a weaver's son from Rotterdam.[33] Pablo Flamenco and John Perin were from Flanders,[34] Roger Armour and John Williams from Germany,[35] and Andres Martin from Brittany.[36]

The crew reflected a variety of backgrounds, too. Many had long experience of seafaring, or fathers who were sailors. Some, like John Moon, William Griffin, and Morgan Tillert, had sailed with Lovell on the previous transatlantic slave hunt.[37] Others relied on the sea in different ways: John Williams was a fisherman, as was John Moon.[38] Thomas Stephens, a gunner on the *Jesus*, was a Thames boatman by trade.[39] In difficult economic times the life at sea provided some with a viable alternative: Robert Cook was one of a number of men on board who was the son of a laborer;[40] William Lowe was the son of a blacksmith.[41] It was far from true, however, that all came from lowly backgrounds. In addition to the gentlemen adventurers, there were others on board who claimed gentle or more refined birth. The eighteen-year-old William de Orlando was a nobleman from London who had lived in the queen's palace.[42] William Collins had also served in the court of Philip II, and accompanied him to Flanders, where a harquebus disabled his right hand.[43] Christopher Bingham had later haughtily informed a Spanish court that despite being forced onto the voyage, he expected no salary "and that in any case it was not the custom for gentlemen to be paid."[44]

Not all men on board were receiving wages, and almost no one knew before he left exactly how much he would receive at journey's end. Most of the ordinary seafarers would claim a share in a third of the profits, but others were willing to travel on a much vaguer basis: Richard Matthews and Michael Soul were happy to be paid at the discretion of John Hawkyns;[45] George

Fitzwilliams believed Hawkyns would pay him what he thought proper.[46] Of course, everything depended on the successful completion of the mission.

THREE DAYS into the voyage Hawkyns sensed a change in the weather and issued instructions to his ships' masters that if they should get separated by foul weather to head for Santa Cruz on Tenerife. The very next day the heavens opened, and the most ferocious of tempests crashed down on their heads. Four days in hell followed: the fleet splintered into three groups in the darkness, two men caught in the *Minion*'s longboat lost their lives, and two more died in the pinnace being dragged along by the *Swallow*. Only quick reactions on the part of Hawkyns saved the men sitting in the boat that the *Jesus* trailed.

And his problems grew: the storm-whipped waves gashed open the stern of the *Jesus*, and the old ship began to leak like a sieve. Desperate patchwork was applied to the stern, but with the storm showing no signs of relenting, the crew were set to the pumps day and night in a frantic effort to keep her from sinking. As soon as one leak was stopped, another broke out: the men were exhausted, and Hawkyns was downcast, believing "that we were dead men and in a ship that was so weak that she was not able to endure the wind or the sea." As the *Jesus* grew heavier she rocked violently on the huge waves. Hawkyns summoned the whole crew from their duties to tell them they had no choice but to head for home. There was little chance of surviving, he added, and then led them in prayer: to those present it seemed like the last rites were being administered. The anonymous account in Cotton Otho recorded that "his words pierced the hearts of all his company, and it seemed unto them that death had summoned them when they heard him recite the aforesaid words, for they knew such words could not issue out from so invincible a mind without great cause. There was not one that could refrain his eyes from tears."[47]

Prayers over, Hawkyns dismissed his men with the instruction to keep searching the ship for leaks and plug them wherever they were found. At midnight on the fourth day of incessant storms the wind dropped. Daylight broke a few hours later to "seas waxing calm," a blue sky, and a reviving sun. Hawkyns called the men together again and informed them that the easing of the weather, and the wind being a northerly, he had changed his mind and they would sail on to Tenerife.[48]

TWENTY

In the days after the storm the *Jesus*, *Judith*, and *Angel* came together, and eventually appeared in the roadstead off Santa Cruz de Tenerife on 23 October. The other ships were missing; Hawkyns had no idea of where they were, or even whether they were still afloat. He signaled his arrival by firing off a dozen pieces of ordnance and sent word to the governor that he would be waiting there until joined by the rest of his ships.[1]

Over the next few days there was a string of visitors to the *Jesus:* Josepe Prieto, the bailiff of Tenerife, came out because one of his duties was to inspect all ships arriving at the island.[2] Officers from two Spanish ships loading up in the harbor for a voyage to the Indies came on board for conversation and remained for dinner.[3] Hawkyns sent presents ashore to various of the island's dignitaries, many of whom also joined him on the ship for food and invited him to bring his ships into the harbor and take time ashore.[4] Beneath the veneer of friendship, however, relations were uneasy. Hawkyns had never had a great rapport with officialdom in Santa Cruz: on his previous visit he had been forced to depart quickly following the meddling by the Inquisition into his affairs, and he feared that both he and de Ponte were under scrutiny. He was correct to be vigilant: his arrival had caused

great agitation in the town. Lovell's behavior before him and the fact that he was sitting out at sea rather than docking aroused great suspicion, and the people were arming themselves to resist what they thought might be an attack by a "thieving pirate ship." Outlying garrisons were drafted in from across the island to fortify Santa Cruz, artillery was set up at strategic points, and according to Juan de Valverde, alderman of the city, plans were afoot "between the agents of justice and the regiment and the captains, they would try to seize them [Hawkyns and crew] if they came upon the land."[5]

The invitations continued to arrive at Hawkyns's door, tempting the Englishman ashore, but he deflected them with the reply that "the Queen's Majesty had given him commandment to the contrary."[6] Besides, despite the general animosity toward him, plenty of the island's residents were still happy to come out to him, buy his cloth, and even—contrary to their Catholic beliefs—eat meat with him on a Friday.[7]

Despite Hawkyns's overtures, there was reason enough for the people of Santa Cruz to be wary. The three ships continued to sit offshore awaiting news of the rest of the fleet, and while nobody was allowed on land except isolated groups of twos or threes detailed to buy provisions or find sources of freshwater, even these could get up to mischief. Valentine Green slipped into town without incident, where he bought a barrel of wine and negotiated the delivery of six further pipes of wine, each holding over one hundred gallons;[8] but on another occasion a gang of young lads headed by William Bennet the baker sent to an isolated spot with water casks were spotted by locals seizing a cross from a hermitage near where they had landed and overturning it. Roger Armour, who sailed on the *Jesus*, remembered that the boys "came running over the crest of a low hill followed by some Spaniards, and the longboats of the fleet had to be sent to their aid." Bennet was triced up to the mainmast for two hours as punishment.[9]

Whether because of the delay or the lack of shore leave, tensions rose on the *Jesus*. On the second day at anchor, two of

Hawkyns's closest companions, the gentleman adventurer George Fitzwilliams and Edward Dudley, captain of the soldiers of the fleet, clashed. Words were exchanged, and so violent was their disagreement that they agreed to settle the matter in a duel on land. Dudley rowed ashore, but Hawkyns caught wind of the trouble, prevented Fitzwilliams from leaving the ship, and ordered Dudley to return. Facing both men, he demanded that they forget their dispute or save it for a time when it could be satisfied away from the eyes of the Spanish. Dudley was incensed and spluttered out a string of profanities. Hawkyns struck him with his fist, Dudley drew his dagger, and Hawkyns pulled out his rapier. There was the brief flash of steel, and the mutinous soldier was slashed on the hand and arm. Then Dudley thrust out, catching Hawkyns just above the right eye, but before he could go any further, watching crewmen pounced on him. Hawkyns ordered him shackled in irons, and retired to clean up his grazed eye.

Later, when things had calmed down, Hawkyns demanded to know what Dudley thought he had been up to. Dudley fell to his knees, and acknowledged his insubordination, adding that if one of his men had committed such an act he would have had him hanged on the spot. Nonetheless he pleaded for mercy. Hawkyns responded that he would love to be magnanimous, but given the circumstances, and the danger of setting the wrong sort of example, Dudley had to be punished: he was to be shot. He called for a harquebus to be charged with two bullets, and told the captain of soldiers to prepare to die. Dudley broke down into hysterical weeping. There were rumblings among the gathered company for Hawkyns to be merciful. He ignored them and asked Dudley if he had said his final prayers. Dudley fell to his knees once more and begged forgiveness. Hawkyns stood over him, and then in an act of unexpected compassion, or well-founded pragmatism uncommon among naval captains either then or in later centuries, Hawkyns helped Dudley from the ground. The matter was finished, he said, it was forgotten. A thankful Dudley watched as his irons were struck, and he was allowed to walk away.

At about the same time, Hawkyns received a visit from Pedro Soler, vicar of Tenerife. It was a visit that he had encouraged by commissioning Diego de Payva, a resident of Santa Cruz, to ride to La Laguna and invite Soler to the *Jesus*.[10] To prove the veracity and authority of the request, de Payva carried Hawkyns's ring, which he was to hand to the vicar. Early the next morning Soler arrived at the customhouse on the waterfront at Santa Cruz. In the current circumstances it was dangerous to be caught surreptitiously boarding the English ship, and Soler decided that a public show would be a safer bet. At the customhouse he met his colleague Mateo de Torres, and the two of them openly went out to the *Jesus* in a boat belonging to de Payva. The three men climbed on board, and Soler sent a member of the crew to fetch Hawkyns. After a short while, with the Englishman nowhere to be seen, Soler handed the ring to a cabin boy and told him to deliver it to his captain. Hawkyns emerged on deck immediately and the two men embraced before strolling around the ship in discussion. There is evidence that the two men knew each other and were friends. Soler was the son of a conquistador who had been rewarded for his efforts with a fine hacienda in Abona, where the family fortune had flourished with the boom in sugar production. The Soler influence ranged far and wide: not only did Pedro's parochial duties make him a force on the island, but two of his brothers were captains in local infantry regiments. Soler was known to have been a friend to English sailors: in a strange incident in 1560 he had hired a boat for a small group of Englishmen so that they could "look for a ship to go to their home." However, once they had obtained the boat the sailors used it to join compatriots on Tenerife—possibly prisoners they helped break out of the jail—and then raided a fully loaded Spanish merchantman, hoisted her sails, and disappeared with her cargo.[11]

On this occasion, however, Hawkyns was keen to help Soler. He told Soler that he was saddened to hear that a house belonging to him had been burned to the ground, and that he was here

to offer what help he could. This is intriguing: not only was Hawkyns upset at the damage to Soler's house, he had brought with him "offerings" to make good the repairs. He must therefore have known of the destruction before he left Plymouth, and his behavior demonstrates either the strength of their friendship or that he felt a sense of responsibility. In the previous year Lovell had threatened Catholic property and in some accounts had made good on his threat. Could it be that Hawkyns was offering to repair Lovell's damage? Soler was overjoyed at the offer, told Hawkyns that he "kissed his hands" and knew that his offer came from God, but that he would be unable to accept. All that he had in the world was a mule, Soler said, but it would not be proper, and could even be problematic, to take up the Englishman's proposition. He thanked Hawkyns again and went ashore for the night, returning briefly the next day for one final, private meeting.[12]

Interestingly, Soler later claimed to be among those who had intervened in the mutiny of Dudley. Perhaps it was the priest's mediation that brought out the surprisingly compassionate strain in Hawkyns. Soler was later questioned by the Inquisition in the Canaries about his visit to Hawkyns and a letter he was said to have written; according to the record, "if the said licenciado Soler had written to the said Juan Achin [John Hawkyns], it was to demand that he pardon a certain soldier with whom the said Juan Achin had had a fight with Christian words, and this and not other things was contained in the said letter."[13]

For the whole of his stay at Santa Cruz, Hawkyns stayed on the alert. On the fourth night after his fleet's arrival, the extent of Spanish animosity became apparent. As darkness descended, all of the Spanish ships and vessels in Santa Cruz Harbor shifted position, giving the castle a clear line of fire on the English ships. Their intention was obvious, but so was their movement, and Hawkyns spotted it. At midnight he pulled his fleet out of range, and at the same time sent the *Jesus*'s boat in to an isolated watering hole to fill the casks one last time. When morning came the governor of Tenerife saw that his plan had been revealed, and

sent word to Hawkyns declaring there had been a misunderstanding.[14] Two days later the English ships weighed anchor and sailed arrogantly past the harbor mouth. As they came in range they fired a volley of half a dozen shots: one smashed through the door of a house, another narrowly missed the church, and another fell short of a chapel. The Spanish returned fire, to no effect.[15]

O N 3 0 October Hawkyns reached the south of the island and the far more congenial territory of his partner Pedro de Ponte.[16] He was still without news of the missing ships, but there is no hint of any anxiety on his part. There was business to attend to: Hawkyns collected Gregory Stephens, a nineteen-year-old Plymouth man who had spent a year working for him with de Ponte, and he learned of a French vessel that had attacked one of de Ponte's caravels, robbing her of a consignment of sugar. Hawkyns promised to keep an eye out for the ship and take retribution if the opportunity arose.[17]

The three missing ships, the *Minion*, *Swallow*, and *William and John*, were all safe. The storms of early October had blown them into San Sebastián, the only port on the island of La Gomera, just fifteen miles west of Tenerife.[18] Their arrival there had caused some consternation, but none of the antagonism that Hawkyns was facing in Tenerife. Shortly after the ships pulled into the harbor, three men came out to visit the *Minion* to ask what they wanted. On hearing that they meant no harm, the men welcomed the ships' crews ashore to buy provisions and organize water supplies. William de Orlando, the London "noble man," lodged in the house of the island's governor while waiting for the fleet to be reconstituted.[19]

Three or four days into their stay the weather improved and Thomas Hampton hired a small vessel to get word to Tenerife that the ships were secure and waiting.[20] On the day after his arrival at Adeje the news reached John Hawkyns. He immediately dispatched the *Judith* to La Gomera, the two other ships

following soon after, pulling into San Sebastián on 2 November.[21] It was an occasion for great celebration: all the ships fired their guns, and the governor of the island, Alonso de Espinosa, and the *regidor,* Martin Manrique de Lara, boarded the *Jesus* to issue an official welcome and to offer them all the provisions they needed. They bought meat from ranchers on the island and jugs of wine and oranges from Licenciado Sarmiento, and the men had "good diversion" in the town of San Sebastián.[22]

Nevertheless, despite the warm reception received by the English, there would later be many complaints that while on La Gomera they committed a number of outrages against the Catholic church there. Perhaps it is simply the fact that there are more sources of information for this voyage, but it seems that in 1567–68 the Hawkyns expedition had a sharper anti-Catholic edge to it: there was the breaking of the cross on Tenerife and the shooting at the church and chapel in Santa Cruz, and here on La Gomera there were new accusations: that the English burned images of the saints in San Sebastián, that the doors to a hermitage at Playa de Santiago had been burned, and that a nearby cross had been overturned by John Breton, the carpenter on the *Jesus.*[23] What was worse, John Perin, page to John Hawkyns, had heard his boss laugh out loud at the incident with the ship's master and quartermaster.[24]

There can be little doubt that such acts were manifestations of a more overt, increasingly aggressive Protestantism that characterized this voyage. In keeping with the puritanical strain of the new religion, no images, religious or otherwise, were allowed in the fleet, except a portrait of the queen that Hawkyns displayed in his cabin, and a golden image of St. John that he intended to sell.[25] Religion was nevertheless central to the fleet's daily activity. When a man lay dying, Hawkyns would take his confession, and soon after, the whole ship's company would kneel around him and ask for mercy for the soul of the deceased. (If anybody fell sick on the *Jesus,* Hawkyns would have him removed to another vessel immediately, in order to keep his flagship healthy.)[26] Every

morning on the *Jesus* there would be a service lasting longer than half an hour, but usually less than an hour. As Richard Williams, a young servant on the ship, would later testify, the men would gather on the third deck, while on the poop deck

> *John Hawkyns or the Master or Quartermaster would take one of the Lutheran books which they had brought out with them, and they did as in England, neither more nor less, and while reading they would be all on their knees and with their headgear doffed and they bowed when the name of Jesus was mentioned . . . and in the afternoon they all met again . . . and recited the Creed and the Hail Mary in the English tongue omitting in the latter the words of intercession which run "pray for us sinners amen Jesus" because they will not pray to Our Lady nor to the saints but only to God as they held that to Him alone and not to any Saint or to Our Lady was it meet to pray.*[27]

Morgan Tillert recalled that when the fleet was sailing at night, "when darkness was falling and the guard went on duty and the hourglass was being turned, the crew of the flagship would gather round the mainmast, kneeling, bareheaded, and the quartermaster would begin to pray and all recited the Psalms of David and the Paternoster and Creed in the English language."[28] Attendance was compulsory: the quartermaster's mate or the boatswain would let out the cry "Come to the service of God" and then prowl the lower decks searching for those who would rather sleep or preferred to avoid the worship.[29] In his hand he carried the end of a rope "thicker than four fingers" for beating the recalcitrant.[30] Punishments did not end there: nonattendance could result in anything from a beating—John Farington, for example, claimed to have received fifty lashes for twice failing to attend prayers[31]—to tricing up on a sail, or twenty-four hours in the stocks. Failure to remove one's cap during the service could be equally severely reprimanded.[32]

Most of the services on board the *Jesus* were conducted by the

firebrand quartermaster William Sanders, the self-professed "greatest Lutheran in all of England."[33] Sanders bellowed out that papists were worse than Turks. He would read from the Epistles, the Gospels, and the Psalms of David, and wind up with an attack on Catholicism. Morgan Tillert remembered him lecturing that "those who went about leading the lambs astray by persuading them that they could redeem sins and so on were ravenous wolves dressed in sheep's clothing."[34]

Sanders had plenty of competition among the ships of the fleet for the mantle of "greatest Lutheran." Robert Barrett, master of the *Jesus,* was known to be a hard-line Protestant, who, according to John Perin, "all day would walk about reading the said book [Book of Common Prayer] held in his hand."[35] On the *Minion* preaching duties were shared by the captain, Thomas Hampton; the gunner Henry Quince (or Harry Quin, as he was sometimes known); and Harry Condero, who "had read many times in a loud voice from the poop."[36] On the *Swallow,* the quartermaster, Robert Hicks, led the services.[37] Others, too, made a bid for Protestant infamy: Morgan Tillert claimed that Henry Newman, Nicholas Anthony, and Francis Drake were notorious Lutherans,[38] and Drake was later to be found conducting services on the *Judith.*

[O]n Sundays the same morning and evening service as was done on the flagship with the exception that having no Bible they did not read out of it at the morning service, but that all the rest of the service was the same as was done on board the flagship and in England, and was read in a loud voice from the foot of the mainmast those on board coming on deck to hear it because they were summoned to do so.[39]

On the long dull stretches of sailing that characterized the voyage the men organized a game known as the Reverend Fathers. Often led by Robert Barrett, the men would sit around a wheel and each would be given a name: Shaven Friar, Friar Lust,

Friar Avarice, Friar Pride, Friar Fuc ("by which they meant one who went with women"), and other insulting names.[40] The game would consist of memorizing your own adopted name and saying it in the correct place, in the correct order. If one "made a mistake the others would spank his buttocks, and thus jeer at the religion of the friars."[41] This reflected the odiousness that the more dogmatic in the fleet felt toward orders of friars: whenever they came across them in the streets of the Canaries or the Americas, they would call out that they were dogs—or women, because they wore long skirts.[42]

And yet the religious divide was not clear-cut. There was, for example, some distinction to be made between the younger members of the crew, who knew nothing more than Protestantism, and the older crew members, who had lived through an uncertain and violent era in which England's official religion had switched between Catholic and Protestant with each change of monarch. The cooper's assistant Thomas Ebren, a boy of barely twelve in 1567, remembered hearing the older crewmen saying in private that "the faith held by the Spaniards was better than theirs."[43] Morgan Tillert recalled that even though rosaries were banned, he saw three or four men using knotted strings in representation of one, even though the very same men would attend the ship services like everybody else.[44] The fearsome quartermaster William Sanders would in his sermons frequently acknowledge the presence of Catholics on the ships, telling the assembled congregation, "Understand ye that there are in this vessel many bad Christians, papists, for which reason a curse will fall inevitably on the armada."[45]

One of those papists was very close to John Hawkyns. George Fitzwilliams was a committed Catholic whose faith would later allow him to play a key role liaising between the Spanish throne and Mary Queen of Scots. While the *Jesus* sat in San Sebastián on La Gomera, he surreptitiously attended mass at great risk to himself.[46]

And what of Hawkyns himself? There were many reports

that he enforced strict Lutheran practices on board, that he brought books recommended by the queen herself, and that he allowed the eating of meat on Fridays. But there were other, more intriguing hints that he was far from committed to the new creed. One crew member recalled that he rarely attended services, but could be heard walking around in his cabin while the company was worshipping.[47] John Farington considered Hawkyns to be "walking between two waters"[48] and Thomas Ebren added that Hawkyns was a good Christian because "although he did not bring images he knelt and prayed to God whenever there was a storm."[49] At the head of this very English, very Protestant enterprise sat a man who may have been deeply troubled by his own ambivalent religious beliefs, and who felt unable to step in when members of his crew carried out acts of religious vandalism.

TWENTY-ONE

The night before the fleet left the Canaries Hawkyns threw a banquet for the count of Gomera and the leading officials of the island.[1] Next morning they set sail and headed due south. It took six or seven days to reach Cape Blanco in "the country of the King of Fez," as one crew member called it.[2] Here in the small inlet of La Ensenada they found three abandoned Portuguese caravels. Not a soul stirred on land or in the ships, whose masts and sails had been stripped. One vessel was badly burned, and with nobody to pump them out, all three were gradually sinking. The Englishmen climbed aboard in the hope of finding gold and silver, but all they discovered was fish and salt. On coming upon a cross and an image of St. Peter, the German sailor John Williams threw them into the sea, shouting, "If you are a disciple of God, and this is thy image, ascend again to the ship."[3]

Although still mystified about the fate of the crews, Hawkyns decided that he should take the best caravel and ordered his men to begin repairs. In the meantime he sent small search parties into the nearby woods in search of the ships' owners and crew, and instructed others to carry out extensive repairs on the *Jesus*,

in particular to sort out the "unwatering of the English flagship which leaked considerably."[4]

As they sat at the cape they spotted two sails in the distance, and the *Judith* and the *Angel* gave chase. The next day they returned with one of the ships, a caravel from Viana do Castelo in Portugal. The ship's master was brought on board the *Jesus*, where through the interpreter, Anthony Goddard, he told Hawkyns that twenty days earlier the three abandoned ships had been set upon by French men-of-war: many of their crew had been hanged, and the rest had fled inland hoping to make it to the Portuguese outpost at Arguin. The French had stolen a fourth ship, and the fleeing Portuguese had not been seen near the vessels since. Hawkyns nodded his understanding, and then told the caravel's master that since he had found the vessels abandoned they now belonged to him by maritime law. He intended to take the newest of the three, which he had already outfitted. Since they had been left on a "hostile coast" in the land of the infidel, he would set the other two ships on fire unless the caravel master could find their original owners.[5]

Two days later, toward nightfall, the caravel master returned to La Ensenada with an old man who had been on one of the abandoned ships. Hawkyns said to him, "I have need of one of these ships to carry black slaves because I have to go to Guinea, but all of them are mine in accordance with maritime law. I will sell thee the other two."[6] The old man answered that though he recognized that the ships were forfeited by law, he had no money with which to make the purchase. It would, he added, be a great pity to burn them. Hawkyns said he could buy the ships and all of their contents for forty ducats, but he need not pay now. Instead, he gave him a bill of payment by which he guaranteed to settle his debts in London in two years. Hawkyns then began the process of taking control of the caravel: men were transferred from around his fleet to it, and repair work was finished. He gave rations of bread, meat, and wine to the old Portuguese man, and after four days the fleet put to sea once more.[7]

A T C A P E Verde in the third week of November, the slave
hunting began all over again. According to one account
the Africans here were the "best sold in the Indies of any other."[8]
Two hours before dawn on the morning after their arrival, a
raiding party of more than one hundred men slipped ashore.
The plan was to capture Africans from a village six miles inland
while the inhabitants slept: Hawkyns and Dudley leaped onto
the beach and led a rapid march into the interior, but they were
spotted, the alarm was raised, and the villagers fled. Just nine men,
women, and children were caught. Faced with an empty township,
Hawkyns ordered its complete destruction: houses and buildings
were torched, and the village was engulfed in flames that made
the dawn sky glow. Twenty-year-old Michael Soul stated that
"they burned everything they could find."[9]

At daybreak the villagers came back. They had taken stock of
the situation, mustered a force estimated to exceed six hundred,
and returned to confront the invaders. A pitched battle broke out:
harquebuses blasted Africans; arrows and darts rained down on the
English, who made jokes at the pinpricks scratching their skin.
One of the raiding party noted, "The wounds which our men re-
ceived then were thought nothing at the beginning, for the point
of the arrows made in the place they struck to the seeming of pins'
heads and our men that were hurt seemed to make laughter
thereat."[10] Nevertheless they broke into a run to their boats. Their
total haul was just eleven captives, of which they released four on
the shore "as they were thin and old."[11] The remaining seven
were placed in the newly requisitioned caravel.

The price of these slaves was quickly to become apparent. The
dart pricks may have amused the fleeing English, but the joke
was on them. Before two days were up the men began to fall ill,
and within eight or nine days they began to die weird and horri-
ble deaths: the darts had been dipped in highly toxic venom. One
man noted,

[T]hose that the arrows had pierced in the leg and other places of little danger, but the very skin, within the said two days died after such a sort that it amazed all the company. The strength of the poison was such that it caused their jaws to shut, the which when they did, there would come up into their throats such abundance of corruption after the manner of phlegm that it would stop their breath. Those men themselves would open their mouths with a wedge, and after the said corruption was cleared out, talk as heartily as they had no hurt.[12]

Still they died. Miles Phillips reported putting "sticks and other things into their mouths, to keep them open,"[13] but the death toll mounted: Robert Barrett reported that twenty-five men were killed or wounded;[14] others placed the figure at nearer ten. Among the injured was Hawkyns himself, who later recalled having "one of the greatest wounds."[15] Job Hortop, a gunner and powder maker on the *Jesus*, pointed out that Hawkyns was lucky: "Our General was taught by a Negro to draw the poison out of his wound with a clove of garlic; whereby he was cured."[16]

S OME OF the new captives told John Hawkyns of a small French fleet currently trading with African villages thirty miles away. He surmised that they could be the ships that had attacked the Portuguese caravels at Cape Blanco and that had also robbed Pedro de Ponte of his cargo of sugar. His fleet set off in pursuit, and early the next morning spotted six ships three miles off. They gave chase, and the French ships put to sea as soon as they saw the English coming, but then hove to as the ships bore down on them. As Hawkyns rounded on them one ship "clapped on all sail in an endeavour to escape."[17] The *Minion* went after her and fired a shot across her bows. She dropped back into line.

Five of the fleet were carrying ironware and other goods for bartering with Africans. These ships were crewed by Bretons and Normans, and carried letters of marque from the French

admiralty. The ship that had tried to escape was different though: she had no letter of marque and no cargo, and was a Portuguese caravel. The only things she had on board were soldiers, biscuits, and Portuguese clothing—strong evidence that she may have been the pirate ship responsible for the attack at Cape Blanco. Hawkyns negotiated with the captain of the French fleet, buying almonds, figs, and cider from him; then, turning his attention to the stolen caravel, he arrested all twenty-five crewmen and tortured the ship's captain into confessing that he had stolen Pedro de Ponte's sugar and distributed it among several of the French ships. He also acknowledged stealing the ship from Cape Blanco. Hawkyns immediately claimed it, dispersing its crew among his fleet, and placing fifteen or sixteen of his own men on the newly acquired caravel. His fleet now numbered eight,[18] but only temporarily: the next morning as anchors were being raised, a boat came out from one of the French ships with a request from her commander, Captain Planes (or Bland, as the English called him). Could they join Hawkyns's fleet and take a share of the spoils? he asked. According to John Corniel, Hawkyns was delighted and replied that "seeing that they were people who were accustomed to trade in slaves they were welcome to do so."[19]

DESPITE THEIR apparent concern for the caravels at Cape Blanco, an extraordinary level of anti-Portuguese feeling characterized this voyage. When later asked how he had expected to get paid, Thomas Bennet, a tailor who had begun the voyage on the *Jesus*, replied that it had been their avowed intention to "attack any Portuguese they might fall in with."[20] When asked a similar question William Sanders, a Cornishman also sailing on the flagship, said they would make money from trade and "from the loot they might obtain from attacking the Portuguese."[21] Such sentiments were about to be sharpened. As the Hawkyns expedition weaved in and out of African river mouths in search of slaves, there would be more fighting than trading.

While the fleet was becalmed off Cape Roxo (in present-day Senegal), time was spent taking on freshwater and attempting to entice Africans off the shore with the lure of pearls. The ploy proved unsuccessful, but as they were waiting for the wind to pick up, a Portuguese bark from the Cape Verde Islands came into view. Somewhat surprisingly the ship was not pounced upon, but was allowed to trade cauldrons and chickpeas for linen cloth with the English.[22] As they exchanged goods the Portuguese captain passed on the interesting information that not far away, up the Rio Grande and the Santo Domingo Rivers, there were many of his countrymen's caravels loading slaves to take to the Indies. Hawkyns's ears pricked up. He moved the fleet around the cape and placed his ships in the mouth of the Santo Domingo River. Unable to enter in his larger vessels, he placed the *Angel*, the *Judith*, and two pinnaces under the command of Robert Barrett. They were to be fully armed, manned by soldiers and ready for trouble. On 24 November 1567 they sailed into the river.[23] According to one English version, they sailed into the midst of several Portuguese caravels that without provocation opened heavy fire. Barrett tried to placate them, but the gunfire was stepped up. The English ships pulled in close and clambered up their sides. The Portuguese jumped ship. Onshore the fleeing men regrouped and watched as the English took over their ships. The English version of events has it that Barrett had 240 men under his command, facing 100 Portuguese backed up by as many as 6,000 Africans. The figures are surely exaggerated to aggrandize his actions, but when the *Jesus*'s master took his men ashore to march them on a nearby town, the Africans

set upon our menne ... with great battes and hatchets, dartes and invenimed arrowes, and fowght at hand strookes. The fight was cruell and 4 of oure menne were slaine by and by, and many of oure menne hurt, and thowgh many of the negros were slaine and hurt, yet they so pressed ... that oure menne beganne to geve grownd, for the negros would ronne uppon the hargabuz withowte feare

Barrett's men were routed, their retreat becoming a dash for the river and the safety of their boats; but even there as they were pushing off from the bank "a negro lepte into the water and perforce plucked an oar out of oure mennes handes, and thowghe one of oure menne shot him so into the bodye that the arrowe wente cleane throwghe him, he caryed the oare and rann with it abowte 40 paces and then fell downe dead."

When the men were out of danger, Barrett sent word of the fiasco to Hawkyns, who was "sore displeased" that so many men had been put in jeopardy. He was furious with Barrett, whose strategy he blamed: the ship's master should not have gone ashore; he should have gone farther upriver to where the king of Portugal's factor was based, and "seized upon the ships that were there." In a temper Hawkyns decided he would enter the fray, but approaching the mouth of the river in the *William and John* he found there was not enough water at the river bar to enable the ship to enter. In a fit of frustration he sent word to Barrett to come out of the river, and instructed him to bring two or three of the abandoned caravels with him. Barrett obliged, and the empty ships were added to the fleet as potential storage for the Africans they were having little luck in rounding up.[24]

Portuguese reports of events on the Santo Domingo River were more detailed, more graphic, and at times quite terrifying. Many of their accusations would later be backed up by statements made by English sailors. According to the Portuguese version, Hawkyns's fleet arrived at the estuary of the Santo Domingo River and launched "many raids and pillaged a great deal of Portuguese property. . . . The English pirates were not content with raiding and acts of pillage, but also charged out into the countryside, set fire to the fields, and plundered ivory, wax and a large quantity of blacks, and made off with many other possessions."[25]

The English, they said, committed "many acts of cruelty."[26] Three ships and three boats had entered the Santo Domingo on the night of 29 November and trespassed as far as the port of

Cacheu, the main Portuguese base and administrative center on the river. Here they were spotted by Franciscus Pirez, an inhabitant of the Azores, who sounded the alarm, jumped into his ship, and sailed away in search of a place to hide. Pirez was followed by other unarmed ships stationed off the town, but two warships owned by the factors in the town kept their position.[27] As daybreak approached, the English launched their attack: Portuguese warships opened fire on them, but following a fierce struggle they were overrun, their crew abandoning their positions "to avoid being enslaved in Britain."[28] The raiders spread across the port, ransacking and burning the town, setting fire to the fields around the settlement, murdering its inhabitants. The Portuguese claimed to have suffered losses of thirty thousand ducats in the town alone, but the rampage continued: as many as five ships were seized. The two ships that had retaliated, the *Our Lady of the Presentation* and the *St. Nicolaus,* were led away down the river, the latter having been pillaged after her "terror-struck" crew fled "the roar of the arquebuses" into the jungle.[29] Smaller ships were seized, too: Antonius Cardosus, Alvarus Gunncalves, and Fernandus Gunncalves Barrasa all lost vessels loaded with slaves, wax, and ivory, the last ship snatched as it attempted to weigh anchor and escape the melee.[30] Franciscus Pirez, who had sailed away from the trouble, found an anchorage upriver and led his men and their African captives off the ship into hiding, but the English arrived to take his ship. Pirez and some of his men were captured while attempting to remove the ship's cargo and "suffered many lashes and tortures and were then lowered onto the land."[31] To make things worse, the Portuguese captains and traders were forced, they claimed, to sign statements that they had traded peacefully and received adequate payment for their cargo.[32]

That the English acted with brutality in Cacheu is backed up by testimonies of several of their own sailors. Pablo de Leon later confirmed that torture had been used on the Portuguese to force them to reveal where they were hiding their slaves.[33] William

Collins recalled that shortly after leaping ashore they captured a group of Portuguese, and began

> *torturing six of them with ropes until they confessed that the ne-groes were concealed in a ravine, and each of the six offered 50 negroes ... to John Hawkyns, who gave them in return some mer-chandise in the shape of tinware and other things of little value, and with these they returned and before leaving that port the sol-diers of the said John Hawkyns entered into the caravels and ships lying in the said port, which form the dwellings of the Por-tuguese, because on shore they have no permanent houses as none exist, and took all the images and crosses they could find and threw them into the sea or into the fire saying that they were mere idols and papistical.*[34]

A crew member of the *Jesus,* Roger Armour, recalled that William Arnold, a gunner called Lawrence, William Williams, Richard Taunchin, and Richard Bear led a frenzied attack on Catholic images—William Arnold taking an ax to a cross marking a Portuguese burial ground.[35] The musician William Lowe also witnessed the attack, and claimed that one of his companions had overturned the cross and "hacked it to pieces with his axe, saying, contemptuously 'Christ died upon a Cross but they have too many crosses here.' "[36] Writing many years later, Job Hortop confirmed that the battle in Cacheu had been furious. He said that on the morning of the sacking of Cacheu, Francis Drake and Edward Dudley had brought reinforcements "being but a hundred sol-diers, and fought with seven thousand Negroes, burned the town, and returned to our General, with the loss of one man."[37]

DESPITE THE ferocity of this engagement, not all en-counters with the Portuguese along the Guinea coast were violent or even tense. As they approached Sierra Leone, Robert Barrett diverted up the Mitombi River in search of Portuguese to

trade with. Two years later a sailor by the name of Miguel Ribeiro remembered meeting him:

> *I was aboard a small vessel which was recruiting slaves when the said Englishman arrived with two launches brigantine-rigged, carrying thirty men more or less of whom he was in command, and coming, as he explained, in search of slaves, for which reason he came aboard two or three times.*
>
> *I had the opportunity of eating and drinking with him. I noticed that he did not cross himself and ask for a blessing on the table, either when he sat down to eat or when he got up; all he did being to cross his hands over his breast and look up to heaven when seating himself.... Every day when I was there, Barrett and those who accompanied him brought out a rush basket filled with books which they put down upon the deck of the ship, and everyone took his copy, Barrett with the rest, and they sat down in two rows and began to sing, each one with the open book in his hand. Happening to take up one of these books, I saw some of the Psalms of David therein, and at the foot of the verses and interlined a musical notation. And so they would sing for half an hour or so, and when they finished they shut up the books, and the English pilot would shout something which I did not understand, and the others would respond just as when we respond "Amen."*

Despite the apparent amity, Ribeiro disliked Barrett intensely and concluded his anecdote by saying that he "would like to see a bonfire made of all the Englishmen because they are said to be Lutherans and because they rob all those that they can."[38]

If not all dealings with the Portuguese were hostile, neither was it the case that all slaves boarded the ships reluctantly. On 14 December the ships touched at the Isles de Los off the coast of present-day Guinea. An African man approached them and said that he wished to be taken into captivity for his own safety. When asked why,

He awnswered that he was a lesser chief belonging to the King of
Zambulo, whoe ruled over a greate parte of the mayne and these
ilonds . . . and as the kings in Guynea had many wyves he had
commytted adultery with one of them. . . . [N]ow he hearde by
other of his friendes that Kinge Zambulo knew thereof, whereup-
pon they cownsayled him to shifte for his life; if the king showlde
take him he wolde put him cruelly to deathe.[39]

IN THE days before Christmas 1567, Hawkyns dispatched ships
and boats up and down the many bays and rivers along the
coast. He himself led a party of 120 men in search of King Zam-
bulo. They were looking for trade, but their efforts were largely in
vain. On 23 December the fleet came to rest and began to reassem-
ble at Tagrin in the mouth of the Sierra Leone River. An element
of desperation had crept into their operations: while Hawkyns had
been successfully gathering new vessels to his fleet with his attacks
on the Portuguese, the number of Africans he had rounded up re-
mained paltry. One estimate put it at fewer than 50, another at 150.
This was a poor return in terms of the effort and human cost and
nowhere near enough to make it economically worth crossing the
Atlantic. Hawkyns had already considered, and indeed suggested
to his officers, a change of plan: that they should abandon the few
slaves they had and head to the Gold Coast, trade for gold and, in
the words of Hawkyns, "thereby to have defraied our charge."[40]

Matters were made more urgent by debilitating levels of sick-
ness on the ships. Malaria and other diseases had taken hold, and
at Tagrin the death toll began to rise. Thomas Fowler, a gentle-
man adventurer on the *Jesus*, recalled, "While lying in the said
river a great many of the Englishmen fell sick, about one hun-
dred of them dying."[41] The Bristolian Richard Williams would
remember that

when we were off the Guinea coast picking up blackmen, we would
go on shore of a morning to labour on that which was needful, and

more than once some Englishman after walking a distance would
fall down dead without a word, whereupon our captain John
Hawkyns ordered that before setting out thus of a morning, the
doctrine should be preached to us; and for the purpose, a preacher
would go aloft in the maintop as we call it and repeat the Lord's
Prayer to us followed by other prayers used in our country, after
which they gave us breakfast.[42]

Nevertheless, despite his growing doubts, Hawkyns took the opportunity of the good anchorage to take on supplies of water and any provisions he could get his hands on. Pinnaces were sent upstream and up the Callowsa River to see if there were any Portuguese to trade with.[43] Once again the search was fruitless: a week after they had left, the boats that had gone up the Callowsa returned empty-handed, but carrying the wounds of a bizarre attack. While sailing upstream, one of the vessels, with twenty-six men on board, had been attacked by a hippopotamus and sunk. Job Hortop witnessed the incident: "In this river, in the night time, we had one of our pinnaces bulged by a sea horse: so that our men swimming about the river were all taken into the other pinnaces; except two that took hold of one another, and were carried away by the sea horse who did eat them."[44] Twenty-four men were saved, and the damaged pinnace with her sides staved in was towed back to Tagrin. According to another witness, the hippos began to follow them, "whereupon they cut off the foot of one of the monsters, having put in his fore foot which is like unto a horse's foot over into the boat that towed her and almost pulled her over therewith. . . . These monsters, by the report of the Portugals doe not only sinck boates but alsoe they have soncken caravyls that have bene 60 tonnes of burthen."[45]

Hawkyns dispatched more ships up more rivers in a last-ditch bid to get more slaves. Just when he was at the point of giving up, his luck changed. Two men arrived claiming to be the emissaries of Shere and Yhoma, the kings of Sierra Leone and Castros, which was located on the Cess (or Cestos) River.

These ambassadors told Hawkyns that their masters were involved in a protracted struggle against two other kings, Zacina and Zetecamay, and were besieging the island town of Konkaw in the Sierra Leone River. The town was built in a very warlike fashion, they told Hawkyns, "and was walled round with mighty trees bound together with great withes, and had in it soldiers that had come thither one hundred and fifty leagues [450 miles]." As many as six thousand African soldiers were inside the city walls, with many more civilians, and they were fighting off the best efforts of the two kings to capture it. The ambassadors requested that Hawkyns join the fray: if he did so he could have all the prisoners for slaves.[46]

Hawkyns was tempted: the promise of slaves was welcome, but he thought it "a hard enterprise." Nevertheless, after giving the matter thought, he agreed to a partial involvement: he would send a raiding party by river to "annoy and enter the towne," while at the same time the African kings and their men would launch an assault from the land. Hostages were exchanged to seal the deal, and at some point in mid- to late January 1568[47] a force of ninety men was sent upriver under the command of Robert Barrett.[48]

However, the encounter was not at all simple. Once again, Barrett, at the head of the English force, got more than he expected: the besieged Africans fought valiantly, and over two days of skirmishing more than twenty of Barrett's men were wounded, and as many as six of them were killed.[49] Under heavy fire, Barrett cleared his company from the field of battle, the musician Gregory Simon reporting that his "men returned fleeing from the enemy,"[50] while ship's boy John Holland was more explicit. "[T]he English contingent," he said, came back "flying from the opposing Negroes."[51]

Hawkyns decided to intervene personally. He sent forty soldiers to join the African force and gave word that the next afternoon, at the sound of a trumpet, they should again begin their assault. This time he would move out from Tagrin and they "should go to it with stomach on both sides."[52] The next day, as

Hawkyns moved within sight of the town, the besieged Africans attempted to treat for peace, but their overtures were rebuffed. That afternoon as planned the trumpet sounded and the English force jumped ashore. The going was difficult: traps of ditches covered with light sticks snared them, and envenomed darts poured down on them from loops in the town's walls. Hawkyns urged his men on, even though some had sustained seven or eight wounds. They made fire pikes and threw fireworks that landed on the palm-leaf rooftops, which exploded into flame. The town defenders sought to dowse the fire and fight on, but with the houses so close to each other the fire swarmed all around them and finally they ran for the river. As Hawkyns kept his men together, his African allies, who had yet to enter the town, broke down the walls and drove their enemies into the water. Zacina and Zetecamay escaped, but for the rest of their people a dreadful slaughter ensued. Men, women, and children were butchered in and around the riverfront.[53] According to Job Hortop, who watched the rout, "[T]he kings drove seven thousand Negroes into the sea, at low water, at a point of land: where they were all drowned in the ooze."[54]

Conservative estimates put Hawkyns's losses at at least four men dead on the day of the battle, followed by four or five more who died of their wounds in the days that followed. One witness, Thomas Bennet, said sixty perished. That estimate seems high, but it suggests that the casualties were more than minor.[55] Many of Hawkyns's allies were killed, too, including Sheri Bangi, the son of the king of Sierra Leone. Most distressingly for the English, they were forced to stand and watch as their allies proceeded to ceremonially eat their prisoners.

It was in Hawkyns's interests to stop the killing: every prisoner who died was one fewer slave. In the gruesome aftermath he had managed to capture 250 prisoners before withdrawing to a safe position above the town as night fell. He estimated that his allies held a further 600 prisoners, which by the deal he had made should have been his. However, at midnight his African allies

broke camp, setting fire to the remainder of the settlement behind them.[56] Treachery was suspected; Miles Phillips wrote that "there were taken prisoners . . . which our General ought to have had for his share: howbeit the Negro king which requested our aid, falsifying his word and promise, secretly, in the night, conveyed himself away, with as many prisoners as he had in his custody."[57]

Hawkyns was aghast at the treachery, but an explanation was on the way: the king of Sierra Leone sent word that because his son had been killed they were returning to the Cess, but that if Hawkyns or his men followed, then more slaves would be made available. He sent a ship south on their tail, and acquired by gift and barter another 150 captives.[58]

The estimates of the number of slaves the ships now held range from 400 to 600. The official line was 470 although, according to William Cornelius, "they took on board many Negroes until they could not find room for any more"[59]—and with the fleet now consisting of ten ships, including one stolen Portuguese bark, the figure must have been substantial. The situation had been transformed: there was no longer any question of not going to the Americas, but it was most definitely time to sail: sickness was sweeping through Hawkyns's men, and must therefore also have been raging through the slave decks. After final preparations that included taking on fuel and promoting Francis Drake to the captaincy of the *Judith*,[60] the ships departed Guinea for the last time. It was early February 1568.[61]

TWENTY-TWO

The crossing of the Atlantic took a grueling eight weeks, the weather playing games with them, at times becalming the ships, at others throwing up monstrous seas and storms. A number of the English crew—including the mutinous Edward Dudley—died from diseases and wounds picked up in Guinea, and without doubt there were many unrecorded deaths among the Africans. Hawkyns was moved to comment that it was "a passage more hard than before hath been accustomed."[1] As for the navigation, he could now dispense with a pilot, having picked up the routes and navigational knowledge on his previous two voyages. A gunner from the *Minion*, Henry Quince, noted that the commander of the *Jesus* "worked the chart and handled the astrolabe and cross-staff and compasses and the other necessary instruments[,] the other ships following the course he set, there being nobody else among the captains of the said ships capable of commanding the said fleet."[2] And by such means he brought the ships to the Indies at the end of March 1568.

There was a brief stopover at Dominica, long enough to take on wood and water, before pushing on to the island of Margarita, where they found the capital abandoned, its population having fled in terror to the interior. The French had stepped up their

marauding in the region in the wake of the slaughter in Florida, and Margarita had borne the full force of their wrath. Hawkyns sent one of the barks with a message of reassurance to the governor: they had come only to buy victuals and take some relaxation after the rigors of their crossing; they were peaceful and meant no harm. It was nighttime when the bark arrived, and the Spanish were not convinced at its coming. A small posse went on horseback to the shore to investigate, their leader demanding from a safe distance what the ship wanted. The messenger shouted back that they had come for meat, maize, and water, for which they were happy to pay with iron, cloth, and linen.[3]

The Spaniards took Hawkyns's letter to the island's governor. By morning, he had replied, and the relief in his letter was tangible: Hawkyns was welcome, he wrote, his ships could tarry at the island as long as they wished, and despite his being in his sickbed, he would personally welcome them ashore.[4]

At nine in the morning the fleet came into port and anchored. Onshore a large party of Spaniards waited on the quayside to greet them: at their head was the governor, who, despite being clearly very ill, insisted on giving Hawkyns and his officers a tour of the town.[5] The looting of the French was evident everywhere: one account talks of the town being "in a manner all spoiled and many houses burned."[6] William Collins was shocked by the burned-out church, and the interpreter from the *Jesus*, Anthony Goddard, who strolled around town with a group of locals, recalled seeing "scrawled in charcoal on the wall of a house a phrase in the French language, which tongue he understood very well, "Vengeance for La Florida."[7] In an attempt at crowd pleasing, John Hawkyns vowed to "kill or arrest the Frenchmen responsible";[8] despite, or possibly because of, this threat, the English stay in Margarita was a pleasant, relaxed affair of onshore and offshore banqueting and drinking with their Spanish hosts. The ships remained for nine days, during which time they took on wild boars, oxen, sheep, sixty measures of maize, and sugarcane. Cloth and linen were traded for gold, and out of charity

Hawkyns, showing a surprisingly humane side to his character, even gave away some fabrics to two of the poorest Spanish women on the island.[9]

T HE SHIPS reached Burburata on the eve of Easter—17 April 1568—to find that the French had beaten them there again and laid waste the town. Nicolas Balier had burned the church, destroyed many of the houses, and terrorized the people, and had remained in port for three months. From here he had launched an attack on Coro, the seat of Spanish government, and forced Governor Pedro Ponce de Leon and his family to flee for their lives. Little wonder the settlers were apprehensive, and no surprise they had run away to Valencia on the first sight of Hawkyns's sails. Just two men remained in town: Luis de Savallos and a younger, unnamed relative. These men bought goods from the English, and also agreed—for the reward of an African woman—to go to their fellow settlers to encourage them to come back and trade.[10]

As a result, the people began to dribble back in small groups. Trades took place: small stalls were erected on the waterfront, and guards were placed over them at night to make sure that neither the Spanish broke in nor the Africans broke out. In the meantime, Hawkyns wrote to the governor, now at Santiago de Leon, requesting a license to trade. Once again he played the role of the accidental slave trader, driven to the West Indies by misfortune. He requested the opportunity to sell just sixty of his African captives and a parcel of his cloth, and asked the governor to consider coming to Burburata.

This voyage on the which I was ordered by the Queen's Majesty of England, my mistress, another way and not to these parts, and the charges being made in England, before I set sail the pretence was forcibly overturned. Therefore I am commanded by the Queen's Majesty my mistress to seek here another traffic with the wares I

*already had and Negroes which I should procure in Guinea, to
lighten the great charges hazarded in the setting out of this navy.*[11]

Hawkyns knew that it would be several weeks before he re-
ceived a reply, and he took full advantage of the breathing space.
One by one his ships were careened and trimmed. Water supplies
were replenished, and wood was chopped in the hills around
town for use in crossbows and arrow.[12] One unfortunate John
Breton, a carpenter and soldier from the *Jesus*, accidentally
sliced off his left thumb with a hatchet while cutting a log.[13]
Some of the men, according to later testimony by sailor George
Riveley, even surreptitiously joined the locals at mass, though
many "did not know how to cross themselves nor what to do, al-
though the witness believes that the Old Englishmen who came
here were good Catholic Christians but not the young men."[14]

It was brought to Hawkyns's attention that there was in Va-
lencia an influential bishop who might be able to help them, not
only with revictualing their ships, but also in garnering influ-
ence with the governor of Venezuela. Hawkyns set out to make
him an ally, perhaps once again casting some doubt on his reli-
gious allegiance. He sent the bishop a letter asking him to sell
him one hundred oxen and grant him a license to sell sixty
slaves. He also called on the bishop to use his influence: "I be-
seech you to be a means to the governor," Hawkyns wrote, "all
that you may that my request to him may take effect, and any
thing that I may pleasure you in you shall command it, the which
you shall have the better proof of it you would do me so much ho-
nour as to visit me in this port."[15]

The amiable old bishop was suffering from ill health and un-
able to come to Burburata, but he sent word that he would "do
what I may therein to cause the licence be granted."[16] Hawkyns
sent him a present of twelve silver spoons and two Africans, "the
dearest in the market."[17] A few days later they were returned
with kind thanks, coinciding more or less with a reply from the
governor. As Hawkyns had expected, it was negative. Ponce de

Leon wrote that to say no caused him "a great grief," but that "before my eyes I saw the governor my predecessor carried away into Spain for giving licence to the country to traffic with you at your last being here, an example for me that I fall not in the like or worse."[18]

On hearing of the governor's prohibition, those colonists who had come down to Burburata to trade began to drift away. Before departing, however, one of them persuaded Hawkyns that a show of force against Valencia could produce positive results. Once again Robert Barrett was put at the head of sixty men and sent to feign an attack against the hillside town. The roads were treacherous: heavy rains had muddied the dirt track, and progress the twenty miles inland and uphill was slow. On the way they came across "a monstrous venomous worm with two heads. His body was as big as a man's arm, and a yard long." Barrett cut it in two and the creature turned ink black.[19] By the time the force had reached Valencia, the alarm had been raised and the town had been evacuated. Even the bishop had gone; the only man who remained was a sick priest, who pointed them in the direction of refreshments that the bishop had left for them in his house. Barrett and men returned to the ships, taking with them a roost of stolen chickens.[20]

With the careening nearing completion, the English stay in Burburata passed the month mark. Hawkyns was now actively preparing for departure, and ordered three ships to Curaçao to buy and dry enough beef and mutton for the homeward journey. Others were dispatched to Coro, where, he speculated, the governor's absence might make trade possible. Hawkyns himself lingered in Burburata until the beginning of June: despite the prohibitions there were still enough furtive nighttime trades in slaves to keep him in port. A young man from the town, who had himself bought more than twenty slaves, was taken onto Hawkyns's books to act as a guide along the South American coast; and shortly before leaving, letters of favor arrived from the bishop in Valencia, which Hawkyns thought might be useful at other Spanish settlements.[21] With the bishop in hiding and under no coercion, this once again

hints at the levels of collusion Hawkyns had been receiving or expecting to receive in the colony.

Shortly after Hawkyns pulled out of Burburata, the town was abandoned for the last time: sickened and exhausted by the constant attention of foreign corsairs, its inhabitants either moved to the remoter and safer Valencia or sought a more protected site farther along the Venezuelan coast.[22]

T HE PLAN was now to head back to Rio de la Hacha, and the English fleet reconstituted itself off Curaçao, where there was another example of the aggressive misbehavior that had come to characterize this voyage. At the entrance to the island's main port, Thomas Pollard, a quartermaster on the *Jesus,* jumped ashore and demolished a large cross that stood at the water's edge. The vandalism complete, he climbed back into his boat, to the cheers of those around him.[23]

After the fiasco of Lovell's dealings in Rio de la Hacha, Hawkyns sent Drake ahead with the *Judith* and the *Angel* to test the waters. Rather than risk entering the port, the two barks rode out at sea and sent a boat in with a request for permission to collect freshwater. Instead of assent, the reply was a hail of cannon and harquebus fire. One of the men in the boat was killed. The English ships fired a broadside that pulverized the roof of the governor's residence. Drake then pulled the ships out of range and sat out at sea, menacing the port for five days.[24] When a dispatch vessel from Hispaniola pulled into view, he chased it down and forced the crew to flee for their lives. There was nothing of interest in the dispatch vessel except glasses and crockery made by the Indians of the region, but the people of Rio de la Hacha nevertheless opened fire, and in a short gun battle the English lost three men, including a sergeant major, with another man wounded in the thigh.[25]

Hawkyns and the remainder of the fleet came alongside on 10 June. He was still smarting from the town's treatment of Lovell

in the previous year: he felt that the treasurer, Miguel de Castel-
lanos, had made a fool of him; after all, Hawkyns now revealed,
he had even received orders, including cavalry saddles, from Rio
de la Hacha while in London.[26] That Castellanos had made
things tough for Lovell and refused to buy from him was unfor-
givable. It had cost Hawkyns as much as twenty thousand pe-
sos.[27] Nevertheless, his first approach was friendly: he sent
presents in to the treasurer, along with a letter in which he par-
tially blamed Lovell for the misunderstanding between them. "I
cannot lay the fault so much the less upon you," Hawkyns wrote;

> *I blame not much more the simpleness of my deputies who knew
> not how to handle that matter.... The Negroes they left behind
> them I understand are sold and the money to the King's use, and
> therefore I will not demand it of you. This I desire, that you will
> give me licence to sell 60 Negroes only, towards the payment of
> my soldiers, to help to lighten the charges of this voyage, which
> was appointed to be made otherways and to none of these parts.*

He concluded with a gentle warning: "If you see in the morn-
ing armed men aland let it nothing trouble you, for as you shall
command they shall return aboard again."[28]

However, Castellanos was in a bullish and confident mood.
Whether stung by the punishment he had received from the
Spanish authorities after the last Hawkyns visit, or fearing
reprisals for his handling of Lovell, he was no longer able or ready
to negotiate. Twenty men had rowed ashore to deliver the mes-
sage, and while they sat waiting for a reply or busied themselves
collecting water, gunfire shattered the silence around them. One
man was shot dead; the others scattered to the boat, which pulled
swiftly away.[29]

Startled by this response, Hawkyns sent ashore Anthony God-
dard, his most fluent interpreter, with another conciliatory mes-
sage. Castellanos refused to read it. Instead he threw the
gauntlet down, sending back the boastful reply that he had more

and better soldiers waiting to tackle the English if they so much as touched land.

At sunrise the following day, Hawkyns accepted the challenge. He landed four boats two miles from the town. They carried more than two hundred men clad in armor and carrying swords, harquebuses, crossbows, pikes, halberds, and arrows.[30] Near their point of disembarkation a small welcoming party of the treasurer and twenty men on horseback watched them: the Spanish kept their distance, and replied to a demand to trade with a defiant "[D]o what you think you must."[31] Hawkyns obliged: forming his men into ranks, he marched them along the road in the direction of the town. The Spanish horsemen followed behind—never threatening, just enticing. After a quarter of a mile, the English spotted a rapidly constructed bulwark, across which was spread the treasurer's ensign. Behind it, in battle formation, were ninety Spaniards with harquebuses, a contingent of African slaves, and a great many Indians with poisoned darts. A volley of harquebus shots blasted out. Fighting erupted around the rampart, and two English soldiers fell dead.[32] The Spanish would later claim they had killed thirty men: Castellanos, in his own words, "disputed his passage as fully as I was able. . . . I inflicted serious damage on him."[33] Two more Spaniards, Lazaro de Vallejo Alderete and Hernando Castilla, reported that it was as "fine and valorous a defence as has ever been made in these Indies."[34]

The truth was less glorious: the first volley had hurt the English—several men were wounded in addition to the dead—but had merely caused them to accelerate their advance. As swords were pulled from their scabbards, the Spanish abandoned their positions. The hand-to-hand skirmishing around the earthwork was minimal; the way to the town was left open, and the pursuit was rapid. The Spaniards left the path and fled into nearby woods. One man was caught and made prisoner, being transferred out to the *Jesus*, where he remained for three days.[35]

At a slight distance from the English ranks, a horseman appeared with a white linen cloth flapping from a lance. Hawkyns

sent the man he had taken on board at Burburata to find out what was wanted, and to repeat the demand to be allowed to trade. Word came back that though Hawkyns was now in control of the town, Castellanos would die in the field before permitting any trade to take place. The messenger was sent back with the stark threat: trade or watch as your town disappears in flames. Castellanos remained resolute and obstinate. His answer was a grandly worded gesture of defiance: even if he "saw all the Indies afire he would give no licence."[36]

It was not long before he saw that fire, for soon smoke began curling above Rio de la Hacha, and then flames erupted that reached to the sky. Whether deliberately or otherwise, Hawkyns had put the town to the torch. House after house burned to the ground. Some would later say that Hawkyns knew nothing about it, and was very annoyed. Others said that he ordered twenty of the older houses to be put to the torch as a threat. One report insisted that he had wished to make a show of one house being burned, but the house being made of dry straw, the blaze ran out of control.[37] Various witnesses blame the Frenchmen in the party, but Thomas Bennet claimed the arson was an act of revenge for the killing of the sergeant major.[38]

The fire may have been an accident: the English lodging in the deserted town overnight had found six pipes of wine—630 gallons. Much drunkenness followed, and according to one report the blaze began when intoxicated attempts were made to cook a couple of scrawny chickens on an open fire.[39] According to the gentleman adventurer Richard Temple, who had witnessed events, Hawkyns "held an enquiry as to who had lit the fire and how the huts came to be burned, and threatened to hang half a dozen of them, but learning that they were drunk when they lit the fire did not put his threat into execution."[40]

The arson was accompanied by widespread vandalism and looting. The crew turned their attention to the church, where they tore down brocades, ransacked the organs for silver components, and pulled down and burned all of its religious images.

The leaden baptismal font was smashed and carried back onto the *Jesus,* the altarpiece was stripped, and in what could only be a bizarre religious statement, horns were placed on the altar and the building was fouled. One of Hawkyns's pages, John Perin, would later recall that

> *Pablo de Leon and Pablo de la Cruz [Paul Hawkins] ... boasted of having entered the church and hung horns in the pulpit where the sermons were preached and defiled the pulpit which they re-lated openly on board the ship when they returned, and he had seen two carpenters ... bring on board the leaden font in which the infants were baptised claiming credit for having taken it from the church and smashed it.*[41]

Hawkyns was incensed at the damage to the church, threat-ening to punish those responsible and demanding the return of all stolen property. He told a Dominican friar who visited him over the course of the next few days that "he lamented that things had been done which he confessed had been ill done, but the damage should be paid for, and that this was done."[42]

Out in the countryside, the rampage also failed to impress Castellanos, who sent down a scornful note that "the fire pleased him well . . ."

> *for our general did him no sort of hurt therein, and for the houses that he had burned, if he had burned the town altogether the King of Spain, his master would build it again for the inhabitants much better than before at his own charges, and that the longer he stayed in the place it should be the worse for him, for he would so prepare for him that he should wish himself elsewhere.*[43]

D ESPITE CASTELLANOS'S vigilance, some trading in slaves managed to go on under the cover of dark. Hawkyns used these cloak-and-dagger meetings to tell every trader and

every messenger who came to see him that the treasurer was working in his own interests, that his actions were punishing the townspeople, and that Hawkyns would seek him out wherever he was and force him to grant a license.[44] Two days after taking the town, Hawkyns brought ashore two field guns on their carriages and began scouting the countryside around Rio de la Hacha. The search turned up little more than the treasurer's ensign, and the news that Castellanos was employing a scorched-earth policy, burning the fields, crops, and farmhouses, and driving the livestock farther into the interior. Hawkyns was infuriated. He ordered the immediate destruction of the governor's residence and the remainder of the surviving houses, leaving just enough shelter for his men. He also sent word to Castellanos that from now on Spaniards, who were frequently glimpsed in the distance on horseback, would be the object of target practice for his guns.[45]

AMID ALL the business of pinning the Spanish down, this was a time of relaxation for many of Hawkyns's company, and a chance for macabre entertainment. A large alligator was spotted swimming in the Hacha River, and at sunset Job Hortop and several of his colleagues went on a bizarre fishing trip.

> Seven of us went in the pinnace up the river, carrying with us a dog, unto whom, with rope yarn, we bound a great hook of steel, with a chain that had a swivel, which we put under the dog's belly, the point of the hook coming over his back, fast bound as aforesaid. We put him overboard, and veered out our rope by little and little, rowing away with our boat.
>
> The alligator came and presently swallowed up the dog, then did we row hard until we had choked him. He plunged and made a wonderful stir in the water. We leapt on shore and hauled on land.[46]

The beast was twenty-three feet long, according to Hortop, with feet like those of a dragon, scales as broad as saucers, and "knots as big as falcon shot." They cut it open, dried the skin, and stuffed the carcass with straw, meaning to carry it home as an exotic and possibly valuable trophy. Hortop was in awe of the creature, adding for effect, "These monsters will carry away and devour both man and horse." And sometimes the alligators did get their revenge: Christopher Bingham "was washing his feet in the river from a boat when he was bitten on the leg by an alligator receiving a nasty wound which confined him to the ship. . . . [H]e was laid up for a month from the injury."[47]

O N T H E English party's fifth day in Rio de la Hacha, two men walked into town. Pedro, an African slave of Miguel de Castellanos, and a mulatto relative were taken to Hawkyns on the *Jesus*, where they made him an offer: if he would grant them their liberty and carry them away from Rio de la Hacha, they would take him to where the Spanish were hiding their clothes, valuables, and munitions. It was too good an opportunity to miss, and Hawkyns jumped at it. Hawkyns promised them their freedom, and allotted sixty men to go with them that night. Three hours before dawn they found what they had been looking for on a plain six miles away: Castellanos's tent camouflaged by bushes and in it four disheveled and sick families, a few of their slaves, a large pile of valuables, and the town's treasure chest.[48]

One of the Spanish men there was sent back to Rio de la Hacha, where Hawkyns questioned him in the presence of the man from Burburata and the prisoner taken earlier in the week: Why would the treasurer not give him a license to trade? Had he ever done them any harm? Was it not true that they had traded successfully in the past? The man responded frankly:

The treasurer was a man of greed and without conscience and cared not what mischief he caused to be done unto others, being sure himself to lose nothing but to gain very much by this he had done, and that all the Spaniards were willing and desired in their hearts to traffic for the gains they would all get thereby, but for all they could do they could never cause the treasurer to give his consent thereunto.[49]

Hawkyns rounded up one hundred men and marched them briskly to the hideout. When they arrived they found that there had been several skirmishes, but his men were in command of the situation. He ordered all of the captured valuables to be loaded into two large carts and carried back to the ships. He then asked the Spanish prisoner to go to Castellanos and make it clear to him that if he did not grant a license to trade, the fleet would sail away with all of the town's riches.[50]

But on receiving the news the treasurer remained unwilling to comply. Along with the rest of his people he listened as the Spanish messenger told how all of their goods had been seized, how they would be taken away, and how Hawkyns had promised to kill those that he found at the tent. There was dismay among the gathering, but Castellanos was furious. He lambasted his colleagues, painting a colorful and almost satanic vision of an English captain in the act of blackmailing them: "There is not one of you that knoweth John Hawkyns. He is suche a manne as that any manne taulking with him hath no power to deny him anything he dothe request." Such was Hawkyn's power, Castellanos warned, that anybody listening to him might be in danger of putting the Englishman's interests before those of the king of Spain. However, restlessness spread through Castellanos's audience. They heard and understood what he was saying, but they wanted the situation resolved. Demands grew into a clamor: Hawkyns was offering a safe-conduct for talks, and the treasurer must at least go to see what was being offered. They risked losing too much.[51]

THAT AFTERNOON Hawkyns and Castellanos met out of earshot for over an hour on a hill overlooking the plain, their respective armed guards standing back, a crossbow's shot apart. The settlement they agreed to was simple: Hawkyns was given a license to trade and four thousand pesos of gold, which though not expressed in these terms may have been compensation for the losses of Lovell. Sixty Africans would be handed over to the treasurer as payment for the damage in the town, and Castellanos agreed to buy a further twenty slaves for himself for one thousand pesos. All the confiscated goods in the carts would be returned. In the cruelest twist of the deal, Hawkyns reneged on his agreement with the guides Pedro and his mulatto kinsman, handing them over to Castellanos, to be made an example "to all the rest on this coast." Pedro was hanged, drawn, and quartered; his relative was hanged.[52]

The deal was kept secret for the moment. Castellanos returned to his people and made a great play of defiance before gently acceding to the settlers' persistence. Word was sent to Hawkyns that the colonists were ready to agree. The two men met publicly and embraced, the cartloads of valuables were handed over, and Hawkyns returned to the coast.[53]

The slave market opened the very next day, and it was as if nothing had passed between the two sides. To mark the opening Hawkyns handed Castellanos a pearl-studded velvet cloak with gold buttons,[54] and a gown of taffeta lined with martin. The treasurer reciprocated with a woman's girdle of large pearls.[55] The ship's band struck up, and trading began. Over the next two weeks, boatloads of Africans were ferried ashore, and more than two hundred were sold, along with a large quantity of linens and cloth. They were paid for with gold, silver, and pearls: some claimed Hawkyns made as much as thirteen thousand ducats. As promised, captives were handed over for the damage to the town, and it seems that Hawkyns decided to be generous, increasing

their number to seventy-five.[56] For his part, Castellanos would later claim that "there was not a slave worth anything at all," that they were "dying on his hands" and consisted of old men and infants at their mother's breast. They had needed expensive care before being fit for auction, he added, and he had taken them into his household to prevent Hawkyns from throwing them overboard.[57]

TWENTY-THREE

After a night and a day's sailing, the English fleet came into the roadstead off Santa Marta just after dusk. This pleasant little town was the first Spanish settlement on mainland South America. Founded by Rodrigo Bastidas in 1525, it was situated on the edge of a group of beautiful sandy beaches looking out across the Caribbean. Work had started on building a cathedral there in 1531, but by the time Hawkyns pulled in, the town was dying: there were no more than twenty-five households in the settlement, with a few itinerant workers, and a substantial number of African slaves and Indians in *encomienda*. Incessant pirate attacks had been made doubly worse for the colonists by the presence of hostile Indians in the area.[1]

In spite of the hour, Hawkyns sent a letter to the provincial governor, who resided in the town: "I brought out of Guinea certain Negroes, the which I had there by traffic. To help to lighten the charges of this voyage which was determined, I have in a manner sold them all saving a few. I beseech you, being as they are a small number that are left, you will licence me to sell or truck them here."[2] The messengers stayed overnight in the town, returning at nine the following morning with an invitation for Hawkyns to meet with the governor at ten.

When the English captain stepped ashore, he noted that the town was too small to cause him any great problem if trouble broke out. But such calculations were unnecessary: the governor said that all he required from the English was a show of strength and the burning of one hut, and the license was theirs. He even pointed out an appropriate hut to burn.[3] Shortly after the interview, Hawkyns returned to the *Jesus*. One hundred fifty armed men were ordered into the boats: a short burst of cannon fire echoed out from the town, and ten shots were fired back in response.[4]

An advance party of two men landed and put a torch to the dilapidated hut. The building went up in flames, and the people of the town made a show of fleeing for their lives. Hawkyns and the main contingent of men followed hard on their heels, entering the town, clad in armor. They marched into the marketplace, where a man waving a white flag greeted them with the information that the governor was awaiting them at the town's end. The meeting of the two men was brief and cordial: not only was the governor willing to hand over a license to trade, he was also happy to set aside a warehouse where the Africans could be housed while they waited to be sold.[5]

The next fourteen days were filled with relaxation, entertainment, present giving, and banquets of fresh beef and good wine, both in the town and on the ships.[6] George Fitzwilliams would later remember "the best of feeling prevailing between the people of the island [Santa Marta] and those of the fleet."[7] Trade was brisk, the locals purchasing more than one hundred slaves as well as other goods, paying in gold, silver, pearls, and reals. Hawkyns even paid the duties owed to the royal tax gatherer who resided in the town.[8] According to Thomas Fowler, on board the *Jesus*, another twelve thousand to thirteen thousand ducats were added to the fleet's coffers.[9]

On 26 July the fleet moved off in the direction of Cartagena, where six days later they announced their presence by firing a series of salvos. The city responded in kind.[10] Cartagena was the

most important Spanish city in South America, the treasure house
of the plundered interior and a major staging post for the silver
fleet returning the booty to Spain. This was a city too large and too
well defended for Hawkyns to contemplate assaulting, or involv-
ing in a charade like the one just acted out at Santa Marta. There
were more than 250 households in town, and a company of horse-
men accompanied by 500 well-armed Spaniards, their slaves, and
up to 8,000 Indians was ready to repel any attack. At the same
time, English numbers were falling fast: the source that had
counted 408 men in Plymouth now calculated that there were
370. Since the original accounting had been made, two French
crews had been added to the complement. Conservatively estimat-
ing that the Frenchmen numbered as many as 70, that left still
alive just 300 of those who had departed Plymouth. More than 100
men had succumbed to African darts, Portuguese resistance, tropi-
cal disease, hippo attacks, and Spanish gunfire. Wisely, therefore,
Hawkyns entered cautiously into the wide haven of the Boca
Grande: he was aware of the need to behave, but he still had more
than 50 Africans to dispose of before the journey home could be-
gin. In his customary way, he wrote to the governor requesting
permission to set up a stall.[11]

As Anthony Goddard carried the message ashore, Hawkyns
prepared presents as sweeteners,[12] but the governor was not only
unwilling to contemplate Hawkyns's offer, he was belligerent.
Goddard was met with short shrift. The stony-faced governor re-
fused to read the letter: news of the meddlesome Hawkyns had
preceded him, and the authorities in Cartagena were not going
to deal. The governor spat at Goddard that "if he had not come
as a messenger he would punish him severely," then "ordered the
two townspeople who had brought Goddard before him thrown
head first into a ditch."[13] Goddard begged the governor to take
the letter, but he refused to receive it and silenced the visitor. His
advisers stepped in and suggested that he should at least take a
look at it. The governor read it and scribbled out a quick reply:
Hawkyns was an enemy of the king of Spain, and he should

depart immediately or face the consequences. He gave word that no more messengers would be received, and that was the end of the matter.[14]

The situation was clearly not worth pressing: Hawkyns sailed the *Jesus* and the *Minion* within firing range of the town, and sent the smaller ships hard under the fort to see if he could precipitate any action, or a climbdown from the city. Neither was forthcoming, and Hawkyns sent one last message ashore expressing his regret at the poor reception he had been afforded. As an act of petulance the *Minion* primed her cannons, and there was a brief flurry of gunfire as the fleet sailed away.[15]

Time was closing in rapidly on the fleet: they had to get out of the region quickly or face a season of hurricanes that could shred their ships. Before they could leave, however, they had to take on board provisions for the long journey home. Stocks were running low, and any hopes for resupplying at Cartagena had now been dashed. The young man from Burburata said that he knew of an island standing slightly off from the city where there were orchards, a pleasure garden, a large pool of water, and a good well. The inhabitants of Cartagena would come here for a stroll or a picnic. That night four pinnaces pulled up to the island and disgorged fifty men.[16] John Perin would later say that they had ransacked the island, but it was more complicated, and less serious, than that.[17] The men came to the estate of Geronimo Rodriguez, which was currently being watched over by two of his servants. There were two small houses, and at the back of one a cave in which were stored demijohns of wine and oil: Hawkyns's men helped themselves to over one hundred of the containers. They also took one hundred measures of maize. It was no quick operation: the provisions had to be ferried out to the larger ships, and water butts had to be brought ashore to be filled. They spent a week on the island, ensuring that they had enough to get home with. It was not exactly robbery, since they paid for everything they took with a bale of London cloth, another of Rouen linen, and a number of kerseys and sailcloths worth three hundred

ducats, but Geronimo Rodriguez had no choice in the matter. His servant was given a receipt, and on the eighth day the ships weighed anchor and turned in the direction of England.[18]

Hawkyns hoped to make haste. He still had Africans in the holds of both the *Jesus* and the *Minion*, but they would have to be used to trade for provisions on the way home, sold in London, or brought back on his next expedition. Not far out to sea the wind dropped, and for two days the fleet was becalmed. The lull gave an opportunity for rearrangement and streamlining. Following the pleading of several Frenchmen, Hawkyns announced that they did not have enough food and drink for everybody: he removed all of the English crew from the French pirate ship captured off Cape Verde, and then restored its original company. With little ceremony they were freed to fend for themselves.[19] The other French ship, the *Grace of God* under the command of Captain Bland, continued in the fleet. Finally, Hawkyns ordered that the Portuguese bark taken in the battle at Santo Domingo be stripped of everything that was serviceable—she was weak and slowing their progress—and sunk. The fleet was now just eight strong, and ready to cross the Atlantic one more time.[20]

TWENTY-FOUR

The season was getting late and storm clouds were collecting on the horizon. As Hawkyns sailed for the Florida Channel and the open Atlantic, he was headed for a region that could in the summer be subjected to the most violent storms: hurricanes and tornadoes crumpled the waters and could lead to the suspension of shipping for weeks on end. The eight ships rounded the west end of Cuba, so close to land that Anthony Goddard said "they could smell it."[1] And then on 22 August a storm hit, providing a terrible symmetry to the voyage's opening days. Fierce gales and turbulent seas battered the fleet; the shallow waters threatened shipwreck and drowning. The *Jesus* began to break up and was "not able to bear the sea longer, for in her stern on either side of the stern post her planks did open and shut with every sea, the seas being without number, and the leaks so big as the thickness of a man's arm, the living fish did swim upon her ballast as in the sea.[2]

Hawkyns barked out orders to stop the leaks. The raised poop of the *Jesus* and its forecastle were cut down, the ship's rudder was shattered; Goddard later confirmed that she "made so much water that fish were killed in her pumps."[3] Miles Phillips recalled,

"Our ships were most dangerously tossed and beaten hither and thither, so that we were in continual fear to be drowned."[4]

As the storm rolled on, Hawkyns contemplated abandoning ship, but hung on, fearing the disgrace of giving up a royal vessel to the sea. At the height of the storm, one of his own ships, the *William and John*, disappeared, presumed perished. The small fleet took the wind, turned around, and scoured the shoals and coastline for a decent berth, but when the gales dropped and the rain halted, their anxiety only grew: the *Jesus* needed major repairs, they were running short of food and water, and they desperately needed time to lick their wounds. They stumbled around for days, lost, without a pilot in unfamiliar territory, wondering what to do. On 11 September they found themselves in the Gulf of Mexico, drifting aimlessly near the Arrecifes Triangulos, a small group of reefs off the Yucatan Peninsula,[5] when two sails were spotted in the distance. Hawkyns sent the *Judith* and the *Angel* in pursuit, and though one ship escaped, a cargo vessel carrying wine from Hispaniola was overhauled, and her captain, Francisco Maldonado, was brought onto the *Jesus*. Hawkyns interrogated him: Where was he from? Where could they find succor? Where was the best port for them to sort out the problems with their flagship? Maldonado replied that he had just departed from Campeche and was now headed for San Juan de Ulúa, the port of Veracruz—the principal port of all of the Gulf of Mexico. This was the best place for Hawkyns to carry out his repairs, he said, but it was more than two hundred miles away, and worse still, the annual treasure fleet from Spain was due any day. But Hawkyns saw no choice: he ordered Maldonado to remain on board the *Jesus* and dragged his pilot, Bartolome Gonzalez, onto the ship as well. With the Spanish bark in tow they set off for San Juan de Ulúa.[6]

The journey took four days. On their way the English overtook and commandeered two more ships carrying honey, beeswax, mastic, and more than one hundred passengers, who Hawkyns hoped would be a "means to us the better to obtain victuals for our

money, and a quiet place for the repairing of our fleet."[7] Among
their number was Agustin de Villanueva, one of the richest men in
all New Spain (Mexico), who had recently helped suppress a re-
bellion there. He had been on his way to receive a reward from
Philip II in Madrid when illness forced him back.[8] Hawkyns took
great account of him, permitting him to eat at the captain's table,
treating him like the noble that he was.[9] All the ships would sail to
San Juan together so that none could raise the alarm.

O N 1 5 September 1568 the port came into view. For those
expecting to be impressed by the greatest port in Spanish
America the experience was no doubt underwhelming. San Juan
de Ulúa was barely an island, more a reef of shingle, "a little island
of stones," as cabin boy Miles Phillips described it, "not past three
feet above water in the highest place; and not past a bow shot
over."[10] The island, which sat just a quarter of a mile from the
mainland, had been discovered for Spain by Juan de Grijalva in
1517 while he was exploring the Mexican coast for Diego Ve-
lasquez, governor of Cuba. It was the only natural opening on the
whole coast where large ships could shelter, so this small, unas-
suming hummock had been pivotal in both the conquest of
Mexico[11] and its future economic well-being. The island could be
approached by channels from the north and south, but special
care was needed to avoid dangerous rocks submerged just below
the surface and exposed only when the tide was low. Barely 250
yards long, it had trouble accommodating twenty ships at the same
time, but by 1568 a large, strong wall stretched the full length of
the side fronting the land, and to this ships could dock head-on to
the island. At the eastern end of the wall was an uncompleted bul-
wark; at the western extremity was a small platform.[12]

Ships stopping here had to remove their rigging, and tie them-
selves down with as many as six cables to avoid swinging danger-
ously. Fierce northerly winds raced across the exposed banks of
the island, sometimes lifting roofs off houses and dumping boats

on land. It was not a place designed for lingering: facilities were basic, and there were few buildings. At the heart of the island was its biggest structure, the Casa de Mentiras, which functioned as an arsenal. There was also a small church, a customhouse, a few wooden houses for the garrison, warehouses for temporary storage, and a couple of big huts for the slave workforce. The island's permanent population consisted of a garrison of 50 soldiers, 150 African slaves employed in loading and unloading ships as well as repair work on storm damage, and the government authorities. In 1568 these consisted of Anthony Delgadillo, the captain of the island; Martin de Marcana, the deputy mayor; and Francisco de Bustamante, the king's treasurer.[13]

The town that San Juan de Ulúa served sat fifteen miles north on the Veracruz River. Small boats carried the goods unloaded at San Juan to this hot, dusty settlement, humid enough that it was said to rust iron in two days. There was a church in Veracruz but no monastery, three hospitals, houses of wood, and a permanent population of six hundred African slaves, yet it existed only at the convenience of the annual treasure fleet coming from and going to Spain. From September to March it was home to four hundred factors, the agents of rich merchants in Mexico City. The streets, warehouses, and quaysides thronged as cargos were loaded, unloaded, and dispatched. But the air was unwholesome and the town inhospitable. John Chilton, an Englishman in Mexico in the 1560s, wrote,

> *There is never any woman delivered of child in this town; for so soon as they perceive themselves conceived with child they get them up into the country to avoid the peril of the infected air: although they use every morning, to drive through the town about two thousand head of cattle, to take away the ill vapours of the earth.*[14]

For this reason the city emptied as soon as the work with the fleet was over, the merchants and their families moving inland

to the altogether more healthy climate of Xalapa. From April until the end of August Veracruz was a virtual ghost town.

On 15 September both San Juan de Ulúa and Veracruz were waiting for their work to begin. The treasure fleet that once a year came to collect the gold and silver of Mexico and the New World had been spotted off the Yucatán and was expected any hour. That night the royal officials of Veracruz gathered at San Juan in anticipation, and the next morning at just before noon there was great excitement when sails were spotted on the horizon. Francisco de Bustamante and Martin de Marcana jumped in a skiff and sailed out to greet the fleet and take from it the letters and dispatches of the king of Spain.[15]

Three miles out Hawkyns saw them coming: he ordered the flag of St. George to be kept out of sight, and noted that the queen's arms flying at the top of the masts on both the *Jesus* and the *Minion* were so faded by foul weather as to be indistinguishable. The Spanish sailed right into the heart of a trap, and the moment they realized their mistake, Hawkyns ordered their arrest. On board the *Jesus* he told the dismayed Bustamante and Marcana not to be afraid, as he came in peace.[16] All he needed was victuals and a place to repair the *Jesus*. They would be released soon.[17]

Hawkyns's cautious deceit continued. As the ships docked, Anthony Delgadillo ordered the firing of a welcome salute from the shore, and Hawkyns responded in kind.[18] Only then were the English flags spotted by the Spanish onshore: panic broke out, and people fled in all directions, running from the port. There were eight other ships tied up on the island—carrying, it was said, two hundred thousand pounds sterling in gold—and as soon as news of the English reached them, their crews could be seen bolting.[19] Spaniards and Africans jumped into boats and scuttled to the mainland. Delgadillo quickly tried to muster a rearguard action, but found himself deserted by the whole garrison except eight men.[20] Within hours word of the English arrival reached Veracruz, sparking rioting and looting, as the dispossessed seized their opportunity to grab their masters' valuables. Luis Zegri,

the town's mayor, wrote an urgent letter to the Audiencia in Mexico City:

> *This place has been sacked as badly as if it had been taken by the Englishmen, because with the commotion created by the entrance of the English into the port, those who had little or nothing volunteered to help those who had property to save it, but apparently carried off the goods for themselves, and thus there is nothing to eat, nor even anyone to send to seek for food, as since the arrival of our fleet all the residents are wandering about the sand hills in the endeavour to recover their lost property.*[21]

On San Juan, Hawkyns released all his prisoners except the thirty-five-year-old Francisco de Bustamante, and sent his interpreter, Anthony Goddard, to take Captain Delgadillo assurances that he meant no harm, and that "neither he nor his men would land on the island."[22] In an attempt to cover all of the bases Hawkyns also scribbled out a letter to the Mexican viceroy, who he assumed was in his residence two hundred miles away in Mexico City. In the dispatch Hawkyns described their arrival in San Juan as a consequence of the weather, and promised they would pay for victuals and space to repair the *Jesus*. He also betrayed some anxiety, hoping that the viceroy might ensure "that at the arrival of the Spanish fleet which was daily looked for, there might be no cause of quarrel rise between us and them, but for the better maintenance of amity, their commandment might be had in that behalf."[23]

THE ENGLISH fleet was not alone for long. Daybreak broke on Friday 17 September with the news that they had been dreading: a sailor aloft on the *Jesus* pointed to the horizon and called out three sails nine miles distant. The advance guard of the Spanish fleet was in sight.[24] Worse still, Anthony Delgadillo had sent out Cristoval Sanchez to warn the Spanish ships,

so by the time Hawkyns spotted them, they already knew of his presence in the port.[25] The flagship of the fleet, which was under the command of General Francisco de Luxan, carried a very important passenger: the recently appointed viceroy of New Spain, Don Martin Enriquez de Almansa. The new viceroy was perturbed by the news that he was hearing. He stopped the ships so that the remaining ten ships of the fleet could catch up, and then—having refused the opportunity for himself—he arranged for his ten-year-old son, a gentleman-in-waiting, a horse, and a bag of valuables to be secretly ferried ashore out of sight of the English.[26]

As he watched the Spanish ships slow to a halt, Hawkyns had what Miles Phillips called "a great perplexity of mind."[27] Should he keep the Spanish out of port? Or should he let them in and risk "their accustomed treason"? If he barred their entry until his ships were ready to leave, then he was gambling with high stakes. He guessed that the Spanish ships were carrying riches totaling almost two million pounds sterling. One storm and they could be sent to the bottom, and if they were to sink in bad weather as they sat exposed offshore, then he would have to face "the Queen's Majesty's indignation in so weighty a matter."[28] The situation called for quick thinking. Francisco de Bustamante was sent ashore with an armed guard to summon Anthony Delgadillo, with Hawkyns threatening to "send a party to fetch him a prisoner by force" if he refused to come.[29] Once the captain of the island was on board the *Jesus,* Hawkyns demanded that he organize the immediate evacuation of the island. He did not want Spanish soldiers in the vicinity of the ships, nor did he want the large body of African slaves that worked the port nearby. Hawkyns was afraid that the Africans might cut his ships' cables in order to rob and loot them, but with fifty-seven African captives still huddled in his holds, he was particularly scared that they would "demand that the Negroes aboard be set free."[30] Hawkyns also wanted Delgadillo to broker a peace between the two fleets. He was to sail out to the Spanish vessels and

inform the admiral of the peaceful intentions of the English. He was to tell them that they needed fifteen to twenty days to make repairs, and that if the Spanish ships were allowed into the port, they were to acknowledge that Hawkyns was the master of the island: neither side would come within the defined territory of the other, and no one would carry arms on land.[31]

W HEN HE heard Hawkyns's demands and that the Englishman in fact occupied the port, the new viceroy was aghast. Here was a man, Enriquez told Delgadillo, who "had committed serious ravages on these coasts and was as a matter of fact little better than a pirate and a corsair on whose word scant reliance could be placed."[32] And now he had the audacity to make demands of the viceroy of New Spain. Enriquez was purple with rage. As soon as more ships of his fleet arrived, he convened a council of captains and masters. To each he put the question: Should they attempt to force an entrance into the port? Or should they deal with the pirate? To a man they replied that it was best to enter peacefully and tie up; "the ships were in danger of loss, for the wind was from the north and the enemy had the advantage in that he was within the roadstead, his ships lightened, while those of the fleet were merchantmen, heavily laden."[33]

Delgadillo was sent back to Hawkyns with the message that they intended to deal with him peacefully, and that he would be allowed to buy provisions, but he must supply specific conditions. Yet even as Delgadillo approached the English fleet the sight that greeted him shocked him to the core: the English had spent the day fortifying the island and entrenching their positions. Hawkyns had placed three guns off the *Grace of God,* at the entrance to the port, and seized all the Spanish artillery there. A formidable battery was trained on the roadstead. Three redoubts had been built. At the Casa de Mentiras stockades had been erected, six bronze guns off a hulk docked in port had been placed there, and forty men occupied the position. More fortifications

had gone up around the smithy's forge and the small inn. With his men stationed in battle formation, he now commanded all approaches to the island.[34]

On board the *Jesus*, Delgadillo found that her numbers had been swelled by the transfer of men from the smaller ships. Both the flagship and the *Minion* had their guns ready and loaded with powder and iron shot. Along the quarterdecks and the midship gangways of the *Jesus* he saw that pikes, harque-buses, shields, and corselets had been brought up from the stores and laid out. The rigging was occupied by archers. The English were at battle stations, and it was an impressive but disturb-ing sight.[35]

Delgadillo delivered the message from Enriquez. It was the first Hawkyns knew of the presence of the viceroy in the Spanish fleet, and this was cause for concern, for he knew that there would be no possibility of fudging a deal. The viceroy was, after all, Philip II's personal representative in New Spain. Hawkyns quickly clarified the terms under which he would allow the Spanish fleet in:

> *The first was that we might have victuals for our money, and li-cense to sell as much wares as might suffice to furnish our wants.*
>
> *The second, that we might be suffered peaceably to repair our ships.*
>
> *The third, that the island might be in our possession during the time of our abode there.*
>
> *In which Island, our General, for the better safety of him and his, had already planted and placed certain ordnance; which were eleven pieces of brass. Therefore he required that the same might so continue; and that no Spaniard should come to land in the said Island, having or wearing any kind of weapon about him.*
>
> *The fourth, and last, that for the better and more sure perfor-mance and maintenance of peace, and of all the conditions; there might 12 gentlemen of credit be delivered of either part, as hostages.*[36]

On Saturday morning the next stage of the shuttle diplomacy was launched. Anthony Goddard accompanied Delgadillo back to the viceroy in the hope of finalizing a deal. Delgadillo's news of the English arms buildup further infuriated Enriquez, but also emphasized the need to come to a swift resolution. He tinkered with Hawkyns's warrants, making some final amendments: there would be ten hostages, not twelve; a buoy would be placed marking a line that, with the exception of designated persons, neither side was to cross, on pain of death; and the English would pay for everything they received. He handed Goddard a written agreement for his boss. It concluded: "I well believe that although the people of this fleet enter without arms into the island, they will not be prevented from going about their affairs, not harassed in any fashion. And I am very confident that when we meet, friendship will augment between these fleets, since both are so well disciplined."[37]

T HE ENGLISH played the hostage card straight, selecting ten men from among the gentlemen adventurers and others of gentle birth. They included George Fitzwilliams, William de Orlando, Richard Temple, Michael Soul, Christopher Bingham, John Corniel, Thomas Fowler, and John Varney. Delgadillo collected them on Saturday and took them out to the Spanish fleet.[38] In the meantime, the viceroy and de Luxan were contemplating a fraud: soldiers and sailors were picked randomly, told to draw lots to see which ones would become hostages, and then "attired like their betters." De Luxan offered the opinion that "in such junctures it was advisable to give persons of secondary importance as hostages."[39] However, the selected men objected, and they were backed up in their complaint by Agustin de Villanueva, who had recently joined the Spanish flagship. The nobleman who had eaten at Hawkyns's table said that when he saw the hostages that were to be sent "the disgust which filled him was enormous, and he felt exceedingly ashamed."[40] He immediately offered his

own services, and in the face of such objections, the intended hostages were replaced by a group of four Viscayan gentlemen and six noncommissioned officers—among them Vice Admiral Juan de Ubilla's nephew.[41] On the arrival of the English hostages the swap took place without a hitch, and the ten Spanish men were taken to the *Jesus,* where they were placed under the charge of Valentine Green.[42] The deal could now be proclaimed by the sounding of a trumpet. Orders were given by both sides that no one "should violate or break the peace upon pain of death."[43]

ADVERSE WIND kept the Spanish fleet out of port until Tuesday, but in the meantime events moved apace. By Saturday night news had reached Mexico City that what was initially believed to be a French fleet had pulled into San Juan de Ulúa, and urgent preparations were made to repulse an attack.[44] The following day an emergency session of the Audiencia resolved that Dr. Vasco de Puga should be given ten thousand pesos of common gold in reals with which to raise an army in the city and march to Xalapa, where he would assemble his forces. Artillery and other weaponry would be sent on in carts.[45]

Similar measures were being taken elsewhere: in Veracruz the captain of the infantry, Pedro de Yebra, was instructed to take charge of the armed forces, while the city council sent word to the mayor of Xalapa that he should bring down an armed force, gathering up all Spaniards, African slaves, and Indians that he passed on the way.[46] Luis Zegri, the mayor of Veracruz, turned back from a visit he was making to Xalapa as soon as he heard the news, ensuring that the people there were on a state of high alert before he left.[47] Letters went to the chief alcaldes and justices of Puebla, the province of Tlaxcala, Tepeaca, and Xalapa to "assemble hastily all the people of war, Spaniards and Indians, that they could, and such supplies as might be necessary."[48] Not realizing that the Spanish treasure fleet was already aware of the situation, several boats were ordered out to sea to intercept and warn it.[49]

On Monday 20 September Hawkyns finally released Francisco de Bustamante.[50] Later that night the liberated Spaniard helped Pedro de Yebra to secretly ferry out 120 men brought in from Veracruz to two privately owned Spanish ships tied up to the island. Soon after, the treasure fleet moved to within gunshot of the port in preparation for its entry in the morning.[51]

T HE ARRIVAL of the fleet was a delicate and tense operation: not only was the small quayside already crowded, but there were sensibilities and sensitivities to be conscious of. Both parties were fully aware that one small slip could result in trouble. Behind the welcoming salvos the viceroy and his chief officers were mightily galled to see the extent of Hawkyns's presence and fortifications. For the moment they bit their tongues, as the ships and crews performed a complex dance, tiptoeing around one another to avoid offense. Two days of rearranging ships followed, and a buffer zone was created to keep the parties apart. Miles Phillips wrote, "[W]e laboured on all sides, in placing the English ships by themselves, and the Spanish ships by themselves: the captains and inferior persons, of either part, offering and shewing great courtesy one to another; and promising great amity on all sides."[52] Some of the Spanish ships harbored too close to the *Jesus*, and Hawkyns insisted that they move; a large hulk belonging to one Diego Felipe was shifted because it interfered with the English line of fire.[53]

In spite of its fragility, Hawkyns appears to have believed that the truce could hold. It was a question of pragmatism over judgment. Life continued as normally as possible: preparations for careening continued, the yards on several of the ships were lowered, and Spanish officers were entertained on board the English vessels.[54] To further ensure the peace, Hawkyns, "being anxious to avoid any damage or mischief in the said port or elsewhere assembled all his people and warned them swearing by the life of the Queen that if any of them picked a quarrel with any person

on shore he would hang him out of hand as his instructions were to keep the peace."[55]

But Hawkyns had read the mood of the Spanish incorrectly. Not only was he unaware of the massing of men from cities around Mexico, but he had no idea that the new viceroy was seething: to the Spanish official, the English occupation of the island was an act of delinquency, an affront to Spanish sovereignty. Enriquez never left his flagship, and his determination to punish the English pirate grew by the hour. Once more he summoned his council of captains and ships' masters for a conference. This time the agenda had just one item: "to determine ways and means to seize and punish him [Hawkyns] and eject him from the island."[56] Over Tuesday and Wednesday a plan was concocted that consisted of an all-out assault on the English fleet on several fronts. With the Spanish flagship too far away to maneuver into place without arousing suspicion, the large, empty hulk belonging to Diego Felipe would be brought back between the two fleets—this time with 150 heavily armed men on board. When the hulk was close enough to grapple the *Minion*, Francisco de Luxan would wave a white towel from her. This meant that "the people aboard her had their fuses lit and were armed and ready to fight and to grapple with the English vice flagship and flagship."[57] The viceroy would then order a blast on a trumpet, which would be the signal for those on the hulk to storm the *Minion*. At the same time, the men from Veracruz under Pedro de Yebra, and another squadron under Delgadillo, would leap from the ships on which they were hiding and seize the unsuspecting English fortifications on the island before the defenders knew what had hit them. Reinforcements would pour into the fray from ships across the Spanish fleet. Francisco Maldonado, the captain of the bark Hawkyns had seized off Campeche, would lead 70 men into battle from a ship in which they were hidden. The English artillery on San Juan de Ulúa would be turned on Hawkyns and his ships.[58]

Preparations began in earnest on Wednesday afternoon. Rather

than risk its loss, de Luxan ordered a longboat towing a barge to visit and remove a valuable cargo of quicksilver—vital to the production of silver—from the flagship and vice flagship. By seven that evening, when the vice admiral decided to use the longboat to collect wine for his ship, only 90 of the 120 cases had been unloaded.[59] Meanwhile, carpenters were busy around the Spanish fleet, cutting new portholes through which to point artillery at the English fleet.[60] That night one last porthole was cut just above the waterline of Diego Felipe's hulk, and 150 men carrying harquebuses and shields quietly squeezed aboard.[61] Just before daybreak Admiral de Luxan and his deputy de Ubilla entered the hulk, which was then moved slowly into position between the two fleets, and a hawser was connected to the tackle of the *Minion*. At the signal, they could now swiftly pull themselves alongside.[62]

WHEN HAWKYNS awoke on the morning of Thursday 23 September his suspicions were quickly aroused: there was no denying that something was going on, as he later wrote:

> [T]he treason being at hand, some appearance shewed, as shifting of weapons from ship to ship, planting and bending of ordnance from the ships to the Island where our men warded, passing to and fro of companies of men more than required for their necessary business, and many other ill likelihoods which caused us to have a vehement suspition.[63]

Hawkyns sent the Spanish-speaking Robert Barrett to visit the viceroy on his flagship. As a gesture of goodwill Barrett took with him the musicians from the *Jesus* to "play solos and other pieces as a mark of the friendship existing between them."[64] The viceroy seemed genuinely apologetic and promised to remove anything suspicious at once. But an hour later it was clear that Enriquez had not kept his promise, and the causes for concern

were growing. Hawkyns caught a glimpse of men on the hulk that now lay close to the *Minion*. He sent the *Jesus*'s master back to the viceroy with a demand that they be removed immediately, but this time Barrett was jumped upon, tied hand and foot in chains, and thrown below the hatches.[65] At this very moment, unbeknown to Hawkyns, the English hostages spread throughout the Spanish fleet were being led belowdecks with their hands tied behind their backs.[66]

With Barrett apparently doing the business on the Spanish flagship, John Hawkyns took the opportunity to have breakfast with Agustin de Villanueva. Juan Suarez de Peralta, a resident in Mexico at the time and an eyewitness to events that were about to unfold, described the scene. As Hawkyns looked out of a cabin window he noticed Diego Felipe's hulk closing in on the *Minion*. Shocked, he demanded of his table companion, "What strange business is this, good sir? Have we not agreed that the ships of the armada of Spain shall not cross yonder mark until I depart, and that they shall disembark their men in a given place? Methinks that this is a breach of our agreement and that yonder hooker is coming far too close."[67] He stood up and realized the other ships were moving, too. Hawkyns ordered Villanueva and the ten Spanish hostages belowdecks and then dashed outside. To get a better view he jumped from the *Jesus* to the *Minion*, from where he realized the danger his fleet was in. From the deck he spotted Vice Admiral de Ubilla and shouted that he was not conducting himself like a gentleman, to which the Spaniard responded that he was behaving like "a captain and a fighter." Hawkyns grabbed a crossbow and fired, just missing de Ubilla. A soldier at Hawkyns's side let off a harquebus shot, killing a soldier standing next to the Spanish commander.[68]

The plan of attack had been discovered. De Ubilla jumped out of Hawkyns's range and waved a white neckerchief that could be seen across the Spanish fleet. On their flagship the viceroy took the signal and ordered a blast on the trumpet. A confident cry of "Santiago and Spain" boomed across the port, but everything

was erupting too soon. De Ubilla's signal had come almost an hour early—the Spanish assault force was not yet ready, and the hulk was too far from the exposed *Minion* to grapple her.[69] Chaos and carnage ensued. As three hundred Spaniards attempted to climb aboard the English ship, soldiers and sailors leaped across from the *Jesus* and fought them hand to hand. The *Minion*'s crew cut her head cables, and belowdecks seamen hauled on her stern-fasts: she lurched slowly off the quayside.[70] The first shot from the *Minion*'s gunners blasted the Spanish vice flagship, killing an artilleryman. Their next shots smashed through the flagship's broadside, punching gaping holes in her sides. Her timbers were shattered just above the waterline. A powder keg detonated, and the ship exploded, taking with her twenty men. Slowly she began to sink. Within minutes the Spanish vice flagship was engulfed in flames, too.[71]

Meanwhile, two Spanish ships had fastened themselves to the *Jesus*, and men were pouring aboard. "The *Minion* being passed out they came aboard the *Jesus*," wrote Hawkyns, "which also with very much ado and the loss of many of our men were defended and kept out." Desperate sailors battled with all of their sweat and blood to release the flagship from the island. Men pulled hard on cable around the capstan: both the *Jesus* and the *Minion* lurched away, sitting two ships' lengths from the Spanish fleet, at which point, Hawkyns wrote, "the fight began hot of all sides. . . . [W]ithin one hour the Admiral [flagship] of the Spaniards was supposed to be sunk, their Vice-Admiral burned and one other of their principal ships supposed to be sunk, so that the ships were little able to annoy us."[72]

Yet it was not at sea that the crucial battle was to be fought. On hearing the trumpet the men from Veracruz, under the command of de Yebra and Delgadillo, had swarmed onto the island, leaping from ships moored at the dockside, wading through the water, and piling off longboats. Spaniards who had been fraternizing with the English suddenly turned on them, plunging knives into their chests.[73] The slaughter on shore was appalling:

Delgadillo estimated that up to 150 men were killed. Miles Phillips claimed that in the battle for control of the island "they slew all our men they could meet with, without any mercy."[74] Job Hortop, a survivor of the fight for the island, remembered, "They came upon us on every side, and continued the fight from ten o'clock until it was night. They killed all our men that were on shore in the island; saving three which by swimming got aboard the *Jesus of Lubeck*."[75]

Cannon fire boomed around the small haven, smoke filled the morning sky, ill-equipped Spanish ships took huge hits. The wisdom of the Spanish attack was open to question: only the vice flagship was a man-of-war, the sinking admiral was a well-armed but heavily laden merchantman, and the rest of the fleet simply carried cargo. Now, with the *Jesus* and the *Minion* pulling farther out to sea, Hawkyns was able to take the battle to the enemy. Anthony Goddard noted that the two ships "fighting fiercely made their way through the centre of the Spanish fleet, leaving behind them in a mass of flames the Spanish vice-flagship."[76] With space between them, the *Jesus* and the *Minion* fired more than sixty direct hits on the Spanish fleet. Thirty-four men lay dead or badly burned on the Spanish vice flagship, and her sister ship, the Admiral, had hit the bottom, her decks teetering just above the water in the shallow port.

De Ubilla, the man who had set off the whole confrontation, realized they were in danger of losing the day, and in a panic climbed ashore and "made a mulatto put two barrels of powder aboard a vessel and set fire to it that it might drive against the English and burn their ships."[77] The fire failed to take. In the meantime, shouts alerted de Ubilla to the vulnerability of the viceroy. Enriquez had been left almost completely exposed on board the flagship, as all around the crew abandoned her.[78] De Ubilla rounded up men and raced them back onto the doomed ship, where he found the viceroy standing by the mainmast taking potshots at the English. As de Ubilla reached him a shot smacked against a pike being carried by one of his attendants.[79]

Spanish despair was short-lived, for at this point the capture
of the island began to play its part: de Luxan assumed control of
the land-based artillery there and began to bombard the English
ships. Cannonball after cannonball rained in; Miles Phillips later
complained that "from the shore, they beat us cruelly with our
own ordnance."[80] The English fleet began to suffer serious dam-
age: the *Angel* sank; the *Swallow* and the Portuguese caravel
were overrun. The *Grace of God* attempted to make a run for it,
but her mainmast was knocked overboard by chain shot. Captain
Bland anchored the ship, set her on fire, and then with the rest
of his crew jumped into a boat and headed for the *Jesus*.[81]

Yet things were no better there. The flagship was taking a
mighty battering from the shore—her masts and yards were de-
stroyed, and she was virtually immobile. Job Hortop tells how at
the height of the fighting Hawkyns demanded a cup of beer
from his page and then toasted his gunners.

> *He had no sooner set the cup out of his hand, but a demi-culverin
> shot struck away the cup and a cooper's plane that stood by the
> mainmast, and ran out on the other side of the ship; which nothing
> dismayed our General, for he ceased not to encourage us, saying
> "Fear nothing! For God, who hath preserved me from this shot,
> will also deliver us from these traitors and villains!"*[82]

The battle, however, had been turned. The *Minion* had moved
out of range of the shoreline artillery, but on the *Jesus*'s attempts
to raise a new mast and yards were frustrated by fresh hits. The
big old ship limped out to shelter the *Minion* and began the
transfer of plunder. In her hold there was all of the treasure and
booty accumulated over the past few months. There was also a
large group of no doubt terrified slaves. Hawkyns called in Fran-
cis Drake on the *Judith* to take some men and goods.[83]

Juan Suarez de Peralta reported that as it became obvious that
the battle was being lost, Hawkyns, in an astonishing cameo,
went belowdecks to visit his Spanish hostages. He had a halberd

in one hand and, according to Suarez de Peralta, was armed to the teeth. The hostages believed that he was going to order them to be stabbed, but instead he addressed them: "Senor Villanueva, is this the fashion in which folks keep their plighted word in Spain? I have been met with usage which will cost more than the value of my ships: in my country our chivalry would make such a thing impossible!"

Villanueva feared death and was said by Suarez de Peralta to have replied, "I do not know what this new thing may mean. But here we are: your excellency will do with us what you please—you have the right to do with us what may be done to your own people."

But once again Hawkyns proved himself capable of humane gestures by being merciful. He alleviated the hostages' fears by replying, "Ample grounds have I for proceeding to extremities, but as a gentleman I cannot do so. I regret having to leave your worships among low and cruel folk, who will want to take their revenge: in that cabin are arms, take them and defend yourselves, because I must perforce be off!"[84]

The captain hoped to be able to take his time unloading, and then escape on the *Minion* when it was dark, but the Spanish had other ideas. At three in the afternoon, de Ubilla sought out Felipe Boquin and offered him any price he might ask for a ship which he could set "ablaze in all four quarters."[85] Boquin agreed, and his vessel and a ship of the fleet were set on fire, pointed toward the ailing *Jesus,* and cast loose.

The fire ships caused hysteria on the English ship. There was no way of maneuvering out of the way, and, as Hawkyns said, they "bred among our men a marvellous fear."[86] Without orders, the crew on the *Minion,* which was hard against the flagship, unfurled her sails. She staggered and then began to move. Men jumped from the *Jesus,* others plunged into the sea below, and some followed in a small boat. Among those surprised at the sudden movement was Hawkyns himself: an inquest would later hear that if he had for "one minute deferred his coming off from the

said *Jesus* either he had in her, by reason of the continual shooting at her, been slain or else taken by the Spaniards."[87] As the *Minion* pulled away, many on the *Jesus,* including the Africans belowdecks, were left to their fate. Paul Hawkyns, the captain's nephew, had been instructed to fetch a rich goblet and plate of fine crystal studded with precious stones and pearls from the *Jesus,* but while he was preparing to jump into a launch to return to the *Minion,* he saw a colleague gunned down, "and being afraid that he might be killed, and also because he was among bad people he threw the plate and goblet into the sea and stayed on board the flagship."[88]

The *Minion* and the only other surviving ship, the *Judith,* moved off two bow shots from the port, and the Spanish did not have the ships to pursue them. In the words of the viceroy, "the discomfited tyrant"[89] had fled. According to Miles Phillips, who was escaping on the *Minion,* those that looked back at San Juan de Ulúa witnessed a dreadful sight:

> [I]t is a certain truth, that when they had taken certain of our men ashore they took them and hung them up by the arms upon high posts, until the blood burst out at their fingers' ends. Of which men so used, there is one Copstowe and certain others, yet alive... carrying still about with them (and shall, to their graves), the marks and tokens of those their inhuman, and more than barbarous, cruel dealings.[90]

The battle had lasted almost eight hours: amid the carnage on the shore, around the Casa de Mentiras, in the gently lapping waters, and in the carcasses of ships, exhausted men took their breath, tended to their wounded, buried their dead, or rounded up prisoners. De Ubilla was to write to Philip II that "It was a well fought battle and one of the hardest in which I ever took part, although I have served your Majesty in most of the notable fights in the Levant and in the West, from the battle of Tunis until now."[91] Estimates of the dead cannot be relied on: suffice it to

say it had been a brutal and bloody day. Job Hortop would claim the English had slain 540 Spaniards and sunk five of their ships.[92] In addition, their general, de Luxan, had been hit in the leg by an arrow. Thomas Fowler, one of the hostages, said that after the battle he saw 40 or 50 English dead on the island at the time of clearing up.[93]

Out on the abandoned and crumbling *Jesus*, looting had begun: Hawkyns had been forced to halt the transfer of treasure to the *Minion* by that ship's sudden departure, and there was a healthy pile sitting waiting to be collected. Furthermore, forty-five Africans had been left behind, the majority chained in the hold of the *Jesus*. As the English scuttled off, taking just twelve away with them on the *Minion*, these remaining captives must have wondered what would happen next. General de Luxan placed de Ubilla in charge of the ship, but the vice admiral readily admitted that sailors and soldiers plundered all around him, seizing as much as three thousand ducats' worth of linen, cloth, silver, and gold.[94] Many would later say that de Ubilla encouraged the looting and divided the Africans up among his friends. The viceroy would also come under scrutiny for his handling of the booty: a scrivener by the name of Lazaro Gutierrez would tell how he had heard it said that "those who had fought were allowed to pillage, while those who had not fought got nothing, and two of those who had fought well were given one a black woman and another a black man, by order of the viceroy."[95] Baltasar de Torres, resident of Seville, had observed Enriquez giving a lame slave to Hernando de Maluenda, an ensign,[96] and Jacome Porcelin, also of Seville, had seen that "the viceroy gave one of his servants a negro slave and another a gold chain which he ordered to be taken from another soldier." Porcelin had heard several sailors and soldiers saying that "they had gone to ask the favour of the viceroy, on the ground that since they had fought they should be given a share of the spoils, and that to some of them he had given something, and to others nothing, and in short had done as he pleased in the matter."[97]

Francisco Gutierrez Moreno, a seaman from Triana, had seen the viceroy "give a Negro to a friar on board and to a major-domo another."[98]

It seems, however, that the day's biggest victor may well have been Agustin de Villanueva: he had taken the opportunity of being on board the *Jesus* when Hawkyns left to seize seventeen Africans and more than twenty thousand gold ducats that he found in a coffer. His fellow hostages were so outraged that they had him arrested, but the viceroy later ordered his release.[99]

Home

TWENTY-FIVE

I n the fourth week of January 1569 a ghostly remnant of a once powerful ship limped into view off the Cornish coast of southwest England. A man in one of its small boats came ashore carrying a letter. It read:

> *To the Right Honourable, Sir William Cecil, Knight and Principal Secretary to the Queen's Majesty, give this*
>
> *25 January 1569*
>
> *Right honourable my duty most humbly considered, it may please your honour to be advertised that the 25th day of January, thanks be to God, we arrived in a place in Cornwall called Mounts Bay, only with the Minion which was last of all our fleet, and because I would not in my letters be prolyxe after what manner we came to our disgrace ... but if I should write of all our calamities I am sure a volume as great as the Bible will scarcely suffice. All which things I most humbly beseech your honour to advertise the Queen's Majesty and the rest of her council such as you shall think met.*
>
> *Our voyage was, although very hardly, well achieved and*

brought to reasonable pass but now a great part of our treasure merchandise shipping and men devoured by the treason of the Spaniards.

I have not much or any thing more to advertise your honour now the rest, because all our business hath had infelicity misfortune and an unhappy end and therefore will trouble the Queen's Majesty nor the rest of my good Lords with such ill news....

I mind with God's grace do make all expedition to London myself at what time I shall declare more of our estate that is here committed....

Your most humbly to command

John Hawkyns[1]

The story of the *Minion*'s journey to England was, as Hawkyns promised, one of epic proportions.

WITH SMOKE swirling around them, and the sound of guns booming in the distance, the *Minion* pulled two bow shots from San Juan de Ulúa, where Hawkyns judged they were safe for the night. The next morning they edged in close to a reef known as the Isla de Sacrificios—the Island of Sacrifices—where they threw down their two remaining anchors and waited a couple of days for a decent wind to carry them away from the misery of defeat. No pursuit was mounted by the Spanish: their forces were too scattered, and too engrossed in looting. Besides, the battle had been won at a great price: there was exhaustion everywhere, too many Spanish ships had been lost already, and the remainder of the Spanish fleet consisted of heavily laden merchantmen, no match for the guns of the *Minion*, or the reefs that she sat alongside. Men were dispatched along the coast on horseback in case the English ship foundered, but otherwise the enemy was allowed to escape.[2] Francisco de Bustamante was in a

minority when he suggested they should hunt them down and administer a killer blow: by the time Friday dawned a strong northerly wind made the chase impossible.[3] In 1517, Juan de Grijalva had landed on this island and found

> *two stone buildings of good workmanship, each with a flight of steps leading up to a kind of altar, and on those altars were evil-looking idols, which were their gods. Here we found five Indians who had been sacrificed to them on that very night. Their chests had been struck open and their arms and thighs cut off, and the walls of these buildings were covered with blood.[4]*

As Hawkyns looked around the deck of the *Minion* and heard the groans of the wounded and dying, he may have wondered at the human costs incurred in pursuit of slave trading.

Saturday brought fair weather and the first of fourteen days in which the *Minion* wandered aimlessly around the Gulf of Mexico. Hawkyns had a vague notion of finding the Pánuco River and replenishing stocks of freshwater, but the ship was now a floating hell: more than two hundred men, many of them severely wounded, crammed her decks, the freshwater was spent, and food provisions had reached the bottom of the barrel. Official rations were down to two ounces of bread a day.[5] Men chewed on cowhides and chased rats and mice. Cats and dogs became delicacies; pet parrots and monkeys exchanged hands at exorbitant prices. Miles Phillips wrote, "[T]o be short, our hunger was so great, that we thought it savoury and sweet, whatever we could get to eat."[6]

Hawkyns was enraged by the duplicity of the Spanish, and also nursed a grudge against his cousin Francis Drake, who commanded the *Judith*, the only other ship to escape. However, when he later came to write his account of the battle he merely noted, "[S]o with the *Minion* only and the *Judith* (a small bark of fifty tons) we escaped, which bark the same night forsook us in our great misery."[7] Had Drake abandoned them? Hawkyns could not believe it to be so, but the controversy would dog his cousin until

his death. Nineteen years later, when Francis Drake brought a charge of mutiny against one William Borough, the accused put it on record that "Sir Francis Drake . . . doth altogether forget how he demeaned himself towards his master and admiral, Mr John Hawkyns, at the port of San Juan de Ulúa in the West Indies, when contrary to his said admiral's command he came away and left his said master in great extremity."[8]

Whatever the reason, John Hawkyns and crew found themselves on their own, and in danger of watching their ship turn into a floating coffin. On 8 October they edged toward land hoping to find inhabitants, victuals, and a place to make good the ship, "which was so sore beaten with shot from our enemies and bruised with shooting of our own ordnance"[9] that it was shipping water, but their hopes were dashed: the area was deserted and barren. Mutterings of discontent among the men began to get louder. Job Hortop would later call it "a mutiny among them for want of victuals."[10] Several of the crew expressed the desire to be set ashore rather than wait to sink or starve somewhere in the mid-Atlantic. The cry grew more vociferous: Miles Phillips recalled the men demanding to be allowed to "submit themselves to the mercy of the savages or infidels than longer to hazard themselves at sea . . . where they very well saw, that if they should remain together, if they perished not by drowning, yet hunger would enforce in them in the end, to eat one another."[11]

Though it might be too strong to label this a mutiny, the moment certainly had the potential of developing into one. Whether through pragmatism—Hawkyns had only to look around him to realize that there were too many men for the journey home—or an inability to effectively resist the demands of the lower decks after the devastation and weariness caused by the battle, Hawkyns was only too happy to accede to the clamor. He soon discovered that it was one thing to make the demand, and another to take the action: when he accepted his men's grumbles at face value, and arranged for them to be put off the ship, many of those voices crying out to be landed fell silent. Hawkyns ordered all of those wishing to stay

on the *Minion* to collect at the aft mast, and those wanting to be put ashore to gather around the foremast. He had hoped to halve his ship's company, but instead now found most men hovering at the rear of the ship. Miles Phillips wrote,

> *[I]t was a world to see how suddenly men's minds were altered! for they which, a little before, desired to be set on land, were now of another mind, and requested rather to stay. So Hawkyns had to make an order:*
>
> *First, he made choice of such persons of service and account as were needful to stay: and that being done, of those who were willing to go, he appointed such as he thought might best be spared.*[12]

The Spanish general, de Luxan, would later put it another way, saying "they picked out the most useless of the people they carried."[13] In fact, Hawkyns's choice reflected class and utility rather than intelligence: he kept on board his officers and acquaintances, while dumping for starters all of the ship's boys. One hundred fourteen men were abandoned in Mexico; fewer than one hundred would be allowed to stay on the *Minion* and sail for England. Hawkyns embraced each of the men chosen to be left behind, gave every one of them six yards of Rouen cloth, and money to those that demanded it. Many broke down in anguish at what lay before them.[14] Hawkyns promised that if he reached home safely, he would return for them in a year, and then ordered them into the waiting boats.[15] The weather was turning nasty, the sea choppy to rough. The men in the first boat landed safely, but a mile from shore the second boat hit a high sea. Hampton, at its helm, ruled it unsafe to go farther, and ordered the passengers into the water to swim ashore. The men roared with disbelief, but the boatswain and mate kicked the reluctant ones overboard. Two drowned; the rest reached the beach, soaked, exhausted and empty-handed.[16]

Yet further controversy was stored below the *Minion*'s deck: twelve Africans hungry, scared, and chained down. At this crucial

juncture Hawkyns decided to keep them on board. This would lead to rumblings of discontent in both Mexico and England: how could he abandon white men and yet carry on homeward with black slaves? His reasons were simple: they were counters for buying victuals from passing ships or ports along the way, human cash that might make the difference between starvation and survival. It was a pragmatic, not humanitarian, act.

The next days saw further storms, but on 16 October the clouds drifted over the horizon and the strong northerlies changed direction. They had water on the ship, but little else. Rudimentary repairs had been completed. It was time to make a dash for England.[17]

Twenty-Six

The good weather stayed with them for a month, carrying the ship past Cuba, through the Florida Channel, and up the eastern seaboard of North America. Nevertheless, their plight worsened: the *Minion* had no food and little water in her stores, and along the way she found nowhere to stock up. As they headed for Newfoundland, hunger and scurvy gripped the ship's company. John Hawkyns wrote, "[O]ur men being oppressed with famine died continually, and they that were left grew into such weakness that we were scantly able to manage our ship."[1]

Ill winds hampered their progress, and the normally fertile fishing grounds of Newfoundland provided little relief for the starving crew and slaves. Staring at the dying men around him, Hawkyns determined to make a dash for Galicia in northern Spain—a decision that must have been driven by desperation, considering the battering they had so recently suffered at the hands of the Spanish. Despite their enfeeblement, or perhaps driven to despair by it, Hawkyns drew out sufficient energy from among his ailing crew to carry out two or three acts of brutal piracy as their journey across the Atlantic neared its end. One of the slaves on the *Minion* would later tell the authorities in Spain that in the hunt for food they had attacked and looted two or

three Portuguese vessels near the Galician coast, and had "cut off the legs of the people on board and thrown them alive into the sea."[2]

There was certainly cause for despondency on the *Minion:* in early January 1569, as Spain came into sight, the men chewed on cowhides for sustenance, drank seawater and water condensed on the sails, and looked on in horror as the death toll mounted.[3] In the twentieth century, controlled experiments were carried out on volunteers to discover the effects of starvation. In one, a man allowed only a daily ration of distilled water for a month lost thirty pounds in weight. His heart shrank by almost two inches, and his liver halved in size. He became irritable and depressed, lost his reflexes, and found muscular and endurance work increasingly difficult. His fast lasted just thirty-one days. The crew and the slaves on the *Minion* were without nutrition for more than three times as long. It is hardly surprising, therefore, that in the approach to Galicia, forty-five men perished, their bodies lowered into the sea with little ceremony. Worse still, hunger was accompanied by its natural ally, scurvy, a deficiency of vitamin C graphically described by Hawkyns's son, Richard, twenty-five years later:

> [I]t possesseth all those of which it taketh hold, with a loathsome slothfulness, that even to eat they would be content to change with sleep and rest, which is the most pernicious enemy in this sickness that is known. It bringeth with it a great desire to drink, and causeth a general swelling of all parts of the body, especially of the legs and gums, and many times the teeth fall out of the jaws without pain. The signs to know this disease in the beginning are divers, by the swelling of the gums, by denting of the flesh of the legs with a man's finger, the pit remaining without filling up in a good space: others show it with their laziness, others complain of the crick of the back etc all which, are for the most part, certain tokens of infection. The cause is thought to be the stomach's feebleness, by change of air in untemperate climates, of diet in salt meats, boiled also in salt water and corrupted sometimes; the want

of exercise also either in persons or elements, as in calms. And
were it not for the moving of the sea by the force of winds, tides
and currents, it would corrupt all the world.[4]

The fisherman Gregorio de Saa was the first to spot the ship,
while out in a boat off Portonovo. Hailed by the signaling of a
flag and the calls of men from the *Minion*, he pulled alongside,
climbed on board, and at Hawkyns's request piloted them into
the small port of Marín near to Pontevedra. De Saa spent a few
days on board and noted the sorry state of the ship: he saw a man
who had had one leg blown off below the knee by a cannonball
and noted that the *Minion* carried "some fifty persons, among
them some Negroes; that a number of them were very sick and
worn out and they complained that many of them had nearly
died from hunger."[5]

The *Minion* entered port firing its guns in distress, or wel-
come, and de Saa went ashore with a present for the mayor
of Pontevedra—a parrot that had somehow survived the
crew's hunger.[6] Visitors began to arrive in small boats, but
Hawkyns would allow only the mayor and a couple of other
dignitaries aboard. They had heard of the sorry state of the ship
and came to check out a rumor, possibly encouraged by Hawkyns
as a defensive measure, that it carried the plague. Hawkyns as-
sured them otherwise, but demanded provisions: offering to pay
for them, but threatening to seize them if they were denied him.[7]
Despite the sickness so evident around the decks, Hawkyns was
judged to be in rude health: Juan de Torres described him coming
out onto the poop deck to speak "dressed in a pelisse lined with
martin's fur, and trimmed with black silk lace, a red doublet with
silver lace, and trunk hose trimmed with the same, a large gold
chain hanging from his neck."[8] Pedro de Salnes, a resident of Pon-
tevedra, remembered him as a "young man, well dressed" who
showed off three gold rings encrusted with valuable stones.[9] How
he had maintained his health spoke volumes about either his
health, his self-interested command over rations on board, or both.

Several men went ashore, and the ailing captain of the *Minion*, Thomas Hampton, lodged at an inn, where he spent three days in bed attended by two or three of his countrymen.[10] For many of the debilitated crew, though, landfall brought a new and grievous danger. Provisions began to pour in: fresh meat, bread, and wines were loaded into the ship's hold, much of it from two English ships docked in Marín and about to set off for Flanders.[11] But for men who have not eaten a decent meal for so long there were hidden and lethal dangers in suddenly satisfying the hunger pangs. Hawkyns wrote that once they had full stomachs, his men "with excess of fresh meat grew into miserable diseases, and died a great part of them."[12] This is what has come to be known as "refeeding syndrome," where malnourished people who resume normal eating can experience extreme heart, lung, and neurological trauma, organ and respiratory failure, convulsions, coma, and death. Only gradual reintroduction to food, in particular through the use of saline solutions, could have avoided disaster. On board the *Minion*, the sudden arrival of food spelled death. As more of his men succumbed, Hawkyns heard a rumor that the Spanish were about to take advantage of his frailty and launch an attack. For his part, Hawkyns refused to go on land, claiming he had vowed not to set foot ashore until he reached England, sensibly realizing the dangers of arrest that he faced if he did so.[13] He now hastily recalled his men, and they pulled away to the nearby Islas Cies, sufficiently far down the coast to deter pursuit. Gregorio de Saa wrote that after they had abandoned Marín "there were washed ashore on the bank of the said port three or four dead men one of whom was lacking a leg. . . . [T]he said bodies came with their feet tied with cords, to which stones had been attached to sink them to the bottom of the sea so that they should not rise."[14]

THE *MINION* anchored near the Monasterio de Santistevo de Cies, where its presence caused some disquiet. The islands sit at the mouth of the estuary commanded by the Spanish

port of Vigo, and when news of the English ship's presence got out, several ships delayed their departure for fear that Hawkyns would rob them.[15] Nevertheless, as the crew sat there recovering from all that had befallen them, they received more visitors. Among them were Gregorio Sarmiento de Valladares, a resident of Vigo; Pedro Ramos, the administrator of the salt tax; an Englishman by the name of Ralph Cotton; and Edward Boronel, another expatriate.[16] All came in search of trade but found little of interest: some Rouen linens, Anjou cloth, and a few emaciated African slaves.[17] Boronel, however, proved invaluable to Hawkyns: he collected supplies of wine, meat, and bread from Marín and Vigo, and he allowed some of the ship's company to lodge with him; one Spaniard testified to seeing the "very thin and emaciated and ill and swollen" men that were entering his house.[18] Boronel also negotiated with English ships sitting in Vigo for a dozen fit sailors to help out on the *Minion*. In return for his efforts, Hawkyns rewarded Boronel with an African woman.[19]

All the visitors to the *Minion* agreed on the "wretched condition" of the ship and its company. Still, Hawkyns now felt strong enough to head for home, but the *Minion*'s first attempt to pull away from the Spanish coast was hampered by a strong wind which forced it farther up the estuary. Two English ships sitting in the harbor of Teys, a mile from Vigo, came to their rescue and helped them into port. Hawkyns took the opportunity to sell the last of his merchandise, including twelve hundred yards of Anjou cloth, and several of the remaining slaves. The people at Teys were far more hospitable than those at Pontevedra, and during this six-day stay there was much entertaining for Hawkyns to do. He restocked his larder and took on goods to sell at home: three live cows were marched onto the ship, and four pipes of wine. Edward Boronel supplied another pipe of wine, a bag of eels, fresh bread, chickens, and sheep. For his sales of cloth and slaves, Hawkyns received payment in silks, velvet, and taffeta.[20]

Many of the visitors to the ship continued to comment on the sorry state of those around Hawkyns. Men were still suffering

from serious wounds inflicted at San Juan de Ulúa, and several of the sick and injured on the *Minion* were siphoned off onto other ships about to depart for England. Local resident Simon Vasquez said that when he had been on board the crew looked as if they had been "badly mauled."[21] Another visitor added that he thought that there might have been as many as sixty people on board the ship: "Among them he saw one who had lost his leg close to the knee, two more with their heads bandaged, who it seemed to him were wounded because they looked haggard and exhausted."[22]

As they killed time before final departure, three or four of the men went ashore to dine in the house of an English resident by the name of John Althorp.[23] Hawkyns, for the most part, busied himself with arrangements: ensuring the fresh crew members were in place, and obtaining anchors and cables to replace the ones lost in Mexico.[24] Nevertheless, even he had time for diversion, one day taking a group of Spanish visitors out to sea with some cannons for firing practice. They were impressed, but Hawkyns told them rather bitterly that it had been nothing "because when the vessel started from England . . . it had carried seventy tons of artillery."[25]

In the middle of January the *Minion* finally set sail for England. One might have expected her to head straight home, but it seems that in their rejuvenated state the English could not resist one last act of minor piracy: just off the Islas de Cies they overhauled a ship coming from the Canaries, and took off her leather bottles of sweet malmsey.[26] On 25 January the *Minion* pulled up in the shadow of St. Michael's Mount, Cornwall.

TWENTY-SEVEN

The fleet had been expected back in England by the summer, but with no sightings of the ships and no news, there had been growing consternation at Hawkyns's prolonged absence. On 25 October 1568 the new Spanish ambassador, Guerau de Spes, wrote to Philip II from London that "the people here are much disturbed by the delay in Hawkyns's arrival, and are afraid that the Portuguese fleet has sent him to the bottom as reported by a ship which brings the news from Rochelle."[1]

News took time to spread from the Americas, and it is clear the Spanish themselves knew little or nothing of the events at San Juan de Ulúa. As the days went by, though, the rumors began to grow. By December the stories were weaving their way into what would become an international crisis that began in the Spanish Netherlands. Here the duke of Alva had been brutally suppressing a popular uprising, but in doing so had exhausted the finances of the Spanish crown. As a result his soldiers had been unpaid for weeks. To head off widespread mutiny, Philip II borrowed half a million ducats in silver bullion from a Genoese banking house, to be delivered to Antwerp by a small squadron of unarmed Spanish ships. In late November, however, the vessels carrying the treasure were swarmed over by as many as fifty privateers—most of

them English with commission from the Huguenot leader the prince of Condé. The Spanish fleet dispersed and took refuge in Southampton, Plymouth, Falmouth, and Fowey, where a tense standoff persisted between hunter and hunted.[2]

The English government found itself in a dilemma: the last thing it wanted was for the money to reach Alva and revitalize his Netherlands campaign, but it would be a scandal of outrageous proportions to allow the privateers to grab the booty. With the port authorities in cahoots with the privateers—William Hawkyns, for example, had only just stepped down as mayor of Plymouth—and already beginning to unload the treasure for "safekeeping," Elizabeth attempted to stall the process by offering Alva two choices: she could supply a squadron to accompany the silver to Antwerp, or it could be unloaded and carried overland to Dover. Alva sent word that he preferred the second option, and on 2 December a deal was reached.[3]

It was now, however, that Benedict Spinola, an Italian banker who had invested in Hawkyns's second and third voyages, picked up on a rumor that disaster had befallen the English fleet. He sent word to William Wynter, who was at that very moment sailing to Plymouth to protect the Spanish fleet. The next day William Hawkyns asked Cecil to call an immediate meeting with Spinola to get the full details of what had happened to his brother John. He also demanded that if the story should prove true, he be allowed to exact full retribution. "There might be some stay made of King Philip's treasure here in these parts," he asserted, "till there be sufficient recompense made for the great wrong offered."[4]

The Spanish rightly felt vulnerable. Details of events in Mexico had begun to reach them, too, and as they sat in English harbors the last thing they needed was for their hosts to hear of the battle at San Juan de Ulúa. One Spanish officer on a ship holed up in Fowey attempted to spread disinformation: on 6 December he wrote that he had heard in Spain that Hawkyns had successfully collected slaves, sacked ships, and attacked the town of Rio

de la Hacha. His fleet was weighed down with gold, silver, pearls, and jewels such that "the worst boy in those ships might be a captain for riches." But he had tarried too long at San Juan de Ulúa and missed the winds. He would be spending the winter in Mexico and would not make it home before the end of May.[5]

It was a desperate ploy that had little effect. Seeing the urgency of the situation, Guerau de Spes sent out copies of the agreement signed with Elizabeth at the beginning of the month to all ports where the Spanish ships were sheltering, but on 8 December the treasure in Southampton was seized by the authorities, and in Plymouth sixty-four cases of silver coinage were carried to the guildhall for "safekeeping." At about this time Cecil met with Spinola. What he learned was more interesting than simply the rumor of Hawkyns's mauling: Spinola told Cecil that until the moment the bullion was delivered in Antwerp, it still belonged to the Genoese banking house. Elizabeth was immediately informed, and in an act as audacious as it was treacherous, she asked whether the bullion could be diverted to her as a loan. The answer was yes. The deal was quickly done: the money being offloaded in the country's ports became English, half to be used to improve the navy, the other half to go to the beleaguered prince of Orange.[6]

The Spanish were incensed: de Spes demanded the return of the treasure, but was told bluntly that it would no longer be going to Antwerp. In retaliation, Alva ordered the seizure of all English property and all English ships in the Netherlands. It was as understandable as it was illegal by international law. In early January, Elizabeth issued an edict that "instructed all her magistrates to arrest all the subjects of the said King of Spain living in this kingdom, along with their goods and wares."[7] All trade with Spain was banned, and Elizabeth's subjects were prohibited from traveling to any region of the Spanish king. There were many Spanish ships in English ports, and every one of them was seized. Spanish sailors and merchants were thrown into prison, order was given that the treasure should be removed to the Tower of

London, and the Spanish ambassador was castigated by the Privy Council as "an unworthy person with so little discretion."[8]

Into the middle of this controversy sailed Francis Drake. On 20 January 1569 the *Judith* pulled into Plymouth bringing bad tidings. Drake came ashore and sought out his cousin, to whom he told the full story of the Spanish attack in Mexico. William Hawkyns sent him straight to London with two letters demanding that he be allowed to avenge the losses at San Juan de Ulúa. He asked for permission to take compensation from the stayed Spanish goods, and for a commission of four ships to carry out reprisals. The first letter was addressed to William Cecil and stated that his brother John's absence "unto me is more grief than any other thing in this world, whom I trust God hath preserved will likewise preserve, and send well home in safety."[9] The second letter, directed to the Privy Council, repeated the request for revenge, pointing out that the chances of his brother's safe return were now "very dangerous and doubtful, but that it resteth in God's hands."[10]

TWENTY-EIGHT

L ess than a week later, John Hawkyns's arrival off the Cornish
coast was announced to his brother by a man dispatched
from the *Minion* to Plymouth. The messenger took news of the
stricken state of the vessel, of the many deaths and the immedi-
ate need for cables and anchors. William hastily organized a bark
loaded with victuals, two anchors, three cables, a store of special
rope, and thirty-four sailors. Within days John Hawkyns was
back in Plymouth,[1] where, amid the general celebration and re-
lief, he learned that both the *Judith* and the *William and John*
had made it home—the latter had not perished after all, but had
reached Ireland with the help of a Spanish vessel. Such obvious
pleasure at his return was not enough, however, to hide some dis-
content that he had abandoned white men in Mexico, yet arrived
home with black Africans on board.[2]

In Plymouth the Spanish treasure had been packed into
ninety-one boxes and was ready to go. Arthur Champernowne was
in charge of transporting it to London, accompanied by fifty horse
and fifty foot soldiers. John Hawkyns joined forces with him,
adding to the pile four or five boxes of gold, which, according to
the Spanish ambassador, amounted to twenty-eight thousand gold
pesos and a box of pearls.[3] No mention was made of what happened

to the surviving Africans. It has to be assumed that they stayed in England, possibly employed as sailors on ships leaving Plymouth, or more likely as exotic servants to London's rich.

The treasure cortege arrived in London on 13 February, and on hearing of Hawkyns's approach, the Portuguese ambassador wrote to Cecil with a request that they should meet to thrash out the matter of the Guinea traffic once and for all.[4] Guerau de Spes, the Spanish ambassador, reported to Philip II, "Hawkyns has come from the Indies, and entered here with four horses loaded with the gold and silver that he brings, which, however, I believe will not pay the costs."[5]

A MONG THE many concerns Hawkyns faced—the rescue of the men in Mexico, his reports to the syndicate that backed him and to the queen herself, the normalization of his family life, and the return to English business and political life—the scale of his losses in the Americas was uppermost in his and his backers' minds. There were some who did not feel that he was telling the whole truth, and believed that he had brought more treasure off the *Jesus* than he was owning up to. By early March Hawkyns felt the need to write to Cecil on the matter:

> *I have to pray your honour to suspend your opinion of me for that although I have had a painful journey yet because it hath not had a prosperous end, there are some which can be contented to speak the worst in everything and to find many faults.... I pray you to consider the manner and quality of the person that speak ill and could be contented to have me ill thought of.*[6]

Toward the end of the month, at the behest of two of the expedition's senior backers, William Garrard and Rowland Heyward, an inquiry was begun in the High Court of the Admiralty into the events at San Juan de Ulúa. The inquiry, which lasted

until July, was in many ways a pointless exercise: it sought to establish the size of the losses incurred by Hawkyns, but the claims made were undoubtedly exaggerated, and would never be recompensed by the Spanish. It felt like an exercise in clearing the decks, of tying up the loose ends of the expedition, at least as far as the financial backers were concerned.[7] Among the witnesses at the inquiry were John Hawkyns himself; the captain of the *Minion*, Thomas Hampton; a merchant adventurer from the *William and John* by the name of William Clarke; John Turren, who had sailed as a merchant's factor on the *Jesus;* Humphrey Fones, who had been the overseer of victuals on the *Angel;* and a servant of Hawkyns called John Tomes. The emphasis was very much on men who had knowledge of the merchandise loaded in England, how well it had sold, and the size of the pot of treasure Hawkyns had accumulated by the time they left Cartagena and turned for Mexico. Important players in the fleet, most notably Francis Drake, were not called upon to give evidence.

The fleet, with its merchandise, victuals, furniture, and clothing, was valued at almost seventeen thousand pounds on the day it departed England. The value of the fleet had increased enormously as it had progressed to Africa and then the Americas. The inquiry discussed and agreed to a schedule of losses suffered at San Juan de Ulúa. It listed the ships and their equipment, linens, cloth, dyed sheets, woolen goods, mountains of pearls, gilded swords, wax, a small sack of gold worth £2,400. There was mention of silver plate and silver currency, casks of Cretan and Spanish wine, butts of malmsey and sherry, packs of cloaks, and the personal clothing of John Hawkyns—estimated to be worth an astonishing £300. Item eight on the list stated:

> Likewise on an articled
> ship called the *Jesus,*
> and three other ships,
> aforesaid, or on some

of them, 57 black
Africans, commonly
called negroes, of the
best kind and stature,
each worth 400 pieces
of gold in the regions
of West India £9,120[8]

It is an inaccurate detail because twelve of the fifty-seven were removed from Mexico on the *Minion*. Nevertheless, it demonstrates, if it was ever in doubt, just how valuable Africans were to the financial success of the Hawkyns fleet. With the sale of slaves, Hawkyns had been able to accumulate a treasure trove that, it was claimed, included "whole bars of gold, and pieces of gold pesos, of silver coriente, wrought plate of silver, pearls." All of this, William Clarke would tell the court, was stored in chests and bags on board the *Jesus*. The treasure alone was worth almost thirty thousand pesos of gold, a figure equivalent to £240,000, though a substantial portion of this was brought off the flagship before it was abandoned. In its final reckoning the court agreed that as a consequence of the Spanish action in Mexico the expedition had sustained losses in the region of £30,000. It was a hefty sum for the financial backers to absorb.[9]

Hawkyns's sense of grievance and need to defend himself led him to write down his own version of the third voyage. *A true declaration of the troublesome voyadge of M John Haukyns to the parties of Guynea and the west Indies, in the yeares of our Lord 1567 and 1568* was published in a small print run in the early summer 1569, though it eventually reached a greater and more enduring audience when included in Richard Hakluyt's popular *The Principall Navigations, Voyages, Traffiques and Discoveries of the English Nation* twenty years later.[10] For the normally guarded Hawkyns, this was a detailed, though selective and partial, account of a difficult journey made disastrous by Spanish treachery. It concluded with a plaintive lament that echoed the

letter he had sent to Cecil from Mounts Bay: "If all the miseries
and troublesome affaires of this sorowfull voyage should be per-
fectly and thoroughly written, there should neede be a painfull
man with his pen, and as great a time as he had that wrote the
lives of the martyrs."[11]

Twenty-Nine

The Spanish saw San Juan de Ulúa in a completely different light. It was a great victory over the English, a marvelous trouncing of a heretical pirate. In 1570, Alvaro de Flores penned a stirring poem to celebrate the triumph of "The friends of Jesus." It was a work of epic proportions, almost four hundred lines long, that celebrated the conflagration in all its visceral glory:

> *Today we drench our hands*
> *In the blood of the Antichrist,*
> *Dying like Romans*
> *And as faithful Christians*
> *For the faith of Jesus Christ.*

The issue of religion and heresy was of the utmost importance to the poet, and in so writing he gives some useful information on the scale of English losses:

> *One hundred and thirty Lutherans*
> *Did die, without counting the wounded,*
> *And only twenty Christians*

Were there killed at the hands
Of the godless dogs.[1]

Among the many "godless dogs" who died on the field of bat-
tle were John Lee, the Lombardy gunner who had been in the
personal service of the queen in London,[2] and George Hall, the
purser's mate.[3] Others who had been captured in the battle per-
ished from their wounds while languishing in prison at Vera-
cruz, including Richard Goodal, John Goodbody, William
Suitar, and an oddly named tailor who gave his name as Banfle.[4]
The Spanish took many prisoners, including all of the hostages
handed over on the Saturday before battle; Robert Barrett, who
had gone to confer with the viceroy in the immediate prelude to
the fight; and the band of musicians sent to entertain Enriquez
on the morning of hostilities. Valentine Green, John Farington,
Henry Morris, and David Alexander were among those who had
missed the boat as the *Minion* escaped, and were left on board
the *Jesus*.[5] Thomas Bennet was captured after being wounded
during the battle,[6] as was John Hicks, who had been shot in the
head.[7] Other prisoners included the coopers Richard Reed and
John Hall, the gunner Thomas Stephens, Thomas Hales, an ar-
morer, and a sailor, Noah Sergeant.[8]

For the Spanish there was much to do after the smoke and
carnage of battle cleared. First and foremost, there were the
spoils of war. Inventories of the stricken ships were produced,
their armaments listed in precise detail and then carried to
the island to bolster the defenses against reprisal attacks.[9] The
wrecked hulls sitting in the shallow waters of the port were
pumped, and basic repair work was carried out on their shattered
planking, to help them float long enough for them to be auc-
tioned.[10] A series of slipshod sales followed in which the *Jesus*
was eventually sold for six hundred ducats—an amount, Vice
Admiral de Ubilla complained, "the cables alone were worth—a
most grievous matter."[11] The Portuguese caravel fetched four
hundred ducats, while the *Swallow* and the French *Grace of God*

raised three hundred each.[12] Four years after the battle, John
Chilton, an Englishman living in Mexico, saw a large brass
demiculverin from the *Jesus* at Tehuantepec on the Pacific coast.
It had been "carried a hundred leagues [three hundred miles] by
land, over mighty mountains to the said city, to be embarked to
the Philippines."[13]

The Spanish authorities also organized a perfunctory inquiry
into the battle in which most witnesses toed the same line. Yet
there was discord and tension at the top of the command struc-
ture, much of it focusing on the premature signal to attack given
by Ubilla, and also the blurring of lines of command between
the viceroy and his general. Two years after the event, long after
it had ceased to matter, de Luxan was still attempting to clarify
his role in the attack.[14]

The English prisoners were rounded up, chained in gangs of
four, and marched two hundred miles to Mexico City, where
they entered the city as part of the elaborate celebrations to wel-
come the new viceroy. The greatest city in the Americas was now
approaching its fiftieth year as a Spanish settlement, and despite
the fact that much of the old town had been destroyed, it re-
tained an aspect of magnificence and solidity: the English pris-
oners would have seen no place as grand. Mexico City was
located in the midst of a rapidly drying lake, and access to the
city was by one of three great causeways. There were more than
fifteen hundred Spanish families living here, many of them in
fine houses of lime and stone. Out in the suburbs lived another
three hundred thousand Indians.[15] Writing in 1560, Francisco
Cervantes de Salazar noted:

> The streets are, without exception, so wide that two carts travel-
> ling in opposite directions can pass each other comfortably, while
> three can go in the same direction. The streets are very long and
> straight, and are lined on either side by rows of stone houses, high,
> wide and spacious, and no town of Spain, of equal size, can boast
> of such fine and substantial mansions.[16]

The central plaza was bigger than any in Europe, "a good bow shot over from side to side." Around it stood the palaces of the viceroy and the bishop, and the provincial governor had a house here, too. There was a hospital for venereal disease, and arcades and shops where vast quantities of merchandise were for sale. The city also boasted a courthouse, a jail, a town hall, a foundry, and a royal treasury where silversmiths worked diligently on the spoils of Zacatecas and Guanajuato. It positively bulged with friaries, nunneries, churches, and chapels.[17]

Water ran through all the streets, and there was a stone reservoir at each intersection from where it could be taken. For the sixteenth century this was a healthy city, with a temperate climate and a good supply of food. Beef, mutton, chickens, capons, quails, and guinea cocks were all very cheap, and bread was as good as in Spain, recalled Robert Tomson, a merchant from Andover who had lived there. There was plenty of fruit, too, to supplement the diet: apples, pears, pomegranates, and quinces. And the supply was guaranteed thanks to

> a great ditch of water that cometh through the city, even into the high Place; where come, every morning, at break of the day, twenty or thirty canoes or troughs of the Indians; which bring in them all manner of provisions for the city that is made and groweth in the country: which is a very good commodity for the inhabitants of that place.[18]

The English prisoners were escorted to a country house and orchard a mile out of town, where they were isolated from the general population, receiving visits only from the occasional charitable friar.

FOR THE men put ashore by Hawkyns, survival was difficult from the first day. They had stepped ashore into the midst of hostile Indians, and while searching for food they were

attacked and rounded up. Eight men were killed, and anyone wearing colored clothing was stripped naked. When the Indians realized they were not Spanish, they released them, pointing them in the direction of the nearest settlement. Shortly afterward, the party split up: one group of seventy-eight headed west under the leadership of Anthony Goddard; the other group headed north, and with one notable exception, out of history.[19]

For those heading west it was a tough walk, through a country where bramble and bushes tore at their naked flesh, and mosquitoes feasted on them. Cabin boy Miles Phillips wrote,

> They will suck one's blood marvellously, and if you kill them, while they are sucking, they are so venomous that the place will swell extremely even as one that is stung with a wasp or bee: but if you let them suck their fill and to go away of themselves, they do you no other hurt, but leave behind them a red spot, somewhat bigger than a flea-biting. At first we were terribly troubled with these kind of flies, not knowing their qualities: and resistance we could make none against them, being naked. As for cold, we feared not any: the country there is always so warm.[20]

Following the battle, word had gone out to all the ports in Mexico to be on the lookout for English stragglers. On 15 October Luis de Caravajal, mayor of Tampico, received news of the arrival in the harbor of his town of a large number of Englishmen.[21] He had them surrounded and threatened to execute the lot, offering the weak and the sick "none other surgeon but the hangman."[22] They were thrown into a pigsty and fed on sodden maize, while the Spanish-speaking Anthony Goddard was questioned by Caravajal. He spun a story of how his real name was Antonio Texeda, he was the son of Duarte Diaz of Punta Delgada, and he was a trader who had been kidnapped by John Hawkyns. His Spanish was good enough to convince Caravajal of his nationality, but not that he had been kidnapped. The mayor suspected he was a pilot engaged by the English, and therefore a traitor. Caravajal tortured

another of the Spanish-speaking prisoners, John Pomes, and interrogated him about Hawkyns's intentions. In his agony, Pomes constructed a story in which their captain had ordered them "to come to search for the port of this town with instructions that on discovering the same they should light three fires." These would be beacons to direct the fleet in, but they had failed to carry out their instructions, having got lost. This was sufficient to convince Caravajal that the men had to be moved to Mexico City. After three smothering days in the sty, the English were hauled before him and searched for money. Two hundred and nine pesos were removed, along with a velvet purse belonging to Goddard containing some pesos, two gold chains, and two gold jewels. Their names were taken, and seventy-seven of them were handed over to Antonio de Villadiego for transportation. They were tied together with cords, "four and four," and marched out of the town to be delivered to the royal court prison in the capital city. A seventy-eighth man was left behind to die.[23]

I T W A S a grueling and brutal two-hundred-mile march, relieved only by the kindness of friars and villagers along the way, who supplied food and resting places. Two Spaniards accompanied them, a kindly older man and a cruel youth who carried a spear and about whom Miles Phillips remembered,

> *when our men, with very feeblenes and faintness, were not able to go as fast as he required them; he would take his javelin in both his hands and strike them ... between the neck and the shoulders so violently that he would strike them down: then he would cry, and say, "marches! marches Ingleses perros! Lutheranos; enemigos de Dios!"*[24]

As they neared their journey's end, many people came out on horseback to stare at them. After several days of exhausting walking they entered Mexico City at four in the afternoon, along

the Calle de Santa Catarina, stumbling into the main plaza and the viceroy's palace. Juan Suarez de Peralta saw them enter the city: "The newcomers arrived with their feet, from their being barefooted, oozing blood, in tatters, most of them in their bare skin, with hair and beard extraordinarily long, turned into savages, without strength or spirit to offend a cat."[25]

The viceroy wanted to hang them all, and had already had a new gallows built, but his advisers dissuaded him, telling him that since no charge could be found on which to carry out executions, he should wait for word to arrive from Philip II.[26] In the meantime the ragged Englishmen were ferried by canoe to a hospital on the edge of town, where they met up with former comrades from the Hawkyns fleet: many of the men who had been captured during the battle. They also learned that it had been intended for them to go to a different hospital, but there were so many wounded and sick English there that there was no room.[27] Over the course of the next two weeks, fifteen or sixteen men would die, making room in the hospital of Nuestra Señora for the other Englishmen, so the prisoners all came together under one roof.[28]

When sufficient numbers had recuperated, the men were removed to Texcoco, twenty-five miles away. Here there were many houses of correction and workshops, and the prisoners were made to work alongside Indians carding wool. There was an irony the captured English slave hunters did not like; an indignant Miles Phillips would later note, "It was no small grief unto us, when we understood that we should be carried thither; and to be used as slaves. We had rather be put to death."[29]

His was not the only voice of discontent, and general revolt followed. One night the English prisoners attacked their guards and escaped. It was dark and raining heavily, and they had no guide. By morning they found themselves in Mexico City; by noon they were in front of an enraged viceroy, who once again threatened to hang them all. Instead, they were taken to work as laborers in one of his orchards, where they found Robert Barrett

and the seven surviving hostages from San Juan de Ulúa. The group was allowed two sheep and two loaves of bread a day as sustenance, and although this was very stretched, the number of prisoners was soon to be reduced.[30]

In March 1569 the viceroy decided he wanted to be rid of his English problem. Those prisoners well enough to travel were taken to San Juan de Ulúa, where de Luxan's treasure fleet was preparing to head back to Spain. The ships carried five hundred thousand ducats in silver bullion and *reales,* as well as a valuable cargo of ginger and cinnamon from China. Enriquez instructed de Luxan to take the prisoners and deliver them to the Casa de Contratación in Seville.[31] The general refused. He claimed to be wary of overloading his ships,[32] though with few soldiers on board he was probably more afraid of an uprising. He told the viceroy that the English "besides being heretics ... displayed great audacity in the disservice of your Majesty in all parts of the Indies," so it was too risky to take them.[33] They reached a compromise: when the ships sailed in the middle of the month, they carried with them thirty-two prisoners. Apart from the seven surviving hostages and two French sailors, there seems to have been no rhyme or reason to the selection process. These were not the gentlemen or the merchant factors, the old or the young. Among their number were men such as Valentine Green, who had guarded the Spanish hostages on the *Jesus of Lubeck,* the interpreter Anthony Goddard, and the musician Gregory Simon. There were coopers and sailors, gunners and tailors. The bugler Thomas Johns was carried to Spain, as was the armorer Walter Johns, and at least three cabin boys.[34] As they stepped onto the ships, all must have believed they were getting closer to freedom.

The remaining prisoners were taken back to Mexico City, where they were offered up for service in the homes and businesses of rich Spaniards.[35] In 1571 a second treasure fleet returned to Spain with Robert Barrett and ten others on board. For the remainder of the prisoners the three years after 1569 saw many of them progress from being servants to taking up jobs and

making a living. By 1572 they were dispersed all over the country, employed in a myriad of tasks, as miners, butchers, clothiers, armorers, carpenters, and muleteers. They lived in Mexico City, Puebla, Taxco, Texcoco, Guanajuato, and Zacatecas.[36] There were those who had done well: John Hawkyns's nephew Paul owned more than twenty small mines,[37] John Lee had built a reputation as a hosier in Mexico City,[38] Roger Armour had married,[39] and so had Thomas Goodal—a fact his brother-in-law Robert Barrett disliked intensely. Goodal was already married to Barrett's sister back in England, and responded to Barrett's anger with a defiant "the devil take his country because he had been married there at the hands of a married clergyman such marriage being consequently invalid."[40]

Not everything was working out positively. John Deadman, William Cook, Henry Condero, and Nicholas Anthony were all dead, the latter having been stabbed to death in the house of a Portuguese man named Don Hernando.[41] At least two of the men had become vagabonds,[42] while Roger Armour, Pablo de Leon, William Griffin, and John Gilbert faced serious charges after a brawl in a bar had resulted in a picture of the Madonna being splashed with wine.[43]

T HE Y EAR 1572 brought a terrible change of fortune for the English prisoners. In 1569, Philip II had established a tribunal for the Holy Office of the Inquisition in Mexico. In late 1571 its first chief inquisitor, Pedro Moya de Contreras, arrived in the country,[44] and by November 1572 he had issued a general prosecution of all the men from John Hawkyns's fleet still in the country. The warrant ordered that "all shall be taken prisoners in whatever place and locality they may be found, with seizure of their property, and that they be brought under custody and placed in the gaols of this Holy Office, that I may prosecute them."[45] Notices were posted around the country, and instructions were issued that "fetters and any other things which it may

be necessary to acquire in order to convey the prisoners be obtained at the lowest prices."[46] Thirty-one men were brought back to Mexico City and thrown into the secret prison of the Holy Office. Over the next eighteen months they were questioned, cross-questioned, tortured, and made to inform on each other in front of the tribunal. Each man was told to make the sign of the cross, kneel, recite the Lord's Prayer in Latin, and say the Creed, the Ave Maria, and the Salve Regina. On oath they were asked if they believed the sacraments, whether there remained any bread and wine after words of consecration, and if they agreed that the wine and bread were the body and blood of Christ.

In front of the inquisitors the men fought for their lives: they lied about their Protestantism, admitting that they had been to services during the voyage, but claiming they had been forced at the end of a whip. They said they had not listened to the onboard preachers, that they were really Catholics. In gestures of honesty they admitted their marauding activities in West Africa, but wisely denied all allegations of piracy and pillage in the Spanish Americas. Some denounced Elizabeth: William Lowe claimed that he was too young to remember the old religion of Philip and Mary, but added that "in the times of this witch of a Jewish Queen—may the Devil take her—we have been rank bad Christians not a doubt of it, and she has been the cause of our perdition and of those damnable Lutheran works."[47]

The inquisitors were frequently unimpressed by the answers, and sentenced at least ten of the prisoners to torture, a decision that was announced with a declaration that it would last as long as it took to force a confession of the whole truth "on the understanding that should he die under the torture or be injured thereby, or suffer effusion of blood or mutilation of limb, the responsibility and fault will be his."[48] A scrivener recorded every action and every utterance during sessions that could last up to two hours. Thomas Goodal burst into tears as he was led to the torture chamber. Here he was stripped naked, made to wear a pair of drawers, and had his arms lightly bound. There followed

six bone-breaking twists of the cord on his arms, and when that failed to elicit the desired response he was stretched out and tied to the rack, "whereupon he threw himself upon his knees in front of it and with tears implored that he might be treated with mercy because he had spoken the truth and they were likely to kill him there." There was to be no mercy: his left ankle was turned, then his right. With these in excruciating positions, the torturers then turned his left thigh. Still Goodal refused to confess his sins. A dampened hood was placed over his face, and water was poured down his mouth and nostrils. They removed the hood and asked if he was ready to admit his sins, but he said that he had spoken the truth and was drowning. The rack was tightened on his right thigh, and then on a fleshy part of his left arm. Goodal screamed and wept that his arms were broken, but still they continued: the hood was put back over his head and more water was applied. He started to confess, but then he retracted: when he said he had been a good Catholic the rack was tightened further still. He shouted that he had never believed in the Lutheran doctrine "and if he had said so it was from fear of the torture, and he revoked it." This was not what the inquisitors wanted. They needed to hear Goodal admit to having strayed into Protestantism—in order to repent, he had to admit his sins. The fact that he claimed to be a good Catholic who had never agreed with Lutheranism was, to them, simply unbelievable. Once more the hood was put on and water was poured over it. Goodal stubbornly repeated "that all he had declared was out of fear and that he had nothing further to say." The cords and rack were wetted with vinegar. For a fourth time he was smothered with the damp hood. Still he persisted. The rack was tightened: he screamed that "he was dying and would be glad when he was dead." On went the hood for a fifth time, but when it was removed he spluttered many times, "I have nothing more to say and can say no more even if you kill me with blows." The inquisitor called an end to the proceedings, warning that they would be continued later.[49]

Others who endured torture included John Gilbert, Miles Phillips, George Day, John Williams, Pablo de Leon, William Griffin,[50] and Morgan Tillert, who had both arms broken at the second twist of the cords.[51] John Breton broke down as he was being prepared in the torture chamber, and evaded the punishment by making a full confession.[52] When William Brown was put on the rack he begged for "a blow on the forehead with a bludgeon to kill him outright."[53]

The prospect of torture made an already appalling prison life even harder. Food rations were poor and the dungeons uncomfortable in the extreme. One sailor, George Day, built a reputation for violence: in separate incidents he pulled a dagger on a cellmate, battered two other inmates with his bare fists, and cracked John Williams's head open with a rock, "breaking a blood vessel and causing him a great loss of blood."[54] The Welshman John Evans was put on suicide watch after demanding two yards of rope and publicly declaring that he wished they would "burn him at the stake, for it would not be worse than being locked up in a cell, which was worse than Purgatory." His guards responded by placing a yoke around his neck.[55] In March 1573, Paul Hawkyns and Andres Martin were part of a foiled prison breakout that resulted in their receiving one hundred lashes and being paraded seminaked through the streets of Mexico City.[56] Three months later eight prisoners tried to escape by scraping a hole in their dungeon walls. Two stones had been removed before the alarm was sounded. David Alexander, Richard Williams, George Riveley, John Storey, and William Lowe were all flogged in the courtyard of the jail.[57]

After the questioning and torture were over, the inquisitors came to their decisions. These were made public at the first auto-da-fé in Mexican history on Thursday 28 February 1574. It was to be a huge spectacle: a dramatic representation of the Final Judgment on earth, with bonfires, chanting monks, crosses, and thousands of spectators. The event was advertised weeks in advance, and everybody from across Mexico, even in its farthest

reaches, was expected to make every effort to be there. Non-attendance was considered suspicious.[58]

On the night before the ceremony, officers of the Inquisition brought "fool's coats" for the English prisoners to wear—*sambenitos*, sackcloth aprons that stretched to the knees. Miles Phillips reported that the prisoners were so agitated that none got any sleep that night. Shortly after daybreak they were given a breakfast of bread fried in honey and a cup of wine. They then joined a procession of monks following the green cross, symbol of the Inquisition. Each of the Englishmen wore his *sambenito* and carried an unlit green candle. They were tied to each other by a rope around their necks. Although they did not yet know their fate, the style of *sambenito* was a key: black with pictures of flames meant death; two bars and a green cross meant reconciliation or abjuration.[59]

The route they took led to a large scaffold that had been constructed in the main plaza. The way there was lined with so many people that their horsebacked escort had trouble clearing a path. At the platform the prisoners climbed a set of stairs and sat in seats allocated to them in the order they would hear their sentences. There followed the inquisitors, the viceroy, the chief justices, and three hundred friars. When all were seated the auto-da-fé began. In a long, slow ceremony each of the accused heard his name called out, followed by his sentence. Roger Armour was first; his sentence followed a form that would become very familiar that day:

> [W]e condemn him to be led through the public streets of this city mounted on a saddle horse and naked from the waist upwards and that after the voice of the Town Crier shall have proclaimed his backsliding he shall be given two hundred lashes, after which he shall be sent to the galleys of His Majesty to serve as a galley-slave on the bench of rowers, without wages, for the time and space of six years.[60]

One by one the men came forward to hear their sentences. Of the thirty-one Englishmen, seventeen were sentenced to receive a whipping of either two hundred or three hundred stripes, and each of these was sent into slavery on the galley ships for up to ten years. Ten of the boys, who were judged too young to have known better, were treated compassionately and sent to monasteries for three to five years. And two men—Roldan Escalart and Andres Martin—were pardoned on the grounds that they were not English, that they were good Catholics and had been forced to join the voyage.[61] Finally, with daylight beginning to fade, George Riveley's name was called out. The thirty-one-year-old man from Gravesend, who had come out as a sailor on the *Jesus*, had repeatedly refused to acknowledge any dalliance with Protestantism. The inquisitors had refused to believe him. Sentence was pronounced. Riveley was to be

> taken on a saddled beast from this place ... with a halter on his neck, and wearing the cuirass and penitential garb of a condemned prisoner, through the streets of this city, with a crier announcing his crime, to the market place of San Hipolito outside this city ... and there he shall be garrotted until he dies naturally; and when this is done, his body and bones shall be at once publicly burned to ashes.[62]

It was sensational, and his punishment was immediate. Along with another penitent, a Huguenot arrested in a separate incident at Cozumel, Riveley was led by Anthony Delgadillo along the Calle San Francisco to where a stake had already been erected at San Hipolito. He was tied by his hands and feet, and the garrote was tightened around his neck. As soon as he was dead, wood was piled around him and lit. "In the midst of it was burned the body of the said Jorge Ribli, Englishman," the official report stated blandly, "in such a way that it was converted to dust and ashes."[63] Juan Suarez de Peralta called it "a most remarkable and fearsome

sight."[64] One other English prisoner, William Cornelius, was to suffer the same fate, having been caught lying to the Inquisition. His death, however, was delayed for a year.[65]

The next day the men to be punished were mounted on horses and stripped from the waist up. They were then paraded through the crowded streets with two town criers at their head shouting, "Behold these English dogs! Lutherans! Enemies to God!" Whip lashes rained down on them. By the time they got back to the Inquisitor's House the men had been pulped, their bodies black and red, swollen with great welts. They stopped briefly at the prison before being transported to San Juan de Ulúa and the waiting galleys that would become their homes for years to come.[66]

WITH TIME the names of those put ashore at Tampico and who had faced the Inquisition began to disappear from the records. Paul Hawkyns, John Storey, and Robert Cook were all given jobs as cleaners in the Audiencia chamber and chapel, and at different times suffered life-threatening bouts of typhoid.[67] Storey was eventually sent to Spain, where in 1578 he completed his sentence.[68] Paul Hawkyns, on the other hand, remained in Mexico for the rest of his life. In 1685, Martin Garcia Rendon applied for the stigma to be removed from his family: they were debarred from public life because his wife, Maria de Origuela, was descended from Paul Hawkyns.[69] David Alexander, who had been sentenced to three years in a monastery, was still in Mexico City in 1585, when he was found wandering the town dressed in silk, carrying a sword and a harquebus. He told the authorities that he was off to the Philippines to fight for God and the king, but the Inquisition intervened, impounded his weapons, and banned him from leaving the country.[70]

Others were even less fortunate. Thomas Ebren died while serving his sentence in the monastery of Santo Domingo.[71] John Perin, who was sent to a monastery for five years, had continual run-ins with the authorities. One of the friars called him a

"shameless rapscallion" for nightly adventures in which he scaled the monastery walls to spend time drinking, fighting, and mixing with prostitutes. Countless floggings and prohibitions could not prevent his misbehavior. Another of the friars said that Perin was "quite insufferable, haughty and headstrong, morose, insubordinate and impatient of correction." In 1576 he faced the Inquisition once again on a charge of having "fallen into a vicious life of carnal pleasures and gambling practices and drunken habits with which he has scandalised the holy places where he has been confined." He was sentenced to four years without wages on the galleys.[72]

Some of the men put ashore at Tampico did make it home and had remarkable stories to tell. In 1569, David Ingram, Richard Brown, and Richard Twide arrived home after claiming to have walked more than two thousand miles from Mexico to Cape Breton. Here they were given a lift in a French ship. Though their story was initially believed, and included in the first edition of Richard Hakluyt's *The Principall Navigations*, it was later expunged when doubt was cast over its veracity. Nevertheless, however they had actually made it back, there was no doubting they had made an incredible journey.[73]

The other, more widely believed story was that of the cabin boy Miles Phillips, who had been offered up to John Hawkyns by his parents. He arrived at Poole in Dorset in February 1583, almost fifteen years after the battle of San Juan de Ulúa. Drawn to misfortune like a moth to light, he had cheated death on several occasions and had had a series of astonishing escapes and unfortunate recaptures before finally driving home.[74]

THIRTY

Not for the first time John Hawkyns's slaving voyages were about to affect the wider politics of the era. Both he and his brother, William, had been keen to receive commissions of reprisals from the queen, which would allow them to recoup their losses at San Juan de Ulúa by legitimately attacking Spanish ships, but none were forthcoming. These were difficult and politically dangerous times. The Continent, it seemed, was ablaze. In the Spanish Netherlands, the duke of Alva had put down the Protestant rebellion with unbounded brutality. The ruthlessness with which he carried out his mission caused uprisings, led for the most part by William of Orange. Yet when he was forced out of the country, Alva continued to tyrannize the population. Simultaneously another bout of the seemingly perennial religious wars was raging in and around La Rochelle, from where the prince of Condé and Admiral Gaspard de Coligny commanded a formidable fleet of privateers.

Any deterioration in England's relations with Spain therefore had potentially serious repercussions, and these were reflected closer to home, too. In May 1568, Mary Stuart, Queen of the Scots, had fled into England demanding the protection and help of Elizabeth. Mary had been a constant vexation for Elizabeth,

but one against which her own good relations with Spain had given her much comfort. It was true that Mary Stuart was a Catholic, but Philip II had had no desire to see her wearing the English crown, as he judged that that could transform the British Isles into an annex of France. However, the events in Mexico, the seizure of the treasure fleet, and Elizabeth's obvious support for the prince of Orange in the Netherlands were making the Spanish king think again. The secretary of state, William Cecil, was only too aware of the danger of pushing Philip too far, and granting commissions of reprisal to the Hawkyns brothers would be like placing a lighted stick under a tinder pile.

If the Hawkyns brothers wanted to avenge their losses and to rescue the abandoned men, they would have to organize it themselves. As a consequence, there is some mystery over exactly what happened next, not the least in relation to Francis Drake. Hawkyns's cousin disappeared from the public record between his arrival in London in January 1569 and his marriage in Plymouth on 4 July of the same year. It might have been expected that he would appear before the inquest at the High Court of the Admiralty in March, but he was absent. This has opened the way to speculation: some historians say that he was instructed by Hawkyns to redeem himself and "do his worst" against the Spanish, and in particular to return to the Americas to exact some retribution, but the time frame seems too short. The Spanish historian Antonio de Herrera, writing in the first decade of the seventeenth century, claimed that Drake had been thrown into prison for three months. He had left San Juan de Ulúa, the Spanish historian argued, with a good proportion of the English fleet's treasure, which he divided up among his crew. This they intended to keep, while spinning a yarn about how it had been lost in the battle. This plan was scuppered when John Hawkyns pulled into Mounts Bay only a few days after Drake, who was punished accordingly. This seems unlikely, yet his whereabouts remain a mystery.[1]

For his part, in the immediate aftermath of his return to England, John Hawkyns may have commanded a convoy of sixty ships that were sent to resupply La Rochelle in April 1569. Beef and grain, arms and munitions, and volunteers were carried across the Channel. Salt, wine, sherry, cloth, and church bells looted from Catholic churches were brought back.[2] Nevertheless, rumors persisted of his imminent return to the West Indies, and the Spanish remained understandably edgy. On 26 December, Philip II informed Guerau de Spes that John Hawkyns had been spotted at the head of a fleet of twenty-two ships passing Cape St. Vincent at the southwestern tip of Portugal.[3] By February 1570 the ambassador was able to put his master's mind at ease: no fleet had sailed, and in fact he had met with Hawkyns in London. In June, de Spes passed on another rumor he was hearing: Hawkyns was in town to talk about a voyage to the Indies;[4] and by the end of the month he was writing to report, "Hawkyns has been sent post haste to Plymouth to finish the equipment of his three ships, with a like number of others which, it is believed, will go towards the Indies."[5]

Other stories reached Spanish ears thick and fast: Hawkyns was going to rescue his men, he was putting together a massive fleet to join up with the French to seize Florida, he was going to build a fort in West Africa. On 12 August 1570, Guerau de Spes wrote that he had heard that Hawkyns was in the final stages of preparation for an assault on San Juan de Ulúa. "He threatens to revenge himself well for the past injuries done him," noted de Spes, "and if he should fail in consequence of finding the island fortified he will do the worst damage he can."[6]

The truth was that the situation at home was too dangerous for the queen to allow Hawkyns to venture far. In November 1569, Catholic earls in the north of England had rebelled, and there was talk of the duke of Alva massing his forces to come to their aid: now was not the time to head off for the Americas. In 1570, Hawkyns continued to make plans for another expedition, and early that year Francis Drake headed to the West Indies in

two ships, for the sole purpose of plunder.[7] By the autumn, however, Hawkyns was making promises to the Spanish ambassador not to go to the Caribbean. He was working on another strategy, one aimed at getting back some of the men left in Mexico. In the first instance this meant getting the men taken to Spain in March 1569 released.

I F T H E prisoners who had been taken to Spain had imagined that their return to Europe would provide some relief, then they were badly mistaken. On arriving in Seville they were thrown into jail and left to scratch out a miserable existence in wretched conditions. The Spanish crown was unwilling to spend any money in accommodating them: they went for days without food, had little clothing and no blankets, and relied on the diligence and generosity of the English merchant Hugh Tipton. By 22 November 1569 the prisoners had signed a petition to Philip II begging to be allowed to collect alms so that they might supply themselves. The plea pointed out "the great misery and hunger and nakedness which we are suffering."[8] In early 1570 the number of inmates in the prison was swelled by the arrival of ten Frenchmen brought from Hispaniola. They were men from the ship Hawkyns had allowed to go free off Cartagena. All had been sentenced to perpetual banishment from the Indies.[9] It was only a matter of weeks before sickness took hold: on 25 February 1570 a letter signed by three of the prisoners was smuggled out to William Cecil. It told of the hunger and cold, of the kindness of Tipton and the duchess of Feria (who was a relative of the inmate George Fitzwilliams), and it added, "Of late a sickness and death hath begun amongst us, which before the date hereof hath taken away four of those that were in the Indies. And at this instant six more of the company lie at the point of death."[10]

Under diplomatic pressure it was agreed in April that two of the hostages Hawkyns had handed over at San Juan de Ulúa would be released. The prisoners agreed on were Thomas Fowler

and Christopher Bingham. Unfortunately, the latter had been dead for more than two months, having succumbed to "spotted fever" on 16 February 1570.[11] Days earlier the body of Richard Temple had been placed at the door of the prison for removal following a terrible bout of sleeping sickness.[12] Barely a week later William de Orlando also died.[13] In July, Henry Quince followed them to the grave.[14] By June even the prison authorities were expressing concern, writing to Philip II, "[T]heir imprisonment has been so long and they are very naked and ill and dying in it, we beg your Majesty to decide soon what shall be done with them."[15]

IN AUGUST 1570, George Fitzwilliams was allowed to leave prison. His release would have a profound effect on the consequences of Hawkyns's voyages, and draw him into the heart of a notorious international conspiracy to assassinate the queen and restore the country to Catholicism.[16] In February 1570, Pope Pius IV had issued a bull of excommunication against the heretic queen Elizabeth; it called for her to be deposed. Soon after, a papal spy, Roberto Ridolfi, moved to London with the aim of bringing the queen down. Ridolfi, a Florentine banker, hatched a plot that would involve tying what he believed to be popular disaffection with Elizabeth to an invasion by Spanish forces under the dukes of Alva and Medina. Together they would place Mary Stuart on the throne. In February 1571, Mary gave her support to the conspiracy, and a month later the Catholic duke of Norfolk agreed to head the English revolt. As a precondition for Spanish support, the queen was to be assassinated as she made her autumn progress through the country.

William Cecil (who in 1571 was raised to the peerage as Lord Burghley) had caught a scent of the plot, and began to activate his network of spies and double agents. He knew that to carry out an invasion of the scale being contemplated, the Spanish fleet would have to be massive. He also knew that Philip II had insufficient ships to carry the thousands of soldiers it was envisaged

would pour into England from Flanders, and that the king was worried about having to confront Hawkyns and the Plymouth fleet at the mouth of the English Channel. Both sides knew that Hawkyns was the key to the scheme's success or failure. Over the coming months, the Ridolfi affair would become a murky plot of deception, intrigue, and double-dealing from which Hawkyns would not emerge unscathed. Indeed, while the balance of probabilities suggests that Hawkyns went undercover for Burghley, it is far from clear how close the Plymouth man came to treachery.

Hawkyns had a long record, stretching back to the days of Guzman de Silva, of apparently confiding in Spanish ambassadors about his discontent with the political-religious situation in England. The evidence of his ambivalent attitude to religion during the slaving voyages suggests that this was not all make-believe. Nevertheless, there can be no doubting Hawkyns's continuing annoyance at his misfortunes in the Americas, and his concern at the plight of the English prisoners. Throughout the first half of 1570 he pushed their cause with Guerau de Spes, and the release of Fowler and the deceased Bingham, along with that of Fitzwilliams, may be evidence of his successful diplomacy. Yet even while holding convivial, conspiratorial talks with the ambassador, he also let it be known that he was considering a fleet to go against the Spanish in Mexico, that he might challenge the Spanish in the Indies, and that he might seek retribution by attacking Spanish ships wherever he found them.

In September reports flooded in from Spanish agents warning de Spes that Hawkyns was indeed about to sail for San Juan de Ulúa. De Spes took the news without flinching. Philip II's new wife, Anne of Austria, was about to set sail from Flanders, and the ambassador correctly assumed that Elizabeth would be so nervous about the high level of Spanish traffic in the Channel that if Hawkyns really intended to go to Mexico she would prevent his leaving. De Spes had other reasons for his confidence. In letters to Madrid he revealed that Hawkyns was so bitter about the way he

had been treated since arriving home that he had privately of-
fered to abandon any attempt at a voyage to the Caribbean,
though he was still concerned for the release of his men. On 2 Sep-
tember the influential Spanish merchant Antonio de Guaras
wrote, "I cannot bring myself to believe it," but de Spes confirmed
it nine days later when he reported to Philip that Hawkyns had
solemnly promised him that he would not to go to the Indies.[17]

Over the coming months Hawkyns pushed the issue with de
Spes. In the process, his offer changed from one of merely prom-
ising no harm to one of positively offering help. As the two men
became fully acquainted, the Spanish ambassador came to be-
lieve that scratch the surface, and Hawkyns was a man whose
Catholic loyalties and devotion outweighed his public patriotism.

Throughout 1571 the Ridolfi plot thickened, and Hawkyns,
with the help of Fitzwilliams, became embroiled in, and in many
ways integral to, the Spanish scheming. Fitzwilliams, a man of
known Catholic beliefs, carried messages to Philip II in Spain
and to the imprisoned Mary Stuart. In a series of meetings, he
convinced both that Hawkyns was a good Catholic, heartily sick
of the heretical Elizabeth, and ready to help bring the Spanish
invasion to fruition. All he asked was the release of the remain-
der of his prisoners in Seville. Tokens—rings and gold-bound
books—were passed between Mary and Philip II to prove their
trust in the scheme.[18] By the summer Guerau de Spes was laying
to rest any lingering doubts over the reliability of Hawkyns. In a
letter of 12 July 1571 he wrote that Fitzwilliams and Hawkyns

*have always been looked upon as Catholics, and Hawkyns is am-
bitious and expects to rise to great things if the Government here
is changed and he serves your Majesty. This, I think, is his motive
for entering into such affairs, which may result in great profit,
particularly if he allows your Majesty's soldiers to out-number
Englishmen in the ships. The only fear is lest [Burghley] himself
may have set the matter afoot to discover your Majesty's feelings,
although I have seen nothing to make me think this.*[19]

By August, after a series of negotiations in the Escorial, Philip II's palace just outside Madrid, Fitzwilliams and Philip II's adviser the duke of Feria drew up and signed an agreement that Hawkyns would keep a fleet of the queen's ships fully equipped, with 420 guns and 1,600 men, for two months. In September or October, when the duke of Norfolk rose against Elizabeth, the duke of Medina would sail from Spain, and Hawkyns would desert his post in Plymouth.

On 4 September, Hawkyns wrote to Burghley, "The pretence is that my power should join with the duke of Alva's power." It was planned that he would collect Alva and his army in Flanders and carry them across the Channel. Together with Medina they would put Mary Queen of Scots on the English throne. Hawkyns warned Burghley, "They have practised with us for the burning of Her Majesty's ships, wherefore there should be some good care had of them, but not as it may appear that anything is discovered."[20] In return for his help, Philip II had granted Hawkyns a royal pardon for his activities in the Americas, made him a Spanish noble, and awarded him a monthly allowance of almost seventeen thousand ducats to pay for the preparations for invasion. By September the remaining prisoners in Spain were free, each with ten pesos in his pocket and the best wishes of Philip II.[21]

In the same letter to Burghley, Hawkyns also claimed that Philip had sent Mary an expensive ruby, and the message that "[h]e hath now none other care than to place her in her own." Fitzwilliams had been to see the Queen of Scots "to render thanks for the delivery of our prisoners which are now at liberty"; but Hawkyns cautioned, "Their practices be very mischievous; and they be never idle; but God, I hope, will confound them! and turn their devices upon their own necks!"[22]

That Hawkyns could so openly divulge the secrets of his negotiations to Burghley suggests that de Spes's fear that the secretary of state "himself may have set the matter afoot" was true, and that all along Hawkyns had been a double agent. Certainly it was true that throughout the negotiations with the Spanish

embassy, and indeed the Spanish king, Hawkyns had kept in constant touch with Burghley. However, it was only in this letter that he appears to have openly revealed the depth of his plotting. Of course, Burghley might have known from other sources: the men were certain to have talked, there were bound to be intermediaries, and there are sure to be letters missing. Nevertheless, there is no firm evidence that he came clean until just as the Ridolfi plot was about to fall apart. The plot had in fact been in disarray for some time. In May 1571 letters from Ridolfi to the bishop of Ross, Mary Stuart's ambassador in London, had been intercepted at Dover. Arrests had followed, and under the threat of torture Ross had implicated both his mistress and the duke of Norfolk. Just three days after Hawkyns's crucial letter to Burghley, on 7 September, Norfolk was sent to the Tower of London; by June 1572 he had lost his head on the executioner's block.

It is possible that realizing the danger he was in, Hawkyns played the game as if he had been working for the English side all along. Once again the plot reveals moments of real ambivalence in Hawkyns: Was he what he claimed to be? What did he claim to be? Which side was he really on? Not for the first time, intelligent Spanish diplomats and senior councillors were seduced by his charm, and potential. They believed wholeheartedly in his Catholicism and the strength of his faith. When the plot finally unraveled he was not blamed by them. However, in light of the events at San Juan de Ulúa, the confiscation of his ships and cargo on his first voyage, and the treatment of the English prisoners in Mexico and Spain, it seems unlikely, though far from certain, that Hawkyns was genuinely conspiring with the Spanish. Burghley was involved throughout the plot: arranging access to Mary Queen of Scots, granting licenses to Fitzwilliams to go to Spain, and reading correspondence that passed both ways. It is certainly possible that Hawkyns was playing for both sides, biding his time while watching which way the breeze blew, though it is difficult not to conclude that his heart rested with Elizabeth. Soon after the whole intrigue was completed Hawkyns received

an augmentation to his coat of arms, ostensibly for his defeat of Miguel de Castellanos on the last slaving voyage. It seems unlikely that a man suspected of high treason would receive such a prestigious award.

One strange aspect to the whole affair persisted after the plot was exposed: Hawkyns and Fitzwilliams continued to push de Spes for action. As late as 12 December 1571 the ambassador wrote to Philip II that Hawkyns and Fitzwilliams were

firmly fixed on serving your Majesty, and [Hawkyns] is afraid of arousing suspicion, which, up to the present, he has not done. They are distressed and surprised that at such a time some decided orders have not been sent as to what they have to do. I have entertained them as well as I could, but if the decision is much longer delayed they will have to take some other course, as they have incurred great expense in the fleet which they now have ready.[23]

Perhaps they were trying to flush de Spes out. Just days after he sent this letter, the whole matter was finally settled. A plot by the Spanish ambassador to have Burghley assassinated was unearthed. He was expelled from the country. Even as Hawkyns and Fitzwilliams escorted him from Gravesend to Calais, de Spes was writing to Philip that "Hawkyns being very desirous of serving your Majesty gives me great facilities."[24]

THERE WAS a group of prisoners in Seville who would not benefit from the shenanigans of Hawkyns and Fitzwilliams. In 1571, Juan Velasco de Barrio sailed from San Juan de Ulúa at the head of the annual treasure fleet. On board one of his ships was a party of Englishmen that included the master of the *Jesus*, Robert Barrett. They were not there as prisoners, but as members of the crew. Among them Barrett became a pilot, Job Hortop a gunner; William Cawse worked with the boatswain, John Beare

with the quartermasters, Edward Rider and Geoffrey Giles with the ordinary seamen; and a boy called Richard acted as cabin boy.

After a stay in Havana, Hortop and Barrett distinguished themselves off the coast of Florida when their quick-wittedness saved the whole fleet from wrecking on Cape Canaveral. For a short while they were heroes, even being feted by the admiral. However, near the Azores they attempted to escape by jumping ship and sailing away in a pinnace. Their plan was discovered and they were placed in the stocks, where they remained until they arrived in Seville in August 1571. Here they were marched straight to the Casa de Contratación prison, from which their former colleagues would soon be leaving as part of the deal struck by Fitzwilliams. The new prisoners were kept apart from the others and prohibited from communicating with them. The Spanish stayed quiet about their presence in the jail, and the names of Barrett and his companions did not figure in any of the negotiations with Hawkyns. They became forgotten men. When, in September, the first prisoners were released, these men were not among them.

On 26 December seven of them broke out of jail, but five of them—Barrett, Hortop, John Emery, Humphrey Roberts, and John Gilbert—were captured and placed in the stocks for another eleven days. Soon afterward they were handed over to the Inquisition, and in February 1573 they were given their auto-da-fé in the center of Seville. Once again a great crowd gathered. As they mounted the platform there were cries of "Burn the heretics, burn the heretics!" Two hours later the crowd's wish was granted: Robert Barrett and John Gilbert were sentenced to execution. They were hurried to the stake and burned on the spot.

The rest of the men were sentenced to be galley slaves for up to ten years, their sentences differing from those in Mexico in that once the sentences were completed, they would be returned to Seville and thrown back into prison until dead. The gunner Job Hortop, who wrote a picturesque account of his experiences, was

sentenced to ten years on the galleys. It was, as he described it, a harsh experience:

> [W]e were chained four and four together. Everyman's daily allowance was twenty six ounces of coarse black biscuit and water. Our clothing for the whole year, two shirts, two pair of breeches of coarse canvas, a red coat of coarse cloth soon on and off, and a gown of hair with a friar's hood. Our lodging was on the bare boards and banks of the galleys. Our heads and beards were shaven every month.
>
> Hunger, thirst, cold and stripes, we lacked none!

Hortop actually served twelve years on the galleys and a further four years in prison, and then, while engaged as a household drudge to Hernando de Soria, treasurer of the king's mint, he escaped on a flyboat, arriving home in England just before Christmas 1590, twenty-two years after the battle of San Juan de Ulúa.[25]

EPILOGUE

In the autumn of 1619, John Rolfe, recorder of Virginia, based in the English tobacco-producing colony of Jamestown, jotted down: "About the last of August came a Dutch man of war that sold us twenty negroes."[1] The Dutch ship had been cruising the West Indies loaded with African captives and, according to legend, was running short of food and about to throw its human cargo overboard. The sale of Africans in Jamestown, at the mouth of the Chesapeake Bay, constituted the first trade in slaves in an English colony, and possibly the first such sale in North America. It did not open the floodgates—the following decades witnessed only a trickle of Africans into the region—but the existence of an English colony willing to buy slaves was a new development. It had been missing when Hawkyns made his voyages, but had it been there earlier, the settlement might have played a significant role in the success of his voyages.

It had been more than fifty years since the debacle of San Juan de Ulúa, a half century that marked a hiatus in English slave trading. Hawkyns had shown the way, but he had also demonstrated the cost. His three voyages were considered an experiment, a tentative exploration of the Spanish monopoly, and while they had shown that when things went well the returns could be

good, the third voyage had also confirmed the high degree of risk involved. Most important, it had become clear that though there was a market for slaves in the West Indies, it was not yet great enough to attract sustained major investment by English capitalists. Assuming they came home safely, there would always be decent profits for small-scale operations like Hawkyns's fleets, but even on these voyages there was difficulty in selling all of the captives: Lovell had dumped one hundred Africans at Rio de la Hacha and returned home with fifty in the holds of his ships; at the onset of the battle at San Juan de Ulúa, and despite having trawled the Spanish Main for months, John Hawkyns still carried fifty-seven unsold slaves. In short, the market remained relatively small, the returns were insufficient, and the risks too high to attract an influx of capital great enough to make slavery a major English commercial activity. The country did not yet need slaves to drive her economy; when it did, when her colonies were in place, that would be a different story.

None of which is to say that English slaving activities came to a complete halt. There were undoubtedly others trading slaves in the final decades of the sixteenth century and the early years of the seventeenth, but they were such small-scale operations that they barely registered in the public records. These had been around for a while, some perhaps competing with Hawkyns for the dubious honor of being England's first slave trader—though the meager scale of their operations, the lack of official backing, their haphazard methods, and the poor recording of their activities largely disqualify them from the claim. In 1564 a Londoner called Cobham was accused of seizing a Portuguese ship and stealing "many negroes," and the Portuguese made numerous complaints about English pirates robbing slave ships off the Cape Verde Archipelago and the island of São Tomé.[2] In March 1567 the wife of one William Makepeace was seeking support from the Privy Council for her husband, who was a prisoner in Seville for trafficking in the West Indies without license—though it is by no means certain he was trading in Africans.[3] Later that same

year George Fenner traded five Africans he had captured in Guinea to the captain of a Portuguese ship encountered off Cornwall for forty chests of sugar.[4] In July 1570 the Spanish ambassador Guerau de Spes wrote to Philip II, "John Wyatt, an English pirate, has arrived here, who, having had some of his people killed on the coast of Hispaniola, and seeing that he could not trade there, came hitherward."[5]

Slivers of information reveal that in the winter of 1569 there were ships that intended to go to Africa and then the Caribbean, but tell nothing more of whether they went, what their purpose was, and how successful they were.[6] In March 1571 two ships belonging to William Cartes and William Nonnez, merchants of London, were forced to hand over bonds after rumors were spread that they were headed for Guinea and the Indies.[7] At about the same time, John Hawkyns and William Wynter were said to have sent as many as eight ships in the same direction, but hard information is as tantalizing as it is absent.[8] All one can say for sure is that the period marked at one extremity by the battle of San Juan de Ulúa and at the other by the arrival of the Dutch man-of-war in Jamestown was one in which slaving activity was negligible but not completely absent from English maritime life. Without colonies and without the economic need for cheap labor, the English attitude to slavery was ill-defined. In 1625 the explorer Richard Jobson was approached by a merchant on the Gambia River with the offer of slaves, but he turned them down, replying that the English "were a people who did not deal in such commodities, neither did we buy or sell one another, or any that had our own shapes."[9] If it was ever true, the later seventeenth century would see an end to that.

The missing ingredient to the Hawkyns expeditions had been English colonies craving slave labor. Interestingly, in 1625 the writer Samuel Purchas was to use Hawkyns as a justification for English expansion into the Americas in his *Hakluytus Posthumus; or, Purchas His Pilgrims.* He argued that for lack of a colony on the American seaboard the crew on the third voyage suffered

"cruel elements, crueller savages, cruellest Spaniards. . . . Had Sir John Hawkyns had a Virginian opportunity of refreshing, the first danger should not have needed, and the last had not proved worse than the first: that exposing being not far from the Virginian shore, and the current fitting to carry him thither."[10]

The main motive for setting up colonies in the Americas was profit. There were English settlers in Bermuda by 1609, and a first official colony on St. Kitts in 1624. Soon after, Barbados fell to the English, followed quickly by Antigua, Nevis, and Montserrat. By 1640 the English West Indies had a population in excess of twenty thousand, and that was before Jamaica was added to the list of English possessions in 1655. At the same time, colonies in Virginia and Massachusetts were laying down firm roots.

The jewel in this early imperial system was Barbados: many crops flourished there, but sugar was the greatest. In 1641, using money borrowed from the Dutch, the island built its first sugar refinery, and so set in train a revolution: smallholdings that had characterized the island's early settlement began to give way to huge plantations. Farms that had grown up using European peasant methods were swamped by large operations where the work was performed by African slave labor. For the plantation owners there were immense profits: by 1645 there were six thousand slaves at work in the fields of Barbados, five years later the island could boast three hundred plantations, and by 1673 there were more than thirty-five thousand Africans at work there.[11]

Figures for the scale of the slave trade are always controversial, but the number of Africans forcibly transported to the Americas would almost certainly fall within a very wide window of ten million to twenty million people, with as many as a third of the captives dying on the transatlantic journey. English involvement stepped up several gears toward the end of the seventeenth century, one estimate suggesting that the country's slave traders were responsible for shipping as many as three hundred thousand Africans between 1680 and 1700, and in the century that followed they carried more than three million slaves into British colonies

alone. In 1713, at the end of the War of Spanish Succession, the Treaty of Utrecht awarded the English the *Asiento*—the monopoly to supply slaves to Spanish colonies—for thirty years. England guaranteed to supply nearly five thousand captives a year: slavery rapidly became the country's biggest, most profitable business.[12]

England, and later Great Britain, got fat on the backs of slaves, becoming the biggest slave-trading nation on the earth. The Africans they shipped into the West Indies and North America were the fuel that drove the Industrial Revolution, powered the empire, and fired the nation's economy. Plantation owners and slave traders became immeasurably wealthy, and British ports boomed: Bristol became the country's second largest city, Liverpool a major world port. Slavery provided the capital that built the textile mills of Lancashire and Manchester, the steel mills of Sheffield, and the gun shops of Birmingham. National institutions were founded with money made from human bondage, the National Gallery, the Bank of England, Barings, and Barclays Bank among them, the latter with money invested by a group of Quaker slave traders in the West Indies.[13]

At the same time, the rape of Africa and the removal of a huge proportion of its populace had dire consequences for that continent. It was not just about numbers, but also a matter of who it was that was shipped: the captives were mainly the youngest, strongest, healthiest people. They were also overwhelmingly male. Their enslavement retarded development in Africa, devastated commodity production, stifled the internal market, destroyed any chance of early industrial or technological advancement, and altered irrevocably the continent's relationship with the outside world. In short, while African labor paid for the rest of the world to be propelled into the modern era, the African continent suffered arrested development.[14] And it was not just about the people who went: slavery, and the machinery of slavery, ate deep into the fabric of African life. It encouraged corrupt and greedy leaders willing to sell their own people to white men in exchange for baubles and trinkets, it whipped up violent and bloody inter-

tribal wars, it promoted kidnapping, and it encouraged the changing of laws so that once minor offenses now carried the major punishment of being sold into captivity.[15] It has been estimated that between 1650 and 1900 the population of Europe quadrupled while that of Africa increased by just a fifth.[16]

And in all of this John Hawkyns led the English. He was the first Englishman to trade in slaves, and the first to benefit from the triangular trade, whereby goods were carried to Africa, slaves to America, and precious commodities to England at a massive profit. Hawkyns was the first Englishman known to have sailed into the West Indies to trade with any sizable and deliberate operation, and the first Englishman to engage the Spanish militarily in the New World. He provided the blueprint for future incursions by the English and in many ways opened the eyes of his countrymen to the economic importance of the Caribbean and America. Riding roughshod over any moral qualms that some might have had, he showed the profits that were there for the taking, and demonstrated both the dangers that the trade held and the risks involved in challenging the Spanish. Between 1562 and 1568, John Hawkyns was responsible for shipping between fifteen hundred and two thousand slaves from Guinea to the Caribbean. In the same period the Spanish authorities sanctioned the transportation of just over four thousand slaves. Hawkyns's clandestine operation was responsible for supplying as much as half as many slaves as officially permitted in that period.

Perhaps most significant, John Hawkyns seduced royalty and opened a shameful line of Crown involvement in the dark trade. If Elizabeth's initial response to his first voyage was that it was detestable, a trawl through Hawkyns's balance sheets and a glance at the booty in his ships soon convinced her to reconsider. First one, and then two, of her navy's ships were dedicated to the slave hunts. Elizabeth had private audiences with John Hawkyns, gave him orders on the way he should exercise his duties, shielded him against the tirades and demands of Spanish and Portuguese ambassadors, covered for him while he carried on his business,

employed her ambassadors to fight his cause, and ultimately—despite the loss of the behemoth *Jesus of Lubeck*—made a very tidy profit. John Hawkyns was very much the queen's personal slave trader. There can be no mistaking the interest that she took: in 1575, while out walking in Richmond with Antonio de Guaras, she took the opportunity to raise the question of one of the English prisoners. The Spanish merchant would later report:

> *She was very gracious afterwards and spoke about Collins of Gravesend, who was captured in the Indies in one of Hawkyns's ships, and is now in prison in Spain; giving me the enclosed memorial about him. I said I would do my best for him, whereupon she replied: "You understand full well, old wine, old bread, and old friends should be valued, and if only for the sake of showing these Frenchmen who are wrangling as to whether our friendship is firm or not, there is good reason to prove outwardly the kindly feeling which inwardly exists."*[17]

Elizabeth's involvement in the slave trade set a royal precedent. In 1618 the queen's successor, James I, granted a royal charter to the Company of Adventurers to Guinea and Benin, whose initial role was to supply slaves for tobacco plantations in the fledgling colony of Virginia. Fourteen years later Charles I handed a license to ship slaves from Africa to a new syndicate.[18] The restoration of Charles II after the Civil War saw increased royal interest in the Atlantic trade. The newly formed Royal Adventurers into Africa was granted a monopoly in the trade for a thousand years. The duke of York was its president; he would have the initials DY branded onto the left buttock or breast of each of his own three thousand slaves before shipping them to the Caribbean sugar islands. The company's major shareholders included four members of the royal family, two dukes, a marquess, five earls, four barons, and seven knights. A new coin worth twenty-one shillings, the guinea, was struck with African gold.[19]

In 1672 the company was closed down and replaced with the Royal African Company, which had a monopoly on slave trading from the Barbary Coast to the Cape of Good Hope. Its governor was the duke of York, Charles II was among the major shareholders, and both retained an interest in two-thirds of all gold discovered in West Africa and claimed territorial rights over land controlled by the company.[20] By 1680 the company was transporting more than five thousand Africans a year, though of the seventy thousand captives hoarded onto English ships between 1680 and 1688 only forty-six thousand completed the journey alive.[21]

THE HAWKYNS slaving voyages were all undertaken at a moment of great change and ferment in Europe: the deepening crisis in the Netherlands, wars in France, domestic rebellions in England, doubts over survival of the monarch, and the connected problem of Mary Queen of Scots. All served to blur the wider importance of the expeditions, but the voyages were a symptom of England's need to carve out a place for herself in the world. From the middle of the sixteenth century the Atlantic routes, and indeed the ways to the East Indies and India, were becoming increasingly crowded. Spanish and Portuguese ships had been joined by growing numbers of French and Dutch men-of-war. The Hawkyns expeditions played a part in defining England's relationship to these other powers. Most important, the events at San Juan de Ulúa helped to augment a late-sixteenth-century cold war between England and Spain: it built resentment, suspicion, and jealousy into the two countries' dealings with each other, and helped foster an atmosphere in which piracy and skirmishes flourished. Some have argued that the battle made the Spanish Armada of 1588 inevitable. This is not true, but it did go a significant way toward developing the hostile climate in which the Spanish could realistically contemplate a full-scale invasion of England.

And what of Hawkyns himself? From instances in his slaving

voyages a man of pragmatism can be discerned, able where the moment demanded it to be either ruthless or compassionate. There was a tough self-centeredness to Hawkyns, born both on the streets of Plymouth and on the high seas. He was a son of privilege, who liked his comfort and luxury, despite having opted for one of the most uncomfortable professions possible. That amid the suffering and starvation of the *Minion*'s voyage home he remained well dressed and, from the reports in Vigo, well fed attests to his thick skin and his ability to get what he wanted through respect or intimidation. Hawkyns commanded admiration rather than warmth. It could be said that when dealing with Dudley's mutiny, he acted with a degree of compassion that was rare among captains of English ships. In others this might have been taken as a weakness. In Hawkyns it may just demonstrate his unalloyed self-confidence. In the rivers of Africa necessity demanded that he delegate to his junior officers: Robert Barrett, for example, seemed to command a great deal of responsibility. The evidence suggests that Hawkyns never felt threatened by passing on such powers, though there is no doubt that when Drake abandoned the fleet on the coast of Mexico Hawkyns was sorely aggrieved by his cousin's behavior. Nor can there be any doubting Hawkyns's charm or his intelligence. Despite his being a power in the West Country, there was never any guarantee of success or influence in London. That he quickly garnered so many powerful backers, and that he managed to gain the confidence so effectively of the Spanish ambassadors, is surely a testament to more than just his affability.

There is some evidence that Hawkyns was a troubled character—too much just to dismiss. These were dangerous times in the political circles in which he moved, and his clear ambivalence over religion was always a liability. In dealing with the Spanish wherever he met them—in the Canaries, the Americas, or the embassy—it paid to voice doubts over the prevailing religious situation in England. Elsewhere, if the sentiments were genuinely held, then it was wise that he kept them close to his heart.

Of course, one thing that never troubled Hawkyns was the morality of slaving. He was imbued with the racism of his time, and history has largely treated him with kid gloves. Criticism of his role in the slave trade has been repeatedly rebutted by his biographers, who have argued that the use of hindsight and modern political perspective is morally and politically anachronistic. They argue that Hawkyns would not have thought twice about enslaving Africans, because no such moral debate existed in the sixteenth century. Trading in human cargo was as natural to Hawkyns as trading in broadcloth, pearls, or gold. For four and a half centuries Anglophile historians have preferred to see John Hawkyns as a bold sea rover, a romantic figure with a salt-encrusted beard and the bulldog spirit coursing through him. The eminent Victorian Clements Markham, president of the Royal Geographical Society, wrote of Hawkyns's activities,

> No blame attaches to the conduct of Hawkyns in undertaking a venture which all the world, in those days, looked upon as legitimate and even as beneficial.... [T]he measure was adopted for philanthropic motives, and was intended to preserve the Indians. It was looked upon as prudent and humane, even if it involved some suffering on the part of a far inferior race.[22]

James Williamson, Hawkyns's most scholarly biographer, claimed that Africans should have been grateful for the help they were given to escape "bloody and capricious tyrannies to which the negroes were subject in Africa."[23] Others echo his sentiments: James Froude wrote in the late nineteenth century, "One regrets that a famous Englishman should have been connected with the slave trade; but we have no right to heap violent censures upon him because he was no more enlightened than the wisest of his contemporaries." Hawkyns, Froude added, went to Africa, where he "secured 400 human cattle, perhaps for a better fate than they would have met with at home."[24]

Others have been even more strident supporters: writing in

the 1930s, the South African C. R. Prance accused those who dared to reproach Hawkyns of "cant and *Uncle Tom's Cabin* sentimentality," inadvertently demonstrating how the issue of race has chased Hawkyns down the centuries. In his book *Knights of the Sea: A Viking Family,* Prance wrote:

> [B]ut for Hawkins, South Africa, as one of the great white countries of the coming age, on a foundation of Dutch-English-Huguenot blood, would never have come to birth. In its place would have been an oligarchy, only nominally a Republic, on the lines of the smaller Republics of Central and South America, with an upper-crust of diluted Iberian blood ruling a mob of hybrid Africans with a varying tinge of white. The statue at the foot of Adderley Street, instead of van Riebeeck, would have been that of a "conquistador," or of a hybrid Liberator of hybrids from the decaying yoke of Spain. And few, surely, will be found to say that the world would not have been a heavy loser by the difference.[25]

Yet it is not good enough to say that Hawkyns is above criticism, for there were voices even in his own time that found slavery repellent. The French philosophically opposed the trade: in 1571 the Parlement of Guienne declared, "France, mother of freedom, does not allow any slaves."[26] In the Spanish empire, there were powerful and influential dissenters, too. In 1560, Alonso Montufar, archbishop of Mexico City, wrote to Philip II that he did not know of "any cause why the Negroes should be captives any more than Indians, since we are told that they receive the Gospel in good will and do not make war on Christians."[27] In 1569 another Spaniard, Thomas de Mercado, voiced his concern that "when the Portuguese and Castilians buy a Negro because there has been a war, they create in the Ethiopians an interest in having more wars."[28] The cleric Bartolomé de Las Casas, whose writing on the suffering of the Indians had been partially responsible for the introduction of African labor, wrote shortly before his death that he no longer felt convinced that Africans

should be used to do Spanish work, for "it is as unjust to enslave Negroes as Indians and for the same reasons."[29] Even the period's greatest advocates of slavery, the Portuguese, had their own concerns. In 1555 the Portuguese cleric Padre Fernando Oliveira, who had served Henry VIII in England, violently denounced slavery, which he called a "manifest tyranny," and regretted that the Portuguese had been "the inventors of such a vile trade, never previously used or heard of among human beings."[30]

It is true that slavery was not the subject of great debate in England in the middle of the sixteenth century. It did not need to be debated, because there were no slaves, yet there were voices raised against it. In 1577, William Harrison wrote:

> As for slaves and bondsmen we have none, naie such is the privilege of our countrie by the especial grace of God, and bountie of our princess, that if any come hither from other realms, so soon as they set foot on land they become so free of condition as their masters, whereby all note of servile bondage is utterly removed from them.[31]

Harrison was merely echoing an English legal judgment of 1569 that ruled in the case of a Mr. Cartwright, who had brought a slave from Russia "and would scourge him, for which he was questioned: and it was resolved. That England was too pure an air for slaves to breathe in."[32]

Nonetheless, it remains true that Hawkyns was a man of his time. His encounters were among the first between Englishmen and Africans, and they were carried out on the basis of master and slave. He approached Africans as bestial, worthless savages, and he suffered few moral pangs as he ordered the loading of hundreds of captives into the dark holds of his ships or burned their villages to the ground. He arrived off Guinea viewing the people as entries in an accounting ledger. The suffering inflicted upon the slaves was truly dreadful, and his activities helped foster and confirm the prevalent racist attitudes of Elizabethan England.

Ironically, the Hawkyns voyages, and subsequent expeditions to Guinea by others, helped to create a black community in England. Many blacks, such as the Africans surviving the third voyage, were brought back to London, where they became trophies of the rich or were sold into domestic servitude. Others became sailors on merchant ships and interpreters for expeditions to Guinea.[33] As early as 1578 the Londoner George Best was noting, "I have myself seene an Ethiopian as blacke as cole brought into England, who taking a faire English woman to wife, begat a sonne in all respects as blacke as the father."[34] Black people became prized servants, and familiar figures at court. They were signs of opulence and extravagance for their rich owners. Others achieved a degree of independence and even freedom: there are records of black people paying taxes toward the end of the century, and some had even moved into the property-owning classes.[35]

By 1596, however, with the country's economy in a mess, blacks were identified by Elizabeth as a problem. She wrote to the lord mayor of London that "there are of late divers blackamoores brought into these realms, of which kind there are already here to manie, considerynge how God had blessed this land with great increase of people."[36] She then commissioned the rounding up of all "blackamoores" for deportation back to Africa. It was an unsuccessful command that was repeated, with equal lack of satisfaction to Her Majesty, in 1601.[37] Elizabeth, the slave mistress, would it seems be the first person to demand repatriation of black people—four hundred years before extremist right-wing groups such as the National Front and the British National Party echoed her call.

For John Hawkyns, slavery was but a stepping-stone in a career that history has painted with glory, but which in truth falls short of the hype. After returning to England he divided his time between London and Plymouth, and in the years that followed he twice acted as member of Parliament for Plymouth, in 1571 and 1572, and his privateering and small-scale trading activities continued unabated. It was a long while, however, before

he attempted any journey that came close to the scale of the three voyages in the 1560s. This was largely because in 1573 he succeeded his father-in-law, Benjamin Gonson, to the post of treasurer of the navy.[38]

In many ways the life of administration strained and bored Hawkyns. He struggled to come to grips with the finer detail of naval finances, and missed the practical, thrilling demands of the sea. Nevertheless, he was credited with a number of important innovations in the country's shipping stock: chain pumps were introduced to clear out leaks more effectively, keels were made longer and sleeker, sterns and forecastles were lowered. English ships were transformed from lumbering hulks into swift and versatile craft. Other improvements included boarding nettings, better methods of striking the topsails, and increased pay for sailors.[39] The result was that by the time the Spanish Armada arrived off the coast of England in 1588, the English navy was in a stronger state of readiness than it had ever been.

Hawkyns was number three in the command chain for that battle, and as a result of his activities on board the *Victory* he was knighted on 25 July 1588, alongside Martin Frobisher, by Lord Thomas Howard.[40] The remaining years of his life were, however, far from happy. He had been suffering terrible bouts of illness since 1581, when his life was believed to be in danger. In early January 1586 he endured fits every other day.[41] Ill health, lack of application, and the sheer quantity of work that came with the post of treasurer of the navy combined to overwhelm him, and Hawkyns earned a reputation for being curmudgeonly, short-tempered, and inefficient. He called on his brother-in-law Edward Fenton to help with the accounts, but this did little to stem the tide of complaints against him.[42] Allegations of corruption flew: in 1587 a series of articles alleged that he was "injust and had deceitful dealings"; among other things, he was accused of enriching himself at the expense of the navy.[43]

Several of the accusations are undoubtedly without substance; as treasurer of the navy Hawkyns would have had to make many

difficult and unpopular decisions, so it is not surprising that he made enemies. However, other charges raised eyebrows, even among Hawkyns's allies. It was said that ships in the building yard of Richard Chapman, a business partner of John Hawkyns, were built and fitted out with timber and equipment bought for royal naval ships. It was also said that Hawkyns bought wood cheaply and sold it on to the navy at an exorbitant rate. No formal charge was ever made, but Lord Burghley was moved to draw up a set of regulations that made such conduct impossible in the future. On the first draft of the code Burghley scribbled, "Remembrances of abuses past: John Hawkyns was half in the bargain with Peter Pett and Matthew Baker."[44] These were the shipwright and storekeeper at Chapman's Deptford yard.

In 1590, Hawkyns took to the sea again, joining Martin Frobisher in a fleet that had instructions to sit off the coast of Portugal and "do all possible mischief." Their aim was to attack the annual Spanish treasure fleet returning from the Indies, but forewarned of their presence, the fleet failed to turn up, and Spanish ships in ports around the country stayed put until the danger was over. The two fleet commanders returned somewhat embarrassed, Hawkyns writing to Burghley with the rather obtuse excuse that "God's infallible word is performed in that the Holy Ghost said, 'Pawle dothe plant, Apollo dothe watter, but God gyvethe the increase.' "[45] When Burghley passed the letter on to Elizabeth, it is said, she snorted, "God's death! This fool went out a soldier and has come home a divine."[46]

Five years later and not in the best of health, Hawkyns joined Francis Drake for what was planned as a major assault on the Spanish Caribbean. Twenty-seven ships carrying 2,500 men set off with plans to burn the port settlement Nombre de Dios on the Central American isthmus, march across Panama, and seize Spanish treasure that had been delivered up from Peru. On the way they would attack a treasure ship sitting off Puerto Rico. It was an audacious gamble that quickly unraveled. Drake and Hawkyns squabbled constantly over tactics, and when Drake

proposed an attack on Gran Canaria in the Canary Islands, the two clashed violently. Thomas Maynard left a vivid account of their "choleric speeches": "Now the fire which lay hid in their stomachs began to break forth, and had not the colonel (Thomas Baskerville) pacified them it would have grown further, but their heat somewhat abated they concluded to dine next day aboard the Garland."[47]

The attack was a farce, and by the time the English fleet reached the West Indies the Spanish were expecting them. The project was a disappointment for the English. Off the coast of Puerto Rico Hawkyns fell ill, and on 11 November 1595 he died. Three days later he was buried at sea. At the end of January 1596 he was joined in his watery grave by Francis Drake.

John Hawkyns left a substantial will that dealt generously with his wife, family, friends, and servants. It supported a number of important charities such as the Chest at Chatham, a fund for maimed and wounded sailors, and the Sir John Hawkyns Hospital, which had been built at Chatham in 1592.[48] He also left a legend that emphasized the events of his later years: the glory of smoke, gunshot, and fire ships against the invincible armada, the raids on the Spanish Main, and the death with Drake in the far-off Caribbean. All have a schoolboy hero feel to them, the selfless battle for country against foreign aggressor, the patriot stand against the evil Catholic empire, the Elizabethan rogue, the salty sea dog so fondly and vaguely remembered and reconstructed in the modern era. But John Hawkyns left another, more damning and important legacy, glossed over or hidden in the shadows of his early career. Here was a man who was directly responsible for the suffering of hundreds of West Africans, a man who indirectly set England on an enterprise at which she would truly excel—the enslavement and brutalizing of millions upon millions of innocent Africans.

In the popular eighteenth-century children's novel *Westward Ho!* John Hawkyns's wife looks up with regret at the roof of her house, upon which is emblazoned the family crest, the

"Demi-moor proper, bound," and says to the English adventurer Sir Humphrey Gilbert, "I tell you, Mr. Gilbert, those negroes are on my soul from morning until night! We are all mighty grand now, and money comes in fast; but the Lord will require the blood of them at our hands yet, He will!"[49] The novel was written at a time when the debate on slavery was still at its hottest in England. The real Mrs. Hawkyns would never have uttered such words; but had she, her husband would merely have shrugged his shoulders, rubbed his hands with glee, and pointed out the profit and public standing that he had achieved through human misery.

Notes

Introduction

1. Letter from John Hawkyns to William Cecil, 25 January 1569, PRO, State Papers, Domestic, Elizabeth, SP12/49.

One

1. Patent Rolls, 4 Edward 6, pt. 9, 12 July 1552.
2. Prince, *Danmonii Orientales Illustres.*
3. See Worth, *Calendar of Plymouth Municipal Records;* Bracken, *A History of Plymouth;* Walling, *The Story of Plymouth.*
4. See Baron, *Mayors and Mayoralties;* Bracken, *A History of Plymouth;* Worth, *History of Plymouth.*
5. See Gill, *Plymouth: A New History.*
6. Copy of exemplification of proceedings in the common pleas at Westminster, Easter, 1527, in Worth, *Calendar of Plymouth Municipal Records.*
7. See Lewis, *The Hawkins Dynasty.*
8. For a fuller explanation of this power struggle in Plymouth see Williamson, *Hawkins of Plymouth,* and Lewis, *The Hawkins Dynasty.*
9. See Andrews, *Drake's Voyages.*
10. See Williamson, *Hawkins of Plymouth;* and Gill, *Plymouth: A New History.*
11. "A voyage to Brasill, made by the worshipful M. William Hawkyns of

Plimmouth, father to Sir John Hawkyns, knight, now living, in the yeere of 1530," in Hakluyt, *The Principall Navigations.*

12. Ibid.

13. In Blake, *Europeans in West Africa,* document 6, vol. 2, sec. 3.

14. In Blake, *Europeans in West Africa,* document 7, vol. 2, sec. 3.

Two

1. See Worth, *History of Plymouth.*

2. Geoffrey of Monmouth quoted in Bracken, *A History of Plymouth.*

3. *The Faerie Queene,* bk. 2, canto 10, stanza 10.

4. See Jewitt, *A History of Plymouth;* Gill, *Plymouth: A New History.*

5. See Gill, *Plymouth: A New History.*

6. Cotton MSS, Augustus I.i,38.

7. See Baron, *Mayors and Mayoralties;* and Jewitt, *A History of Plymouth.* Sweating sickness first appeared in England in 1485 and seems to have disappeared after several epidemics in the late 1550s. It began with a fever and heavy sweating. Coma and death often followed.

8. See Jewitt, *A History of Plymouth.* This ritual battle was abandoned in 1782 because of serious injuries, and replaced by an event called Liberty Day, which proved even more troublesome, as schoolchildren used the opportunity to riot and loot the town.

9. Worth, *Calendar of the Plymouth Municipal Records.*

10. See Gill, *Plymouth: A New History;* and Bracken, *A History of Plymouth.*

11. See Gill, *Plymouth: A New History;* Bracken, *A History of Plymouth;* Jewitt, *A History of Plymouth.*

12. See Worth, *History of Plymouth.*

13. See Walling, *The Story of Plymouth.*

14. In 1527, William Hawkyns assumed his position in the front line when French pirates drove an Italian merchant ship into the sound and threatened to destroy it unless its merchandise was surrendered. Likewise in 1543 the town's audit books show William receiving jewelry and plate worth £37, 11s (shillings), 5d (pence). "This was spent by Hawkyns thus" the book quoted in Worth, *Calendar of the Plymouth Municipal Records,* notes: "10 barrels of gunpowder in London, 1009lbs at 5d per lb, £21 5s; 20 bows at 2s each, £2; [30] sheffe of arrows at [22] the sheaf, £2 15s; cwt of saltpetre and carriage, £2 15s. Other expenses, canvas for bow cases, etc, £3 19s 1d; left £5 1s 11d."

15. See Worth, *History of Plymouth.*

16. See Jewitt, *A History of Plymouth.*

17. See Worth, *History of Plymouth.*

18. See Jewitt, *A History of Plymouth.*

19. See Williamson, *Hawkins of Plymouth;* also Williamson, *Sir John Hawkins,* and Andrews, *Drake's Voyages.*

20. Mary Hawkins, *Plymouth Armada Heroes,* quotes a deed dated 8 February 1554 that states that one Henry Hawkins, clerk, "brother and heir of William Hawkins Merchant recently deceased, for a sum of money gives up land in Plymouth to William Hawkins son of Joan Trelawny."

21. See Williamson, *Hawkins of Plymouth,* and Froude, *English Seamen in the Sixteenth Century.*

22. Kingsley, *Westward Ho!*

23. From Edmund Spenser's *Colin Clout's Come Home Again,* lines 249–51. Attention drawn to the reference by Mary Hawkins, *Plymouth Armada Heroes,* and Markham, *The Hawkins' Voyages.*

24. Account of the battle between John Hawkyns and the fleet of New Spain in the port of San Juan de Ulúa, Conway Collection Add. 7257.

25. Evidence presented to the High Court of the Admiralty inquiry into events at San Juan de Ulúa: PRO, State Papers, Domestic, Elizabeth, SP12/53.

26. Purchas, *Hakluytus Posthumus,* vol. 16, chap. 4, pp. 131–33.

27. Maynard, in *Sir Francis Drake, His Voyage, 1595,* in BL, Add. MSS 5209.

28. See Lansdowne MSS, vol. 52, fol. 13, and vol. 53, cap 43, fol. 109, and also *Dictionary of National Biography,* vol. 25, Harris–Henry I, pp. 212–19.

29. *Dictionary of National Biography,* vol. 25, Harris–Henry I, pp. 212–19.

30. See Caraman, *The Western Rising.*

THREE

1. See *Dictionary of National Biography,* vol. 25, Harris–Henry I, pp. 212–19; Williamson, *Sir John Hawkins;* Williamson, *Hawkins of Plymouth;* Mary Hawkins, *Plymouth Armada Heroes;* Markham, *The Hawkins' Voyages;* and Gill, *Plymouth: A New History.* See also Hawkyns's wedding certificate MS 7857/1 of the parish register of St. Dunstan-in-the-East, London Guildhall Library.

2. "The first voyage of the right worshipful and valiant knight sir John Hawkyns . . . made to the West Indies, 1562," in Hakluyt, *The Principall Navigations.*

3. See Rumeu de Armas, *Los Viajes de John Hawkins a America.*

4. Thomas Nicols, "A description of the fortunate islands, otherwise called the islands of Canaria," in Hakluyt, *The Principall Navigations.*

5. For Hawkyns's dealings in the Canaries and the background of the de Ponte family, see Rumeu de Armas, *Los Viajes de John Hawkins a America.*

6. "The first voyage of the right worshipful and valiant knight sir John Hawkyns ... made to the West Indies, 1562," in Hakluyt, *The Principall Navigations;* Hope, *My Lord Mayor;* and Ramsay, *The City of London.* Thomas Lodge was perhaps the most interesting and unfortunate of the group. The year of his mayoralty was to be an *annus horribilis.* Caught up in a scandal over the theft of a dozen chickens from the lord mayor's table and ruined by the looting of one of his ships off Normandy, he would be insolvent by the end of his incumbency, stripped of his aldermanry within four years, and eventually bailed out of his horrendous debts by the queen, at the prompting of William Cecil and Robert Dudley, earl of Leicester.

FOUR

1. See Diffie and Winius, *Foundations of the Portuguese Empire;* Fage, *A History of West Africa;* Thomas, *The Slave Trade.*

2. See Blake, *Europeans in West Africa;* Diffie and Winius, *Foundations of the Portuguese Empire;* Prestage, *The Portuguese Pioneers.*

3. See Birmingham, *Portugal and Africa;* Boxer, *The Portuguese Seaborne Empire;* Diffie and Winius, *Foundations of the Portuguese Empire;* Prestage, *The Portuguese Pioneers;* Rout, *The African Experience;* Winius, *Portugal, the Pathfinder;* and see Livermore, "Portugal and the Prelude to the European Expansion"; Fernandez-Armesto, "Medieval Atlantic Exploration: The Evidence of Maps"; and Verlinden, "European Participation in the Portuguese Discovery Era," all in Winius, *Portugal, the Pathfinder.*

4. See Boxer, *Four Centuries of Portuguese Expansion,* and Verlinden, "European Participation in the Portuguese Discovery Era," in Winius, *Portugal, the Pathfinder.*

5. See Winius, "The Work of Don João II," in Winius, *Portugal, the Pathfinder.*

6. See Casson, "Setting the Stage for Columbus," and Corbett, *Drake and the Tudor Navy* for developments in shipping in the sixteenth century.

7. See Prestage, *The Portuguese Pioneers.*

8. See Blake, *Europeans in West Africa.*

9. See ibid.; Boxer, *Four Centuries of Portuguese Expansion;* Boxer, *The Portuguese Seaborne Empire;* Fage, *A History of West Africa;* Prestage, *The Portuguese Pioneers;* Rout, *The African Experience;* Thomas, *The Slave Trade.* See also Cadamosto, *The Voyages of Cadamosto.*

10. See Diffie and Winius, *Foundations of the Portuguese Empire,* and Prestage, *The Portuguese Pioneers.*

11. See Diffie and Winius, *Foundations of the Portuguese Empire;* Prestage, *The Portuguese Pioneers;* Rout, *The African Experience;* Thomas, *The Slave Trade.*

12. See Thomas, *The Slave Trade.*

13. Prestage and Beazley [eds.], *The Chronicle of the Discovery and Conquest of Guinea Written by Gomes Eannes de Azurara,* vol. 1, chap. 25, pp. 80–83.

14. See Diffie and Winius, *Foundations of the Portuguese Empire.*

15. See ibid.

16. Cadamosto, *The Voyages of Cadamosto.*

17. See Prestage, *The Portuguese Pioneers.*

18. See Donnan, *Documents Illustrative.*

19. Rout, *The African Experience,* and Winius, *Portugal, the Pathfinder.*

20. See Rodney, *West Africa and the Atlantic Slave Trade,* and Thornton, *Africa and Africans.*

21. See Klein, *African Slavery;* Rodney, *A History of the Upper Guinea Coast;* Rodney, *West Africa and the Atlantic Slave Trade;* and Mannix and Cowley, *Black Cargoes.*

22. See Hair, *Africa Encountered,* and Cadamosto, *The Voyages of Cadamosto.*

23. See Birmingham, *Portugal and Africa;* Rodney, *A History of the Upper Guinea Coast;* Rout, *The African Experience;* Cadamosto, *The Voyages of Cadamosto.*

24. See Klein, *African Slavery.* It is important to note, however, that estimates vary considerably; for example, see also Curtin, *The Atlantic Slave Trade,* and Rodney, *A History of the Upper Guinea Coast.*

25. See Blake, *Europeans in West Africa;* Curtin, *The Atlantic Slave Trade;* Diffie and Winius, *Foundations of the Portuguese Empire;* Birmingham, *Portugal and Africa;* Klein, *African Slavery;* Rodney, *A History of the Upper Guinea Coast;* Thomas, *The Slave Trade.*

26. See Hair, "Discovery and Discoveries of the Portuguese in Guinea, 1444–1650," in *Africa Encountered,* and Thomas, *The Slave Trade.*

27. See Birmingham, *Portugal and Africa;* Blake, *Europeans in West Africa;* Fage, *A History of West Africa.*

28. See Boxer, *The Portuguese Seaborne Empire.*

29. See Blake, *Europeans in West Africa;* Donnan, *Documents Illustrative;* Fage, *A History of West Africa;* Thomas, *The Slave Trade.*
30. Jorge Vaz, quoted in Blake, *Europeans in West Africa,* vol. 1, document 67.
31. Francisco Pires, quoted in Blake, *Europeans in West Africa,* vol. 1, document 73.

FIVE

1. In 1935, Swedish archaeologist Sven Loven applied the term *Taino,* from the Indian word for "ruling class."
2. Letter from Christopher Columbus to King Ferdinand of Spain, describing the results of his first voyage to the Indies, 4 March 1493.
3. See discussions in Cook, "Disease and the Depopulation of Hispaniola," in Kiple and Beck, *Biological Consequences of European Expansion;* and Sauer, *The Early Spanish Main.* For further details on the Taino/Arawak, see Parry, Sherlock, and Maingot, *A Short History of the West Indies.*
4. Quoted in Mannix and Cowley, *Black Cargoes.*
5. See Johnson, "The Story of the Caribs and Arawaks."
6. Las Casas, *A Short Account of the Destruction of the Indies.*
7. See Pons discussion in Cook, "Disease and Depopulation of Hispaniola," in Kiple and Beck, *Biological Consequences of European Expansion;* Sauer, *The Early Spanish Main;* Rout, *The African Experience;* Newton, *The European Nations in the West Indies;* Anthony Pagden, introduction to Las Casas, *A Short Account of the Destruction of the Indies.*
8. See discussion in Cook, "Disease and the Depopulation of Hispaniola," in Kiple and Beck, *Biological Consequences of European Expansion.*
9. Mannix and Cowley, *Black Cargoes.*
10. See Newton, *The European Nations in the West Indies,* and Parry, Sherlock, and Maingot, *A Short History of the West Indies.*
11. See Rout, *The African Experience.*
12. Las Casas, *A Short Account of the Destruction of the Indies.*
13. See Newton, *The European Nations in the West Indies,* and Parry, Sherlock, and Maingot, *A Short History of the West Indies.*
14. Quoted in Sauer, *The Early Spanish Main.*
15. See Rout, *The African Experience;* Newton, *The European Nations in the West Indies;* Donnan, *Documents Illustrative.*
16. See Donnan, *Documents Illustrative.*

17. See Parry, Sherlock, and Maingot, *A Short History of the West Indies*, and Donnan, *Documents Illustrative*.
18. See Parry, Sherlock, and Maingot, *A Short History of the West Indies*, and Thomas, *The Slave Trade*.
19. See Curtin, *The Atlantic Slave Trade*.
20. See ibid.
21. Taken from a list in Kiple, *The Caribbean Slave*.
22. Quoted in Mannix and Cowley, *Black Cargoes*.
23. See Rout, *The African Experience*, and Klein, *African Slavery*.
24. For further details see Rout, *The African Experience*.
25. For further details see ibid.
26. See ibid.; Newton, *The European Nations in the West Indies*; Donnan, *Documents Illustrative*; Thomas, *The Slave Trade*.
27. See Thomas, *The Slave Trade*.
28. Quoted in Walvin, *Black and White*.
29. See Thomas, *The Slave Trade*, and Donnan, *Documents Illustrative*.
30. See Rout, *The African Experience*; Thomas, *The Slave Trade*; Donnan, *Documents Illustrative*.
31. Camden, *The history of the most renowned and victorious Princess Elizabeth*.

SIX

1. Richard Hawkins, *The Observations of Sir Richard Hawkins*.
2. "The first voyage of the right worshipful and valiant knight sir John Hawkyns...made to the West Indies, 1562," in Hakluyt, *The Principall Navigations*.
3. Ibid.
4. See Scammell, "Manning the English Merchant Service."
5. Hair and Alsop, *English Seamen and Traders in Guinea*.
6. Ibid.
7. See Scammell, "Manning the English Merchant Service."
8. Accounts for the victualling of the navy, 1560–61, PRO, AO1/1784 300.
9. Benjamin Gonson's declared accounts for the Navy, 1564–65, PRO, AO1/1682/3.
10. See Bisson, *The Merchant Adventurers of England*, and Ramsay, *The City of London*.
11. "The first voyage of the right worshipful and valiant knight sir John

Hawkyns...made to the West Indies, 1562," in Hakluyt, *The Principall Navigations.*

12. "John Sparke's account of the voyage made by the worshipful John Hawkyns ... to the coast of Guinea, and the Indies of New Spain in 1564," in Hakluyt, *The Principall Navigations.*

13. Letter from Edward Kingsmill to Hugh Tipton, 16 March 1562, PRO, State Papers, Foreign, Elizabeth, SP70/35.

14. See Rumeu de Armas, *Los Viajes de John Hawkins a America.*

15. See ibid., including document 6, the testimony of Christoval Nunez Vela, 8 July 1563, on the presence of English corsairs in Santa Cruz (MC: Inquisición. Signatura LXXX-12, fol. 871-v).

16. "The first voyage of the right worshipful and valiant knight sir John Hawkyns...made to the West Indies, 1562," in Hakluyt, *The Principall Navigations.*

17. Evidence of Mateo de Torres, 16 May 1568, to an Inquisition investigation into the stay of John Hawkyns in Tenerife and La Gomera in 1567 (MC: Inquisitión. Signatura LXII-5, the trial of Pedro Soler ff Lii-v) in document 19, in Rumeu de Armas, *Los Viajes de John Hawkins a America.*

18. See Rumeu de Armas, *Los Viajes de John Hawkins a America.*

19. See ibid.

SEVEN

1. See various documents in Blake, *Europeans in West Africa*, vol. 2, sec. 3.

2. See Andrews, *Drake's Voyages;* Corbett, *Drake and the Tudor Navy;* Ramsay, *The City of London.*

3. For further details see Corbett, *Drake and the Tudor Navy*, and Milton, *Nathaniel's Nutmeg.*

4. In Blake, *Europeans in West Africa*, document 23, vol. 2, sec. 3.

5. In Blake, *Europeans in West Africa*, documents 13 and 27, vol. 2, sec. 3.

6. In Blake, *Europeans in West Africa*, documents 38 and 39, vol. 2, sec. 3.

7. In Blake, *Europeans in West Africa*, document 41, vol. 2, sec. 3.

8. Letter of Recommendation from Throckmorton to William Cecil, 14 March 1561, in PRO, *Calendar of State Papers, Foreign Series, of the reign of Elizabeth*, SP70/24.

9. Declaration by the Ambassador of Portugal 20 April 1561, in PRO, *Calendar of State Papers, Foreign Series, of the reign of Elizabeth*, SP70/24.

10. "Certain articles delivered to John Lok ... 8 September 1561," in Hakluyt, *The Principall Navigations*.

11. Ibid.

12. Letter from Alvarez de Quadra to the Duchess of Parma, London, 27 September 1561, PRO, *Calendar of Letters and State Papers Relating to English Affairs Preserved Principally in the Archives of Simancas*, vol. 1, Elizabeth 1558–67.

13. Letter from the King of Portugal to Elizabeth, 22 October 1561, PRO, State Papers, Foreign, Elizabeth, SP70/31.

14. "Certain articles delivered to John Lok ... 8 September 1561," in Hakluyt, *The Principall Navigations*.

15. See Williamson, *Sir John Hawkins*.

16. Letter from Alvarez de Quadra to Philip II, London, 27 November 1561, PRO, *Calendar of Letters and State Papers Relating to English Affairs Preserved Principally in the Archives of Simancas*, vol. 1, Elizabeth 1558–67.

Eight

1. The following works were helpful in constructing a short geography of Sierra Leone and the Upper Guinea Coast: Alie, *A New History of Sierra Leone*; Fyfe, *A Short History of Sierra Leone*; Fyle, *The History of Sierra Leone*; Jarrett, *A Geography of Sierra Leone and Gambia*; Rodney, *A History of the Upper Guinea Coast*; Thornton, *Africa and Africans*.

2. See Alie, *A New History of Sierra Leone*; Curtin, *The Atlantic Slave Trade*; Fyfe, *A Short History of Sierra Leone*; Fyle, *The History of Sierra Leone*; Hair, *Africa Encountered*; Palmer, *The First Passage*; Rodney, *A History of the Upper Guinea Coast*.

3. Quoted in Purchas, *Hakluytus Posthumus*.

4. For further details see Alie, *A New History of Sierra Leone*; Rodney, *A History of the Upper Guinea Coast*; Fyfe, *A Short History of Sierra Leone*; Fyle, *The History of Sierra Leone*.

5. In Blake, *Europeans in West Africa*, document 27, vol. 2, sec. 3.

6. For further discussion see Walvin, *Black and White*, and *The Black Presence*.

7. Quoted in Jordan, *White over Black*.

8. George Puttenham quoted in Walvin, *Black and White*.

9. Hair, *Travails in Guinea*.

10. Quoted in Walvin, *The Black Presence*.

11. Letter of Licenciado Echegoyen to the Casa de Contratación, Santo Domingo, 2 November 1563, in Archivo General de Indias, Justicia, file 92, no. 2.

12. "The first voyage of the right worshipful and valiant knight sir John Hawkyns...made to the West Indies, 1562," in Hakluyt, *The Principall Navigations.*

13. This may well have been the Cess or Cestos River in Liberia.

14. Various witness statements in PRO, State Papers, Foreign, Elizabeth, SP70/ 99, Inquisitions and depositions of certain spoils committed by Englishmen, chiefly John Hawkyns, on the Guinea coast and elsewhere.

15. Ibid.

16. Curtin, *The Atlantic Slave Trade.*

17. See Kiple, *The Caribbean Slave.*

NINE

1. "The first voyage of the right worshipful and valiant knight sir John Hawkyns...made to the West Indies, 1562," in Hakluyt, *The Principall Navigations.*

2. Evidence of Juan Pizarro, resident of Monte Christi, and Juan Ortiz Oñate in the trial of Cristobal de Santisteban, Santo Domingo, 17 August 1566, Archivo General de Indias, Justicia, file 999, fol. 13 and fol. 23 reverse; also various letters from the Audiencia of Santo Domingo to Philip II included in Archivo General de Indias, Audiencia of Santo Domingo, file 71, book 1.

3. "Thomas Tyson in the West Indies," in Hakluyt, *The Principall Navigations.*

4. See Kirkpatrick, "The First Recorded English Voyage to the West Indies."

5. See Marsden, "Voyage of the Barbara."

6. "Robert Tomson, Voyage to the West Indies and Mexico, 1556–58," in Hakluyt, *The Principall Navigations.*

7. Evidence of Juan Ortiz Oñate in the Trial of Cristobal de Santisteban, Archivo General de Indias, Justicia, file 999, fol. 23 reverse.

8. Letter of Alonso Arias de Herrera to the Crown, Santo Domingo, 20 May 1563, Archivo General de Indias, Audiencia of Santo Domingo, file 71, book 1, fol. 264.

9. Evidence of Miguel de Luzon in the trial of Cristobal de Santisteban, Archivo General de Indias, Justicia, file 999, fol. 8 reverse.

10. Evidence of Juan Ortiz Oñate in the trial of Cristobal de Santisteban, Archivo General de Indias, Justicia, file 999, fol. 23 reverse.

11. Ibid.

12. Evidence of Juan Ortiz Oñate and Cristobal de Santisteban in the trial of Cristobal de Santisteban, Archivo General de Indias, Justicia, file 999, fol. 25 reverse and fol. 42.

13. Evidence of Juan Ortiz Oñate in the trial of Cristobal de Santisteban, Archivo General de Indias, Justicia, file 999, fol. 27.

14. See Velasco, *Geografia y Descripcion de las Indias,* and Parry, Sherlock, and Maingot, *A Short History of the West Indies.*

15. Evidence of Miguel de Luzon in the trial of Cristobal de Santisteban, Archivo General de Indias, Justicia, file 999, fol. 9 reverse.

16. Ibid., and letter of Alonso Arias de Herrera to the crown, Santo Domingo, 20 May 1563, Archivo General de Indias, Audiencia of Santo Domingo, file 71, book 1, fol. 264.

17. Questions to be put to witnesses, and statements of witnesses including Alonso Vivas, alcalde ordinario of Santiago de la Vega, presented by Lorenzo Bernaldez in his defense against charges of collaborating with John Hawkyns, Santo Domingo, September 1563, Archivo General de Indias, Audiencia of Santo Domingo, file 11, no. 36, fol. 3–56; letter of Alonso Arias de Herrera to the Crown, Santo Domingo, 20 May 1563, Archivo General de Indias, Audiencia of Santo Domingo, file 71, book 1, fol. 264; Lorenzo Bernaldez to the Crown, Santo Domingo, August 1563, Archivo General de Indias, Signatura Antigua 53-6-5 fol. 280 et seq., transcribed as document 7 in Wright, *Spanish Documents.*

18. Evidence of Miguel de Luzon in the trial of Cristobal de Santisteban, Archivo General de Indias, Justicia, file 999, fol. 9 reverse.

19. Evidence of Juan Pizarro [fol. 13–14], Bartolome Hernandez [fol. 36–41 reverse], and Cristobal de Santisteban [fol. 41 reverse–57] in the trial of Cristobal de Santisteban, Archivo General de Indias, Justicia, file 999; letter of Alonso Arias de Herrera to the Crown, Santo Domingo, 20 May 1563, Archivo General de Indias, Audiencia of Santo Domingo, file 71, book 1, fol. 264–65; questions to be put to witnesses, and statements of witnesses, presented by Lorenzo Bernaldez in his defense against charges of collaborating with John Hawkyns, Santo Domingo, September 1563, Archivo General de Indias,

Audiencia of Santo Domingo, file 11, no. 36, fol. 3–56; and letter of Lorenzo Bernaldez to the Crown, Santo Domingo, August 1563, Archivo General de Indias, Signatura Antigua 53-6-5 fol. 280 et seq., transcribed as document 7 in Wright, *Spanish Documents.*

20. Report of Alonso Caballero and Lope de Bardeci to the Crown, Archivo General de Indias, Audiencia of Santo Domingo, file 71, book 2, fol. 215–16; and statement of Alonso Vivas, alcalde ordinario of Santiago de la Vega, in case presented by Lorenzo Bernaldez in his defense against charges of collaborating with John Hawkyns, Santo Domingo, September 1563, Archivo General de Indias, Audiencia of Santo Domingo, file 11, no. 36, fol. 3–56.

21. Letter of Alonso Arias de Herrera to the Crown, Santo Domingo, 20 May 1563, Archivo General de Indias, Audiencia of Santo Domingo, file 71, book 1, fol. 264; also letters to the crown from Licentiate Echegoyen [August 1563] and Lorenzo Bernaldez [28 July 1563], both in Santo Domingo, Archivo General de Indias, Signaturas Antiguas 53-6-5, 11, fol. 273 et seq and 53-6-5 fol. 280 et seq., transcribed as documents 6 and 7 in Wright, *Spanish Documents;* Letter from Licentiate Echegoyen, 2 November 1563, presented in Madrid, 21 March 1567, Archivo General de Indias, Justicia, file 92, no. 2. The document refers to both Diego and Francisco Martinez and Diego and Francisco Martin; it is reasonable to assume that they are the same person, and to refer to him as Martinez.

22. Evidence of Juan Pizarro [fol. 14], Bartolome, a black slave belonging to Juan Fernandez Montanes [fol. 36], Bartolome Hernandez [fol. 36–40 reverse], and Cristobal de Santisteban [fol. 42–42 reverse] in the trial of Cristobal de Santisteban, plus the statement that criminal proceedings were pending against the named men on 17 April 1564, Archivo General de Indias, Justicia, file 999.

23. Evidence of Juan Pizarro [fol. 14 and fol. 17 reverse] and Bartolome Hernandez [fol. 36–40 reverse] in the trial of Cristobal de Santisteban, plus the statement that criminal proceedings were pending against the named men on 17 April 1564, Archivo General de Indias, Justicia, file 999.

24. Evidence of Bartolome Hernandez [fol. 36–40 reverse] in the trial of Cristobal de Santisteban, plus the statement that criminal proceedings were pending against the named men on 17 April 1564, Archivo General de Indias, Justicia, file 999, plus questions to be put to witnesses, presented by Lorenzo Bernaldez in his defense against charges of collaborating with John Hawkyns, Santo Domingo, September 1563, Archivo General de Indias, Audiencia de Santo Domingo, file 11, no. 36, fol. 3–56.

25. Evidence of Miguel de Luzon in the trial of Cristobal de Santisteban, Archivo General de Indias, Justicia, file 999, fol. 9 reverse.

26. Evidence of Juan Pizarro in the trial of Cristobal de Santisteban, Archivo General de Indias, Justicia, file 999, fol. 16 reverse.

27. Evidence of Cristobal de Santisteban in the trial of Cristobal de Santisteban, Archivo General de Indias, Justicia, file 999, fol. 42.

28. Evidence of witnesses in the trial of Cristobal de Santisteban, plus the statement that criminal proceedings were pending against the named men on 17 April 1564, Archivo General de Indias, Justicia, file 999, general and fol. 114.

29. Questions and evidence in the trial of Cristobal de Santisteban, Archivo General de Indias, Justicia, file 999.

30. Evidence of Juan Pizarro in the trial of Cristobal de Santisteban, Archivo General de Indias, Justicia, file 999, fol. 15. The document refers to "a brother of Pedro Esteban"; it seems likely that this was the same as Pedro de Santisteban, in which case his brother was Cristobal.

31. Ibid.

32. Questions and evidence in the trial of Cristobal de Santisteban, Archivo General de Indias, Justicia, file 999.

33. Evidence of Cristobal de Santisteban in the trial of Cristobal de Santisteban, Archivo General de Indias, Justicia, file 999, fol. 41 reverse–57.

34. Evidence of Cristobal de Santisteban, 3 December 1565, Madrid, in the trial of Cristobal de Santisteban, Archivo General de Indias, Justicia, file 999, fol. 110–12 reverse.

35. Admission of Cristobal de Santisteban, given at his trial in Madrid, 3 December 1565, Archivo General de Indias, Justicia, file 999, fol. 110–12 reverse.

36. Questions and evidence in the trial of Cristobal de Santisteban, Archivo General de Indias, Justicia, file 999.

37. "The first voyage of the right worshipful and valiant knight sir John Hawkyns... made to the West Indies, 1562," in Hakluyt, *The Principall Navigations*.

38. Letters to the Crown from Licentiate Echegoyen, Santo Domingo, 28 July 1563 and 4 November 1563, Archivo General de Indias, Signaturas Antiguas 53-6-5, 11, fol. 273 et seq. and 53-6-5, 11, fol. 286 et seq., transcribed as documents 6 and 8 in Wright, *Spanish Documents*.

39. Letter of Alonso Arias de Herrera to the Crown, Santo Domingo, 20 May 1563, Archivo General de Indias, Audiencia of Santo Domingo, file 71, book 1, fol. 264.

40. Letter of Licentiate Echegoyen to the Crown, Santo Domingo, 14 December 1563, Archivo General de Indias, Audiencia of Santo Domingo, file 71, fol. 292–95.

41. See Williamson, *Sir John Hawkins;* Williamson, *Hawkins of Plymouth;* Rumeu de Armas, *Los Viajes de John Hawkins a America.*

TEN

1. See Ramsay, *The City of London.*
2. Camden, *The history of the most renowned and victorious Princess Elizabeth.*
3. Quoted in Ramsay, *The City of London.*
4. See ibid.
5. Camden, *The history of the most renowned and victorious Princess Elizabeth,* and Black, *The Reign of Elizabeth.*
6. Letter from Elizabeth to Thomas Challoner, 8 September 1563, PRO, State Papers, Foreign, Elizabeth, SP70/63.
7. Letter from Hugh Tipton to Thomas Challoner, Seville, 8 December 1563, PRO, State Papers, Foreign, Elizabeth, SP70/66.
8. Thomas Challoner note, 23 February 1564, PRO, State Papers, Foreign, Elizabeth, SP70/68.
9. Challoner had arrived in Spain eighteen months earlier and had had an uncomfortable time: while he was making the difficult and dangerous journey from the Low Countries, his luggage had been stolen by thieves, and his books had been confiscated by the Inquisition. He hated the Spanish weather and food, and found himself isolated from English politics and frozen out of Philip II's court. Nevertheless, he was a man of great experience, with a residual respect for the Spanish. Many years earlier he had accompanied Philip II's father, Charles V, on an expedition from Genoa to Algeria, during which the galley on which he had crossed the Mediterranean sank. Challoner survived by swimming for hours and, when he could no longer move his arms, by holding on to another ship's cable with his teeth. As he wrote of the incident himself, this was accomplished "with great difficulty and . . . not without breaking and loss of certain of his teeth."
10. Letter from Thomas Challoner to John Hawkyns, 5 July 1564, PRO, State Papers, Foreign, Elizabeth, SP70/73.
11. Ibid.
12. See Andrews, *Drake's Voyages.*
13. Froude, *English Seamen in the Sixteenth Century.*
14. Letter from Hugh Tipton to Thomas Challoner, 27 December 1563, PRO, State Papers, Foreign, Elizabeth, SP70/66.

15. See Ramsay, *The City of London.*

16. Camden, *The history of the most renowned and victorious Princess Elizabeth.*

17. See Ramsay, *The City of London.*

18. Quoted in Bisson, *The Merchant Adventurers of England.*

19. See Ramsay, *The City of London.*

20. See Bisson, *The Merchant Adventurers of England,* and Ramsay, *The City of London.*

21. Quoted in Mannix and Cowley, *Black Cargoes,* p. 22.

22. "Book of Sea Causes," State Papers, Domestic, Elizabeth, iii, 44. Quoted in Corbett, *Drake and the Tudor Navy.*

23. For an example of a contemporary indenture and charter party see PRO, State Papers, Domestic, Elizabeth, SP12/26, Indenture and charter party, 1562.

24. Letter from Guzman de Silva to Philip II, London, 31 July 1564, in PRO, *Calendar of Letters and State Papers Relating to English Affairs Preserved Principally in the Archives of Simancas,* vol. 1, Elizabeth 1558–67.

25. Letter from Philip II to Guzman de Silva, Madrid, 6 August 1564, in PRO, *Calendar of Letters and State Papers Relating to English Affairs Preserved Principally in the Archives of Simancas,* vol. 1, Elizabeth 1558–67.

26. Letter from George Gilpin to William Cecil, Cadiz, 2 September 1564, PRO, State Papers, Foreign, Elizabeth, SP70/74.

27. Letter from Guzman de Silva to Philip II, London, 21 November 1564, in PRO, *Calendar of Letters and State Papers Relating to English Affairs Preserved Principally in the Archives of Simancas,* vol. 1, Elizabeth 1558–67.

28. The request of the ambassador of Portugal, 19 November 1564, PRO, State Papers, Foreign, Elizabeth, SP70/75.

29. Letter from Elizabeth to the King of Portugal, 24 November 1564, in BL, BM, Cotton MSS, Nero, B. I.

ELEVEN

1. "The voyage made by the worshipful John Hawkyns . . . to the coast of Guinea, and the Indies of New Spain in 1564," in Hakluyt, *The Principall Navigations.*

2. Ibid.

3. Ibid.

4. Letter from George Gilpin, Antwerp, to William Cecil, 28 October 1564, SP70/74 in PRO, *Calendar of State Papers, Foreign Series, of the reign of Elizabeth.*

5. "Report of a meeting at Sir William Garrard's house, 11 July 1564," in Hakluyt, *The Principall Navigations.*

6. "The voyage made by the worshipful John Hawkyns ... to the coast of Guinea, and the Indies of New Spain in 1564," in Hakluyt, *The Principall Navigations.*

7. Ibid.

8. In 1583 and 1591; see Baron, *Mayors and Mayoralties.*

9. "The voyage made by the worshipful John Hawkyns ... to the coast of Guinea, and the Indies of New Spain in 1564," in Hakluyt, *The Principall Navigations.*

10. Ibid.

11. Ibid.

12. Ibid.

13. Ibid.

14. Ibid.

15. Extract of a process begun by Licenciado Juan de Rada, 14 November 1564, quoted in Rumeu de Armas, *Los Viajes de John Hawkins a America,* pp. 143–46.

16. Extract of a process begun by Licenciado Juan de Rada, 14 November 1564, included in the Inquisition trial of Mateo de Torres [MC: Inquisición. Signatura LXXX-12], quoted in Rumeu de Armas, *Los Viajes de John Hawkins a America,* pp. 144–45.

17. Rumeu de Armas, *Los Viajes de John Hawkins a America,* p. 145.

18. "The voyage made by the worshipful John Hawkyns ... to the coast of Guinea, and the Indies of New Spain in 1564," in Hakluyt, *The Principall Navigations.*

19. Ibid.

20. Declarations of Andrea Estevez and Juan Vaez Cabrera in the Inquisition trial of Mateo de Torres [MC: Inquisición. Signatura LXXX-12], quoted in Rumeu de Armas, *Los Viajes de John Hawkins a America,* p. 146.

21. "The voyage made by the worshipful John Hawkyns ... to the coast of Guinea, and the Indies of New Spain in 1564," in Hakluyt, *The Principall Navigations.*

22. Ibid.

23. Ibid.

24. Ibid.

25. Ibid.

26. Ibid.

27. Ibid.

28. Ibid.

29. Ibid.

30. Ibid.

31. Evidence of Lupus Roderigues, given on 9 July 1568 in Lisbon to an inquiry into the damage cause by English pirates, in PRO, SP70/99, Inquisitions and depositions of certain spoils by Englishmen, chiefly Hawkyns, on the Guinea coast and elsewhere.

32. Evidence of Mathaeus Fernandes, ship's master, given on 8 July 1568 in Lisbon to an inquiry into the damage cause by English pirates, in PRO, SP70/99, Inquisitions and depositions of certain spoils by Englishmen, chiefly Hawkyns, on the Guinea coast and elsewhere.

33. Evidence of Emmanuel Ferreira, given in Guinea in 1565, and presented to an inquiry in Lisbon in September 1567 into the damage cause by English pirates, in PRO, SP70/95, investigation into the spoils of the English on the Guinea coast.

34. Various witness testimonies, given between 8 and 13 July 1568 in Lisbon to an inquiry into the damage cause by English pirates, in PRO, SP70/99, Inquisitions and depositions of certain spoils by Englishmen, chiefly Hawkyns, on the Guinea coast and elsewhere.

35. "The voyage made by the worshipful John Hawkyns . . . to the coast of Guinea, and the Indies of New Spain in 1564," in Hakluyt, *The Principall Navigations*.

36. Ibid.

TWELVE

1. "The voyage made by the worshipful John Hawkyns . . . to the coast of Guinea, and the Indies of New Spain in 1564," in Hakluyt, *The Principall Navigations*.

2. Ibid.

3. Ibid.

4. Ibid.

5. Ibid.

6. See Mosk, "Spanish Pearl Fishing Operations," and Newton, *The European Nations in the West Indies*.

7. Oviedo, *Historia General*, quoted in Mosk, "Spanish Pearl Fishing Operations."

8. "The voyage made by the worshipful John Hawkyns . . . to the coast of Guinea, and the Indies of New Spain in 1564," in Hakluyt, *The Principall Navigations*.

9. Ibid.

10. Velasco, *Geografia y Descripcion de las Indias*.

11. Letter from Guzman de Silva to Philip II, London, 4 February 1566, in PRO, *Calendar of Letters and State Papers Relating to English Affairs Preserved Principally in the Archives of Simancas*, vol. 1, Elizabeth 1558–67, says Hawkyns had "captured a Negro in Guinea who had been brought up in Portugal and used him as an interpreter, bringing him to England with him"; see also Deposition of Juan Pacheco, Burburata, 16 April 1565, Archivo General de Indias, Signatura Antigua 47-3-52/9 fol. 99 et seq., transcribed as document 10 in Wright, *Spanish Documents*, which names Llerena as the interpreter.

12. "The voyage made by the worshipful John Hawkyns . . . to the coast of Guinea, and the Indies of New Spain in 1564," in Hakluyt, *The Principall Navigations*.

13. Ibid.

14. Evidence of Agustin de Ancona, alderman of Burburata, 20 July 1566, to an inquiry into the conduct of Licenciado Alonso Bernaldez, former governor of the province of Venezuela, inquiry carried out by Pedro Ponce de Leon, new governor of the province, Archivo General de Indias, Justicia, file 93, fol. 251.

15. Deposition of Juan Pacheco, Burburata, 16 April 1565, Archivo General de Indias, Signatura Antigua 47-3-52/9 fol. 99 et seq., transcribed as document 10 in Wright, *Spanish Documents*.

16. Letter of Antonio de Barrios to Alonso Bernaldez, from Burburata, 4 April 1565, Archivo General de Indias, Signatura Antigua 47-3-52/9 fol. 81 et seq., transcribed as document 9 in Wright, *Spanish Documents*.

17. "The voyage made by the worshipful John Hawkyns . . . to the coast of Guinea, and the Indies of New Spain in 1564," in Hakluyt, *The Principall Navigations*.

18. Ibid.

19. Deposition of Juan Pacheco, Burburata, 16 April 1565, Archivo General de Indias, Signatura Antigua 47-3-52/9 fol. 99 et seq., transcribed as document 10 in Wright, *Spanish Documents*.

20. Evidence of Agustin de Ancona, alderman of Burburata, 20 July 1566, to an inquiry into the conduct of Licenciado Alonso Bernaldez, former governor of the province of Venezuela, inquiry carried out by Pedro Ponce de Leon, new governor of the province, Archivo General de Indias, Justicia, file 93, fol. 251.

21. Evidence of Agustin de Ancona, alderman of Burburata, 20 July 1566, to an inquiry into the conduct of Licenciado Alonso Bernaldez, former governor of the province of Venezuela, inquiry carried out by Pedro Ponce de Leon, new governor of the province. Archivo General de Indias, Justicia, file 93, fol. 251 reverse.

22. Deposition of Juan Pacheco, Burburata, 16 April 1565, Archivo General de Indias, Signatura Antigua 47-3-52/9 fol. 99 et seq., transcribed as document 10 in Wright, *Spanish Documents*.

23. Deposition of Alonso Bernaldez, 18 April 1565, Archivo General de Indias, Justicia, file 93, fol. 112.

24. "The voyage made by the worshipful John Hawkyns . . . to the coast of Guinea, and the Indies of New Spain in 1564," in Hakluyt, *The Principall Navigations*.

25. Depositions of Alonso Bernaldez, 19 and 24 April 1565, and statement of Antonio de Barrios, Archivo General de Indias, Justicia, file 93, fol. 113, 113 reverse, 127 reverse, and 115.

26. "The voyage made by the worshipful John Hawkyns . . . to the coast of Guinea, and the Indies of New Spain in 1564," in Hakluyt, *The Principall Navigations*. See also the official relation by Alonso Bernaldez, 19 April 1565, concerning the advance of the English on Burburata, Archivo General de Indias, Justicia, file 93, fol. 113, 113 reverse, and 127 reverse.

27. Official relation by Alonso Bernaldez, 19 April 1565, concerning the advance of the English on Burburata, Archivo General de Indias, Justicia, file 93, fol. 113 and 113 reverse.

28. Official relation by Alonso Bernaldez, 19 April 1565, concerning the advance of the English on Burburata, Archivo General de Indias, Justicia, file 93, fol. 114.

29. Official relation by Alonso Bernaldez, 19 April 1565, concerning the advance of the English on Burburata, Archivo General de Indias, Justicia, file 93, fol. 114 reverse; and "The voyage made by the worshipful John Hawkyns . . . to the coast of Guinea, and the Indies of New Spain in 1564," in Hakluyt, *The Principall Navigations*.

30. "Official relation by Alonso Bernaldez, 19 April 1565, concerning the advance of the English on Burburata, Archivo General de Indias, Justicia, file 93, fol. 114 reverse.

31. Evidence of Agustin de Ancona, alderman of Burburata, 20 July 1566, to an inquiry into the conduct of Licenciado Alonso Bernaldez, former governor of the province of Venezuela, inquiry carried out by Pedro Ponce de Leon, new

governor of the province, Archivo General de Indias, Justicia, file 93, fol. 251 reverse and 252.

32. Statement of Diego Ruiz de Vallejo, accountant in the province of Venezuela, to Alonso Bernaldez, 25 April 1565, Archivo General de Indias, Justicia, file 93, fol. 127 reverse.

33. "The voyage made by the worshipful John Hawkyns ... to the coast of Guinea, and the Indies of New Spain in 1564," in Hakluyt, *The Principall Navigations.*

34. Letters from Guzman de Silva to Philip II, London, 2 and 9 July 1565, in PRO, *Calendar of Letters and State Papers Relating to English Affairs Preserved Principally in the Archives of Simancas,* vol. 1, Elizabeth 1558–67. See also Hair and Alsop, *English Seamen and Traders in Guinea.*

35. Evidence of Juan de Frias, alderman of Burburata, May 1566, to an inquiry into the conduct of Licenciado Alonso Bernaldez, former governor of the province of Venezuela, inquiry carried out by Pedro Ponce de Leon, new governor of the province, Archivo General de Indias, Justicia, file 93, fol. 18 reverse.

36. "The voyage made by the worshipful John Hawkyns ... to the coast of Guinea, and the Indies of New Spain in 1564," in Hakluyt, *The Principall Navigations.*

37. Proclamation of charges against Alonso Bernaldez, former governor of the province of Venezuela, inquiry carried out by Pedro Ponce de Leon, new governor of the province, 2 May 1566, Archivo General de Indias, Justicia, file 93, fol. 11.

38. Evidence of Agustin de Ancona, alderman of Burburata, 20 July 1566, to an inquiry into the conduct of Licenciado Alonso Bernaldez, former governor of the province of Venezuela, inquiry carried out by Pedro Ponce de Leon, new governor of the province, Archivo General de Indias, Justicia, file 93, fol. 252 reverse.

39. Letter from Diego Ruiz de Vallejo to Philip II, New Segovia, 21 April 1568, in Archivo General de Indias, Signatura Antigua 53-6-12, transcribed as document 21 in Wright, *Spanish Documents.*

THIRTEEN

1. "The voyage made by the worshipful John Hawkyns ... to the coast of Guinea, and the Indies of New Spain in 1564," in Hakluyt, *The Principall Navigations.*

2. Ibid.

3. Velasco, *Geografia y Descripcion de las Indias.*

4. Questions to, and evidence presented by, witnesses at the trial in Santo Domingo of Miguel de Castellanos and other inhabitants of Rio de la Hacha, 13 February to 8 April 1567, Archivo General de Indias, Justicia, file 38, no. 2, exhibit 1.

5. Ibid.; see also "The voyage made by the worshipful John Hawkyns . . . to the coast of Guinea, and the Indies of New Spain in 1564," in Hakluyt, *The Principall Navigations.*

6. Questions to witnesses at and statement of Licenciado Santiago to the trial in Santo Domingo of Miguel de Castellanos and other inhabitants of Rio de la Hacha, 13 February to 8 April 1567, Archivo General de Indias, Justicia, file 38, no. 2, exhibit 1.

7. "The voyage made by the worshipful John Hawkyns . . . to the coast of Guinea, and the Indies of New Spain in 1564," in Hakluyt, *The Principall Navigations.*

8. See The crown prosecutor versus Miguel de Castellanos, treasurer, and other inhabitants of Rio de la Hacha, 13 February to 8 April 1567, Santo Domingo, Archivo General de Indias, Justicia, file 38, no. 2, exhibit 1. See also "The voyage made by the worshipful John Hawkyns . . . to the coast of Guinea, and the Indies of New Spain in 1564," in Hakluyt, *The Principall Navigations.*

9. "The voyage made by the worshipful John Hawkyns . . . to the coast of Guinea, and the Indies of New Spain in 1564," in Hakluyt, *The Principall Navigations.*

10. John Hawkyns's license to trade at Rio de la Hacha, 21 May 1565, Archivo General de Indias, Signatura Antigua 12-5-1/20/9-3, item 9, transcribed as document 14 in Wright, *Spanish Documents.*

11. Questions to witnesses at and statement of Licenciado Santiago to the trial in Santo Domingo of Miguel de Castellanos and other inhabitants of Rio de la Hacha, 13 February to 8 April 1567, Archivo General de Indias, Justicia, file 38, no. 2, exhibit 1.

12. Question to witnesses at the trial in Santo Domingo of Miguel de Castellanos and other inhabitants of Rio de la Hacha, 13 February to 8 April 1567, Archivo General de Indias, Justicia, file 38, no. 2, exhibit 1, fol. 2.

13. See The crown prosecutor versus Miguel de Castellanos, treasurer, and other inhabitants of Rio de la Hacha, 13 February to 8 April 1567, Santo Domingo, Archivo General de Indias, Justicia, file 38, no. 2, exhibit 1.

14. Questions to witnesses at, statement of Licenciado Santiago to, and evidence

of Diego Guerrero, inhabitant of Rio de la Hacha, to the trial in Santo
Domingo of Miguel de Castellanos and other inhabitants of Rio de la Hacha,
13 February to 8 April 1567, Archivo General de Indias, Justicia, file 38, no. 2,
exhibit 1, fol. 2, 8, and 23.

15. See Rout, *The African Experience.*
16. Gonzalo Ferdinando de Oviedo, *Historia General,* quoted in Purchas, *Hakluy-
tus Posthumus.*
17. The Jesuit Joseph Acosta quoted in Purchas, *Hakluytus Posthumus.*
18. Quoted in Palmer, *The First Passage.*
19. Las Casas, *A Short Account of the Destruction of the Indies.*
20. "The voyage made by the worshipful John Hawkyns ... to the coast of
Guinea, and the Indies of New Spain in 1564," in Hakluyt, *The Principall
Navigations.*
21. Questions to, and evidence presented by, witnesses at the trial in Santo
Domingo of Miguel de Castellanos and other inhabitants of Rio de la Hacha,
13 February to 8 April 1567, Archivo General de Indias, Justicia, file 38, no. 2,
exhibit 1, fol. 2.
22. See the crown prosecutor versus Miguel de Castellanos, treasurer, and other
inhabitants of Rio de la Hacha, 13 February to 8 April 1567, Santo Domingo,
Archivo General de Indias, Justicia, file 38, no. 2, exhibit 1; see also various
items of correspondence in Archivo General de Indias, Audiencia de Santo
Domingo, file 71, book 1, fol. 445–486 reverse.
23. "The voyage made by the worshipful John Hawkyns ... to the coast of
Guinea, and the Indies of New Spain in 1564," in Hakluyt, *The Principall
Navigations.*
24. See the crown prosecutor versus Miguel de Castellanos, treasurer, and other
inhabitants of Rio de la Hacha, 13 February to 8 April 1567, Santo Domingo,
Archivo General de Indias, Justicia, file 38, no. 2, exhibit 1.
25. "The voyage made by the worshipful John Hawkyns ... to the coast of
Guinea, and the Indies of New Spain in 1564," in Hakluyt, *The Principall
Navigations.*
26. John Hawkyns's certificate of good conduct at Rio de la Hacha to Philip II,
19–30 May 1565, in Archivo General de Indias, Signatura Antigua 2-5-1/20,
9-4, transcribed as document 15 in Wright, *Spanish Documents.*
27. "The voyage made by the worshipful John Hawkyns ... to the coast of
Guinea, and the Indies of New Spain in 1564," in Hakluyt, *The Principall
Navigations.*
28. See The crown prosecutor versus Miguel de Castellanos, treasurer, and other

inhabitants of Rio de la Hacha, 13 February to 8 April 1567, Santo Domingo, Archivo General de Indias, Justicia, file 38, no. 2, exhibit 1; also various items of correspondence in Archivo General de Indias, Audiencia de Santo Domingo, file 71, book 1, fol. 445–86 reverse.

Fourteen

1. "The voyage made by the worshipful John Hawkyns ... to the coast of Guinea, and the Indies of New Spain in 1564," in Hakluyt, *The Principall Navigations.*

2. Ibid.

3. Ibid.

4. Ibid.

5. Newton, *The European Nations in the West Indies.*

6. "The voyage made by the worshipful John Hawkyns ... to the coast of Guinea, and the Indies of New Spain in 1564," in Hakluyt, *The Principall Navigations.*

7. Ibid.

8. "The arrival and courtesie of M Hawkyns to the distressed Frenchmen in Florida ... in the history of Laudonnière, written by himself, and printed in Paris, anno 1586," in Hakluyt, *The Principall Navigations.*

9. See Andrews, *Drake's Voyages.*

10. "The arrival and courtesie of M Hawkyns to the distressed Frenchmen in Florida ... in the history of Laudonnière, written by himself, and printed in Paris, anno 1586," in Hakluyt, *The Principall Navigations.*

11. "The voyage made by the worshipful John Hawkyns ... to the coast of Guinea, and the Indies of New Spain in 1564," in Hakluyt, *The Principall Navigations.*

12. Ibid.

13. "The arrival and courtesie of M Hawkyns to the distressed Frenchmen in Florida ... in the history of Laudonnière, written by himself, and printed in Paris, anno 1586," in Hakluyt, *The Principall Navigations.*

14. See Froude, *English Seamen in the Sixteenth Century,* and Williamson, *Hawkins of Plymouth.*

15. "The voyage made by the worshipful John Hawkyns ... to the coast of Guinea, and the Indies of New Spain in 1564," in Hakluyt, *The Principall Navigations.*

FIFTEEN

1. Certificate to W. Wynter, Benjamin Gonson, William Holstock, and G. Wynter for the use of the *Jesus of Lubeck*, now returned, PRO, State Papers, Domestic, Elizabeth, SP12/37.
2. "The voyage made by the worshipful John Hawkyns...to the coast of Guinea, and the Indies of New Spain in 1564," in Hakluyt, *The Principall Navigations.*
3. Letter from Guzman de Silva to Philip II, Antwerp, 5 November 1565, in PRO, *Calendar of Letters and State Papers Relating to English Affairs Preserved Principally in the Archives of Simancas,* vol. 1, Elizabeth 1558–67.
4. Letter from Guzman de Silva to Philip II, London, 1 October 1565, in PRO, *Calendar of Letters and State Papers Relating to English Affairs Preserved Principally in the Archives of Simancas,* vol. 1, Elizabeth 1558–67.
5. Prince, *Danmonii Orientales Illustres.*
6. Letter from Guzman de Silva to Philip II, London, 27 August 1565, in PRO, *Calendar of Letters and State Papers Relating to English Affairs Preserved Principally in the Archives of Simancas,* vol. 1, Elizabeth 1558–67.
7. Letter from Guzman de Silva to Philip II, London, 1 October 1565, in PRO, *Calendar of Letters and State Papers Relating to English Affairs Preserved Principally in the Archives of Simancas,* vol. 1, Elizabeth 1558–67.
8. Letter from Guzman de Silva to Philip II, London, 8 October 1565, in PRO, *Calendar of Letters and State Papers Relating to English Affairs Preserved Principally in the Archives of Simancas,* vol. 1, Elizabeth 1558–67.
9. See Newton, *The European Nations in the West Indies.*
10. See Andrews, "Thomas Fenner and the Guinea trade, 1564."
11. See Williamson, *Sir John Hawkins.*
12. Letter from Guzman de Silva to Philip II, London, 22 October 1565, in PRO, *Calendar of Letters and State Papers Relating to English Affairs Preserved Principally in the Archives of Simancas,* vol. 1, Elizabeth 1558–67.
13. Letters from Guzman de Silva to Philip II, London, 22 October and 5 November 1565, in PRO, *Calendar of Letters and State Papers Relating to English Affairs Preserved Principally in the Archives of Simancas,* vol. 1, Elizabeth 1558–67.
14. Letter from Guzman de Silva to Philip II, London, 5 November 1565, in PRO, *Calendar of Letters and State Papers Relating to English Affairs Preserved Principally in the Archives of Simancas,* vol. 1, Elizabeth 1558–67. The word *dollar* was often used in England to mean Spanish peso.

15. Letter from Guzman de Silva to Philip II, London, 5 November 1565, in PRO, *Calendar of Letters and State Papers Relating to English Affairs Preserved Principally in the Archives of Simancas,* vol. 1, Elizabeth 1558–67.

16. Ibid.

17. Letter from Guzman de Silva to Philip II, London, 4 February 1566, in PRO, *Calendar of Letters and State Papers Relating to English Affairs Preserved Principally in the Archives of Simancas,* vol. 1, Elizabeth 1558–67.

18. Letter from Guzman de Silva to Philip II, London, 11 February 1566, in PRO, *Calendar of Letters and State Papers Relating to English Affairs Preserved Principally in the Archives of Simancas,* vol. 1, Elizabeth 1558–67.

19. Letter from Guzman de Silva to Philip II, London, 23 March 1566, in PRO, *Calendar of Letters and State Papers Relating to English Affairs Preserved Principally in the Archives of Simancas,* vol. 1, Elizabeth 1558–67.

20. Letter from Guzman de Silva to Philip II, London, 30 March 1566, in PRO, *Calendar of Letters and State Papers Relating to English Affairs Preserved Principally in the Archives of Simancas,* vol. 1, Elizabeth 1558–67.

21. Letter from Guzman de Silva to Philip II, London, 4 May 1566, in PRO, *Calendar of Letters and State Papers Relating to English Affairs Preserved Principally in the Archives of Simancas,* vol. 1, Elizabeth 1558–67.

22. Letter from Guzman de Silva to Philip II, London, 3 August 1566, in PRO, *Calendar of Letters and State Papers Relating to English Affairs Preserved Principally in the Archives of Simancas,* vol. 1, Elizabeth 1558–67.

23. Letter from Philip II to Guzman de Silva, 12 August 1566, in PRO, *Calendar of Letters and State Papers Relating to English Affairs Preserved Principally in the Archives of Simancas,* vol. 1, Elizabeth 1558–67.

24. Letter from Guzman de Silva to Philip II, London, 12 October 1566, in PRO, *Calendar of Letters and State Papers Relating to English Affairs Preserved Principally in the Archives of Simancas,* vol. 1, Elizabeth 1558–67.

25. Ibid.

26. Letter from Dr. David Lewes to William Cecil, 13 October 1566, PRO, State Papers, Domestic, Elizabeth, SP12/40.

27. Letter from the Privy Council to the mayor of Plymouth, Westminster, 17 October 1566, in *Acts of the Privy Council of England,* vol. 7, 1558–70.

28. Letter from Dr. David Lewes to the Privy Council, 31 October 1566, PRO, State Papers, Domestic, Elizabeth, SP12/40, inclosing bonds.

29. Letter from the Privy Council to the mayor of Plymouth, Westminster, 31 October 1566, in *Acts of the Privy Council of England,* vol. 7, 1558–70.

30. Letter from Guzman de Silva to Philip II, London, 4 November 1566, in PRO,

Calendar of Letters and State Papers Relating to English Affairs Preserved Principally in the Archives of Simancas, vol. 1, Elizabeth 1558–67.

SIXTEEN

1. MS 7857/1 of the parish register of St. Dunstan-in-the-East, London Guildhall Library.
2. Mexican Inquisition trial: Morgan Tillert, 1574, Conway Collection add. 7235.
3. Evidence given in the Canaries Inquisition against Bartolome de Ponte, resident and alderman of Tenerife, prisoner in the jail of the Holy Office, appendix document 18, in Rumea de Armas, *Los Viajes de John Hawkins a America.*
4. Article 18 of the charges against the English, in PRO, State Papers, Foreign, Elizabeth, SP70/99, Inquisitions and depositions of certain spoils committed by Englishmen, chiefly John Hawkyns, on the Guinea coast and elsewhere.
5. Article 18 of the charges against the English, plus testimonies of Mathaeus Fernandes, ship's master, Lupus Roderigues, merchant, and Georgius Valasques, in PRO, State Papers, Foreign, Elizabeth, SP70/99, Inquisitions and depositions of certain spoils committed by Englishmen, chiefly John Hawkyns, on the Guinea coast and elsewhere.
6. Articles 18 and 19 of the charges against the English, plus testimonies of Mathaeus Fernandes, ship's master, Lupus Roderigues, merchant, and Georgius Valasques, in PRO, State Papers, Foreign, Elizabeth, SP70/99, Inquisitions and depositions of certain spoils committed by Englishmen, chiefly John Hawkyns, on the Guinea coast and elsewhere.
7. Article 21 of the charges against the English, plus testimonies of Mathaeus Fernandes, ship's master, Lupus Roderigues, merchant, and Georgius Valasques, in PRO, State Papers, Foreign, Elizabeth, SP70/99, Inquisitions and depositions of certain spoils committed by Englishmen, chiefly John Hawkyns, on the Guinea coast and elsewhere.
8. Letter from the city of Rio de la Hacha to Philip II, 9 July 1567 in Archivo General de Indias, Signatura Antigua 54-4-24, transcribed as document 17 in Wright, *Spanish Documents.*
9. Letter from Diego Ruiz de Vallejo to Philip II, New Segovia, 21 April 1568, in Archivo General de Indias, Signatura Antigua 53-6-12, transcribed as document 21 in Wright, *Spanish Documents.*
10. Letter from the city of Rio de la Hacha to Philip II, 23 June 1567, in Archivo

General de Indias, Signatura Antigua 54-4-24, transcribed as document 16 in Wright, *Spanish Documents*.

11. Ibid.

12. Letters from the city of Rio de la Hacha to Philip II, 23 June and 9 July 1567 and 8 January 1568, plus letters from Miguel de Castellanos to Philip II, 1 January 1568, and Hernando Castilla and Lazaro de Vallejo Alderete to Philip II, 8 January 1568, in Archivo General de Indias, Signaturas Antiguas 54-4-24, 53-6-12 1, 54-4-28, 1, transcribed as documents 16, 17, 18, 19, and 20 in Wright, *Spanish Documents*.

13. Letter from the city of Rio de la Hacha to Philip II, 23 June 1567, in Archivo General de Indias, Signatura Antigua 54-4-24, transcribed as document 16 in Wright, *Spanish Documents*.

14. Letter from the city of Rio de la Hacha to Philip II, 9 July 1567 in Archivo General Indias, Signatura Antigua 54-4-24, transcribed as document 17 in Wright, Spanish Documents.

15. Letter from the city of Rio de la Hacha to Philip II, 23 June 1567, in Archivo General de Indias, Signatura Antigua 54-4-24, transcribed as documents 16 in Wright, *Spanish Documents*.

Seventeen

1. Letter from Guzman de Silva to Philip II, London, 25 January 1567, in PRO, *Calendar of Letters and State Papers Relating to English Affairs Preserved Principally in the Archives of Simancas*, vol. 1, Elizabeth 1558–67.

2. Letter from Guzman de Silva to Philip II, London, 31 May 1567, in PRO, *Calendar of Letters and State Papers Relating to English Affairs Preserved Principally in the Archives of Simancas*, vol. 1, Elizabeth 1558–67.

3. Ibid.

4. Letters from Guzman de Silva to Philip II, London, 14 and 26 June 1567, in PRO, *Calendar of Letters and State Papers Relating to English Affairs Preserved Principally in the Archives of Simancas*, vol. 1, Elizabeth 1558–67.

5. Letter from Guzman de Silva to Philip II, London, 26 June 1567, in PRO, *Calendar of Letters and State Papers Relating to English Affairs Preserved Principally in the Archives of Simancas*, vol. 1, Elizabeth 1558–67.

6. Letter from Guzman de Silva to Philip II, London, 12 July 1567, in PRO, *Calendar of Letters and State Papers Relating to English Affairs Preserved Principally in the Archives of Simancas*, vol. 1, Elizabeth 1558–67.

7. Letters from Guzman de Silva to Philip II, London, 12 and 21 July 1567, in PRO, *Calendar of Letters and State Papers Relating to English Affairs Preserved Principally in the Archives of Simancas*, vol. 1, Elizabeth 1558–67.

8. Letter from Guzman de Silva to Philip II, London, 21 July 1567, in PRO, *Calendar of Letters and State Papers Relating to English Affairs Preserved Principally in the Archives of Simancas*, vol. 1, Elizabeth 1558–67.

9. Ibid.

10. Letter from Guzman de Silva to Philip II, London, 26 July 1567, in PRO, *Calendar of Letters and State Papers Relating to English Affairs Preserved Principally in the Archives of Simancas*, vol. 1, Elizabeth 1558–67.

11. Letter from Guzman de Silva to Philip II, London, 2 August 1567, in PRO, *Calendar of Letters and State Papers Relating to English Affairs Preserved Principally in the Archives of Simancas*, vol. 1, Elizabeth 1558–67.

12. Letter from Hernando Castilla and Lazaro de Vallejo Alderete to Philip II from Rio de la Hacha, 8 January 1568, in Archivo General de Indias, Signatura Antigua 54-4-28, 1, transcribed as document 19 in Wright, *Spanish Documents*.

EIGHTEEN

1. BM, Cotton MSS, Otho E VIII fol. 17–41b. This document was written by an unknown crew member on the *Jesus of Lubeck* and is one of the major sources for Hawkyns's third and final slaving voyage. Although it is preserved in the British Library, it has been damaged by fire. Three centuries after it was written, J. A. Williamson transcribed it and included it as an appendix in his *Sir John Hawkins: The Time and the Man*. He made intelligent, informed guesses at what the missing words were. Where necessary, I have gone with his judgment.

2. "Letter of M John Lok to the worshipful company of merchant adventurers for Guinea, Bristol, 11 December 1561," in Hakluyt, *The Principall Navigations*.

3. Ordnance etc for a fort to be built in Guinea, signed by John Hawkyns, 24 June 1567, PRO, State Papers, Domestic, Elizabeth, SP12/43.

4. BM, Cotton MSS, Otho E VIII fol. 17–41b.

5. As speculated upon by Williamson in *Hawkins of Plymouth*.

6. For further details see ibid., and Corbett, *Drake and the Tudor Navy*.

7. See Williamson, *Hawkins of Plymouth*.

8. BM, Cotton MSS, Otho E VIII fol. 17–41b.

9. Ibid.

10. Richard Hawkins, *The Observations of Sir Richard Hawkins.*

11. BM, Cotton MSS, Otho E VIII fol. 17–41b.

12. Richard Hawkins, *The Observations of Sir Richard Hawkins.*

13. Ibid.

14. BM, Cotton MSS, Otho E VIII fol. 17–41b.

15. Ibid., letter from John Hawkyns to William Cecil, 28 September 1567, PRO, State Papers, Domestic, Elizabeth, SP12/44, and also complaints of de Wachen on 23 and 24 October 1567, in PRO, State Papers, Foreign, Elizabeth, SP70/94.

16. Complaints of de Wachen on 23 and 24 October 1567, in PRO, State Papers, Foreign, Elizabeth, SP70/94.

17. Letter from Guzman de Silva to Elizabeth, 6 October 1567, in PRO, State Papers, Foreign, Elizabeth, SP70/94.

18. BM, Cotton MSS, Otho E VIII fol. 17–41b.

19. Letter from Guzman de Silva to Philip II, London, 28 September 1567, in PRO, *Calendar of Letters and State Papers Relating to English Affairs Preserved Principally in the Archives of Simancas,* vol. 1, Elizabeth 1558–67.

20. Mexican Inquisition trial: William Collins 1574, Conway Collection add. 7231.

21. Lord Clinton to William Cecil, 30 September 1567, in BL, *Calendar of the Manuscripts of the Most Honourable Marquis of Salisbury, Preserved at Hatfield House,* vol. 1.

22. John Perin in the Mexican Inquisition trial of William Cornelius, 1575, Conway Collection add. 7239.

23. Letter from John Hawkyns to Queen Elizabeth, 16 September 1567, PRO, State Papers, Domestic, Elizabeth, SP12/44.

24. The details of Cecil's letter can be discerned from John Hawkyns's reply, 28 September 1567, PRO, State Papers, Domestic, Elizabeth, SP12/44.

25. Letter from John Hawkyns to William Cecil, 28 September 1567, PRO, State Papers, Domestic, Elizabeth, SP12/44.

Nineteen

1. Declaration of Michael Soul [26 November 1569] and John Truslon [7 December 1569] in Various documents from Seville, Conway Collection add. 7258; Thomas Bennet, 18 October 1568, in Certified notarial copy of the declarations

of certain Englishmen taken at San Juan de Ulúa, Conway Collection add. 7257; and items listed in the schedule of losses presented to the High Court of the Admiralty inquiry into events at San Juan de Ulúa, PRO, State Papers, Domestic, Elizabeth, SP12/53.

2. Mexican Inquisition trial: William Collins 1574, Conway Collection add. 7231.

3. Mexican Inquisition trial: Miles Phillips, 1574, Conway Collection add. 7241.

4. John Hawkyns, "The third troublesome voyage made . . . to the parts of Guinea, and the West Indies," in Hakluyt, *The Principall Navigations.*

5. Confession of Richard Temple, 28 November 1569, in Various documents from Seville, Conway Collection add. 7258.

6. Domingo Xuarez in the Mexican Inquisition trial of William Cornelius, 1575, Conway Collection add. 7239.

7. Mexican Inquisition trial: Morgan Tillert, 1574, Conway Collection add. 7235.

8. Mexican Inquisition trial: John Gilbert, 1574, Conway Collection add. 7243.

9. Mexican Inquisition trial: Miles Phillips, 1574, Conway Collection add. 7241.

10. For further discussion of relationships in the Hawkyns household see Kelsey, *Sir Francis Drake,* p. 9.

11. Mexican Inquisition trial: Paul Hawkyns, 1574, Conway Collection add. 7237.

12. Mexican Inquisition trial: Thomas Goodal, 1574, Conway Collection add. 7243.

13. Mexican Inquisition trial: Thomas Ebren, 1573, Conway Collection add. 7245.

14. Confession of Richard Temple, 28 November 1569, in Various documents from Seville, Conway Collection add. 7258; confessions of John Corniel [26 November 1569] and Christopher Bingham [1 December 1569] in More confessions . . . , Conway Collection add. 7260.

15. Mexican Inquisition trial: Morgan Tillert, 1574, Conway Collection add. 7235.

16. Andrews, *The Elizabethan Seaman,* quoting Hakluyt, *The Principall Navigations,* book 1, pp. xxxiv, 1598.

17. Testimony of John Moon in the Mexican Inquisition trial of John Farington, 1574, Conway Collection add. 7241.

18. Confession of John Hall, 6 December 1569, in Various documents from Seville, Conway Collection add. 7258.

19. Mexican Inquisition trial: John Lee, 1574, Conway Collection add. 7250.

20. See Scammell, "Manning the English Merchant Service."

21. Mexican Inquisition trial: John Perin, 1574, Conway Collection add. 7249.

22. Mexican Inquisition trial: John Lee, 1574, Conway Collection add. 7250.

23. Mexican Inquisition trial: Andres Martin, 1574, Conway Collection add. 7245.

24. Confession of John Hall, 6 December 1569, in Various documents from Seville, Conway Collection add. 7258.

25. Mexican Inquisition trial: William Collins, 1574, Conway Collection add. 7231.

26. Confessions of Michael Soul [26 November 1569] and Richard Temple [28 November 1569] in Various documents from Seville, Conway Collection add. 7258. Also the Mexican Inquisition trial of Pablo de Leon, 1574, Conway Collection add. 7249.

27. Mexican Inquisition trial: George Day, 1574, Conway Collection add. 7247.

28. Confessions of Thomas Stephens [6 December 1569] and Richard Temple [28 November 1569] in Various documents from Seville, Conway Collection add. 7258.

29. Confession of George Fitzwilliams, 28 November 1569, in Various documents from Seville, Conway Collection add. 7258.

30. Confession of Diego Hen, 7 December 1569, in Various documents from Seville, Conway Collection add. 7258.

31. Mexican Inquisition trials: John Evans and Morgan Tillert, 1574, Conway Collection adds. 7250 and 7235. Confession of John Brown, 26 November 1569, in More confessions . . . , Conway Collection add. 7260.

32. Mexican Inquisition trials: William Cornelius and Morgan Tillert, 1574, Conway Collection adds. 7239 and 7235.

33. Mexican Inquisition trial: Pablo de Leon, 1574, Conway Collection add. 7249.

34. Mexican Inquisition trials: John Perin and Morgan Tillert, 1574, Conway Collection adds. 7249 and 7235.

35. Mexican Inquisition trials: John Williams and Roger Armour, 1574, Conway Collection adds. 7247 and 7250.

36. Mexican Inquisition trial: Andres Martin, 1574, Conway Collection add. 7245.

37. Mexican Inquisition trials: John Moon, Morgan Tillert, and George Riveley, 1574, Conway Collection adds. 7249, 7235, and 7233.

38. Mexican Inquisition trials: John Moon and John Williams, 1574, Conway Collection adds. 7249 and 7247.

39. Confession of Thomas Stephens, 6 December 1569, in Various documents from Seville, Conway Collection add. 7258.

40. Mexican Inquisition trial: Robert Cook, 1577, Conway Collection add. 7249.

41. Mexican Inquisition trial: William Lowe, 1574, Conway Collection add. 7245.

42. Inquisition inquiry into heretical remarks of William de Orlando, 1569, Conway Collection add. 7229.

43. Mexican Inquisition trial: William Collins, 1574, Conway Collection add. 7231.

44. Confession of Christopher Bingham, 1 December 1569, in More confessions . . . , Conway Collection add. 7260.

45. Confession of Richard Matthews, 9 December 1569, in More confessions . . . ,

Conway Collection add. 7260; and declaration of Michael Soul, 26 November 1569, in Various documents from Seville, Conway Collection add. 7258.

46. Confession of George Fitzwilliams, 28 November 1569, in Various documents from Seville, Conway Collection add. 7258.

47. BM, Cotton MSS, Otho E VIII fol. 17–41b.

48. "A discourse written by one Miles Phillips, Englishman, one of the company put ashore northward of Panuco," in Hakluyt, *The Principall Navigations*.

TWENTY

1. BM, Cotton MSS, Otho E VIII fol. 17–41b, plus evidence of Lope de Acoca, alderman of Tenerife, 16 May 1568, to an Inquisition investigation into the stay of John Hawkyns in Tenerife and La Gomera in 1567 [MC: Inquisición. LXII-5, the trial of Pedro Soler fol. xlix–r], in document 19 in Rumeu de Armas, *Los Viajes de John Hawkins a America*.

2. Evidence of Josepe Prieto, resident of Tenerife, 25 May 1568, to an Inquisition investigation into the stay of John Hawkyns in Tenerife and La Gomera in 1567 [MC: Inquisición. LXII-5, the trial of Pedro Soler fol. l–r], in document 19 in Rumeu de Armas, *Los Viajes de John Hawkins a America*.

3. Confessions of Gregory Simon and John Brown [24 and 26 November 1569] in More confessions . . . , Conway Collection add. 7260.

4. BM, Cotton MSS, Otho E VIII fol. 17–41b.

5. Evidence of Juan de Valverde, alderman of Tenerife, 16 May 1568, to an Inquisition investigation into the stay of John Hawkyns in Tenerife and La Gomera in 1567 [MC: Inquisición. LXII-5, the trial of Pedro Soler, fol. xlviii–v], in document 19 in Rumeu de Armas, *Los Viajes de John Hawkins a America*.

6. BM, Cotton MSS, Otho E VIII fol. 17–41b, plus testimony of Juan de Valverde, alderman of Tenerife, 16 May 1568, to an Inquisition investigation into the stay of John Hawkyns in Tenerife and La Gomera in 1567 [MC: Inquisición. LXII-5, the trial of Pedro Soler, fol. xlviii–v], in document 19 in Rumeu de Armas, *Los Viajes de John Hawkins a America*.

7. Declaration of Valentine Green, 3 November 1569, Conway Collection adds. 7260 and 7258, plus evidence of Juan de Valverde, alderman of Tenerife, 16 May 1568, to an Inquisition investigation into the stay of John Hawkyns in Tenerife and La Gomera in 1567 [MC: Inquisición. LXII-5, the trial of Pedro Soler, fol. xlviii–v], in document 19 in Rumeu de Armas, *Los Viajes de John Hawkins a America*.

8. Confessions of Thomas Fowler and Noah Sergeant [2 and 23 November 1569], Conway Collection adds. 7260 and 7257; and declaration of Valentine Green, 3 November 1569, in Various documents from Seville, Conway Collection add. 7258.

9. Roger Armour evidence reported in the Mexican Inquisition trial of William Collins, 1574, Conway Collection add. 7231.

10. Evidence of Josepe Prieto, resident of Tenerife, 25 May 1568, to an Inquisition investigation into the stay of John Hawkyns in Tenerife and La Gomera in 1567 [MC: Inquisición. LXII-5, the trial of Pedro Soler fol. 1–r], in document 19 in Rumeu de Armas, *Los Viajes de John Hawkins a America.*

11. Evidence of Mateo de Torres, 23 June 1568, to an Inquisition investigation into the stay of John Hawkyns in Tenerife and La Gomera in 1567 [MC: Inquisición. LIII-5, the trial of Pedro Soler, second testimony of Mateo de Torres] in document 1, in Rumeu de Armas, *Los Viajes de John Hawkins a America.* It may well be that this incident involving Soler was the same as that on La Palma on Christmas Day 1560, when John Poole, Thomas Champneys, and their men escaped from prison and stole a ship loaded with wines and oils— see page 190. The islands are different, but there is great similarity in the circumstances, and the records may be confused.

12. Testimony given by several witnesses in May and June 1568 before the Inquisition on the stay of John Hawkyns in Tenerife and La Gomera in 1567 [MC: Inquisición. LXII-5, the trial of Pedro Soler], document 19 in Rumeu de Armas, *Los Viajes de John Hawkins a America.*

13. BM, Cotton MSS, Otho E VIII fol. 17–41b; also MC Proceso de Pedro Soler, quoted in Rumeu de Armas, *Los Viajes de John Hawkins a America.*

14. BM, Cotton MSS, Otho E VIII fol. 17–41b.

15. Evidence of Juan de Venero, Lord Mayor of Tenerife, 7 May 1568, and Josepe Prieto, 25 May 1568, to an Inquisition investigation into the stay of John Hawkyns in Tenerife and La Gomera in 1567 [MC: Inquisición. LXII-5, the trial of Pedro Soler], in document 19 in Rumeu de Armas, *Los Viajes de John Hawkins a America.*

16. Note of the places arrived at and time there, from John Hawkyns's journal, attached to a letter from Hawkyns to William Cecil, 25 January 1569, PRO, State Papers, Domestic, Elizabeth, SP12/49; see also BM, Cotton MSS, Otho E VIII fol. 17–41b.

17. Interview with Gregory Stephens, 6 October 1568, in Declarations of the English prisoners, Conway Collection add. 7257; Mexican Inquisition trial: William Collins, 1574, Conway Collection add. 7231; declaration of William

de Orlando, 24 November 1569, in Various documents from Seville, Conway Collection add. 7258.

18. "The rare travels of Job Hortop," in Hakluyt, *The Principall Navigations.*

19. Declaration of William de Orlando, 24 November 1569, in Various documents from Seville, Conway Collection add. 7258.

20. Confession of Christopher Robertson, 23 November 1569, in More confessions . . . , Conway Collection add. 7260.

21. Note of the places arrived at and time there, from John Hawkyns's journal, attached to a letter from Hawkyns to William Cecil, 25 January 1569, PRO, State Papers, Domestic, Elizabeth, SP12/49; see also BM, Cotton MSS, Otho E VIII fol. 17–41b.

22. BM, Cotton MSS, Otho E VIII fol. 17–41b; and declaration of Thomas Bennet, taken at San Juan de Ulúa on 17 October 1568, in Declarations of certain Englishmen, Conway Collection add. 7257; plus Inquisición file 1829, in which Sarmiento was accused of banqueting with the English and supplying them with food and drink, quoted in Rumeu de Armas, *Los Viajes de John Hawkins a America*, p. 225 n. 44.

23. Mexican Inquisition trials: John Breton, 1574, and William Cornelius, 1575, Conway Collection adds. 7249 and 7239.

24. Mexican Inquisition trial: John Perin, 1574, Conway Collection add. 7249.

25. Mexican Inquisition trials: William Lowe and John Farington, 1574, Conway Collection adds. 7245 and 7241.

26. Mexican Inquisition trial: William Collins, 1574, Conway Collection add. 7231.

27. Richard Williams in the Mexican Inquisition trial of William Collins, 1574, Conway Collection add. 7231.

28. Morgan Tillert in the Mexican Inquisition trial of William Collins, 1574, Conway Collection add. 7231.

29. Witness testimonies in the Mexican Inquisition trials of William Collins and George Riveley, 1574, Conway Collection adds. 7231 and 7233.

30. John Perin in the Mexican Inquisition trial of William Cornelius, 1575, Conway Collection add. 7239.

31. Mexican Inquisition trial: John Farington, 1574, Conway Collection add. 7241.

32. Morgan Tillert in the Mexican Inquisition trial of George Riveley, 1574, Conway Collection add. 7233.

33. Reported comment of Richard Williams in the Mexican Inquisition trial of William Collins, 1574, Conway Collection add. 7231.

34. Morgan Tillert in the Mexican Inquisition trial of William Collins, 1574, Conway Collection add. 7231.

35. Mexican Inquisition trial: John Perin, 1574, Conway Collection add. 7249.

36. Mexican Inquisition trial: John Evans, 1574, Conway Collection add. 7250.

37. Mexican Inquisition trial: John Lee, 1574, Conway Collection add. 7250.

38. Morgan Tillert in the Mexican Inquisition trial of George Riveley, 1574, Conway Collection add. 7233.

39. Mexican Inquisition trial: Thomas Goodal, 1574, Conway Collection add. 7243.

40. Mexican Inquisition trials: William Collins, 1574, and William Cornelius, 1575, in Conway Collection adds. 7231 and 7239.

41. Mexican Inquisition trial: William Collins, 1574, Conway Collection add. 7231.

42. John Perin in the Mexican Inquisition trial of William Cornelius, 1575, Conway Collection add. 7239.

43. Mexican Inquisition trial: Thomas Ebren, 1573, Conway Collection add. 7245.

44. Mexican Inquisition trial: Morgan Tillert, 1574, Conway Collection add. 7235.

45. Morgan Tillert in the Mexican Inquisition trial of William Collins, 1574, Conway Collection add. 7231.

46. Evidence of Baltasar Zamora, merchant of Tenerife, to the Inquisition on the Canaries, 1570 [MC: Inquisición. Signatura LXX-15], quoted in Rumeu de Armas, *Los Viajes de John Hawkins a America*.

47. Mexican Inquisition trial: Miles Phillips, 1574, Conway Collection add. 7241.

48. Mexican Inquisition trial: John Farington, 1574, Conway Collection add. 7241.

49. Mexican Inquisition trial: Thomas Ebren, 1573, Conway Collection add. 7245.

TWENTY-ONE

1. Inquisición file1829, in which Sarmiento was accused of banqueting with the English and supplying them with food and drink, quoted in Rumeu de Armas, *Los Viajes de John Hawkins a America*, p. 225 n. 44.

2. Confession of Michael Soul, 26 November 1569, in Various documents from Seville, Conway Collection add. 7258.

3. Mexican Inquisition trial: William Collins, 1574, Conway Collection add. 7231.

4. Noah Sergeant, 2 November 1568, in the Certified notarial copy of the declarations of certain Englishmen taken at San Juan de Ulúa, Conway Collection add. 7257.

5. BM, Cotton MSS, Otho E VIII fol. 17–41b.

6. Declaration of Valentine Green, 3 November 1569, in Various documents from Seville, Conway Collection add. 7258. Also BM, Cotton MSS, Otho E VIII fol. 17–41b.

7. Various, often conflicting, versions exist of the events at Cape Blanco. Among them: the 1574 Mexican Inquisition trials of William Collins, George Day, and William Brown, in Conway Collection adds. 7231, 7247, 7250, and the declarations of Valentine Green [5 October 1568], Thomas Bennet [17 October 1568], Noah Sergeant [2 November 1568], and Henry Morris [10 November 1568], taken in Veracruz or San Juan de Ulúa and collected in Conway Collection add. 7257. In addition there are confessions by Valentine Green [3 November 1569], William de Orlando [24 November 1569], Michael Soul [26 November 1569], and George Fitzwilliams and Richard Temple [both 28 November 1569], collected in Various documents from Seville, Conway Collection add. 7258. There is also a description in BM, Cotton MSS, Otho E VIII fol. 17–41b.

8. BM, Cotton MSS, Otho E VIII fol. 17–41b.

9. Interview with Michael Soul, 6 October 1568, in Declarations of the English prisoners, Conway Collection add. 7257.

10. BM, Cotton MSS, Otho E VIII fol. 17–41b.

11. Confession of Michael Soul, 26 November 1569, in Various documents from Seville, Conway Collection add. 7258.

12. BM, Cotton MSS, Otho E VIII fol. 17–41b.

13. "A discourse written by one Miles Phillips, Englishman, one of the company put ashore northward of Panuco," in Hakluyt, *The Principall Navigations.*

14. Declaration of Robert Barrett, Xalapa, 8 October 1568, in Declarations of the English prisoners, Conway Collection add. 7257.

15. John Hawkyns, "The third troublesome voyage made . . . to the parts of Guinea, and the West Indies," in Hakluyt, *The Principall Navigations.*

16. "The rare travels of Job Hortop," in Hakluyt, *The Principall Navigations.*

17. Confessions of Richard Temple, 28 November 1569, in Various documents from Seville, Conway Collection add. 7258.

18. A number of accounts exist of the encounter with the small French fleet. Among them: BM, Cotton MSS, Otho E VIII fol. 17–41b; the Mexican Inquisition trial of William Collins, 1574, Conway Collection add. 7231; the declarations of William de Orlando [24 November 1569] and Richard Temple [28 November 1569] in Various documents from Seville, Conway Collection add. 7258; the declarations of Valentine Green [5 October 1568], Gregory Stephens [6 October 1568], and Robert Barrett [8 October 1568] in Declarations of the

English prisoners, Conway Collection add. 7257; the confessions of Anthony Goddard [2 November 1569], Christopher Robertson [23 November 1569], John Corniel [26 November 1569] and Christopher Bingham [1 December 1569] in Conway Collection add. 7260.

19. The confession of John Corniel, 26 November 1569, in More confessions . . . Conway Collection add. 7260.

20. Thomas Bennet, 18 October 1568, in Certified notarial copy of the declarations of certain Englishmen taken at San Juan de Ulúa, Conway Collection add. 7257.

21. William Sanders, 19 October 1568, in Certified notarial copy of the declarations of certain Englishmen taken at San Juan de Ulúa, Conway Collection add. 7257.

22. Declaration of Valentine Green, 3 November 1569, in Various documents from Seville, Conway Collection add. 7258.

23. Note of the places arrived at and time there, from John Hawkyns's journal, attached to a letter from Hawkyns to William Cecil, 25 January 1569, PRO, State Papers, Domestic, Elizabeth, SP12/49.

24. BM, Cotton MSS, Otho E VIII fol. 17–41b.

25. Article 22 of the charges against the English, in PRO, State Papers, Foreign, Elizabeth, SP70/99, Inquisitions and depositions of certain spoils committed by Englishmen, chiefly John Hawkyns, on the Guinea coast and elsewhere.

26. Ibid.

27. Testimony of Franciscus Pirez, in PRO, State Papers, Foreign, Elizabeth, SP70/99, Inquisitions and depositions of certain spoils committed by Englishmen, chiefly John Hawkyns, on the Guinea coast and elsewhere.

28. Testimony of Emanuel Lopez, in PRO, State Papers, Foreign, Elizabeth, SP70/99, Inquisitions and depositions of certain spoils committed by Englishmen, chiefly John Hawkyns, on the Guinea coast and elsewhere.

29. Various testimonies, in PRO, State Papers, Foreign, Elizabeth, SP70/99, Inquisitions and depositions of certain spoils committed by Englishmen, chiefly John Hawkyns, on the Guinea coast and elsewhere.

30. Various testimonies, in PRO, State Papers, Foreign, Elizabeth, SP70/99, Inquisitions and depositions of certain spoils committed by Englishmen, chiefly John Hawkyns, on the Guinea coast and elsewhere.

31. Testimony of Gaspar Fernandes, in PRO, State Papers, Foreign, Elizabeth, SP70/99, Inquisitions and depositions of certain spoils committed by Englishmen, chiefly John Hawkyns, on the Guinea coast and elsewhere.

32. Several testimonies, in PRO, State Papers, Foreign, Elizabeth, SP70/99,

Inquisitions and depositions of certain spoils committed by Englishmen, chiefly John Hawkyns, on the Guinea coast and elsewhere.

33. Mexican Inquisition trial: Pablo de Leon, 1574, Conway Collection add. 7249.

34. Mexican Inquisition trial: William Collins, 1574, Conway Collection add. 7231.

35. Ibid.

36. Mexican Inquisition trial: William Lowe, 1574, Conway Collection add. 7245.

37. "The rare travels of Job Hortop," in Hakluyt, *The Principall Navigations.*

38. Denunciation of Robert Barrett by Miguel Ribeiro, in proceedings against Barrett, Mexico, October 1570, Conway Collection add. 7229.

39. BM, Cotton MSS, Otho E VIII fol. 17–41b.

40. John Hawkyns, "The third troublesome voyage made . . . to the parts of Guinea, and the West Indies," in Hakluyt, *The Principall Navigations.*

41. Confession of Thomas Fowler, 2 November 1569, in More confessions . . . , Conway Collection add. 7260.

42. Reported comments of Richard Williams in the Mexican Inquisition trial of William Collins, 1574, Conway Collection add. 7231.

43. BM, Cotton MSS, Otho E VIII fol. 17–41b.

44. "The rare travels of Job Hortop," in Hakluyt, *The Principall Navigations.*

45. BM, Cotton MSS, Otho E VIII fol. 17–41b.

46. BM, Cotton MSS, Otho E VIII fol. 17–41b. Also John Hawkyns, "The third troublesome voyage made . . . to the parts of Guinea, and the West Indies," in Hakluyt, *The Principall Navigations.*

47. The accounts vary. The anonymous Otho E VIII version states that the first engagement took place on 27 January; Hawkyns's own account in "The third troublesome voyage" says it occurred on 15 January.

48. BM, Cotton MSS, Otho E VIII fol. 17–41b.

49. Ibid., although "The third troublesome voyage" says forty were hurt.

50. Confession of Gregory Simon, 24 November 1569, in More confessions . . . , Conway Collection add. 7260.

51. Confession of John Holland, 9 December 1569, in More confessions . . . , Conway Collection add. 7260.

52. BM, Cotton MSS, Otho E VIII fol. 17–41b.

53. Ibid.

54. "The rare travels of Job Hortop," in Hakluyt, *The Principall Navigations.*

55. Thomas Bennet, 18 October 1568, in the Certified notarial copy of the declarations of certain Englishmen taken at San Juan de Ulúa, Conway Collection add. 7257.

56. BM, Cotton MSS, Otho E VIII fol. 17–41b.

NOTES

57. "A discourse written by one Miles Phillips, Englishman, one of the company put ashore northward of Panuco," in Hakluyt, *The Principall Navigations.*

58. Interview with Richard Reed, 6 October 1568, in Declarations of the English prisoners, Conway Collection add. 7257; confession of John Corniel, 26 November 1569, in More confessions . . . , Conway Collection add. 7260; "A discourse written by one Miles Phillips, Englishman, one of the company put ashore northward of Panuco," in Hakluyt, *The Principall Navigations;* BM, Cotton MSS, Otho E VIII fol. 17–41b.

59. BM, Cotton MSS, Otho E VIII fol. 17–41b; Mexican Inquisition trial: William Cornelius, 1575, Conway Collection add. 7239.

60. It is far from clear in the records exactly when Drake took command of the *Judith.* A reading of Job Hortop's account of events suggests that it happened now, but there is informed speculation that Drake was in charge of the *Judith* from the expedition's outset.

61. In *A History of the Upper Guinea Coast, 1545–1800,* Walter Rodney speculates with a good degree of probability that Hawkyns arrived at Tagrin at a critical juncture in African history. For centuries the history of Sierra Leone and the Upper Guinea coast had been tied in with the rise and fall of three huge empires, those of Ghana, Mali, and Songhai. Each had been immensely powerful, sophisticated, and highly respected, and each had come and gone, leaving instability in its wake. By the sixteenth century West Africa was characterized by the constant migration and displacement of peoples, the most significant of which was that of the Manes, who over the course of sixty years had marched from the interior to the Atlantic and then along the coast into Sierra Leone, swallowing up whole villages and towns. As they had advanced, so they had divided up the land among far-from-harmonious chiefs. In the late 1560s the Mane monarch Flansire had begun a new wave of invasions from Cape Mount and had granted the Sierra Leone River and estuary to a warlord by the name of Kandaqualle, whose ascendancy was successfully challenged by a belligerent rival called Falma. Kandaqualle was expelled, but Flansire came to his rescue, and with the aid of Europeans, they besieged Falma in a village before cutting though the palisades and the double row of trees that surrounded it and setting the place on fire. Falma escaped with great difficulty, and Kandaqualle was reestablished. As Rodney says, "None of the names are the same, but the struggle between Sasena and Shere in 1567–8, in which John Hawkins played a part, fits the circumstances in all essentials, if for Sasena one reads Falma and for Shere one reads Kandaqualle."

TWENTY-TWO

1. John Hawkyns, "The third troublesome voyage made . . . to the parts of Guinea, and the West Indies," in Hakluyt, *The Principall Navigations*.

2. Confession of Henry Quince, 6 December 1569, in Various documents from Seville, Conway Collection add. 7258.

3. Declaration of Robert Barrett, Xalapa, 8 October 1568, in Declarations of the English prisoners, Conway Collection add. 7257; plus interview with Gregory Stephens, 6 October 1568, in Declarations of the English prisoners, Conway Collection add. 7257; confession of Anthony Goddard, November 1569, in More confessions . . . , Conway Collection add. 7260; and BM, Cotton MSS, Otho E VIII fol. 17–41b.

4. BM, Cotton MSS, Otho E VIII fol. 17–41b.

5. Ibid.

6. Ibid.

7. Confession of Anthony Goddard, November 1569, in More confessions . . . , Conway Collection add. 7260.

8. Mexican Inquisition trial: William Collins, 1574, in Conway Collection add. 7231.

9. Thomas Bennet, 18 October 1568, Certified notarial copy of the declarations of certain Englishmen taken at San Juan de Ulúa, Conway Collection add. 7257.

10. Declaration of Valentine Green, 3 November 1569, in Various documents from Seville, Conway Collection add. 7258; also declarations of Thomas Bennet [18 October 1568] and William Sanders [19 October 1568] in Certified notarial copy of the declarations of certain Englishmen taken at San Juan de Ulúa, Conway Collection add. 7257.

11. BM, Cotton MSS, Otho E VIII fol. 17–41b.

12. Confession of Henry Quince, 6 December 1569, in Various documents from Seville, Conway Collection add. 7258.

13. Mexican Inquisition trial: John Breton, 1574, Conway Collection add. 7249.

14. Thomas Ebren in the Mexican Inquisition trial of George Riveley, 1574, Conway Collection add. 7233.

15. BM, Cotton MSS, Otho E VIII fol. 17–41b.

16. Ibid.

17. Mexican Inquisition trial: William Collins, 1574, Conway Collection add. 7231.

18. BM, Cotton MSS, Otho E VIII fol. 17–41b.

19. "The rare travels of Job Hortop," in Hakluyt, *The Principall Navigations*.

20. Mexican Inquisition trial: William Collins, 1574, Conway Collection add. 7231.

21. BM, Cotton MSS, Otho E VIII fol. 17–41b.

22. Velasco, *Geografía y Descripcion de las Indias*.

23. Mexican Inquisition trial: William Cornelius, 1575, Conway Collection add. 7239.

24. "The rare travels of Job Hortop," in Hakluyt, *The Principall Navigations*.

25. William Sanders, 19 October 1568, in the Certified notarial copy of the declarations of certain Englishmen taken at San Juan de Ulúa, Conway Collection add. 7257.

26. Roger Armour in the Mexican Inquisition trial of William Collins, 1574, Conway Collection add. 7231.

27. Interview with Robert Barrett, 8 October 1568, in Declarations of the English prisoners, Conway Collection add. 7257.

28. BM, Cotton MSS, Otho E VIII fol. 17–41b.

29. Confessions of Michael Soul [26 November 1569], George Fitzwilliams and Richard Temple [28 November 1569], Thomas Jones and Diego Hen [7 December 1569], and John Birch [10 December 1569], in Various documents from Seville, Conway Collection add. 7258. Also Confession of Thomas Fowler, 2 November 1569, in More confessions . . . , Conway Collection add. 7260.

30. BM, Cotton MSS, Otho E VIII fol. 17–41b, and letter of Lazaro de Vallejo Alderete and Hernando Castilla to Philip II, Rio de la Hacha, 26 September 1568, in Archivo General de Indias, Signaturas Antiguas 54-4-28, 1, transcribed as document 22 in Wright, *Spanish Documents*.

31. BM, Cotton MSS, Otho E VIII fol. 17–41b.

32. Confession of Thomas Fowler, 2 November 1569, in More confessions . . . , Conway Collection add. 7260. See also the confessions of Michael Soul [26 November 1569] and Richard Temple [28 November 1569] in Various documents from Seville, Conway Collection add. 7258. Also BM, Cotton MSS, Otho E VIII fol. 17–41b, and John Hawkyns, "The third troublesome voyage made . . . to the parts of Guinea, and the West Indies," in Hakluyt, *The Principall Navigations*.

33. Letter from Miguel de Castellanos to Philip II, Rio de la Hacha, 26 September 1568, in Archivo General de Indias, Signatura Antiguas 54-4-28, 1, transcribed as document 23 in Wright, *Spanish Documents*.

34. Letter of Lazaro de Vallejo Alderete and Hernando Castilla to Philip II, Rio de la Hacha, 26 September 1568, in Archivo General de Indias, Signaturas Antiguas 54-4-28, 1, transcribed as document 22 in Wright, *Spanish Documents*.

35. BM, Cotton MSS, Otho E VIII fol. 17–41b; also interview with Gregory

Stephens, 18 October 1568, in Declarations of the English prisoners, Conway Collection add. 7257.

36. BM, Cotton MSS, Otho E VIII fol. 17–41b.

37. Ibid.

38. Thomas Bennet, 18 October 1568, in Certified notarial copy of the declarations of certain Englishmen taken at San Juan de Ulúa, Conway Collection add. 7257.

39. Confessions of Michael Soul [26 November 1569], Richard Temple [28 November 1569], and Thomas Stephens [6 December 1569] in Various documents from Seville, Conway Collection add. 7258.

40. Confessions of Richard Temple, 28 November 1569, in Various documents from Seville, Conway Collection add. 7258.

41. Mexican Inquisition trial: William Cornelius, 1575, Conway Collection add. 7239.

42. Roger Armour in the Mexican Inquisition trial of William Collins, 1574, Conway Collection add. 7231.

43. BM, Cotton MSS, Otho E VIII fol. 17–41b.

44. Ibid.; "A discourse written by one Miles Phillips, Englishman, one of the company put ashore northward of Panuco," and John Hawkyns, "The third troublesome voyage made . . . to the parts of Guinea, and the West Indies," in Hakluyt, *The Principall Navigations.*

45. BM, Cotton MSS, Otho E VIII fol. 17–41b.

46. "The rare travels of Job Hortop," in Hakluyt, *The Principall Navigations.*

47. Confession of Christopher Bingham, 1 December 1569, in More confessions . . . , Conway Collection add. 7260.

48. BM, Cotton MSS, Otho E VIII fol. 17–41b; interviews with Gregory Stephens [6 October 1568] and Michael Soul [6 October 1568] in Declarations of the English prisoners, Conway Collection add. 7257; confession of Thomas Fowler, 2 November 1569, in More confessions . . . , Conway Collection add. 7260; confession of Michael Soul, 26 November 1569, in Various documents from Seville, Conway Collection add. 7258. See also the letters of Miguel de Castellanos, Lazaro de Vallejo Alderete, and Hernando Castilla to the Crown, from Rio de la Hacha, 26 September 1568, Archivo General de Indias, Signatura Antigua 54-4-28, 1, transcribed as documents 22 and 23 in Wright, *Spanish Documents.*

49. BM, Cotton MSS, Otho E VIII fol. 17–41b.

50. Ibid.

51. Ibid.

52. Ibid.; also the confession of Michael Soul, 26 November 1569, in Various documents from Seville, Conway Collection add. 7258; Robert Barrett, 8 October 1568, in Declarations of the English prisoners, Conway Collection add. 7257; confession of Thomas Fowler, 2 November 1569, More confessions . . . , Conway Collection add. 7260; and the Mexican Inquisition trials of William Collins, 1574, and William Cornelius, 1575, Conway Collection adds. 7231 and 7239. See also the letters of Miguel de Castellanos, Lazaro de Vallejo Alderete, and Hernando Castilla to the Crown, from Rio de la Hacha, 26 September 1568, Archivo General de Indias, Signatura Antigua 54-4-28, 1, transcribed as documents 22 and 23 in Wright, *Spanish Documents*.

53. BM, Cotton MSS, Otho E VIII fol. 17–41, and interview with Gregory Stephens, 6 October 1568, in Declarations of the English prisoners, Conway Collection add. 7257.

54. Henry Morris, 10 November 1568, in the Certified notarial copy of the declarations of certain Englishmen taken at San Juan de Ulúa, Conway Collection add. 7257.

55. Interview with Robert Barrett, 8 October 1568, in Declarations of the English prisoners, Conway Collection add. 7257.

56. BM, Cotton MSS, Otho E VIII fol. 17–41b; also the confession of Michael Soul, 26 November 1569, in Various documents from Seville, Conway Collection add. 7258; Robert Barrett, 8 October 1568, in Declarations of the English prisoners, Conway Collection add. 7257; confession of Thomas Fowler, 2 November 1569, in More confessions . . . , Conway Collection add. 7260; Mexican Inquisition trial of William Lowe, 1574, in Conway Collection add. 7245; declaration of Thomas Bennet, 18 October 1568, in Certified notarial copy of the declarations of certain Englishmen taken at San Juan de Ulúa, Conway Collection add. 7257.

57. Letters of Miguel de Castellanos, Lazaro de Vallejo Alderete, and Hernando Castilla to the Crown, from Rio de la Hacha, 26 September 1568, Archivo General de Indias, Signatura Antigua 54-4-28, 1, transcribed as documents 22 and 23 in Wright, *Spanish documents*.

TWENTY-THREE

1. Velasco, *Geografia y Descripcion de las Indias*.
2. BM, Cotton MSS, Otho E VIII fol. 17–41b.
3. Declarations of William de Orlando [24 November 1569] and Michael Soul

[26 November 1569] in Various documents from Seville, Conway Collection add. 7258.

4. BM, Cotton MSS, Otho E VIII fol. 17–41b.

5. Declarations of William de Orlando [24 November 1569] and Michael Soul [26 November 1569] in Various documents from Seville, Conway Collection add. 7258.

6. BM, Cotton MSS, Otho E VIII fol. 17–41b.

7. Confession of George Fitzwilliams, 28 November 1569, in Various documents from Seville, Conway Collection add. 7258.

8. BM, Cotton MSS, Otho E VIII fol. 17–41b; confessions of Valentine Green [3 November 1569], Thomas Johns [7 December 1569], and Michael Soul [26 November 1569] in Various documents from Seville, Conway Collection add. 7258; also declarations of Thomas Bennet [18 October 1568] and William Sanders [19 October 1568] in the Certified notarial copy of the declarations of certain Englishmen taken at San Juan de Ulúa, Conway Collection add. 7257.

9. Confession of Thomas Fowler, 2 November 1569, in More confessions . . . , Conway Collection add. 7260.

10. BM, Cotton MSS, Otho E VIII fol. 17–41b.

11. See ibid. and Velasco, *Geografia y Descripcion de las Indias.*

12. BM, Cotton MSS, Otho E VIII fol. 17–41b.

13. Confession of Anthony Goddard, November 1569, in More confessions . . . , Conway Collection add. 7260.

14. BM, Cotton MSS, Otho E VIII fol. 17–41b.

15. Ibid.; "The rare travels of Job Hortop," in Hakluyt, *The Principall Navigations*; Robert Barrett [8 October 1568] and Richard Reed [6 October 1568] in Declarations of the English prisoners, Conway Collection add. 7257; interview of Henry Morris, 10 November 1568, in Certified notarial copy of the declarations of certain Englishmen taken at San Juan de Ulúa, Conway Collection add. 7257.

16. BM, Cotton MSS, Otho E VIII fol. 17–41b; declaration of Valentine Green, 5 October 1568, in Declaration of the English prisoners, Conway Collection add. 7257; declaration of Michael Soul, 26 November 1569, in Various documents from Seville, Conway Collection add. 7258; confessions of Anthony Goddard [November 1569] and John Corniel [26 November 1569] in More confessions . . . , Conway Collection add. 7260. See also Unwin, *The Defeat of John Hawkins.*

17. Mexican Inquisition trial: John Perin, 1574, Conway Collection add. 7249.

18. BM, Cotton MSS, Otho E VIII fol. 17–41b; confessions of William de Orlando

[24 November 1569] and Richard Temple [28 November 1569] in Various documents from Seville, Conway Collection add. 7258; interview with Gregory Stephens, 6 October 1568, in Declarations of the English prisoners, Conway Collection add. 7257; declarations of Thomas Bennet [18 October 1568], William Sanders [19 October 1568], Noah Sergeant [2 November 1568], and Henry Morris [10 November 1568] in Certified notarial copy of the declarations of certain Englishmen taken at San Juan de Ulúa, Conway Collection add. 7257; confession of Thomas Fowler, 2 November 1569, in More confessions . . . , Conway Collection add. 7260. Also the Mexican Inquisition trials of William Collins and John Perin, 1574, Conway Collection adds. 7231 and 7249.

19. Confession of Richard Temple, 28 November 1569, in Various documents from Seville, Conway Collection add. 7258; also BM, Cotton MSS, Otho E VIII fol. 17–41b.

20. BM, Cotton MSS, Otho E VIII fol. 17–41b.

TWENTY-FOUR

1. Confession of Anthony Goddard, November 1569, in More confessions . . . , Conway Collection add. 7260.

2. BM, Cotton MSS, Otho E VIII fol. 17–41b.

3. Confession of Anthony Goddard, November 1569, in More confessions . . . , Conway Collection add. 7260.

4. "A discourse written by one Miles Phillips, Englishman, one of the company put ashore northward of Panuco," in Hakluyt, *The Principall Navigations.*

5. BM, Cotton MSS, Otho E VIII fol. 17–41b.

6. Mexican Inquisition trial: Bartolome Gonzalez, 1573, Conway Collection add. 7255; also BM, Cotton MSS, Otho E VIII fol. 17–41b.

7. John Hawkyns, "The third troublesome voyage made . . . to the parts of Guinea, and the West Indies," in Hakluyt, *The Principall Navigations.*

8. Juan Suarez de Peralta, "Historical Notices of New Spain," 1579–80, Conway Collection add. 7229.

9. Mexican Inquisition trial: Bartolome Gonzalez, 1573, Conway Collection add. 7255.

10. "A discourse written by one Miles Phillips, Englishman, one of the company put ashore northward of Panuco," in Hakluyt, *The Principall Navigations.*

11. "The Expedition of Juan de Grijalva," in Diaz, *The Conquest of New Spain.* It was from here that Cortés moved on to Mexico City.

12. See Velasco, *Geografia y Descripcion de las Indias*; Rumeu de Armas, *Los Viajes de John Hawkins a America*; Purchas, *Hakluytus Posthumus*.

13. See Velasco, *Geografia y Descripcion de las Indias*; Rumeu de Armas, *Los Viajes de John Hawkins a America*; John Chilton, "Travels in Mexico," and "A discourse written by one Miles Phillips, Englishman, one of the company put ashore northward of Panuco," in Hakluyt, *The Principall Navigations*. See also Williamson, *Hawkins of Plymouth*.

14. John Chilton, "Travels in Mexico," in Hakluyt, *The Principall Navigations*.

15. BM, Cotton MSS, Otho E VIII fol. 17–41b; account of the battle between John Hawkyns and the fleet of New Spain in the port of San Juan de Ulúa, Conway Collection add. 7257.

16. John Hawkyns, "The third troublesome voyage made ... to the parts of Guinea, and the West Indies," in Hakluyt, *The Principall Navigations*.

17. BM, Cotton MSS, Otho E VIII fol. 17–41b.

18. Antonio Delgadillo evidence to the Viceroy's enquiry into the opening of the battle, 27 September 1568, in Conway Collection add. 7259. Also BM, Cotton MSS, Otho E VIII fol. 17–41b.

19. BM, Cotton MSS, Otho E VIII fol. 17–41b, and John Hawkyns, "The third troublesome voyage made ... to the parts of Guinea, and the West Indies," in Hakluyt, *The Principall Navigations*.

20. Antonio Delgadillo evidence to the Viceroy's enquiry into the opening of the battle, 27 September 1568, Conway Collection add. 7259.

21. Letter of Don Luis Zegri to the Audiencia in Mexico, 18 September 1568, in Conway Collection add. 7257.

22. Antonio Delgadillo evidence to the Viceroy's enquiry into the opening of the battle, 27 September 1568, Conway Collection add. 7259.

23. John Hawkyns, "The third troublesome voyage made ... to the parts of Guinea, and the West Indies," in Hakluyt, *The Principall Navigations*.

24. BM, Cotton MSS, Otho E VIII fol. 17–41b.

25. Testimony of Cristoval Sanchez, pilot, resident of Seville, included in Further documents of Francisco de Luxan presented by him on 13 October 1570, Conway Collection add. 7259; also Antonio Delgadillo evidence to the Viceroy's enquiry into the opening of the battle, 27 September 1568, Conway Collection add. 7259.

26. Letter of Don Luis Zegri to the Audiencia in Mexico, 18 September 1568, Conway Collection add. 7257.

27. "A discourse written by one Miles Phillips, Englishman, one of the company put ashore northward of Panuco," in Hakluyt, *The Principall Navigations*.

28. John Hawkyns, "The third troublesome voyage made ... to the parts of Guinea, and the West Indies," in Hakluyt, *The Principall Navigations.*

29. Statement of Francisco de Bustamante in Don Martin Enriquez's statement, and supporting depositions, San Juan de Ulúa, 27–30 September 1568, Archivo General de Indias, Signatura Antigua 51-6-16/14 fol. 115 et seq., transcribed as document 27 in Wright, *Spanish Documents.*

30. Confession of Anthony Goddard, November 1569, in More confessions ... , Conway Collection add. 7260.

31. John Hawkyns, "The third troublesome voyage made ... to the parts of Guinea, and the West Indies," in Hakluyt, *The Principall Navigations.*

32. Account of the battle between John Hawkyns and the fleet of New Spain in the port of San Juan de Ulúa, Conway Collection add. 7257.

33. Viceroy's enquiry into the opening of the battle, 27 September 1568, Conway Collection add. 7259.

34. Antonio Delgadillo and Diego Felipe evidence to the Viceroy's enquiry into the opening of the battle, 27 September 1568, Conway Collection add. 7259.

35. Statement of Francisco de Bustamante in Don Martin Enriquez's statement, and supporting depositions, San Juan de Ulúa, 27–30 September 1568, Archivo General de Indias, Signatura Antigua 51-6-16/14 fol. 115 et seq., transcribed as document 27 in Wright, *Spanish Documents.*

36. "A discourse written by one Miles Phillips, Englishman, one of the company put ashore northward of Panuco," in Hakluyt, *The Principall Navigations.*

37. Declaration of Don Martin Enriquez to John Hawkyns, from aboard the Spanish flagship, off San Juan de Ulúa, 18 September 1568, Archivo General de Indias, Signatura Antigua 141-7-7, transcribed as document 25 in Wright, *Spanish Documents.*

38. Inquisition inquiry into heretical remarks of William de Orlando, 1569, Conway Collection add. 7229; confessions of William de Orlando [24 November 1569], Michael Soul [26 November 1569], Richard Temple [28 November 1569], and George Fitzwilliams [28 November 1569] in Various documents from Seville, Conway Collection add. 7258; letter from the Casa de Contratación, 17 June 1570, in Letters, Conway Collection add. 7260; confessions of Thomas Fowler [2 November 1569], John Corniel [26 November 1569], and Christopher Bingham [1 December 1569] in More confessions ... , Conway Collection add. 7260.

39. De Ubilla evidence to the Viceroy's enquiry into the opening of the battle, 27 September 1568, Conway Collection add. 7259.

40. Juan Suarez de Peralta, "Historical Notices of New Spain," 1579–80, Conway Collection add. 7229.

41. De Ubilla evidence to the viceroy's enquiry into the opening of the battle, 27 September 1568, Conway Collection add. 7259.

42. Declaration of Valentine Green, 3 November 1569, in Various documents from Seville, Conway Collection add. 7258.

43. "A discourse written by one Miles Phillips, Englishman, one of the company put ashore northward of Panuco," in Hakluyt, *The Principall Navigations.*

44. News of the arrival of letters in Mexico City, in Official acts—transcript of official acts regarding the Englishmen who arrived at the port, Mexico, 19 September 1568, Conway Collection add. 7257.

45. Decision of the Audiencia in Mexico City, in Official acts—transcript of official acts regarding the Englishmen who arrived at the port, Mexico, 19 September 1568, Conway Collection add. 7257.

46. Letter of Alonso Rodriguez and Miguel de Oñate to the Audiencia in Mexico, 16 September 1568, Conway Collection add. 7257.

47. Letter of Don Luis Zegri to the Audiencia in Mexico, 17 September 1568, Conway Collection add. 7257.

48. Letter from the Audiencia in Mexico to the chief alcaldes and justices of Puebla, Tlaxcala, Tepeaca, and Xalapa, September 1568, Conway Collection add. 7257.

49. Order from the Audiencia in Mexico to James Fortuna in Coatzacoalcos and Lope de Varta in fishing grounds of Julio de Quenca, September 1568, Conway Collection add. 7257.

50. Statement of Francisco de Bustamante in Don Martin Enriquez's statement, and supporting depositions, San Juan de Ulúa, 27–30 September 1568, Archivo General de Indias, Signatura Antigua 51-6-16/14 fol. 115 et seq., transcribed as document 27 in Wright, *Spanish Documents.*

51. Account of the battle between John Hawkyns and the fleet of New Spain in the port of San Juan de Ulúa, Conway Collection add. 7257; also statement of Francisco de Bustamante in Don Martin Enriquez's statement, and supporting depositions, San Juan de Ulúa, 27–30 September 1568, Archivo General de Indias, Signatura Antigua 51-6-16/14 fol. 115 et seq., transcribed as document 27 in Wright, *Spanish Documents.*

52. "A discourse written by one Miles Phillips, Englishman, one of the company put ashore northward of Panuco," in Hakluyt, *The Principall Navigations.*

53. Viceroy's enquiry into the opening of the battle, 27 September 1568, Conway Collection add. 7259; also an account of the battle between John Hawkyns and the fleet of New Spain in the port of San Juan de Ulúa, Conway Collection add. 7257.

54. Evidence of John Turren to the High Court of the Admiralty inquiry into events at San Juan de Ulúa, PRO, State Papers, Domestic, Elizabeth, SP12/53.

55. Declaration of William de Orlando, 24 November 1569, in Various documents from Seville, Conway Collection add. 7258.

56. Viceroy's enquiry into the opening of the battle, 27 September 1568, Conway Collection add. 7259.

57. Diego Felipe evidence to the Viceroy's enquiry into the opening of the battle, 27 September 1568, Conway Collection add. 7259.

58. Viceroy's enquiry into the opening of the battle, 27 September 1568, Conway Collection add. 7259.

59. Questions and witness statements in Further documents of Francisco de Luxan presented by him on 13 October 1570, Conway Collection add. 7259.

60. High Court of the Admiralty inquiry into events at San Juan de Ulúa, PRO, State Papers, Domestic, Elizabeth, SP12/53.

61. Account of the battle between John Hawkyns and the fleet of New Spain in the port of San Juan de Ulúa, Conway Collection add. 7257, plus evidence taken at the Viceroy's enquiry into the opening of the battle, 27 September 1568, Conway Collection add. 7259; and "The rare travels of Job Hortop," in Hakluyt, *The Principall Navigations*. See also the statement of Francisco de Bustamante in Don Martin Enriquez's statement, and supporting depositions, San Juan de Ulúa, 27–30 September 1568, Archivo General de Indias, Signatura Antigua 51-6-16/14 fol. 115 et seq., transcribed as document 27 in Wright, *Spanish Documents*.

62. Diego Felipe evidence to the Viceroy's enquiry into the opening of the battle, 27 September 1568, Conway Collection add. 7259.

63. John Hawkyns, "The third troublesome voyage made ... to the parts of Guinea, and the West Indies," in Hakluyt, *The Principall Navigations*.

64. Confession of John Brown, 26 November 1569, in More confessions ..., Conway Collection add. 7260.

65. Declaration of Robert Barrett, Xalapa, 8 October 1568, in Declarations of the English prisoners, Conway Collection add. 7257.

66. Confessions of Michael Soul [26 November 1569] and Richard Temple [28 November 1569] in Various documents from Seville, Conway Collection add. 7258.

67. Juan Suarez de Peralta, "Historical Notices of New Spain," 1579–80, Conway Collection add. 7229.

68. De Ubilla evidence to the Viceroy's enquiry into the opening of the battle, 27 September 1568, Conway Collection add. 7259.

69. Ibid.

70. John Hawkyns, "The third troublesome voyage made . . . to the parts of Guinea, and the West Indies," in Hakluyt, *The Principall Navigations.*

71. Account of the battle between John Hawkyns and the fleet of New Spain in the port of San Juan de Ulúa, Conway Collection add. 7257; also Duro, *Armada Espanola.*

72. John Hawkyns, "The third troublesome voyage made . . . to the parts of Guinea, and the West Indies," in Hakluyt, *The Principall Navigations.*

73. Evidence of John Turren to the High Court of the Admiralty inquiry into events at San Juan de Ulúa, PRO, State Papers, Domestic, Elizabeth, SP12/53; and Cabrera de Cordoba referred to in Corbett, *Drake and the Tudor Navy.*

74. "A discourse written by one Miles Phillips, Englishman, one of the company put ashore northward of Panuco," in Hakluyt, *The Principall Navigations.*

75. "The rare travels of Job Hortop," in Hakluyt, *The Principall Navigations.*

76. Confession of Anthony Goddard, November 1569, in More confessions . . . , Conway Collection add. 7260.

77. De Ubilla evidence to the Viceroy's enquiry into the opening of the battle, 27 September 1568, Conway Collection add. 7259.

78. Ibid.; and Account of the battle between John Hawkyns and the fleet of New Spain in the port of San Juan de Ulúa, Conway Collection add. 7257.

79. De Ubilla evidence to the Viceroy's enquiry into the opening of the battle, 27 September 1568, Conway Collection add. 7259.

80. "A discourse written by one Miles Phillips, Englishman, one of the company put ashore northward of Panuco," in Hakluyt, *The Principall Navigations.*

81. "The rare travels of Job Hortop," in Hakluyt, *The Principall Navigations.*

82. Ibid.

83. John Hawkyns, "The third troublesome voyage made . . . to the parts of Guinea, and the West Indies," in Hakluyt, *The Principall Navigations.*

84. Juan Suarez de Peralta, "Historical Notices of New Spain," 1579–80, Conway Collection add. 7229.

85. De Ubilla evidence to the Viceroy's enquiry into the opening of the battle, 27 September 1568, Conway Collection add. 7259.

86. John Hawkyns, "The third troublesome voyage made . . . to the parts of Guinea, and the West Indies," in Hakluyt, *The Principall Navigations.*

87. Evidence of Humphrey Fones to the High Court of the Admiralty inquiry into events at San Juan de Ulúa, PRO, State Papers, Domestic, Elizabeth, SP12/53.

88. Mexican Inquisition trial: Paul Hawkyns, 1574–1577, Conway Collection add. 7237.

89. Evidence of Francisco Maldonado to the Viceroy's enquiry into the opening of the battle, 27 September 1568, Conway Collection add. 7259.

90. "A discourse written by one Miles Phillips, Englishman, one of the company put ashore northward of Panuco," in Hakluyt, *The Principall Navigations*.

91. Letter from de Ubilla to Philip II, 16 December 1568, Conway Collection add. 7255.

92. "The rare travels of Job Hortop," in Hakluyt, *The Principall Navigations*.

93. Confession of Thomas Fowler, 2 November 1569, in More confessions . . . , Conway Collection add. 7260.

94. De Ubilla to Philip II, 16 December 1568, in Conway Collection add. 7255.

95. Witness statement of Lazaro Gutierrez, included in Further documents of Francisco de Luxan presented by him on 13 October 1570, Conway Collection add. 7259.

96. Witness statement of Baltasar de Torres, included in Further documents of Francisco de Luxan presented by him on 13 October 1570, Conway Collection add. 7259.

97. Witness statement of Jacome Porcelin, included in Further documents of Francisco de Luxan presented by him on 13 October 1570, Conway Collection add. 7259.

98. Witness statement of Francisco Gutierrez Moreno, included in Further documents of Francisco de Luxan presented by him on 13 October 1570, Conway Collection add. 7259.

99. De Ubilla to Philip II, 16 December 1568, in Conway Collection add. 7255.

TWENTY-FIVE

1. Letter from John Hawkyns to William Cecil, 25 January 1569, PRO, State Papers, Domestic, Elizabeth, SP12/49.

2. Evidence of Francisco Maldonado, Antonio Delgadillo, and Juan de Ubilla to the Viceroy's enquiry into the opening of the battle, San Juan de Ulúa, 27–30 September 1568, in Conway Collection add. 7259.

3. Evidence of Francisco de Bustamante to the Viceroy's enquiry into the opening of the battle, San Juan de Ulúa, 27–30 September 1568, in Conway Collection add. 7259.

4. "The expedition of Juan de Grijalva," in Diaz, *The Conquest of New Spain*.

5. Mexican Inquisition trial: William Collins, 1574, Conway Collection add. 7231.

6. "A discourse written by one Miles Phillips, Englishman, one of the company put ashore northward of Panuco," in Hakluyt, *The Principall Navigations*.

7. John Hawkyns, "The third troublesome voyage made . . . to the parts of Guinea, and the West Indies," in Hakluyt, *The Principall Navigations*.

8. Quoted in Williamson, *Sir John Hawkins*. For further discussion of Drake's "betrayal of Hawkyns" see Appendix C, "Drake's desertion of Hawkins," in Corbett, *Drake and the Tudor Navy*, pp. 400–401.

9. John Hawkyns, "The third troublesome voyage made . . . to the parts of Guinea, and the West Indies," in Hakluyt, *The Principall Navigations*.

10. "The rare travels of Job Hortop," in Hakluyt, *The Principall Navigations*.

11. "A discourse written by one Miles Phillips, Englishman, one of the company put ashore northward of Panuco," in Hakluyt, *The Principall Navigations*.

12. Ibid.

13. De Luxan to Philip II from San Juan de Ulúa, 11 January 1569, Conway Collection add. 7255.

14. "A discourse written by one Miles Phillips, Englishman, one of the company put ashore northward of Panuco," in Hakluyt, *The Principall Navigations*.

15. "The rare travels of Job Hortop" and "A discourse written by one Miles Phillips, Englishman, one of the company put ashore northward of Panuco," in Hakluyt, *The Principall Navigations*.

16. "A discourse written by one Miles Phillips, Englishman, one of the company put ashore northward of Panuco," in Hakluyt, *The Principall Navigations*.

17. John Hawkyns, "The third troublesome voyage made . . . to the parts of Guinea, and the West Indies," in Hakluyt, *The Principall Navigations*.

TWENTY-SIX

1. John Hawkyns, "The third troublesome voyage made . . . to the parts of Guinea, and the West Indies," in Hakluyt, *The Principall Navigations*.

2. Testimony of Antonio Pita to an inquiry held in Vigo, 23 February 1569, Conway Collection add. 7257.

3. Testimony of Fernando de Saa to an inquiry held in Vigo, 24 February 1569, Conway Collection add. 7257.

4. Richard Hawkins, *The Observations of Sir Richard Hawkins*.

5. Testimony of Gregorio de Saa to an inquiry held in Marín, 28 February 1569, Conway Collection add. 7257.

6. Ibid.

7. Testimony of Antonio Pita to an inquiry held in Vigo, 23 February 1569, Conway Collection add. 7257.

8. Testimony of Juan de Torres to an inquiry held in Pontevedra, 28 February 1569, Conway Collection add. 7257.

9. Testimony of Pedro de Salnes to an inquiry held in Pontevedra, 28 February 1569, Conway Collection add. 7257.

10. Testimony of Gregorio de Saa to an inquiry held in Marin, 28 February 1569, Conway Collection add. 7257.

11. Testimonies of Tomas Olanda to an inquiry held in Vigo, 26 February 1569, and Antonio Sarmiento de Monenegro to an inquiry in Pontevedra, 27 February 1569. Alonso Sanchez in testimony to the inquiry in Vigo on 23 February said the two ships were Portuguese (Conway Collection add. 7257).

12. John Hawkyns, "The third troublesome voyage made ... to the parts of Guinea, and the West Indies," in Hakluyt, *The Principall Navigations*.

13. Testimony of Gregorio de Saa to an inquiry held in Marín, 28 February 1569, Conway Collection add. 7257.

14. Ibid.

15. Testimony of Pedro Ramos to an inquiry held in Vigo, 25 February 1569, Conway Collection add. 7257.

16. Testimonies of Antonio Pita, Pedro Ramos, Ralph Cotton, and Gregorio Sarmiento de Valldares to an inquiry held in Vigo, 23–25 February 1569, Conway Collection add. 7257.

17. Testimony of Pedro Ramos to an inquiry held in Vigo, 25 February 1569, Conway Collection add. 7257.

18. Testimony of Antonio Pita to an inquiry held in Vigo, 23 February 1569, Conway Collection add. 7257.

19. Ibid.

20. Testimony of Fernando de Saa to an inquiry held in Vigo, 24 February 1569, Conway Collection add. 7257.

21. Testimony of Simon Vasquez to an inquiry held in Vigo, 24 February 1569, Conway Collection add. 7257.

22. Testimony of Fernando de Saa to an inquiry held in Vigo, 24 February 1569, Conway Collection add. 7257.

23. Testimony of Tomas Olanda to an inquiry held in Vigo, 26 February 1569, Conway Collection add. 7257. The Spanish document refers to Althorp as Juan Atrape.

24. Various testimonies taken in Galicia, February 1569, Conway Collection add. 7257.

25. Testimony of Gregorio Sarmiento de Valladares to an inquiry held in Vigo, 24 February 1569, Conway Collection add. 7257.

26. Testimony of Antonio Pita to an inquiry held in Vigo, 23 February 1569, Conway Collection add. 7257.

TWENTY-SEVEN

1. Letter from Guerau de Spes to Philip II, London, 25 October 1568, in PRO, *Calendar of Letters and State Papers Relating to English Affairs Preserved Principally in the Archives of Simancas*, vol. 2, Elizabeth 1568–79.

2. See the deposition of Spanish ships' masters and pilots on the seizure of Spanish money, 7 January 1569, and the manifesto of Don Guerau de Spes, 10 January 1569, PRO, State Papers, Foreign, Elizabeth, SP70/105; also Froude, *English Seamen in the Sixteenth Century*, and Corbett, *Drake and the Tudor Navy*.

3. Froude, *English Seamen in the Sixteenth Century*, and Corbett, *Drake and the Tudor Navy*.

4. Letter from William Hawkyns to William Cecil, 3 December 1568, PRO, State Papers, Domestic, Elizabeth, SP12/48.

5. Relation of a Spaniard, 6 December 1568, PRO, State Papers, Domestic, Elizabeth, SP12/48.

6. Froude, *English Seamen in the Sixteenth Century*, and Corbett, *Drake and the Tudor Navy*.

7. Public edict of Elizabeth, 6 January 1569, included in High Court of the Admiralty inquiry into events at San Juan de Ulúa, PRO, State Papers, Domestic, Elizabeth, SP12/53.

8. Statement of the Privy Council to Guerau de Spes, 14 January 1569, PRO, State Papers, Foreign, Elizabeth, SP70/105.

9. Letter from William Hawkyns to William Cecil, 20 January 1569, PRO, State Papers, Domestic, Elizabeth, SP12/49.

10. Letter from William Hawkyns, 22 January 1569, PRO, State Papers, Domestic, Elizabeth, SP12/49.

TWENTY-EIGHT

1. Letter from William Hawkyns to William Cecil, 27 January 1569, PRO, State Papers, Domestic, Elizabeth, SP12/49.
2. "The rare travels of Job Hortop," in Hakluyt, *The Principall Navigations*.
3. Letters from Guerau de Spes to Philip II, 12 March and 2 April 1569, in PRO, *Calendar of Letters and State Papers Relating to English Affairs Preserved Principally in the Archives of Simancas*, vol. 2, Elizabeth 1568–79; also a letter from William Hawkyns to William Cecil, 27 January 1569, PRO, State Papers, Domestic, Elizabeth, SP12/49; see also Unwin, *The Defeat of John Hawkins*.
4. Letter from the Portuguese ambassador to William Cecil, February 1569, SP70/105 in PRO, *Calendar of State Papers, Foreign Series, of the reign of Elizabeth*.
5. Letter from Guerau de Spes to Philip II, London, 14 February 1569, in PRO, *Calendar of Letters and State Papers Relating to English Affairs Preserved Principally in the Archives of Simancas*, vol. 2, Elizabeth 1568–79.
6. Letter from John Hawkyns to William Cecil, 6 March 1569, PRO, State Papers, Domestic, Elizabeth, SP12/49.
7. High Court of the Admiralty inquiry into events at San Juan de Ulúa, PRO, State Papers, Domestic, Elizabeth, SP12/53.
8. Ibid.
9. Ibid.
10. In Hakluyt's book, Hawkyns's narrative was published under a slightly different title: "The third troublesome voyage made with the *Jesus of Lubeck*, the *Minion*, and foure other shippes, to the partes of Guinea and the West Indies, in the yeeres 1567 and 1568 by M John Hawkins."
11. A reference to the voluminous *Actes and monuments of martyrs* by John Fox, which had been published in 1563, and which told the story of Christian martyrs and Protestant heroes, particularly from the time of Queen Mary.

TWENTY-NINE

1. Excerpt from *A new work composed on the subject of an admirable victory won by Don Francisco Luxan against Don Juan Acle*, by Alvaro Flores, a native of Malaga and resident of Seville, included in Duro, *La Armada Invencible*.
2. Mexican Inquisition trial: John Lee, 1574, Conway Collection add. 7250.

3. Mexican Inquisition trial: Roger Armour, 1574, Conway Collection add. 7250.

4. Ibid.

5. Declaration of Valentine Green, 3 November 1569, in Various documents from Seville, Conway Collection add. 7258; Mexican Inquisition trials: John Farington and David Alexander, 1574, Conway Collection add. 7241 and 7249; Henry Morris, 10 November 1568, in the Certified notarial copy of the declarations of certain Englishmen taken at San Juan de Ulúa, Conway Collection add. 7257; confession of Henry Morris, 9 December 1569, in More confessions . . . , Conway Collection add. 7260.

6. Declaration of Thomas Bennet, taken at San Juan de Ulúa, 18 October 1568, Conway Collection add. 7257; and confession of Thomas Bennet, 6 December 1569, More confessions . . . , Conway Collection add. 7260.

7. Mexican Inquisition trial: John Lee, 1574, Conway Collection add. 7250.

8. Interviews with Richard Reed, John Hall, and Thomas Stephens, 6 October 1568, in Declarations of the English prisoners, Conway Collection add. 7257; confession of Thomas Hales, 28 August 1570, in Prisoners in Spain, His Majesty's Fiscal against certain Englishmen, Conway Collection add. 7257; and interview with Noah Sergeant, 2 November 1568, in Declaration of certain Englishmen, Conway Collection add. 7257.

9. Letter from de Ubilla to Philip II, 16 December 1568, Conway Collection add. 7255; also De Luxan to Philip II from San Juan de Ulúa, 11 January 1569, Conway Collection add. 7255.

10. Letter from the Viceroy to Delgadillo, 26 September 1568, in Documents of de Luxan presented 30 October 1570, Conway Collection add. 7259.

11. Letter from de Ubilla to Philip II, 16 December 1568, Conway Collection add. 7255. Also Documents of de Luxan presented 30 October 1570, Conway Collection add. 7259.

12. Letter from de Ubilla to Philip II, 16 December 1568, Conway Collection add. 7255.

13. John Chilton, "Travels in Mexico," in Hakluyt, *The Principall Navigations.*

14. Documents of Francisco de Luxan, presented in Madrid on 30 October 1570, Conway Collection add. 7259.

15. Robert Tomson, "Voyage to the West Indies and Mexico, 1556–58," in Hakluyt, *The Principall Navigations.*

16. Francisco Cervantes de Salazar, "Cronica de la Nueva Espana," in Conway, *An Englishman and the Mexican Inquisition.*

17. Robert Tomson, "Voyage to the West Indies and Mexico, 1556–58," in Hakluyt, *The Principall Navigations.*

18. Ibid.

19. "The relation of David Ingram, of Barking," in Hakluyt, *The Principall Navigations*.

20. "A discourse written by one Miles Phillips, Englishman, one of the company put ashore northward of Panuco," in Hakluyt, *The Principall Navigations*.

21. Report of Luis de Caravajal, alcalde ordinary of Tampico, 8 October 1568, Conway Collection add. 7257.

22. "A discourse written by one Miles Phillips, Englishman, one of the company put ashore northward of Panuco," in Hakluyt, *The Principall Navigations*.

23. Report of Luis de Caravajal, alcalde ordinary of Tampico, 8 October 1568, Conway Collection add. 7257.

24. "A discourse written by one Miles Phillips, Englishman, one of the company put ashore northward of Panuco," in Hakluyt, *The Principall Navigations*.

25. Juan Suarez de Peralta, "Historical Notices of New Spain," 1579–80, Conway Collection add. 7229.

26. "The rare travels of Job Hortop," in Hakluyt, *The Principall Navigations*.

27. "A discourse written by one Miles Phillips, Englishman, one of the company put ashore northward of Panuco," in Hakluyt, *The Principall Navigations*.

28. "Confession of Christopher Robertson, 2 November 1569, in More confessions . . . , Conway Collection add. 7260.

29. "A discourse written by one Miles Phillips, Englishman, one of the company put ashore northward of Panuco," in Hakluyt, *The Principall Navigations*.

30. Ibid.

31. De Luxan to Philip II from San Juan de Ulúa, 11 January 1569, Conway Collection add. 7255.

32. Mexican Inquisition trial: William Brown, 1574, Conway Collection add. 7250.

33. De Luxan to Philip II from San Juan de Ulúa, 11 January 1569, Conway Collection add. 7255.

34. Declaration of Valentine Green, 5 October 1568, in Declaration of the English prisoners, Conway Collection add. 7257; confessions of Anthony Goddard [2 November 1569] and Gregory Simon [24 November 1569] in More confessions . . . , Conway Collection add. 7260; confessions of Walter Johns [6 December 1569] and Thomas Johns [7 December 1569] in Various documents from Seville, Conway Collection add. 7258.

35. "A discourse written by one Miles Phillips, Englishman, one of the company put ashore northward of Panuco," in Hakluyt, *The Principall Navigations*.

36. Various documents in the Conway Collection.

37. Mexican Inquisition trial: Paul Hawkyns, 1574–77, Conway Collection add. 7237.

38. Mexican Inquisition trial: John Lee, 1574, Conway Collection add. 7250.

39. Mexican Inquisition trial: Roger Armour, 1574, Conway Collection add. 7250.

40. Mexican Inquisition trial: Thomas Goodal, 1574, Conway Collection add. 7243.

41. General Prosecution of the Mexican Inquisition, November 1572 . . . of the orders and proceedings for the imprisonment of the 30 Englishmen from John Hawkyns's fleet, in Conway Collection add. 7229. Also Mexican Inquisition trial: John Lee, 1574, Conway Collection add. 7250.

42. General Prosecution of the Mexican Inquisition, November 1572 . . . of the orders and proceedings for the imprisonment of the 30 Englishmen from John Hawkyns's fleet, in Conway Collection add. 7229.

43. Mexican Inquisition trial: John Gilbert, 1574, Conway Collection add. 7243.

44. Juan Suarez de Peralta, "Historical Notices of New Spain," 1579–80, Conway Collection add. 7229.

45. General Prosecution of the Mexican Inquisition, November 1572 . . . of the orders and proceedings for the imprisonment of the 30 Englishmen from John Hawkyns's fleet, in Conway Collection add. 7229.

46. Order of the Mexican Inquisition to arrest Englishmen, 10 November 1572, Conway Collection add. 7245.

47. Mexican Inquisition trial: William Lowe, 1574, Conway Collection add. 7245.

48. Mexican Inquisition trial: John Gilbert, 1574, Conway Collection add. 7243.

49. Mexican Inquisition trial: Thomas Goodal, 1574, Conway Collection add. 7243.

50. Mexican Inquisition trials: George Day, John Williams, Pablo de Leon, and John Gilbert, 1574, Conway Collection adds. 7247, 7249, and 7243.

51. Mexican Inquisition trial: Morgan Tillert, 1574, Conway Collection add. 7235.

52. Mexican Inquisition trial: John Breton, 1574, Conway Collection add. 7249.

53. Mexican Inquisition trial: William Brown, 1574, Conway Collection add. 7250.

54. Mexican Inquisition trial: George Day, 1574, Conway Collection add. 7247.

55. Mexican Inquisition trial: John Evans, 1574, Conway Collection add. 7250.

56. Mexican Inquisition trial: Paul Hawkyns, 1574–77, Conway Collection add. 7237.

57. Investigation and punishment of prisoners who drilled a hole in the jail of the Inquisition, June 1573, Conway Collection.

58. For a more detailed description of the pageantry and spectacle of the Mexican Inquisition see *Auto-da-fé in Mexico*, compiled by Melissa Bromfman de Ferrante, for the annual course on Performing Colonialism, 2000,

projects at the Hemispheric Institute Performance and Politics Archive, found at http:hemi.ps.tsoa.nyu.edu/archive/studentwork/colony/auto/auto_definitions.html.

59. "A discourse written by one Miles Phillips, Englishman, one of the company put ashore northward of Panuco," in Hakluyt, *The Principall Navigations.*

60. Mexican Inquisition trial: Roger Armour, 1574, Conway Collection add. 7250.

61. Mexican Inquisition trials: Andres Martin and Roldan Escalart, 1574, Conway Collection adds. 7245 and 7243.

62. Mexican Inquisition trial: George Riveley, 1574, Conway Collection add. 7233.

63. Ibid.

64. Juan Suarez de Peralta, "Historical Notices of New Spain," 1579–80, Conway Collection add. 7229.

65. Mexican Inquisition trial: William Cornelius, 1575, Conway Collection add. 7239.

66. "A discourse written by one Miles Phillips, Englishman, one of the company put ashore northward of Panuco," in Hakluyt, *The Principall Navigations.*

67. Mexican Inquisition trials: John Storey, 1577, Robert Cook, 1577, and Paul Hawkyns, 1574–77, Conway Collection adds. 7249 and 7237.

68. Mexican Inquisition trial: John Storey, 1577, Conway Collection add. 7249.

69. Mexican Inquisition trial: Paul Hawkyns, 1574–77, Conway Collection add. 7237.

70. Mexican Inquisition trial: David Alexander, 1574, Conway Collection add. 7249.

71. Mexican Inquisition trial: Thomas Ebren, 1573, Conway Collection add. 7245.

72. Mexican Inquisition trial: John Perin, 1574, Conway Collection add. 7243.

73. "The relation of David Ingram, of Barking," in Hakluyt, *The Principall Navigations.*

74. "A discourse written by one Miles Phillips, Englishman, one of the company put ashore northward of Panuco," in Hakluyt, *The Principall Navigations.*

THIRTY

1. For a detailed discussion of what Drake might have been up to see Kelsey, *Sir Francis Drake.* pp. 43–46.

2. See Williamson, *Hawkins of Plymouth.*

3. Letter from Philip II to Guerau de Spes, Madrid, 26 December 1569, in PRO,

Calendar of Letters and State Papers Relating to English Affairs Preserved Principally in the Archives of Simancas, vol. 2, Elizabeth 1568–79.

4. Letter from Guerau de Spes to Philip II, London, 18 June 1570, in PRO, *Calendar of Letters and State Papers Relating to English Affairs Preserved Principally in the Archives of Simancas,* vol. 2, Elizabeth 1568–79.

5. Letter from Guerau de Spes to Philip II, London, 22 June 1570, in PRO, *Calendar of Letters and State Papers Relating to English Affairs Preserved Principally in the Archives of Simancas,* vol. 2, Elizabeth 1568–79.

6. Letter from Guerau de Spes to Philip II, London, 12 August 1570, in PRO, *Calendar of Letters and State Papers Relating to English Affairs Preserved Principally in the Archives of Simancas,* vol. 2, Elizabeth 1568–79.

7. See Newton, *The European Nations in the West Indies.*

8. Petition of English prisoners, 22 November 1569, in Various documents from Seville, Conway Collection add. 7258.

9. Letter of Francisco Duarte Ortega de Melgosa and Juan Gutierrez Tello, 17 June 1570, in Various letters from Seville to Philip II, Conway Collection add. 7257.

10. Letter from Fowler and others to William Cecil, 25 February 1570, PRO, State Papers, Foreign, Elizabeth, SP70/110.

11. His Majesty's Fiscal against certain Englishmen brought from New Spain in the fleet of Francisco de Luxan, 16 February, 17 April, and 8 May 1570, Conway Collection add. 7257.

12. His Majesty's Fiscal against certain Englishmen brought from New Spain in the fleet of Francisco de Luxan, 14 February 1570, Conway Collection add. 7257.

13. His Majesty's Fiscal against certain Englishmen brought from New Spain in the fleet of Francisco de Luxan, 22 February 1570, Conway Collection add. 7257. Also Inquisition inquiry into heretical remarks of William de Orlando, 1569, Conway Collection add. 7229.

14. His Majesty's Fiscal against certain Englishmen brought from New Spain in the fleet of Francisco de Luxan, Conway Collection add. 7257.

15. Letter of Francisco Duarte Ortega de Melgosa and Juan Gutierrez Tello, 17 June 1570, in Various letters from Seville to Philip II, Conway Collection add. 7257.

16. His Majesty's Fiscal against certain Englishmen brought from New Spain in the fleet of Francisco de Luxan, 27 July and 3 August 1570, Conway Collection add. 7257.

17. Letters from Antonio de Guaras to Secretary of State Zayas, London, 2 Sep-

tember 1570, and Guerau de Spes to Philip II, London, 11 September 1570, in PRO, *Calendar of Letters and State Papers Relating to English Affairs Preserved Principally in the Archives of Simancas*, vol. 2, Elizabeth 1568–79.

18. See the following letters: John Hawkyns to Burghley, 13 May 1571, *State Papers, Scotland, Mary Queen of Scots*, vol. 6, no. 61; John Hawkyns to Burghley, 7 June 1571, *State Papers, Scotland, Mary Queen of Scots*, vol. 6, no. 73; John Hawkyns to Burghley, 4 September 1571, *State Papers, Domestic, Elizabeth*, vol. 81, no. 7.

19. Letter from Guerau de Spes to Philip II, London, 12 July 1571, in PRO, *Calendar of Letters and State Papers Relating to English Affairs Preserved Principally in the Archives of Simancas*, vol. 2, Elizabeth 1568–79.

20. Letter from John Hawkyns to Burghley, 4 September 1571, PRO, State Papers, Domestic, Elizabeth, SP12/58.

21. See letter of 27 September 1571, in Various letters from Seville to Philip II, Conway Collection add. 7257; see also Mary Hawkins, *Plymouth Armada Heroes*.

22. Letter from John Hawkyns to Burghley, 4 September 1571, PRO, State Papers, Domestic, Elizabeth, SP12/58.

23. Letter from Guerau de Spes to Philip II, London, 12 December 1571, in PRO, *Calendar of Letters and State Papers Relating to English Affairs Preserved Principally in the Archives of Simancas*, vol. 2, Elizabeth 1568–79.

24. Letter from Guerau de Spes to Philip II, Canterbury, 7 January 1572, in PRO, *Calendar of Letters and State Papers Relating to English Affairs Preserved Principally in the Archives of Simancas*, vol. 2, Elizabeth 1568–79.

25. The saga of this group of prisoners is described in "The rare travels of Job Hortop," in Hakluyt, *Principall Navigations*.

EPILOGUE

1. Quoted in Thomas, *The Slave Trade*, p. 174.

2. Included in a summary of the foreign ships stolen by the English off the coast of Portugal, Galicia, and England: PRO, State Papers, Foreign, Elizabeth, SP70/95, English spoils on the Portuguese.

3. Letter from the Privy Council to the English ambassador in Spain, Westminster, 8 March 1566, in *Acts of the Privy Council of England*, vol. 7, 1558–70.

4. "The voyage of M George Fenner to Guinea . . . in the year 1566, written by Walter Wren," in Hakluyt, *The Principall Navigations*.

5. Letter from Guerau de Spes to Philip II, London, 1 July 1570, in PRO, *Calendar of Letters and State Papers Relating to English Affairs Preserved Principally in the Archives of Simancas*, vol. 2, Elizabeth 1568–79.

6. See Newton, *The European Nations in the West Indies*.

7. An inquiry by a judge in the High Court of the Admiralty led to the Privy Council's setting conditions on any voyages being made by Cartes and Nonnez, Greenwich, 29 and 31 March 1571, in *Acts of the Privy Council of England*, vol. 8, 1571–75.

8. See Newton, *The European Nations in the West Indies*.

9. R. Jobson, quoted in Rodney, *A History of the Upper Guinea Coast*.

10. Purchas, *Hakluytus Posthumus*.

11. See Thomas, *The slave trade*, pp. 174, 196; Walvin, *Black Ivory*, pp. 3–8, 69; Galeano, *Open Veins of Latin America*, p. 77.

12. See Shyllon, *Black People in Britain*; Curtin, *The Atlantic Slave Trade*; Walvin, *Black Ivory*, p. 318; and Thomas, *The Slave Trade*.

13. Research of Dr. Nick Merriman of the Museum of London, reported in *Slavery and London* by Seán Mac Mathúna on the flame mag Web site at http://www.flamemag.dircon.co.uk/slavery_in_london.html.

14. See Inikori, *The Chaining of a Continent*.

15. See Rodney, *A History of the Upper Guinea Coast* and *West Africa and the Slave Trade*; Curtin, *The Atlantic Slave Trade*; Inikori, *The Chaining of a Continent*.

16. See "Europe and the Roots of African Underdevelopment to 1885," part 4.1 in Rodney, *How Europe Underdeveloped Africa*, pp. 103–12.

17. Letter from Antonio de Guaras, 29 March 1575, in PRO, *Calendar of Letters and State Papers Relating to English Affairs Preserved Principally in the Archives of Simancas*, vol. 2, Elizabeth 1568–79.

18. See Thomas, *The Slave Trade*, pp. 174–76.

19. See ibid., pp. 198–201, and Galeano, *Open Veins of Latin America*, p. 93.

20. See Thomas, *The Slave Trade*, pp. 202–3.

21. See Galeano, *Open Veins of Latin America*, p. 93.

22. Markham, *The Hawkins Voyages*.

23. See Williamson, *Hawkins of Plymouth*.

24. Froude, *English Seamen in the Sixteenth Century*, lecture 2: "John Hawkins and the African slave trade."

25. Prance, *Knights of the Sea*.

26. Quoted in Williamson, *Sir John Hawkins.*

27. Quoted in Rout, *The African Experience.*

28. Thomas de Mercado, quoted in Hair, "Protestants as Pirates, Slavers, and Proto-Missionaries: Sierra Leone 1568 and 1582," in Hair, *Africa Encountered.*

29. Las Casas quoted in Mannix and Cowley, *Black Cargoes.*

30. Quoted in Boxer, *The Portuguese Seaborne Empire.*

31. Quoted in Jordan, *White over Black.*

32. Quoted in Catterall, *Judicial Cases.*

33. See Walvin, *Black and White.*

34. Quoted in Shyllon, *Black People in Britain.*

35. See Walvin, *Black and White* and *The Black Presence.*

36. Open letter to the Lord Mayor of London and aldermen, and all other mayors and sheriffs, 11 July 1596, in *Acts of the Privy Council of England,* vol. 26, 1596–97, p. 16, as quoted in Walvin, *The Black Presence.*

37. See Walvin, *The Black Presence.*

38. Mary Hawkins, *Plymouth Armada Heroes,* and *Dictionary of National Biography,* vol. 25, Harris–Henry I, pp. 212–19.

39. Ibid.

40. *Dictionary of National Biography,* vol. 25, Harris–Henry I, pp. 212–19.

41. See Mary Hawkins, *Plymouth Armada Heroes.*

42. *Dictionary of National Biography,* vol. 25, Harris–Henry I, pp. 212–19.

43. BL, Lansdowne MSS, vol. lii, fol. 13.

44. *Dictionary of National Biography,* vol. 25, Harris–Henry I, pp. 212–19.

45. Ibid.

46. Ibid.

47. T. Maynard, in *Sir Francis Drake, his voyage 1595,* BL, ADD MS 5209.

48. See Mary Hawkins, *Plymouth Armada Heroes.*

49. Kingsley, *Westward Ho!*

BIBLIOGRAPHY AND SOURCES

PRIMARY SOURCES

British Library, London

Additional Manuscripts: 28, 5209, 26056 (b).
Cotton Manuscripts: Nero B. I, Otho E. VIII.
Lansdowne Manuscripts: 6, 11, 52, 113.

Public Record Office, London

State Papers, Domestic: 12/26, 12/35, 12/37, 12/40, 12/43, 12/44, 12/48, 12/49, 12/53, 12/81.

State Papers, Foreign: 70/31, 70/35, 70/73, 70/75, 70/94, 70/95, 70/98, 70/99, 70/105, 70/110.

High Court of the Admiralty: 24/41.

Navy Records: AO1/1682/3, AO1/1784 300, AO1/1784 301.

University of Cambridge Library, Cambridge

The Conway Collection consisting of documents of the Mexican Inquisition and documents belonging to the Archivo General de la Nación, Mexico (AGN). The Conway Collection also contains documents from the Archivos General de Indias and Simancas in Spain.

Additional manuscripts: 7229 (vol. 9 AGN), 7229 (vol. 49 AGN), 7229 (vol. 75 AGN), 7231, 7233 (vol. 54 AGN), 7235 (vol. 75 AGN), 7237 (vol. 55 AGN), 7239 (vol. 58 AGN), 7241 (vol. 54 AGN), 7243 (vol. 55 AGN), 7243 (vol. 56 AGN), 7243 (vol. 57 AGN), 7245 (vol. 51 AGN), 7245 (vol. 54 AGN), 7245 (vol. 55 AGN), 7245 (vol. 75 AGN), 7245 (vol. 116 AGN), 7246 (vol. 56 AGN), 7247 (vol. 1494 AGN), 7249 (vol. 53 AGN), 7249 (vol. 55 AGN), 7250 (vol. 56 AGN), 7250 (vol. 57 AGN), 7250 (vol. 149 AGN), 7255 (Signatura Antigua Archivo de Indias 59-4-3), 7255 (Signatura Antigua Archivo de Indias 59-4-3 volume of letters), 7255 (vol. 51 AGN), 7257 (Signatura Antigua Archivo de Indias 2-5-1-20-11), 7257 (Signatura Antigua Archivo de Indias 51-3-81/5), 7257 (Signatura Antigua Archivo de Indias 2-5-1/20-12/2), 7257 (Signatura Antigua Archivo de Indias 42-6-2/6 vol. 4), 7257 (Signatura Antigua Archivo de Indias 2-5-1/20-12), 7257 (Signatura Antigua Archivo de Indias 2-5-1-20, doc. 123), 7257 (Signatura Antigua Archivo de Indias 2-5-1-20, doc. 12), 7257 (Signatura Antigua Archivo de Indias 2-5-1-20, doc. 13, 25 1/2), 7258 (Signatura Antigua Archivo de Indias 51-3-81-5), 7259 (Signatura Antigua Archivo de Indias 51-6-16-14), 7259 (Signatura Antigua Archivo de Indias 52-1-12-9), 7260 (Signatura Antigua Archivo de Indias 42-6-2/6), 7260 (Signatura Antigua Archivo de Indias 51-3-81/5).

London Guildhall Library

MS 7857/1.

Archivo General de Indias, Seville, Spain

Justicia: 38, 92, 93, 902, 999.
Santo Domingo: 11, 71.

Original Primary Material and Documents Contained
in Published Works or Collections

Spanish documents included in Antonio Rumeu de Armas, *Los Viajes de John Hawkins a America, 1562–1595* (Seville: Publications de la Escuela de Estudios Hispano-Americanos, 1947).

MC: Inquisición. Signatura LIII-5. The trial of Pedro Soler. Testimony of Mateo de Torres, 23 June 1568, concerning the flight of the English from Santa Cruz in 1560.

MC: Inquisición. Signatura LXXX-12. Testimony of residents of Santa Cruz de Tenerife on the presence of English corsairs in the port, 8 July 1563.

AHN: Inquisición, leg 1824 (1). Information in the archives of the Inquisition of the Canaries against Bartolome de Ponte, prisoner, 1 July 1568.

MC: Inquisición. Signatura LXII-5. The trial of Pedro Soler. Testimony of several witnesses before the Inquisition on the stay of John Hawkyns in Tenerife and La Gomera in 1567.

AI: Patronato Real leg. 265, ramo 12. Account of events at San Juan de Ulúa in 1568.

Documents in Irene A. Wright, *Spanish Documents Concerning English Voyages to the Caribbean, 1527–1568 Selected from the Archives of the Indies at Seville* (London: Hakluyt Society, 1929).

Archivo General de Indias: 53-1-9, certified copy six and a half sheets. Depositions taken at Santo Domingo, 26 November–9 December 1527, concerning the appearance of an English ship in the port.

Archivo General de Indias: 53-6-12, one sheet. Hawkyns's license to trade on the north coast of Hispaniola, dated 19 April 1563, La Isabela.

Archivo General de Indias: 53-6-5, 11, fol. 264 et seq., two sheets. Official report from Santo Domingo to the Crown, on the arrival of the English on Hispaniola, 20 May 1563.

Archivo General de Indias: 53-6-5, 11, fol. 273 et seq. Echegoyan complains to the crown about Bernaldez, Santo Domingo, 28 July 1563.

Archivo General de Indias: 53-6-5, 1, fol. 280 et seq., two sheets. Bernaldez pleads his case to the Crown, Santo Domingo, August 1563.

Archivo General de Indias: 53-6-5, 11, fol. 286 et seq., two and a half sheets. Echegoyan makes further allegations to the Crown, Santo Domingo, 4 November 1563.

Archivo General de Indias: 47-3-52/9, fol. 81 et seq., one page. Call from officials in Burburata for help, 4 April 1565.

Archivo General de Indias: 47-3-52/9, fol. 99 et seq. Juan Pacheco, deposition on events in Burburata, 16 April 1565.

Archivo General de Indias: 17-3-5/9, fol. 88 et seq. Hawkyns to Licentiate Alonso Bernaldez, petition, Burburata, 16 April 1565.

Archivo General de Indias: 47-3-52/9, fol. 112 et seq. Official relation of Hawkyns's advance on Burburata, 19 April 1565.

Archivo General de Indias: 47-1-11/38. Proposed questionnaire for investigation into events at Rio de la Hacha, drawn up in Santo Domingo, 1567.

Archivo General de Indias: 2-5-1/20, 9-3, item 9. Hawkyns's license to trade at Rio de la Hacha, 21 May 1565.

Archivo General de Indias: 2-5-1/20, 9-4. Hawkyns's certificate of good conduct at Rio de la Hacha, 19–30 May 1565.

Archivo General de Indias: 54-4-24. Letter from the city of Rio de la Hacha to the Crown, 23 June 1567.

Archivo General de Indias: 54-4-24. Further letter from the city of Rio de la Hacha to the Crown, 9 July 1567.

Archivo General de Indias: 53-6-12, 1. Miguel de Castellanos to the Crown, from Rio de la Hacha, concerning John Lovell, 1 January 1568.

Archivo General de Indias: 54-4-28, 1. Hernando Castilla and Lazaro de Vallejo Alderete to the Crown, from Rio de la Hacha, concerning John Lovell, 8 January 1568.

Archivo General de Indias: 54-4-24. The city of Rio de la Hacha to the Crown, concerning John Lovell, 8 January 1568.

Archivo General de Indias: 53-6-12. Diego Ruiz de Vallejo to the Crown, New Segovia, 21 April 1568.

Archivo General de Indias: 54-4-28, 1. Report from Rio de la Hacha to the Crown concerning Hawkyns in the port, September 1568.

Archivo General de Indias: 54-4-28, 1. Miguel de Castellanos to the Crown, from Rio de la Hacha, 26 September 1568.

Archivo General de Indias: 72-4-31. The city council of Cartagena to the Crown, 30 September 1568.

Archivo General de Indias: 141-7-1. Don Martin Enriquez to John Hawkyns, from aboard the Spanish flagship, off San Juan de Ulúa, 18 September 1568.

Archivo General de Indias: 1-5-1/20, document 12-3, pp. 10–12. Luis Zegri to the Audiencia in Mexico City from Veracruz, 18 September 1568.

Archivo General de Indias: 51-6-16/14. fol. 115 et seq. Don Martin Enriquez's statement and supporting depositions, San Juan de Ulúa, 27–30 September 1568.

Archivo General de Indias: 2-5-1/20, doc. 11, pp. 29 et seq. Robert Barrett, deposition, Jalapa, 8 October 1568.

Archivo General de Indias: 1-58-6-8, i. The viceroy and Audiencia to the crown, Mexico City, 29 December 1568.

Acts of the Privy Council of England. Vol. 7, *1558–1570.* Edited by J. R. Dasent. Liechtenstein: Kraus Reprint, 1974.

Calendar of Letters and State Papers Relating to English Affairs Preserved

Principally in the Archives of Simancas. Vol. 1, *Elizabeth 1558–68.* Edited by Martin Hume. London: Her Majesty's Stationery Office, 1892.

Calendar of Letters and State Papers Relating to English Affairs Preserved Principally in the Archives of Simancas. Vol. 2, *Elizabeth 1568–79.* Edited by Martin Hume. London: Her Majesty's Stationery Office, 1892.

Calendar of the Manuscripts of the Most Hon. Marquis of Salisbury, Preserved at Hatfield House. London: Eyre and Spottiswoode, 1883.

Calendars of Patent Rolls preserved at the Public Record Office covering the period 1547–1569. Published by Her Majesty's Stationery Office, London.

Calendar of State Papers—Domestic Series, Edward VI, Mary, Elizabeth, 1547–1580. Edited by Robert Lemon. London: Longman, Brown, Green, Longmans and Roberts, 1856.

Calendar of State Papers—Domestic Series, Elizabeth, Addenda, 1566–1579. Edited by Mary Anne Everett Green. London: Longman and Co., 1871.

Calendar of State Papers—Foreign Series of the Reign of Elizabeth I. Edited by Joseph Stevenson. London: Longmans, Green, Reader, and Dyer, 1865.

Calendar of State Papers Relating to English Affairs Preserved Principally at Rome in the Vatican Archives and Library. Vol. 1, *Elizabeth 1558–71.* Edited by J. M. Rigg. London: His Majesty's Stationery Office, 1916.

Calendar of State Papers and Manuscripts Relating to English Affairs Existing in the Archives and Collections of Venice and Other Libraries of Northern Italy. Vol. 7, *1558–1580.* Edited by Rawdon Brown and G. C. Bentinck. London: Her Majesty's Stationery Office, 1890.

Accounts and Collections of Accounts of Explorers, Adventurers, Soldiers, and Others

Beazley, Charles Raymond, and Edgar Prestage, eds. *The Chronicle of the Discovery and Conquest of Guinea Written by Gomes Eannes de Azurara.* 2 vols. London: Hakluyt Society, 1898.

Blake, John W. *Europeans in West Africa, 1450–1560: Documents to Illustrate the Nature and Scope of Portuguese Enterprise in West Africa, the Abortive Attempt of Castilians to Create an Empire There, and the Early English Voyages to Barbary and Guinea.* 2 vols. London: Hakluyt Society, 1942.

Cadamosto, Alvise da. *The Voyages of Cadamosto and Other Documents on Western Africa in the Second Half of the Fifteenth Century.* Translated and edited by G. R. Crone. London: Hakluyt Society, 1937.

Conway, G. R. G., ed. *An Englishman and the Mexican Inquisition, 1556–1560:*

Being an Account of the Voyage of Robert Tomson to New Spain, His Trial for Heresy in the City of Mexico and Other Contemporary Historical Documents. Mexico City: privately printed, 1927.

Diaz, Bernal. *The Conquest of New Spain.* Translated and with an introduction by J. M. Cohen. London: Penguin, 1963.

Equiano, Olaudah. *The Interesting Narrative and Other Writings.* London: Penguin, 1995.

Hakluyt, Richard. *The Principall Navigations, Voyages, Traffiques and Discoveries of the English Nation, Made by Sea or over Land, to the Remote and Distant Quarters of the Earth, at Any Time Within the Compasse of These 1500 Yeeres. Devided into Three Severall Volumes, According to the Positions of the Region, Whereunto They Were Directed.* London: George Bishop, Ralph Newberie and Barker, 1589, 1591, 1598.

Las Casas, Bartolome de. *A Short Account of the Destruction of the Indies.* Edited and Translated by Nigel Griffin. London: Penguin, 1992.

Purchas, Samuel. *Hakluytus Posthumus; or, Purchas His Pilgrimes, Contayning a History of the World in Sea Voyages and Land Travels by Englishmen and Others.* 20 volumes. 1625. Reprint, Glasgow: James MacLehose & Sons, 1905–7.

GENERAL SOURCES

Adams, William H. D. *Neptune's Heroes: or, the Sea-kings of England. From Sir John Hawkins to Sir John Franklin.* London: Griffith & Farran, 1861.

Alie, Joe A. D. *A New History of Sierra Leone.* London: Macmillan Overseas, 1990.

Andrews, Kenneth R. *Drake's Voyages: A Reassessment of Their Place in Elizabethan Maritime Expansion.* London: Weidenfeld & Nicholson, 1967.

———. *The Elizabethan Seaman.* London: National Maritime Museum, in conjunction with the Society for Nautical Research, 1982.

———. "Thomas Fenner and the Guinea Trade, 1564." *The Mariner's Mirror* 38, no. 4 (November 1952), pp. 312–14.

Andrews, Kenneth R., N. P. Canny, and P. E. H. Hair, eds. *The Westward Enterprise: English Activities in Ireland, the Atlantic, and America, 1480–1650.* Liverpool: Liverpool University Press, 1978.

Arber, Edward. *An English Garner: Ingatherings from Our History and Literature.* 8 vols. London: Archibald Constable & Co., 1877–96.

Barnicott, Roger. *Plymouth in History.* London: Cornubian Press, 1906.

Baron, R. W. S. *Mayors and Mayoralties, or the Annals of the Borough*. Plymouth, Eng.: Amelia Arliss, 1846.

Barrow, John. *Memoirs of the Naval Worthies of Queen Elizabeth's Reign*. London: John Murray, 1845.

Benedict, Francis Gano. *A Study of Prolonged Fasting*. Washington, D.C.: Carnegie Institution of Washington, 1915.

Birmingham, David. *Portugal and Africa*. London: Macmillan, 1999.

Bisson, Douglas R. *The Merchant Adventurers of England: The Company and the Crown, 1474–1564*. Newark: University of Delaware Press; London: Associated University Presses, 1993.

Black, J. B. *The Reign of Elizabeth, 1558–1603*. Oxford: Oxford University Press, 1959.

Boxer, C. R. *Four Centuries of Portuguese Expansion, 1415–1825: A Succinct Survey*. Johannesburg: Witwatersrand University Press, 1961.

―――. *The Portuguese Seaborne Empire, 1415–1825*. Manchester, Eng.: Carcanet Press in association with the Calouste Gulbenkian Foundation, 1991.

Bracken, C. W. *A History of Plymouth and Her Neighbours*. Plymouth, Eng.: Underhill, 1931.

Camden, William. *The History of the Most Renowned and Victorious Princess Elizabeth, Late Queen of England*. 4th ed. London: J. Tonson, 1688.

Caraman, Philip. *The Western Rising 1549: The Prayer Book Rebellion*. Tiverton, Eng.: Westcountry Books, 1994.

Casson, Lionel. "Setting the Stage for Columbus." *Archaeology*, May–June 1990, pp. 50–55.

Catterall, Helen Tunnicliff. *Judicial Cases Concerning American Slavery and the Negro*. Vol. 1. Shannon: Irish University Press, 1968.

Corbett, Julian S. *Drake and the Tudor Navy: With a History of the Rise of England as a Maritime Power*. 2 volumes. London: Longmans, Green & Co., 1899.

Curtin, Philip D. A. *The Atlantic Slave Trade: A Census*. Madison: University of Wisconsin Press, 1969.

Diffie, Bailey W., and George D. Winius. *Foundations of the Portuguese Empire, 1415–1580*. St. Paul: University of Minnesota Press, 1977.

Donahue, Patricia. *Plymouth Ho! The West in Elizabethan Times*. Then and There Series. London: Longman, 1958.

Donnan, Elizabeth. *Documents Illustrative of the History of the Slave Trade to America*. New York: Octagon Books, 1965.

Duro, C. F. *Armada Española, desde la Union de los Reinos de Castilla y de Aragon*. Madrid: Sucesores de Rivadeneyra, 1896.

————. *La Armada Invencible*. Madrid: Sucesores de Rivadeneyra, 1884.

Eldred, Charles E., and W. H. K. Wright. *Streets of Old Plymouth*. Plymouth, Eng.: James H. Keys, 1901.

Elton, G. R. *England 1200–1640—the Sources of History*. Cambridge, Eng.: Cambridge University Press, 1969.

Fage, J. D. *An Atlas of African History*. London: Edward Arnold, 1978.

————. *A Guide to Original Sources for Precolonial Western Africa Published in European Languages for the Most Part in Book Form*. Madison: African Studies Program, University of Wisconsin, 1994.

————. *A History of West Africa: An Introductory Survey*. Aldershot, Eng.: Gregg Revivals, 1992.

————. "Upper and Lower Guinea." In *The Cambridge History of Africa*, vol. 3, 1050–1600, edited by Roland Oliver. Cambridge, Eng.: Cambridge University Press, 1977.

Froude, J. A. *English Seamen in the Sixteenth Century: Lectures Delivered at Oxford, Easter Terms, 1893–94*. London: Longmans, Green & Co., 1930.

Fyfe, Christopher. *A History of Sierra Leone*. London: Oxford University Press, 1962.

————. *A Short History of Sierra Leone*. London: Longman, 1979.

Fyle, C. Magbaily. *The History of Sierra Leone: A Concise Introduction*. London: Evans Brothers, 1981.

Galeano, Eduardo. *Open Veins of Latin America*. New York: Monthly Review Press, 1973.

Gill, Crispin. *Plymouth: A New History, Ice Age to the Elizabethans*. London: David & Charles, Newton Abbot, 1979.

————. *Plymouth River: A History of the Laira and Cattewater*. Tiverton, Eng.: Devon Books, 1997.

Gosse, Philip. *Sir John Hawkins*. London: John Lane, 1930.

Gwynne-Jones, D. R. G. *A New Geography of Sierra Leone*. London: Longman, 1978.

Hair, P. E. H. *Africa Encountered: European Contacts and Evidence, 1450–1700*. Aldershot, Eng.: Variorum, 1997.

————, ed. *Travails in Guinea: Robert Baker's "Briefe Dyscourse."* Liverpool: Liverpool University Press, 1990.

Hair, P. E. H., and J. D. Alsop. *English Seamen and Traders in Guinea, 1553–1565: The New Evidence of Their Wills*. Lewiston, N.Y.: Edwin Mellen Press, 1992.

Hawkins, Mary W. S. *Plymouth Armada Heroes: The Hawkins Family*. Plymouth, Eng.: W. Brendon & Son, 1888.

Hawkins, Sir Richard. *The Observations of Sir Richard Hawkins, Knight, in His Voyage into the South Sea, Anno Domini 1593*. London: John Jaggard, 1622.

Hope, Valerie. *My Lord Mayor: Eight Hundred Years of London's Mayoralty*. London: Weidenfeld & Nicholson, in association with the Corporation of London, 1989.

Inikori, Joseph E. *The Chaining of a Continent: Export Demand for Captives and the History of Africa South of the Sahara, 1450–1870*. Mona, Jamaica: Jamaica Institute of Social and Economic Research University of the West Indies, 1992.

Jarrett, H. R. *A Geography of Sierra Leone and Gambia*. London: Longmans, 1964.

Jewitt, Llewellynn. *A History of Plymouth*. Plymouth, Eng.: Simpkin, Marshall and Co., 1873.

Johnson, Kim. "The Story of the Caribs and Arawaks: The Contemporary Context of Carib 'Revival.'" In *Trinidad and Tobago: Creolization, Developmentalism, and the State*. www.raceandhistory.com/Taino

Jordan, Winthrop D. *White over Black—American Attitudes Toward the Negro, 1550–1812*. Baltimore: Penguin, 1971.

Kelsey, Harry. *Sir Francis Drake: The Queen's Pirate*. New Haven, Conn.: Yale University Press, Yale Nota Bene, 2000.

———. *Sir John Hawkins: Queen Elizabeth's Slave Trader*. New Haven, Conn.: Yale University Press, 2003.

Kingsley, Charles. *Westward Ho!* London: T. Nelson and Sons., 1920.

Kiple, Kenneth F. *The Caribbean Slave: A Biological History*. Cambridge, Eng.: Cambridge University Press, 1984.

Kiple, Kenneth F., and Stephen V. Beck, eds. *Biological Consequences of the European Expansion, 1450–1800*. Vol. 26 of *An Expanding World: The European Impact on World History, 1450–1800*. Aldershot, Eng.: Ashgate, 1977.

Kirkpatrick, F. A. "The First Recorded English Voyage to the West Indies." *English Historical Review* 20 (1905), pp. 115–24.

Klein, Herbert S. *African Slavery in Latin America and the Caribbean*. Oxford: Oxford University Press, 1986.

Lemonick, Michael D. "Before Columbus—Destroyed Almost Overnight by Spanish Invaders, the Culture of the Gentle Taino Is Finally Coming to Light." *Archaeology* 152, no. 16 (19 October 1998).

Lewis, Michael A. "The Guns of the *Jesus of Lubeck*." *The Mariner's Mirror* 22 (July 1936), pp. 324–45.

———. *The Hawkins Dynasty: Three Generations of a Tudor Family*. London: George Allen & Unwin, 1969.

Lobban, Richard. "Jews in Cape Verde and on the Guinea Coast." Paper presented at the University of Massachusetts–Dartmouth, 11 February 1996. http://www.umassd.edu/specialprograms/caboverde/jewslobban.html.

Mannix, Daniel P., in collaboration with Malcolm Cowley. *Black Cargoes: A History of the Atlantic Slave Trade, 1518–1865*. London: Longmans, Green & Co., 1963.

Markham, Clements R., ed. *The Hawkins' Voyages During the Reigns of Henry VIII, Queen Elizabeth and James I*. London: Hakluyt Society, 1878.

Marsden, R. G. "Voyage of the *Barbara* of London, to Brazil in 1540." In *English Historical Review* 24 (1909), pp. 96–100.

Matthews, Noel. *Materials for West African History in the Archives of the United Kingdom*. London: University of London, Athlone Press, 1973.

Milton, Giles. *Nathaniel's Nutmeg: How One Man's Courage Changed the Course of History*. London: Hodder and Stoughton, 1999.

Mosk, Sanford A. "Spanish Pearl-Fishing Operations on the Pearl Coast in the Sixteenth Century." *Hispanic American Historical Review* 18, no. 3 (1938), pp. 392–402.

Newton, Arthur P. *The European Nations in the West Indies, 1493–1688*. London: A. & C. Black, 1933.

Nichols, Philip. *Sir Francis Drake Revived taken out of the report of Christopher Ceely, Ellis Hixon and others*. London: E.A. for N. Bourne, 1626.

Palmer, Colin A. *The First Passage: Blacks in the Americas, 1502–1617*. Oxford: Oxford University Press, 1995.

Parry, J. H., P. M. Sherlock, and A. P. Maingot. *A Short History of the West Indies*. London: Macmillan Caribbean, 1987.

Pearson, J. D. *A Guide to Manuscripts and Documents in the British Isles Relating to Africa*. London: Mansell, 1993.

Prance, Cyril Rooke. *Knights of the Sea: A Viking Family: The Voyages and Adventures of Sir John Hawkins, Maker of History, and His Kin*. London: Quality Press, 1938.

Prestage, Edgar. *The Portuguese Pioneers*. London: A. & C. Black, 1933.

Prince, John. *Danmonii Orientales Illustres, or the Worthies of Devon*. Exeter and London: C. Yeo and P. Bishop's, 1701.

Pye, Andrew, and Freddy Woodward. *The Historic Defences of Plymouth*. Truro, Eng.: Cornwall County Council, for Exeter Archaeology Fortress Study Group South West, 1996.

Ramsay, George D. *The City of London in International Politics at the Accession of Elizabeth Tudor*. Manchester, Eng.: Manchester University Press, 1975.

Rodney, Walter. *A History of the Upper Guinea Coast*. Oxford: Clarendon Press, 1970.

———. *West Africa and the Atlantic Slave Trade*. Lagos: Africa Research Group, Afrografika Publishers, 1970.

Rout, Leslie B. *The African Experience in Spanish America, 1502 to the Present Day*. Cambridge, Eng.: Cambridge University Press, 1976.

Rowse, A. L. *The Expansion of Elizabethan England*. London: Cardinal Books, 1973.

Rumeu de Armas, Antonio. *Los Viajes de John Hawkins a America, 1562–1595*. Seville: Publications de la Escuela de Estudios Hispano-Americanos, 1947.

Ryder, Alan Frederick Charles. *Materials for West African History in Portuguese Archives*. London: Athlone Press, 1965.

Sauer, Carl O. *The Early Spanish Main*. Berkeley and Los Angeles: University of California Press, 1969.

Scammell, G. V. "Manning the English Merchant Service in the Sixteenth Century." *The Mariner's Mirror* 56, no. 2 (May 1970), pp. 131–54.

Shyllon, Folarin O. *Black People in Britain, 1555–1833*. London: Institute of Race Relations, Oxford University Press, 1977.

Southey, Robert. *English Seamen: Hawkins, Greenville, Devereux, Raleigh*. London: Methuen & Co., 1904.

Thomas, Hugh. *The Conquest of Mexico*. London: Pimlico, 1994.

———. *The Slave Trade: The History of the Atlantic Slave Trade, 1440–1870*. London: Picador, 1997.

Thornton, John K. *Africa and Africans in the Making of the Atlantic World, 1400–1680*. Cambridge, Eng.: Cambridge University Press, 1992.

Unwin, Rayner. *The Defeat of John Hawkins: A Biography of His Third Slaving Voyage*. London: George Allen & Unwin, 1960.

Velasco, Juan Lopez de. *Geografía y descripción de las Indias desde el año de 1571 al de 1574*. Madrid: Fortanet, 1894.

Walling, R. A. J. *A Sea-Dog of Devon: A Life of Sir John Hawkins*. London: Cassell & Co., 1907.

———. *The Story of Plymouth*. London: Westaway Books, 1950.

Walvin, James. *Black and White: The Negro and English Society, 1555–1945*. London: Allen Lane, 1973.

———. *Black Ivory: A History of British Slavery*. London: Fontana Press, 1993.

———. *The Black Presence: A Documentary History of the Negro in England, 1555–1860*. London: Orbach & Chambers, 1971.

Williamson, J. A. *Hawkins of Plymouth: A New History of Sir John Hawkins and of the Other Members of His Family Prominent in Tudor England.* London: Black, 1969.

————. *Sir John Hawkins: The Time and the Man.* Oxford: Clarendon Press, 1927.

Winius, George D., ed. *Portugal, the Pathfinder: Journeys from the Medieval Toward the Modern World 1300–ca.1600.* Madison, Wis.: Madison Hispanic Seminary of Medieval Studies, 1995.

Worth, R. N. *Calendar of the Plymouth Municipal Records.* Plymouth, Eng.: n. p., 1893.

————. *History of Plymouth, from the Earliest Period to the Present Time.* Plymouth, Eng.: William Brendon and Son, 1890.

Wright, Irene A. *Documents Concerning English Voyages to the Spanish Main, 1569–1580.* Vol. 1, *Spanish Documents Selected from the Archives of the Indies at Seville.* Vol. 2, *English Accounts: "Sir Francis Drake Revived" and Others, Reprinted.* London: Hakluyt Society, 1932.

————. *Spanish Documents Concerning English Voyages to the Caribbean, 1527–1568, Selected from the Archives of the Indies at Seville.* London: Hakluyt Society, 1929.

Zell, Hans M. *A Bibliography of Non-Periodical Literature on Sierra Leone, 1925–1966.* Freetown: Fourah Bay College Bookshop, University College of Sierra Leone, 1967.

INDEX